Poetry of the Revolution

TRANSLATION | TRANSNATION

SERIES EDITOR **EMILY APTER**

MARTIN PUCHNER

Poetry of the Revolution
Marx, Manifestos, and the Avant-Gardes

PRINCETON UNIVERSITY PRESS

PRINCETON AND OXFORD

Library of Congress Cataloging-in-Publication data

Puchner, Martin, 1969–
Poetry of the revolution : Marx manifestos, and the avant-gardes /
Martin Puchner.
Includes bibliographical references and index.
ISBN-13: 978-0-691-12259-5 (cloth : alk. paper)
ISBN-10: 0-691-12259-8
ISBN-13: 978-0-691-12260-1 (pbk. : alk. paper)
ISBN-10: 0-691-12260-1 (pbk.)
1. Avant-garde (Aesthetics)—History—20th century. 2. Arts, Modern—
20th century. 3. Arts—Political aspects. 4. Revolutionary literature—
History and criticism. 5. Marx, Karl, 1818–1883. Manifest der
Kommunistischen Partei. I. Title. II. Series.
NX456.P83 2006
701′.03′0904—dc22 2005016961

British Library Cataloging-in-Publication Data is available
This book has been composed in Minion with Gill Sans Display
Printed on acid-free paper. ∞
pup.princeton.edu
Printed in the United States of America
10 9 8 7 6 5 4 3 2 1

For Amanda Claybaugh

CONTENTS

ACKNOWLEDGMENTS

A book as wide-ranging as this one depends on the generosity of many friends and colleagues. First, I would like to acknowledge the immense work of those who took the time and energy to read through and comment on the entire manuscript: Emily Apter, David Damrosch, Franco Moretti, Bruce Robbins, and a reader for Princeton University Press who remained anonymous. Jed Esty, another reader for Princeton, wrote what I believe is the most extensive and helpful reader's report in the history of the genre. They all made the manuscript infinitely better than it possibly could have been without them. At Princeton, I would like to thank Mary Murrell and Hanne Winarsky for their unfaltering support of this project, Dimitri Karetnikov for finding the perfect format for charts and illustrations, and Susan Ecklund for copyediting.

As I was developing this project, I was particularly thankful for those colleagues who provided venues for presenting it in its earlier incarnations: Christopher Balme, Kelly Barry, Jenny Davidson, Barbara Johnson, Douglas Mao, William Marx, David Román, Judith Ryan, Dietrich Scheunemann, Rebecca Schneider, Rebecca L. Walkowitz, and Laura Winkiel. Their suggestions and comments have helped me shape this book in important ways.

Equally important have been the countless conversations about manifestos I have forced on friends and colleagues, including Alan Ackerman, Stefan Andriopoulos, Jonathan Arac, Arnold Aronson, Philip Auslander, Una Chaudhuri, Sarah Cole, Julie Crawford, Elin Diamond, Ann Douglas, James Engell, Michael Eskin, Martin Harries, Sam Haselby, Andreas Huyssen, Shannon Jackson, Djelal Kadir, Caroline Levine, Pericles Lewis, Janet Lyon, Jon McKenzie, Martin Meisel, Edward Mendelson, Klaus Mladek, Marjorie Perloff, Peggy Phelan, David Savran, Richard Schechner,

James Shapiro, Daniel Sherer, Matthew Smith, Luca Somigli, Gayatri C. Spivak, and Mark Wigley.

I learned much from my students, in particular those in my graduate seminars on modernism. I also would like to acknowledge the collegial support I have enjoyed at both Columbia and Cornell.

During the many years of working on this project, I received the help of excellent research assistants, especially Sun-Young Park and Patricia Akhimie. I would also like to thank Columbia University for a Junior Faculty Development leave, a Chamberlain Fellowship, and a summer fellowship, and Cornell University for a one-semester teaching relief.

In addition to those already listed, many friends supported me while I was working on this project: Rachel Adams, Tim Baldenius, Jon Connolly, Jochen Hellbeck, Noah Heringman, Sascha Lehnartz, Monica Miller, Henry Turner, and Carl Wennerlind. My brothers, Stephan and Elias, and my mother, Annelore, have been unwavering in their support and many times have supplied me with important thoughts and comments.

My greatest gratitude goes to Amanda Claybaugh, to whom this book is dedicated. Without her, I would not have known what to say or whether to say it, and I would have said it very badly indeed. She is present in every argument and every word.

A few sections of this book have been published in earlier forms by Presses Universitaires de France (2004), *Theatre Research International* (2004), *Theatre Journal* (2002), and Rodopi (2000). I thank these publishers for their permission to reprint these articles here in altered form.

Poetry of the Revolution

Manifestos—Poetry of the Revolution

> The social revolution of the nineteenth century cannot derive its poetry from the past, but only from the future. It cannot begin with itself, before it has shed all superstitious belief in the past. Earlier revolutions needed to remember previous moments in world history in order to numb themselves with regard to their own content. The revolution of the nineteenth century must let the dead bury the dead in order to arrive at its own content. There, the phrase exceeded the content. Here the content exceeds the phrase.

Karl Marx published these sentences in *The 18th Brumaire of Louis Bonaparte* to explain the failure of the 1848 revolution in France.[1] The revolution failed, Marx tells us, because it was a mere recapitulation of the great French Revolution, a return to a previous moment in history. Marx acknowledges that all revolutions had looked back in this way: Luther's Protestant revolution had referred to the apostle Paul, and the French Revolution, to Roman antiquity. But while such historical borrowings and regressions may have been adequate for Luther and the French Revolution, they are no longer adequate now, in the middle of the nineteenth century, when we need a "modern revolution" (13). But a modern revolution is difficult to achieve.[2] After shedding the costumes and phrases of the past, the modern revolution must somehow invite the future, come up with phrases, forms, and genres that "derive" their "poetry" from this future—and here Marx's term "poetry" resonates with the original Greek meaning of *poesis* as an act of making.[3]

I argue that Marx had already invented a poetry of the future revolution, a form that would help revolutionary modernity to know itself, to arrive at itself, to make and to manifest itself, namely, the *Communist Manifesto*. The *Manifesto* is a text forged in accordance with Marx's eleventh thesis

on Feuerbach, that philosophers should not only interpret the world but also change it. Divided between doing away with the past and ushering in the future, the *Manifesto* seeks to produce the arrival of the "modern revolution" through an act of self-foundation and self-creation: we, standing here and now, must act! Manifestos tend to present themselves as mere means to an end, demanding to be judged not by their rhetorical or literary merits— their poetry—but by their ability to change the world. Marx, however, helps us understand that it is their form, not their particular complaints and demands, that articulates most succinctly the desires and hopes, maneuvers and strategies of modernity: to create points of no return; to make history; to fashion the future.

Scattered texts had been called manifestos for centuries, but Marx and Engels's *Manifesto* gathered these texts into a distinct genre. However, it took the *Manifesto* decades before it could gain any prominence and therefore define what a manifesto should be. Once the *Manifesto* became the central icon of communism, a new dynamic made itself felt: the genre it helped create could no longer be used without careful deliberation. Many later communist manifestos, such as the founding manifestos of communist parties and of the socialist internationals, were therefore plagued by the fear that writing a new manifesto would somehow displace the *Communist Manifesto*, that new manifestos would relegate the old and original one to the status of a historical document.

The predominance of the *Manifesto* over the subsequent history of the genre means that a history of the manifesto must also entail a history of socialism. A number of Marxian critics, including Antonio Gramsci, Kenneth Burke, Louis Althusser, and Perry Anderson, help me specify how manifestos weave together social theory, political acts, and poetic expression. Manifestos do not articulate a political unconscious that needs to be excavated through careful analysis, as Fredric Jameson does in the case of the novel; rather, they seek to bring this unconscious into the open.[4] This desire for openness and manifestation is central to the manifesto, defining its creative practice, as Raymond Williams might put it, of articulating what has been hitherto unarticulated.[5] Foregrounding this creative practice is at odds with most theories premised on the determining function of history or modes of production. Manifestos need to be recognized not only as symptoms and indices of social formations, as superstructure, but also as moments of actual or attempted intervention, perhaps even as instances of the superstructure altering the base. Whether or not individual manifestos actually accomplish their ambitious goals—some altered history far beyond their wildest dreams—matters less than the literary, poetic, and rhetorical strate-

gies they developed for the single purpose of changing the world. The history of successive manifestos is thus also a history of the futures these manifestos sought to predict, prefigure, and realize.[6]

If identifying the historical formation and poetry of the *Communist Manifesto* is one task, scrutinizing its geographic distribution is another. Here I draw on the invaluable work of Bert Andréas and his publisher, Feltrinelli, who assembled the *Manifesto*'s planned and executed translations and editions. Based on their data, it is possible to track not only the *Manifesto*'s history but also the process through which it became, in its own words, "world literature." The *Manifesto*'s obsession with its own translations, called for in its preamble and reiterated in Marx's and Engels's prefaces, contains the seeds of a new understanding of international literature that resonates in various ways with current discourses on literature and globalization. The map of the *Manifesto*'s geographic diffusion in the late nineteenth and early twentieth centuries also prefigures the map of the European and then non-European avant-gardes. Insisting on an international view of the avant-garde, I trace the trans-European and transatlantic travel routes of the Romanian Tristan Tzara, the Cuban-French Francis Picabia, and the Chilean Vicente Huidobro, including the journals that traveled with them. Just as the diffusion of the *Manifesto* shows how this text acquired the status of world literature, so the transportation, transmission, and adaptation of avant-garde manifestos indicate how these texts formed an international avant-garde, an avant-garde at large.[7]

One of the chief interests of this book is to explain how and why the manifesto enters the sphere of art in the early twentieth century. A crucial moment in the emancipation of the art manifesto from the socialist manifesto is Filippo Tommaso Marinetti's fascist critique of Marxism. This critique, drawing on the French syndicalist Georges Sorel, allowed him to break with the communist reverence for the original *Manifesto* and to forge a new manifesto, one that continued to function as a political document but whose primary purpose was now artistic. The impact of futurist manifestos, what I call the "futurism effect," can be fathomed from the strong reactions they caused in the European semiperiphery of industrialization such as Italy and Russia, but also in England and Latin America. Fascist sympathizers such as Ezra Pound and Wyndham Lewis reacted to the manifesto-driven avant-garde in a mode I call "rear-guardism." Others remained skeptical of Italy's most aggressive export product because it seemed to introduce modes of advertisement and propaganda into the domain of literature. Whether the manifesto was greeted with enthusiasm or suspicion, everyone, including

its detractors, was now relying on it—many even issued manifestos directed against the new manifesto craze itself.

Just as histories of Marxism have tended to foreground the content of the *Manifesto* at the expense of its form, so most histories of twentieth-century art have relied on the definitions and doctrines they found expressed in art manifestos and neglected the form in which these doctrines were articulated. One exception is Marjorie Perloff's important *Futurist Moment,* which relates futurist poetry to the form of the manifesto.[8] Perloff's insight has been taken up recently, yielding studies that are devoted to the various forms and effects of avant-garde manifestos. In his detailed study of French symbolist and Italian futurist manifestos, for example, Luca Somigli has shown how manifestos contributed to legitimizing artists and the art they produced.[9] And Janet Lyon has emphasized the function of the manifesto in articulating group identities, of establishing speaking positions for various minorities seeking to be heard, even if this meant violating the decorum of the public sphere as analyzed by Jürgen Habermas. Finally, her focus on feminist rewritings of manifestos demonstrates the extent to which questions of gender are woven into the fabric of this genre.[10]

Building on these studies, *Poetry of the Revolution* offers a view of the manifesto that is centrally shaped by the insistence on reading avant-garde manifestos alongside political ones. I show how, through their common reliance on manifestos, the socialist internationals and transnational avant-garde movements found themselves in an intimate, if contentious, alliance from which neither could entirely escape. Italian and Russian futurists wrote political manifestos, and Marinetti even ran for political office; dadaism wanted to continue the political struggle of Vladimir Lenin in Zurich and of Rosa Luxemburg in Berlin; Lewis felt the need to declare his political allegiance to the women's suffrage movement; André Breton wanted his manifestos to further the ends of the French Communist Party; and Guy Debord hoped to instigate a revolt against the spectacle. The rivalry between art manifestos and political manifestos came to the fore when these writers' attempts to cross from art into politics were cut short: Benito Mussolini reined in Marinetti and Leon Trotsky, Velimir Khlebnikov; the French Communist Party alienated Breton; and Debord, to escape a similar fate, founded his own political micro-organization. The history of these competing manifestos is thus a history of struggle about the relation between art and politics, a struggle, in other words, about the best poetry of the revolution.

What a study of manifestos requires, therefore, is a poetics of the manifesto that is, at the same time, a politics of the manifesto, an analysis that combines a political theory of speech acts with reading practices in-

torian) past. To be sure, important strains of modernism celebrate an art of impersonal detachment where the manifesto tends to undertake collective attacks. However, modernist depersonalization was itself driven by a submerged desire for collectivity, the hope that bracketing the individual would somehow, *via negativa*, allow a new collectivity to emerge. Manifestos, with their multiple signatories and collective demands, can therefore be seen as the very wish fulfillment of modernism. Indeed, modernists such as Ford Madox Ford and rear-guardists such as Lewis and Pound were drawn into the manifesto mania without giving up on their modernist doctrines and sensibilities, a fact that argues in favor of alliances and shared projects across the presumed line separating high modernism and manifesto-driven or avant-garde modernism.

Whether one wishes to emphasize or downplay the differences between modernism and manifesto art, they participate in an important feature that connects them to the larger themes that form the ultimate subject of this book, namely, the time and space of modernity. T. S. Eliot's conception of a retroactive construction of traditions can appear strikingly similar to the way in which Breton, in his *Manifesto of Surrealism*, identifies surrealists *avant la lettre*, and Pound's archaeological collages resonate with Debord's layers of quotes and misquotes from Marx. All these figures struggle with the specific temporality of modernity, a temporality of breaks and new beginnings that nevertheless continues to be confronted with a past that can never be abandoned for good. This temporality, in all its tensions and contradictions, appears in Enlightenment philosophy and political declarations, in modernist primitivism, avant-garde poetry, and the modernist novel, but it appears nowhere as succinctly and strikingly as in the genre of the manifesto.

In the last instance, then, *Poetry of the Revolution* seeks to study the manifesto not for its own sake but as a means to an end, as a genre that uniquely represents and produces the fantasies, hopes, aspirations, and shortcomings of modernity. Subjecting them to a critical analysis is the project undertaken here. Only if we understand the history of the manifesto can we arrive at our own timely articulations.

Marx and the Manifesto

The Formation of a Genre

The *Communist Manifesto* influenced the course of history more directly and lastingly than almost any other text. The Paris Commune, the Russian Revolution, and the independence movements in the colonial world are only some of the historical events that were inspired and shaped by this document. How could a single text achieve such a feat? To be sure, none of these events are thinkable without the histories of capitalism and colonialism or the effects of the two world wars. And yet, these broad historical forces do not explain why it was the *Manifesto*, and not one of its many rival documents, that acquired such central importance. The answer to this question must be sought not so much in the history of revolutions but in the *Manifesto* itself, and it must be sought not only in its content but also in its form. For the *Manifesto*'s unparalleled success was due in no small part to its ingenious composition, to the fact that Marx and Engels created with this text nothing less than a new genre. This new genre brought into a novel and startling juncture philosophy and politics, analysis and action, historiography and intervention. Understanding the features of this genre and charting its influence over the politics and art of the late nineteenth and twentieth centuries is the purpose of this book.

Even though the *Manifesto* became the single most significant manifesto, the text that defined for many subsequent writers what a manifesto should be, Marx and Engels did not create this genre alone; the manifesto has a history or prehistory before the *Manifesto*. Telling the prehistory of a genre is necessarily a retroactive enterprise. While the etymology of the word "genre" evokes the biological metaphor of a genealogy, of parentage and begetting, of passing on special features and traits through inheritance, it is futile to search for a single lineage where the manifesto has not yet coalesced

into a recognizable form.[1] All we can do is identify retrospectively the various ways of employing this word to name and characterize texts that never amounted to a single genre. Indeed, most texts that are now, post-Marx, called manifesto did not label themselves in this way; it is only now that we can recognize them as precursors of the *Manifesto*. A prehistory of this genre must thus gather heterogeneous threads that were only later woven into a single text and that can be identified only in hindsight as the material out of which the manifesto was later fabricated.

The history of the manifesto is more surprising still, for the first occurrences of the word "manifesto" as a title are in many ways the opposite of the *Manifesto*: instead of a collective, revolutionary, and subversive voice, "manifesto" here designates a declaration of the will of a sovereign.[2] It is a communication, authored by those in authority, by the state, the military, or the church, to let their subjects know their sovereign intentions and laws.[3] This usage continues into the twentieth century, where World War I was declared by Emperor Franz Joseph through a text called "Manifest."[4] The *Manifesto*, by contrast, is preposterous in its claims to power and authority. It challenges the type of declaration that rests on the assumption that whatever is being manifestoed, as the now-obsolete verb form has it, is grounded in authority and thus immediately turned into action. The revolutionary manifesto will break the conjunction of authority, speech, and action on which this old manifesto rests and instead create a genre that must usurp an authority it does not yet possess, a genre that is more insecure and therefore more aggressive in its attempts to turn words into actions and demands into reality.

There exists a second lineage within the prehistory of the manifesto, one that derives from the religious practice of revelation or manifestation. Here, too, something is brought into the open and made known, but this process is seen as a difficult one, with uncertain results and effects. Rather than simply proclaiming a sovereign will, this tradition knows that the work of revelation is laborious and prone to failure. Even though a god's revelation emanates from the most absolute source of authority imaginable, for the human receiver these revelations and manifestations are fraught with obscurity and therefore in need of interpretation. Ambiguous signs of gods exist in many religions, but most pertinent to the manifesto are the so-called revealed religions, in particular what is called the Abrahamic tradition, where the god's revelation to the people becomes a central event, whether in the form of a burning bush, a voice, or the figure of a son or through scripture. The Hebrew Bible and the Revelation to St. John (in the original and in the Vulgate, the latter is called *Apocalypse*, the word for violent revela-

tion) are important texts for this tradition, and indicative of the inherent obscurity this type of revelation brings with it.

When the manifesto turns against the state and its authority, it appeals precisely to this alternate authority of religious revelation. I will mention only two central scenes where this type of revelation intersects with the prehistory of the manifesto, both occurring when the invocation of the scripture becomes a revolutionary act: during the Reformation in Germany, in the debate between Martin Luther and Thomas Münzer about the Swabian peasant riots; and during the Puritan Revolution in England, in the writings of Gerrard Winstanley and the group called the Diggers.[5] Both groups, the Swabian peasants and the Diggers, constituted the violent wing within a more moderate reformist or revolutionary moment. Münzer is to Luther what Winstanley is to Cromwell—the revolution radicalized. Both writers become the organ of a disenfranchised and largely illiterate constituency, inserting their claims into a heated propaganda war about the revolution dominated by short pamphlets, open letters, declarations, and occasionally texts called manifestos.

In both cases, there have been debates about whether these two figures should be considered revolutionaries ahead of their times, veritable proto-Marxists, or rather religious fanatics with a social conscience. The implicit touchstone of these debates has been their choice of genre and rhetoric, for the language in which Münzer and Winstanley formulate these revolutionary interventions and manifestations is that of religious revelation. How to evaluate this language, however, has remained an open question. Did they derive their poetry from the past, from the Hebrew Bible and Revelation, to hide their modern and revolutionary intentions? Was their use of the scripture a calculated strategy for challenging the authority of the church? Or did these two insurrectionists simply not yet have available to them the self-authorizing language of the revolutionary manifesto?

The first scene takes place during the Swabian peasant riots in the early sixteenth century. At an early age, Münzer had become a minister working at the extremist wing of Lutheran reformism, instituting radical practices some of which Luther himself was forced to adopt to appease this independent-minded young rebel priest. While Luther was seizing on the new print culture to flood Germany with his Bible translation, Münzer increasingly questioned and challenged any kind of authority, including the authority of the scripture, by consuming the host without proper ritual and by undermining other church practices.[6] He ended up railing against Luther himself, to the point where he regularly referred to him as "doctor liar" and "the godless flesh in Wittenberg."[7] These tensions exploded once Münzer

was swept up in the various peasant riots of the 1520s. Whereas Luther, as a reformer, wanted to appease the peasants, working as a mediator between them and the ruling classes, Münzer placed himself at the top of the revolution, which culminated in the liberation of the city of Mühlhausen in 1525 and the formation of a revolutionary counsel headed by himself.

Now Münzer found himself the spokesman and defender of a revolution that was about to end in a bloodbath, for Lutheran reformists and aristocratic reactionaries were amassing soldiers to drive out the poorly armed rebels and their preaching leader. It was in this desperate situation that Münzer became what Ernst Bloch calls the "theologian of the revolution." His language is more and more impassioned, and he quotes obsessively from the prophets and Revelation. Finally, Münzer himself becomes the organ of the apocalypse, demanding that true Christianity cannot be based on scripture but only on the continued revelation (*eröffnung*) and manifestation of god.[8] The source of authority is still divine, but there is no longer the mediating text between this source and the receptor. Münzer, in other words, is in the process of usurping revelatory authority himself. Consequently, his language becomes active, even aggressive. While earlier he had signed his polemical letters as "God's servant" or "servant of God's word," he now styles himself "Thomas Münzer with the sword of Gideon" and "Thomas Münzer with the hammer."[9] Luther's Ninety-five Theses, which have also been seen as a precursor of the manifesto, still follow the scholarly form of the *disputatio*. Münzer goes one step further, himself becoming the sword and the hammer of the apocalypse.

Münzer's revolt has become a touchstone for Marx and Marxism throughout its history, beginning with Friedrich Engels's study *The German Peasant Wars*, which can be seen as the counterpart to Marx's *18th Brumaire*.[10] Whereas Marx concluded from the failed 1848 revolution that we need to stop looking for historical models and start working on a poetry of the future revolution, Engels does the opposite. He turns to a past when "Germany produced characters that could be placed next to the great revolutionaries of other countries" (329). One such great revolutionary is Luther, if only because of the immense effect of his Theses: "The Theses of the Augustinian from Thurungia [i.e., Martin Luther] ignited like lightning a barrel of powder" (372). Münzer's impact, and also the means with which he tried to achieve it, are more difficult to evaluate. Even though Engels admires Münzer as a revolutionary much more radical than Luther, he also recognizes Münzer's limitations, seeing in him a tragic revolutionary who was forced to hold together an alliance of plebeian priests, pauperized citizens, and the fragmented mass of exploited peasants when he would have

needed a unified proletariat. The same it true of Münzer's "poetry," in which Engels sees nothing but medieval mysticism and blasphemy. Even though Luther stuck much more rigidly to the inherited form of the scholastic thesis, Münzer's language of apocalyptic manifestation is a poetry of the past as well, a retrograde use of theology. It is this theological language, Engels concludes, that kept the peasant revolt from succeeding. Marx agreed with his friend's assessment: "The peasant revolt, the most radical event in German history, failed because of theology."[11] However, while Marx and Engels are certainly right that Münzer's was a poetry of the past, they did not recognize in it an important step toward their own modern invention: the manifesto.

While Engels and Marx critique Münzer's theological and apocalyptic vocabulary, Ernst Bloch, author of such utopian texts as *The Principle of Hope* (1954–59) and *The Spirit of Utopia* (1918), elevates Münzer as a model for revolutionary writing.[12] His study *Thomas Münzer as Theologian of the Revolution* (1921), written just after the failure of the short-lived revolution in post–World War I Germany, turned Münzer once more into a test case for the success and failure of a revolution and its poetry.[13] But where Marx, Engels, and later Georg Lukács see in Münzer a revolutionary ahead of his time but stuck in old phrases, Bloch celebrates Münzer's theology as a model for future revolutions.[14] In fact, Bloch is so taken with this apocalyptic manifestation that his own text ends in something of an apocalyptic manifesto: "The time will come again, the proletarian womb of the West will bring it again ... a messianic attitude prepared itself to appear again" (228).[15] Bloch recognizes, and awkwardly wants to reenact, the moment when theology becomes not only a language of revolt but also a language of action, an "apocalyptic propaganda of the deed" (63). While Marx and Engels dismiss Münzer's theology without recognizing his writings as important precursors of the manifesto, Bloch is too ensconced in an apocalyptic mode to acknowledge the limits of Münzer's theological language. The truth, I suggest, lies somewhere between Engels and Bloch: Münzer was antiauthoritarian but relied on the authority of revelation; he managed to create a vocabulary of the deed, but only in the mode of an apocalypse.

Even though Münzer forged a language of apocalyptic violence, the manifesto had not yet become the established genre and title for such writing. The first revolutionary document to actually bear the title "manifesto" was written more than a hundred years later by the radicalized wing of the Puritan Revolution, the Levellers' "A New Engagement, or, Manifesto" (1648). Just as Münzer was willing to exploit the revolutionary thrust of Luther's Reformation, so the Levellers voiced rebellious demands in the late

1640s during the Puritan Revolution in England. As Janet Lyon and Christopher Hill detail, groups of disbanded soldiers who were exhausted by the war against Ireland, starved by a succession of poor harvests, and pressed for higher and higher taxes were voicing increasingly radical demands that sometimes took the form of texts called manifesto.[16] This title, however, did not imply distinct features that would differentiate texts so labeled from other Levellers pamphlets, which were indiscriminately called "declaration," "appeale," "agreement," "cal," "proposalle," or "petition." Indeed, the "or" in "A New Engagement, or, Manifesto" indicates that the manifesto is one among many alternative titles, none of which seems to imply a specific set of rules. And yet, the word "manifesto" or "manifestation" begins to function as a center of gravity. There was, for example, a text called "A Manifestation," which in turn prompted a pamphlet subtitled "The Manifestators Manifested."[17] Manifesting, manifestators, manifestos—these terms designate a new revolutionary tone or, in the language of another pamphlet, an understanding of revolutionary writing as "An Arrow against all Tyrants, Shot from the Prison of Newgate into the Prerogative Bowels of the Arbitrary House of Lords and all other Usurpers and Tyrants whatsoever."[18] Where Münzer's poetry was a hammer, Overton's pamphlet functions as an arrow; both are missives aimed at the heart of the tyrant.

The language of these Levellers tracts may have been radical, but it, too, was a poetry of the past, referring mostly to common law and the Magna Carta. The Levellers were seeking better conditions for themselves, not a revolutionary upheaval, and the sources of authority they invoked were natural and national rights. The language of revolution, however, was heard by an even more disempowered group that sometimes called themselves "True Levellers," but that was was mostly known as the Diggers. A band of dispossessed peasants started to dig the wasteland on St George's Hill, Surrey, taking de facto possession of these common grounds. Their justification was not property rights but something very close to Münzer's theology of the revolution. Indeed, their principal writer, Gerrard Winstanley, articulated this revolution in the language of revelatory prophecy and apocalyptic violence, mixing angry invectives and arrows directed at Cromwell with long quotes from the prophets of the Hebrew Bible and Revelation. Much more developed than those of Münzer, the writings of Winstanley contain the seeds of a society without private property, but Winstanley, too, grounds his demands in lived revelation: "This following declaration of the word of Life was a free gift to me from the Father himselfe."[19] Like Münzer, Winstanley becomes the vessel of revelation and the instrument of the apocalypse.

There has been a debate about Winstanley comparable to that about Münzer, whether he should be considered a communist *avant la lettre* or a religious writer with a heart for the poor, an essentially modern revolutionary or a man preparing himself for the end of time. In his *Cromwell and Communism* (1895), for example, Eduard Bernstein regarded Winstanley as a thinly veiled modern revolutionary. A principal proponent of so-called evolutionary socialism, Bernstein was doubly invested in connecting Winstanley almost seamlessly to modern communism rather than emphasizing, as Marx, Engels, and their followers had done, the immense historical and therefore ideological difference between the seventeenth-century revolutionary and modern socialism. Bernstein argued that if Winstanley did not sound like a modern socialist, this was only because his language happened to be "couched in somewhat mystical phraseology, which manifestly serves as a cloak to conceal the revolutionary designs."[20] This sentence, which multiplies phrases of showing and hiding ("mystical"; "phraseology"; "couch"; "cloak"; "conceal"; "design"), shows Bernstein's effort to explain the difference between Winstanley and modern revolutionaries, how much Winstanley was still attached to the language of revelation and how far removed from the modern genre of the manifesto.

The tendency to consider both Münzer and Winstanley as precursors of the manifesto is in part due to the fact that most commentators focus on the content of the writers' texts rather than on their genre and form. This tendency is nowhere as evident as in the recurring gesture of attributing to both of them, retroactively, the Marxian genre of the manifesto even though neither seems to have associated with this word a particular set of rules, when they used it at all. Bloch labels one of Münzer's most aggressive calls to arms "Manifest an die Bergkappe" (Manifesto to the Mountaintop),[21] and Engels refers to Münzer's so-called "Artikelbrief" as a "radikales Manifest" (radical manifesto).[22] The same thing occurred with respect to Winstanley, whose texts are frequently labeled manifestos.[23] This designation should serve as an indication that these texts are not yet manifestos in our post-Marxian sense. Rather than being cunning devices that hide secret manifestos, Winstanley's and Münzer's religious idioms constitute an appropriation of Judeo-Christian revelatory theology. In the course of this appropriation, however, divine manifestation is on its way to becoming political action—arrow and hammer—to challenge the authority of Luther and Cromwell.

The texts by Münzer and Winstanley are not the only ones to have been retroactively labeled as manifestos. Another group of texts thus drawn into the vortex of the manifesto includes the Declaration of Independence

and the Declaration of the Rights of Man and Citizen. A far cry from the apocalyptic upheavals and violent revelations of the likes of Münzer and Winstanley, these declarations are connected to the manifesto in that they are expressions of an autonomous political will and products of the conviction that social history can be actively shaped through the interventions and writings of humans. No reference to divine revelation is necessary; men and women can declare their intentions and through such declarations fashion the future. Like earlier manifestos, declarations are intimately tied to revolutions and revolutionary violence, but the language in which these revolutions articulate themselves has changed: where earlier revolutionary literature had drawn on the Hebrew Bible and Revelation, these declarations draw on Enlightenment philosophy.

Here it is Kenneth Burke who reads the manifesto back into its precursors by trying to "show how the grammar of Constitutional wishes relates to the rhetoric of political manifestoes."[24] This relation, Burke argues, must be sought in the foundational act performed by all constitutions, which makes them "Great Manifestoes" (345): "Constitutions are agonistic instruments. They involve an enemy, implicitly or explicitly" (357), he writes, speaking of the "futuristic, idealistic form" (362) all constitutions take. What interests Burke is not the constitution as a finished product but the act of instituting it, as it is captured in his first definition: "1. The act or process of constituting; the action of enacting" (341). This process turns a value into a right: "If a Constitution declares a right 'inalienable,' for instance, it is a document signed by men who said in effect, 'Thou shalt not alienate this right' " (360). This "agonistic" act of constituting and enacting rights derives from Burke's own speech act theory, which he applied with particular brilliance to the *Manifesto*; in fact, his reading of the *Manifesto* clearly informs his analysis of constitutions to the point where he seeks to expose the hidden manifestos at work within constitutions.

While reading the manifesto back into constitutions, Burke cannot quite explain why these constitutional texts do not present themselves as manifestos and instead choose to hide their agonistic force and foundational violence. Even the Declaration of Independence, an openly polemical document, articulates the rupture it performs, the cutting of the bonds between people, not in terms of an active break in the historical process, the performative institution of new systems and laws. Instead, it refers to "self-evident" truths, "the Laws of Nature and of Nature's God," and to the "unalienable rights" bestowed upon all men by their "Creator." What is being declared are not these rights, laws, and truths themselves, for they do not need to be declared at all; they are self-evident. What is being declared instead, the only

thing that requires eloquence, are the violations of these laws and truths, violations that alone become "the causes which impel them [the authors] to the separation." The same is true of the Declaration of the Rights of Man and Citizen. Here the rights listed are merely being "exposed" (*exposer*) so that the Declaration can function as a memory device to "remind the citizens of their rights" (*leur rapelle sans cesse leurs droits*). These rights, no matter how radical, are not presented as being created, enacted, constituted, or made, and consequently their declaration is not something that is in need of a *poesis*. All that is required is an innocuous mention of rights whose natural authority rests solely in themselves. Nature does not need to be revealed; it is not in need of a manifesto.

Burke, of course, is right in recognizing the agonistic agenda behind the self-evident truths and natural rights evoked in constitutions, but the difference between a hidden agonism and a manifest one is precisely what marks the emergence of the manifesto as a distinct genre. Rather than considering the declarations and the constitution as manifestos in the sheepskins of revealed nature, or the writings of Münzer and Winstanley as manifestos in the sheepskins of revealed religion, we should view both as precursors of the manifesto at a time when the act of self-authorizing manifestation had not coalesced into a distinct genre.[25] It is only with Marx that the poetry of the future revolution arrives not only at its own content but also at its own form, that the manifesto exposes its speech acts as self-authorizing and openly "agonistic" manifestations.

The Manifesto of the Communist Party

The manifesto as conceived of by Marx and Engels borrows from the history of revelatory pamphlets such as the ones written by Münzer and Winstanley; it uses the emancipatory project of Enlightenment philosophy; and it draws on the concealed acts of instituting rights of declarations. But apocalyptic manifestation, philosophical self-foundation, and open declaration of rights do not by themselves amount to a modern manifesto. In order for the manifesto to emerge as a distinct genre, an additional set of acts and circumstances had to come into play. And what these acts and circumstances would be became clear only retrospectively, for even Marx and Engels did not fully know what they were doing when they started to compose what would become the *Manifesto of the Communist Party*.

Originally, the *Manifesto* was envisioned as a "credo," a collection of articles of faith in the form of a catechism. After its formation in 1847, the international Communist League (Bund der Kommunisten) engaged in a heated debate about how best to present its new public face. The London headquarters circulated a "Communist Credo," and Moses Heß, who had published a credo in the form of a catechism two years earlier, submitted a new version to the appraisal of the league from Paris.[26] His credo abounded in calls for love and brotherhood and in emotional rants against money; it contained nothing but articles of faith, enthusiastic but hapless beliefs without reflection on their foundation, form, or language.

Heß's catechism was severely attacked by Engels, who ended up being charged with writing a better one. It was against Heß's credo-catechism that Engels pitted his own draft, called "Principles of Communism," which was likewise composed of questions and answers.[27] This form, however, soon proved to be inadequate for the more ambitious task Marx and Engels had in mind. It was Engels who first recognized this, writing to Marx that the new credo he was drafting was composed in the wrong form: "Think a little about the confession of faith. I believe that the best thing is to do away with the catechism form and give the thing the title: Communist *Manifesto*."[28] What was at stake in this decision?

When Engels proposed the title "manifesto," he was not yet fully aware of the implications of this new designation; the manifesto as a genre was only in the process of being formed. Engels was probably thinking of various revolutionary and postrevolutionary pamphlets so entitled, for example, Sylvain Maréchal's *Manifeste des Egaux* (1796) or Victor Considérant's *Principes du socialisme: Manifeste de la démocratie au XIX ème siècle* (1847). More important than the content of these texts, which had little bearing on the *Manifesto*, was the fact that their titles confirmed the principle of open declaration. Adopting this principle constituted an important moment in the history of the international Communist League, which was in the process of overcoming the secretive and conspiratorial practices associated with such figures as Louis Auguste Blanqui.

But Engels did not just seek to emulate these earlier pamphlets in their openness; he had a specific objection to the form of the catechism: "We have to bring in a certain amount of history, and the present form does not lend itself to this very well. I take with me from Paris what I have written; it is a simple narrative, but miserably composed, in an awful hurry." A credo is a good genre for declaring a set of principles, Engels seems to suggest, but it does not work well for a "narrative," specifically one that will bring in a "certain amount of history." Engels's difficulty points to a central feature of

the *Manifesto*, namely, that it includes an understanding of the historical process, that it thinks in narrative and historical terms.[29] Generically, the manifesto, at this juncture, can be seen as credo plus history.

Part of this history is of course the history of socialism. It is here that the *Manifesto* will seek to differentiate itself from its precursors and rivals, including the writers of socialist pamphlets, who are now dismissed as "reactionary," "petty bourgeois," "German," "conservative," or "critical-utopian" socialists.[30] But the history the *Manifesto* sets out to write is not only the history of socialism but history as such; its first sentence famously declares, "The history of all hitherto existing society is the history of class struggles" (89). In the second sentence, however, the language shifts from struggle (*Kampf*) to revolution, describing how each struggle leads to "a revolutionary reconstitution" of the "society at large" (89). There is a whole series of struggles and revolutions, in other words, culminating in the creation of what Marx calls the revolutionary class as such: the bourgeoisie. The entire first section of the *Manifesto* is a celebration of the "most revolutionary" (91) role of the bourgeoisie, a catalogue of its revolutionary achievements—eleven paragraphs that begin with "The bourgeoisie" as the subject and sole agent of such revolutionary activity that extends to all aspects of society. In fact, the bourgeoisie is so revolutionary that it ends up creating the new and last revolutionary class of the proletariat. This first section of the *Manifesto* presents not only a history *of* previous revolutions but a history *as* revolution, a history driven by a series of revolutionary upheavals leading to a final and all-encompassing one.

This history-as-revolution is a history written according to the new form of the manifesto. Marx and Engels use the manifesto not only to "bring in a certain amount of history" but to forge a specific understanding of history as a revolutionary process leading up to the present, February 1848, as the time when one more revolution is expected any minute. This historiography corresponds to the manner in which Marx re-creates the genre of the manifesto. For Marx, the manifesto is neither a declaration of self-evident principles nor an apocalyptic revelation but an instrument that gathers previous revolutionary events and channels them toward the immediate future, the imminent revolution. This history-as-revolution is something Marshall Berman extracts from the *Manifesto*. Using one of its sentences for his title, *All That Is Solid Melts into Air*, he creates a theory of modernity as a process of innovative self-destruction.[31] In his study, the *Manifesto* becomes a text that represents and echoes the frantic spirit of bourgeois capitalism.

Berman is well attuned to the *Manifesto*'s frenzied prose, the rhythms of the revolutions it describes, but downplays the fact that the *Man-*

ifesto wants to be the harbinger of a new world without bourgeois capitalism and its ever-accelerating pace and destructive violence. Given this interventionist agenda, the *Manifesto* not only writes the history of a process that must culminate in a final revolution but also wants to contribute actively to this revolution; the manifesto not only records revolutionary history but wants to make this history as well. For this making of a revolution, however, something more is required than the telling, however compelling, of history. If the manifesto truly wants to intervene and make history, it must adopt a different voice than that of a historiographer. It must adopt a "political voice," which Maurice Blanchot characterizes thus: "It is brief and direct, more than just brief and direct, since it short-circuits all speech. It no longer carries any meaning, but becomes an urgent and violent appeal, a decision for rupture. It does not strictly speaking say anything, it is only the urgency of what it announces, bound to an impatient and always excessive demand, since excess is its only measure."[32] This voice of appeal certainly culminates in the concluding slogan "Proletarians of all countries, unite!" but it is not restricted to this last call and rallying cry. What Blanchot calls the *Manifesto*'s "impatience" is first of all an impatience with itself, with the fact that it cannot be more than a call, a cry, a demand, an impatience with the fact that no matter how impassioned and effective, the manifesto will always remain a split second removed from the actual revolution itself.

Throughout its subsequent history, the manifesto will be defined by this impatience, by the attempt to undo the distinction between speech and action, between words and the revolution. This attempt contributes to the formation of the *Manifesto*'s distinct voice, although the notion of voice should be extended to include the tone and even the rhetoric of the manifesto, its way of understanding the role of historiography and the philosophy of history, speech, and writing. The manifesto's tone or voice is not only a formal feature but one that describes a fundamental gesture or attitude orienting the manifesto toward the world it seeks to undo and redo. Analyzing this attitude, which shapes both form and content, must be the ultimate purpose of a poetics of the manifesto, an analysis of its makings and doings.

2

Marxian Speech Acts

While the earliest prehistory of the manifesto presents us with a genre steeped in authority, the authorized speech acts of kings, the modern manifesto is formed in the revolutionary challenge to such authority. But how can a modern, revolutionary manifesto fabricate a revolution if it cannot rely on an authoritative position from which to challenge the status quo? Even more troubling, the manifesto wants not only to challenge authority through revolutionary speech but also to turn this speech into an actual instrument of change. How can empty words be turned into actions? To answer this question requires a particular form of a Marxian speech act theory, one revolving around three concepts: (1) authority and its revolutionary challenge, (2) performative and theatrical speech acts, and (3) the context and position from which manifestos speak. The theorists who provide models for addressing these concepts are J. L. Austin, Pierre Bourdieu, Kenneth Burke, and Louis Althusser.

The theory seemingly best suited to analyzing the *Manifesto*'s desired fusion of speech and action is found in Austin's *How to Do Things with Words*, which provides an influential paradigm of how speech can turn into action. In taking his point of departure from such scenes as baptism and marriage ceremonies, Austin chose situations in which uttering certain words is not idle talk but brings about real change: babies and ships actually do get baptized, and people do get married. Words, in these cases, perform actions. From the point of view of Austin, the manifesto would have to be described as a series of speech acts singularly invested, even overinvested, in the effects they produce in the real world, what Austin termed "perlocutionary effects." The condition for such effects to occur is that a given speech act must be

uttered in the right context and by the right kind of person, by people vested with the authority to perform these transformative speech acts.

It was Pierre Bourdieu who pointed out most incisively that Austin's theory of speech acts is bound up with the concept of authority.[1] The figures performing Austin's speech acts, after all, are priests, magistrates, and judges. This reliance on authority makes Austin's theory less ideal for analyzing the manifesto; in contrast to the earliest authoritative manifestos, the modern, revolutionary manifesto seeks to obtain an authority it does not yet possess. The authorizing context and agent, in other words, do not yet exist, and it is through the very speech acts of the manifesto that the context and the agent are being wrought. To capture the *Manifesto*'s lack of authority in Austin's terms, one would have to say, paradoxically, that the *Manifesto* wants to create the context that will have ensured that its speech acts had been properly authorized by an authorizing context. The speech acts of the manifesto thus are launched in the anterior future, claiming that their authority will have been provided by the changes they themselves want to bring about. But this future perfect construction is nothing but a hope, a claim, a pose, a desire that often comes to naught.

It is for this reason, perhaps, that Austin, at the end of the path-breaking lectures on which his influential text is based, stumbled on the genre of the manifesto. In a tone of affected modesty, he says, "I have been sorting out a bit the way things have already begun to go and are going with increasing momentum in some parts of philosophy, rather than proclaiming an individual manifesto."[2] Even though Austin here denies that he has anything to do with the manifesto, he could have recognized in this genre a form of speech yearning for performative authority without fully possessing it. Perhaps there was something unauthorized and therefore preposterous about the manifesto that Austin did not like, something projective and uncertain, something theatrical and ostentatious whose merits and effects would appear only, if ever, in the future.

Just as Austin rejects the manifesto, so he rejects the notion of theatricality, which is so central to understanding this genre. Austin excludes the theater as a space where normal speech acts no longer function precisely because they are not backed up by authority and a properly authorizing context. If you say "I do" on the stage, you are not getting legally married, after all. Nevertheless, Austin's theory has been haunted by this excluded theatricality and, ironically, has been particularly influential in studies of dramatic literature. But this irony in fact points to the functional theatricality of most of the scenes described by Austin and also to the theatrical echoes of his central terms such as "act," "acting," "performative," and so forth.

More important than these echoes, however, is the tension between Austinian performative speech acts and theatrical acts that informs Austin's theory throughout. Speech acts must battle and conquer the threat of theatricality in order to become speech acts. Such a battle between theatricality and performativity is nowhere as visible as in the manifesto. Saying that the manifesto is theatrical means that its speech acts occur in an unauthorized and unauthorizing context; the theater, for Austin, is the paradigm for such an unauthorized context. However, the manifesto does not rest comfortably in this unauthorized space; indeed, it tries to exorcise its own theatricality by borrowing from an authority it will have obtained in the future. All manifestos are intertwined with the theatrical, driven by it and troubled by it, and they all seek to turn the theater into a source of authority.

The theatricality of the manifesto, the projective and presumptuous claim to authority, is something that will come to the fore in the avant-garde manifestos of the twentieth century, which were often performed on the stages of literary clubs, cabarets, and theaters. These theatrical manifestos of the futurists or dadaists seem to have given up entirely on the desire for authority and real change and instead delight in theatrical pranks and the liberties provided by the theater. However, the manifesto's theatricality, or rather the struggle with this theatricality, is visible in all manifestos, including the *Communist Manifesto*. Its preamble begins with the famous invocation of the "Specter of Communism," which Derrida and others have aligned with the ghosts of theater history, in particular that of Hamlet's father.[3] The same preamble also seeks to turn this theatrical, spectral appearance into reality: Marx wants to replace the specter of communism with communism itself. The manifesto is precisely the instrument, the genre that replaces specters with the real thing: "It is high time that Communists should openly, in the face of the whole world, publish their views, their aims, their tendencies, and meet this nursery tale of the Specter of Communism with a Manifesto of the party itself" (87).[4] Theatricality seems to be something of a specter haunting the manifesto, the threat that its speech acts might turn out to be nothing but stage acts. Theatricality thus functions as an obstacle the manifesto must combat in order to achieve its goal. So far, communism has been a theatrical phenomenon, the *Manifesto* seems to suggest, but from now on we will make it manifest and real. This manifesto, which you are reading, is the first step in this direction, the first act in this new era that will no longer belong to the theater.

This account, however, describes the theatricality at work in the *Manifesto* only negatively. But the prevalence of theatrical notions and terms in the *Manifesto* also points to a necessary and productive function of theat-

ricality. Indeed, one may say that theatricality is what enabled the manifesto to speak in the first place, in the absence of proper authority. Since the manifesto speaks from a position of weakness, it must hope that the presumption of future authority, the projective usurpation of the speaking position of the sovereign, will have effects and consequence. In this sense, the theatricality of the manifesto describes a pose of authority without which it could not utter a single word. More precisely still: theatricality describes a space between absolute powerlessness and the secure position of the sovereign, a play that the manifesto exploits without yet knowing whether the project of usurping power will work out. Without theatricality, in other words, there would be no pose, no presumption, no projection, no futurity; without theatricality there would be no manifesto.

While Austin's theory of speech acts can be applied to the manifesto (as well as to the theater) only awkwardly and against his will, there exists a theory of speech acts that systematically links the manifesto to the theater: Kenneth Burke's "dramatism." Dramatism is a formal system explicitly devoted to a theatrical analysis of language and thought. Burke uses a scheme, the "dramatist pentad," which consists of five terms or categories derived from Aristotle: agent, agency, act, purpose, and scene. Whereas four of these terms (agent, agency, act, and purpose) offer different perspectives on action, the primary dramatic category, the fifth term (scene) describes the setting or field within which action occurs. In the hands of Burke, this scheme can be applied to virtually anything. The notion of the "subject" in idealism, for example, can be translated to mean a theatrical "agent," while the material conditions in Marxism become the "scene" that sets and restricts the actions performed within it. Indeed, one of Burke's chief examples is the *Manifesto*, in which he is able to recognize a tension between its desire for a revolutionary act that will transform the world, as scene, and the claim that this world is determined by material conditions.[5] Burke's analysis is based on an entirely abstract scheme, a formalism that erases history (one reason he has no trouble reading the manifesto back into the constitutions, as detailed previously). At the same time, however, his dramatism has the advantage that it borrows directly from drama, and for this reason it is well equipped to analyze the theatricality of the manifesto. Burke's vocabulary registers the desire of the *Manifesto* to make an intervention, the hope of the printed text to become a politically charged, symbolic act, without knowing for sure that its (Austinian) context will have authorized such acts. Burke is thus capable of grasping the theatrical self-authorization at work in the manifesto, the uneasy collaboration between theatricality and performativity that Austin had tried so hard to deny.

As much as a theater-based theory of speech acts allows us to capture a central dynamic within the manifesto, it is important to recognize that Marx himself arrived at his practice of the manifesto through a different route, namely, a critique of philosophy. For him, the question of speech and action, theatricality and performativity, presented itself as a question of disciplines and forms of writing. In a famous argument, made just before the *Manifesto* in his *German Ideology* (1845–46), Marx maintained that philosophy had no history of its own, that it was nothing but a phantom battle of entities he called ideology: "Morality, religion, metaphysics . . . have no history, no development; only humans, who transform their material production and their material commerce, also change with this reality their thinking and the products of their thinking."[6] Attacking not just a particular philosophy but philosophy in general is not unique to Marxism and in fact describes every modernist philosopher after Marx, including Friedrich Nietzsche, Martin Heidegger, Ludwig Wittgenstein, Jacques Derrida, Richard Rorty, and Stanley Cavell, to name but a few and not even those who place themselves explicitly in a Marxian tradition. These philosophers of late modernity seem to share the conviction that philosophy must come to an end, and they each venture to write a final philosophy that would be, at the same time, philosophy's eulogy. Anticipating this tradition, Marx recognized that to stop doing philosophy means to change the very act of writing philosophy, to change the genre of philosophy. Just as Nietzsche created his unique mixture of polemic, fiction, and prophecy, and Wittgenstein his manifesto-like *Tractatus*, so Marx created a new form of theoretical writing.

While for Nietzsche and Wittgenstein the break with philosophy was driven mainly by an epistemological crisis of language, the imperative that stood behind Marx's was a political crisis of language, the question of how the language of philosophy could be used for political purposes. The last of his "Theses on Feuerbach" formulates this desire for political action as a command: "The philosophers have only *interpreted* the world in different ways; the point is to *change* it."[7] In a famous argument, Althusser proposed to consider the break with philosophy as it is announced in the eleventh thesis to be "the act of founding a science" (*la fondation en acte d'une science*) accomplished in Marx's theoretical masterwork, *Das Kapital*.[8] Although Althusser's notion of science remains dubious, what is useful here is his claim that Marx had to create a new mode of writing to fulfill his demand that philosophers change the world.

Such a new mode of writing, I suggest, did not take the form of the "scientific" *Kapital*, of founding a science of political economy, but informed the eleventh thesis itself. This thesis not only formulates the reason Marx

felt it necessary to break with philosophy but also attempts to practice this change by turning philosophical argument into a single, striking, and condensed aphorism. However, the aphorism presents these condensations only as fragments, as compressed but insufficient formulations of a whole that remains ineffable. The genre, however, that finally draws the consequence from the aphorism, both the demand formulated in it and its form, is the manifesto. Only the manifesto practices what the eleventh thesis on Feuerbach preaches, namely, a new practice of philosophy that would be geared not toward theory but toward action, toward actually changing the world. It is the *Manifesto* that changes the world through an "act of foundation" such as Althusser demands and through the genre that is interested in nothing but precisely such foundational acts.

In the end Althusser developed his theory of the manifesto in a commentary on Machiavelli's *Prince*, which he, drawing on Gramsci, labels a "manifesto."[9] Such a title, he acknowledges, inevitably invokes—"is haunted" by—the *Communist Manifesto*: "That it [Machiavelli's *Prince*] is a revolutionary manifesto—a term Gramsci cannot use without thinking of the *Manifesto* that haunts and governs his whole life, just as it has haunted and governed the life of revolutionary militants for more than a century (i.e. the *Communist Manifesto*)—this cannot fail to hold our attention" (13–14). Gramsci always operated with a capacious notion of revolution, attributing a genuinely revolutionary character to the futurist Marinetti and his violent manifestos. Here Gramsci is probably thinking of Marinetti as much as of Marx when he remarks that Machiavelli's "manifesto" is written with a "fanatism of action" (*fanatismo d'azione*). One might even wonder whether Gramsci is not trying to reclaim the manifesto (as well as Machiavelli's political legacy) from its fascist appropriations.

Be this as it may, what matters is that Althusser takes this remark as a point of departure for finally working toward a theory of the manifesto as genre. A manifesto, he declares, is "not a text like others: it is a text which belongs to the world of ideological and political literature, which takes sides and a stand in that world. Better, a text that is an impassioned appeal for the political solution it heralds. . . . A 'manifesto' demands to be written in new literary forms" (23), and he specifies its "new format—barely eighty pages—and a new style: lucid, compact, vigorous and impassioned" (23). Even though Althusser speaks about "format," what he describes is a combination of tone and voice, attitude and gesture that captures the activist and interventionist poetics of the manifesto.

This gloss on format, however, barely scratches the surface of this new genre. For Althusser, a manifesto is a text that not only describes a

political system or dreams up a utopia but also takes a stance toward political agency, projecting and theorizing the political agent that will help realize its vision. In his analysis, *The Prince* theorizes political agency by constructing the figure of the ideal ruler, the prince, whom Althusser calls the "subject of political practice." This prince is the projection of political authority that does not yet exist in actuality. But, according to Althusser, *The Prince* goes further and crucially reflects on its own relation to this source of agency and authority, including and especially its own agency as a political text: "[We] discover that there is not only one place involved—the place of the 'subject' of political practice—but a second: the place of the text which politically deploys or stages this political practice" (22). Rather than pretending to consider the problem of the good ruler in a detached manner, "like a light that has no location," *The Prince* carefully calculates its own role in creating a ruler:

> Machiavelli, who in his text elaborated the theory of the means at the disposal of the Prince set to save Italy, *treats his own text, in its turn and at the same time, as one of those means*, making it serve as a means in the struggle he announces and engages. In order to announce a New Prince in his text, he writes in a way that is suitable to the news he announces, in a novel manner. His writing is new; it is a *political act*. (23; Althusser's emphasis)

The author of a manifesto "must openly declare himself partisan in his writings, and do so with all the resources of rhetoric and passion *required to win partisans to his cause*," but this necessity registers not only on the level of rhetoric, tone, and style but also, and perhaps more importantly, in the manner in which the text understands itself, namely, as a "*means*," an instrument, a "*political act*." Thus Althusser arrives, via his analysis of *The Prince*, at a theory of the manifesto as a genre that writes from the position of weakness and that has to construct the agency that will usurp authority. This is another way of saying that the manifesto must use and instrumentalize the theatricality that enables it to create roles, characters, and agents. The manifesto projects a scenario for which it must then seek to be the first realization.

After developing this theory of agency, Althusser finally turns to the text that "haunts" both Gramsci's analysis and his own: the *Communist Manifesto*. Althusser notes one difference in how the two manifestos place themselves in the political field they create. *The Prince* is written from the point of view of someone who is not a prince but who belongs to the people. In other words, there is an incongruity between the figure, or "subject," of

political agency this text creates—namely, the prince—and the text's own agency. Since all agency—and authority—lies with the prince, the manifesto can only intervene indirectly by hoping that this imaginary prince will adopt its suggestions. This "manifesto"—unlike Althusser, Gramsci had wisely placed quotation marks around this title—requires someone else's agency to enact it. This is precisely not the case with the *Manifesto*, which is written from the point of view of the proletariat, which is also the true agent of the revolution: "The *Manifesto* locates itself on the positions of the proletariat, but to summon that same proletariat. . . . The class viewpoint from which the *Manifesto* is conceived and composed is, in ideology, the *viewpoint* of the proletariat. Class viewpoint and class party pertain to one and the same class: the proletariat" (26). This, finally, is Althusser's distinction between a utopian manifesto and a nonutopian one: the congruity between textual agency and the type of agency projected by the text. Split in the case of *The Prince*, the two are brought together in the *Manifesto*. The mutual reinforcement of theory and practice is the secret to the *Manifesto*'s success; it is the formula that led to the invention of the manifesto as we know it, the manifesto through which all preceding manifestos are retrospectively constituted as manifestos and against which their participation in the genre of the manifesto must be measured.

There is, however, one problem with the happy unity of theory and practice, namely, that the figure of agency, the proletariat, and thus the place from which the *Manifesto* wants to write and stage its intervention, exists only as a kind of latent place; in Althusser's formulation, it exists only "in ideology." Even though the rise of capitalism has created a proletariat in the most advanced countries, this proletariat is not yet fully conscious of being the proletariat in the sense of the *Manifesto*. To use the terminology of Hegel, the proletariat is a class *in* itself, but it is not yet a class *for* itself. The *Manifesto* theoretically constructs the agent of the revolution and identifies with this agent, speaking "from the viewpoint of the proletariat," as Althusser says. However, given the insufficient self-consciousness of the proletariat and its viewpoint, the identity between manifesto and proletariat cannot be a completed state but only a process; not an accomplished identity but only an act of identification. There is, in other words, a split within the neat congruity between theory and practice after all, and this means a remnant of the Machiavellian utopia; there is, I would say, a remainder of theatricality in the *Manifesto* that allows it to speak in the theatrical mode of "as if," as if the unified proletariat already existed.

This split is not simply a bad thing, however, for it creates room for the interventionist practice of the *Manifesto* to unfold. If the proletariat must

become a class *for* itself, it must become conscious of its status, its class position, and how else to achieve this goal than through a manifesto? Unable to rest comfortably on the existence of a proletariat as a class for itself, the *Manifesto* must create such a self-conscious class in a projective manner. Even the last rallying cry, "Proletarians of all countries, unite!" participates in this act of *poesis* and creation, for it means that only once the proletarians of all countries are united will they have reached the full self-consciousness of themselves as the proletariat. The last sentence, like all those of the *Manifesto*, is thus addressed to a recipient who does not yet fully exist. It performatively creates its addressee as agent in the manner the Declaration of Independence creates the "good people" of America as the agent on whose behalf the representatives issuing the Declaration act.[10] There is one crucial difference, however, between the *Manifesto* and the Declaration. The Declaration understands political agency mostly in terms of representation, of taking the place of, or replacing, someone; the fifty-two signatories of the Declaration are the representatives of the people, functioning as their organs of speech and action in the manner of a proxy, as Gayatri Chakravorty Spivak translates this term.[11] The *Manifesto* is not content with simply being a proxy of the proletariat in the same, simple way. Rather, it needs to create, performatively, the proletariat as a self-conscious agent, and for this reason it must also show the proletariat who and what it is by creating a figure, the figure of the proletariat, just as *The Prince* had created the figure of the prince.

Besides representation and performative figuration, a third position can be identified. Since the *Manifesto* wants to speak from the position of the proletariat, and since it alone knows what the self-consciousness of the proletariat should look like, it must take, preemptively, the place of the proletariat, anticipating and enacting the proletariat in the manner that is, for the time being, theatrical. We can thus relate Althusser's theory of genre to the question of theatricality and performativity derived from the theory of speech acts. However, instead of the struggle between theatricality and performativity, we now have three modes. The *Manifesto* speaks for the proletariat; it creates—makes in the sense of a performative poesis—the proletariat; and it theatrically enacts its future. As Ernesto Laclau and Chantal Mouffe have shown succinctly, it is a futurity that has necessarily remained open: "The affirmation of the class struggle as the fundamental principle of political division always had to be accompanied by supplementary hypotheses which relegated its full applicability to the future."[12] The space of this transition from a class in itself to a class for itself is precisely the space in which the *Manifesto* projects itself forward, anticipating what will have happened; it is the space of unauthorized theatricality and performative

poesis. In this sense, the *Manifesto* practices not only a form of political speech act but a form of futuristic speech act. This futurity is different from the merely utopian political speech acts of the *Prince* in that the *Manifesto* envisions an ultimate fusion between the proletariat and itself. The performativity of the *Manifesto* is therefore at once political and futurist. Otherwise, a simple command would be enough: "Revolution now!"—and it never is.

What Gramsci and Althusser recognize, without allowing this recognition its full force, is that the manifesto is a form of literary agency, a new form of political articulation that develops in partial defiance of real existing circumstances even as it seeks to enlist history as an ally in its own project. But even if the *Manifesto* thus remains theatrical, the manifesto as a genre nevertheless generates a history. It is this history that the next chapter describes.

3

The History of the *Communist Manifesto*

The categories that describe the *poesis* of the *Manifesto*, including authority and authorship, theatricality and performativity, reemerge, in altered form, when one turns to this text's history. Since the *Manifesto* speaks from the point of view of the proletariat, should it not be an anonymous text written, at least symbolically, by a collective, the party, the international Communist League, the entire proletariat? This was in fact the way in which the first edition of the *Manifesto* was published. It omitted the names of its authors and presented itself as an anonymous pamphlet, with no mention of the fact that there were one or two authors writing on behalf of the league and enacting, theatrically, the unity of the proletariat. In the same collective spirit, a shorter extract from the *Manifesto* was created and distributed as a flyer among the February revolutionaries. The *Manifesto* appeared to be a text arising from the revolution even as it sought to trigger the revolution.

This happy fiction, however, did not last long. The revolution failed, and for this reason the *Manifesto* failed as well, at least for the time being. The split that had been covered by the fiction of a collective authorship without proxy, a proletariat without representation, a performativity without theater, remained open and was never to be closed again. One consequence was that, from now on, all editions name Marx and Engels as the authors of the *Manifesto*. More importantly, this split became the motor of a history of repetition and adaptation that responded to this text's necessary futurity, its proxy nature, its function as mirror and theater. After the failure of the February Revolution, the desire of the *Manifesto* to exorcise its own theatricality became all the more necessary even as the *Manifesto*'s success became doubtful. These doubts only grew with each year and decade passing without the revolution having taken place. More and more people wondered

whether the *Manifesto* was becoming, prematurely, outdated, overtaken by the course of events, and whether a supplement or even a new manifesto was in order. The first hint of the necessity of updating the *Manifesto* appeared only a few years after its composition, in a letter from Engels to Marx in August 1852, where he observes, "California and Australia are two cases we did not consider in the *Manifesto*: creation of large new markets out of nothing. They need to be added."[1] The *Manifesto* begins to be in need of all kinds of supplementary additions.

At the same time, a second dynamic made itself felt. With the Europe-wide reaction following the failed revolution of 1848, the identity of communism as it was instituted by the *Manifesto* had to be confirmed, this time not only with respect to its predecessors, those so-called utopian socialists against which the *Manifesto* had established itself, but also with respect to contemporary rivals, in particular the strong anarchist wing. In a text from the early fifties, Marx and Engels consider with great worry what they call the "manifesto mania" that has sprung up everywhere around them.[2] These are texts that threaten the original force of the *Manifesto*. In response to this threat, the originality of the *Manifesto* had to be preserved. The two imperatives, updating, revising, or even replacing the *Manifesto*, on the one hand, and preserving its original foundational act, on the other, created a field of tensions that determined the subsequent history of the *Manifesto*. Repetition and difference, preservation and supplementation, are the categories that describe this history.

The tension between preservation and supplementation is visible in the post–1850 editions of the *Manifesto*. Not only did these editions exhibit the names of its two authors, but each new edition and translation acquired a preface, written by the two authors or, after the death of Marx, by Engels alone. It is in these prefaces that the confirmation of the *Manifesto*'s foundational act and its adaptation to new circumstances occur. The first of these prefaces was written for a German edition of 1872, following yet another failed revolutionary upheaval, namely, that of the Paris Commune. Marx and Engels's position at this point is that "the general principles laid down in this *Manifesto* are, on the whole, as correct today as ever" (129). The only qualification concerns the concrete political measures and the relation between the Communist Party and other revolutionary parties. The authors concede that these passages "would, in many ways, be very differently worded today," and they even admit to their being outright "antiquated" (130). Any change, however, has to be strictly limited to preserving the *Manifesto*'s foundational force and authority; the best way of doing so is by declaring the *Manifesto*, as Marx and Engels finally do in this preface,

to be "a historical document which we have no longer any right to alter." This is a decisive moment in the history of the *Manifesto*, namely, the moment when this text becomes history, when the authors have to acknowledge that the future the *Manifesto* envisions might itself be history: the history of the future.

Even though the future envisioned in the *Manifesto* now has a history and therefore threatens to be history as well, the *Manifesto* must never become simply one more historical and therefore outdated document. For this reason, the sentence that declares the *Manifesto* to be a "historical document" is immediately qualified with the attempt to preserve some space for change: "A subsequent edition may perhaps appear with an introduction bridging the gap from 1847 to the present day" (130). If the *Manifesto* and what it did is a historical fact and act, it can no longer be altered. Once it is a historical fact, however, it will automatically be in need of updating. The balancing act of supplementation takes place in the introduction, which must both preserve and enhance a *Manifesto* that wants to be both fixed in time and up-to-date.

The process of updating and preserving intensified after Marx's death. The first preface Engels wrote alone, for the German edition of 1883, takes the project of fixing the *Manifesto* in a different direction: it is a eulogy for Marx. Now Engels takes great pains to present his dead friend as the sole author of the *Manifesto*, declaring that the "basic thought belongs solely and exclusively to Marx. I have already stated this many times; but precisely now it is necessary that it also stand in front of the *Manifesto* itself" (133). Something that stands in front of the *Manifesto*, its supplementary preface and frontispiece, declares that there can no longer be any supplements: "Since his death, there can be even less thought of revising or supplementing the *Manifesto*" (132). A necessary preface, standing "in front of" the *Manifesto* declares that nothing must, from now on, supplement the *Manifesto* in any way. The *Manifesto* becomes Marx's legacy, his testament, and his memorial.

The *Manifesto*, however, did not function as a tombstone for long. In subsequent prefaces, Engels approaches the necessary historicity of the *Manifesto* not so much as a problem but as an asset. Engels writes proudly that now, "The *Manifesto* has had a history of its own" (138); and this means, for example, that the history of the *Manifesto* registers and records the history of communism. After 1852, we learn, when communism was outlawed at the Cologne trial, the *Manifesto* was almost "doomed to oblivion" (134); during the international cooperation following this low point, it had to be suppressed in order not to alienate less radical workers associations; but in

the 1870s the *Manifesto* had in fact "made considerable headway among the working men of all countries" and thus come "to the front again" (135). But Engels is not content with the *Manifesto*'s resurgence and begins to think of its history in terms of a dialectical process whereby it registers not only the volatile history of communism but also, by extension, the history of industrialization.

> It is noteworthy that of late the *Manifesto* has become an index, as it were, of the development of large-scale industry on the European continent. In proportion as large-scale industry expands in a given country, the demand grows among the workers of that country for enlightenment regarding their position as the working class in relation to the possessing classes, the socialist movement spreads among them and the demand for the *Manifesto* increases. (141)

The *Manifesto* records not only the history of communism but also that which, according to its own theory, gave rise to it: industrialization. Where there is industrialization there will be a proletariat, where there is a proletariat there will be communism, and where there is communism there will be the *Manifesto*. Whether or not one believes this logic, it confirms Althusser's argument that far from speaking "from nowhere," the *Manifesto* calculates and projects its own place of articulation, its own emergence and circulation.

While the relation between the history of the *Manifesto* and industrialization is difficult to pinpoint with precision, especially in light of the revolutions it inspired in semi-industrial countries such as Russia and many colonies, it remains true that the history of the *Manifesto* can serve as an index of Marxism itself. Due to the gargantuan efforts of Bert Andréas and the communist Italian publisher Feltrinelli, a history of the *Manifesto*'s circulation from 1848 to 1918 can be based on a substantial data pool.[3] Andréas distinguishes between (1) partial and complete editions, (2) substantial citations, and (3) planned and probably failed editions and translations. These data confirm Engels's weaker claim that the *Manifesto* increasingly became an index of revolutionary activity. The first such period extended from 1848 and 1852, with ten editions, fifteen extractions, and fourteen attempted editions. The next eight years, from 1853 to 1863, mark the period of least activity, with only one more edition and one attempted edition; during this time, the *Manifesto* exists almost exclusively through twelve extractions and quotations. This is, after all, the period of reaction following the failure of the 1848 revolution, the revolution that the *Manifesto* had wanted to bring about and for which it was written. In this time of reaction, the *Manifesto*

circulates primarily through hearsay, through references in newspapers, and occasional quotations; it is nothing but a specter.

The time of the First International, spanning from its formation in 1864 to its demise in the aftermath of the fall of the Paris Commune in the early 1870s, marks a fourth period of moderate activity, with 15 new editions, 3 attempted editions, and 33 extractions. In contrast to the first period, the ratio between edition and quotation has increased; whereas previously 10 editions led to only 15 quotations, now 15 editions lead to 33 quotations. The success is, however, still moderate. Marx downplayed the *Manifesto* throughout the First International, knowing that it would not help unify the British trade unionists, French socialists, and Russian anarchists who composed the principal constituencies of the association. What is significant, however, is that the *Manifesto*'s success rate has increased. While the first period had needed 14 attempted editions in order to achieve 10 successful ones, now there are only 3 failures for 33 successes. (Indeed, the success rate will continue to rise. There are fewer and fewer unsuccessful editions; in the forty-four-year period between 1874 and 1918, for example, there are only 17 unsuccessful editions recorded by Andréas.) We can see that the *Manifesto* is slowly but surely spreading. Some members of the First International noticed this spread with unease. Marx's anarchist rival, Mikhail Bakunin, for example, accused Marx and Engels of hypocritically declaring the *Manifesto* "an antiquated document" while secretly "endeavoring to spread this document in all countries."[4]

Despite the debacle of the Paris Commune and the demise of the First International, the *Manifesto* continues to be referred to at an accelerating speed during the next four years, from 1875 to 1878, with 19 quoted extractions, an average of 4.75 per year (the average up until 1868 had been 1.45), but there are no new editions and only two attempted ones. Word of the *Manifesto* got around, but not the *Manifesto* itself. In the early eighties, however, the *Manifesto* suddenly spreads at an increasingly accelerating pace—to never really die down again. The next eight years show 37 new editions, almost 4 per year, and 58 quoted extractions (7.25 per year, up from 4.75). In the next seventeen-year period (1879–94) the quotation ratio increases from an average of 6.5 to 10.33 and 10.00 per year, but by now it has become virtually impossible to track such quotations; there are simply too many.

Marxism, in this period, is increasingly pushing aside rival socialist movements and associations, especially anarchism. By the late eighties, finally, the *Manifesto* has become a new standard, circulated not only in ever-increasing quoted extractions but also in ever more editions and transla-

tions. There are still up and downs, with a new period of activity spanning 1900 to 1907, mainly fueled by Russia and the activity before, during, and after the 1905 revolution, and then again after 1917. In fact, the two peaks during that period are 1905 and 1917, with 24 and 21 editions, respectively, 13 and 10 of them published in Russia alone. More than just an index, the distribution of the *Manifesto* tracks the periods of revolutionary upheaval of 1848, 1871, 1905, and 1917, during which times it also increases steeply, first through quoted extractions and failed editions, but increasingly through successful editions and translations of the *Manifesto* itself. The data interpreted here also show the extent to which the two Russian revolutions helped catapult the *Manifesto* to the position of being the primary revolutionary text. The *Manifesto* is on its way to becoming one of the most printed, translated, and circulated texts in history, an example of world literature.

The *Manifesto* proliferates over time, but it proliferates in spurts that coordinate with the periods of revolutionary activity. In this, it differs from its kin, the utopia, which thrives not during the hectic activity of revolutionary periods but during times of reaction and status quo. If utopias project the subterranean desire for change into distant futures (or far-flung places) that are unreachable, manifestos allow revolutionary drives to break through the surface and to assume political force and agency. While it may therefore appear that manifesto and utopia are two manifestations of the same revolutionary desire for radical change, it is also true that the rise of the manifesto in the late nineteenth century and then its rapid success in the twentieth century have displaced the utopia (Ernst Bloch's utopian texts are an example of the manifesto influencing utopian writing in the twentieth century). The manifesto makes utopias appear vague and devoid of political force in that they avoid the most pressing question, namely how to get there, precisely the question the manifesto tries to answer.[5]

The *Manifesto* not only proliferated in the late nineteenth and early twentieth centuries, it acquired the status as *the* foundational text of Marxism. This new centrality also meant that the manifesto became a genre that could not be used and adopted lightly. Despite the fact that the Marxist tradition created an unprecedented number of pamphlets, leaflets, propagandist and pedagogical writings, and historical and theoretical studies, it tended to use the title "manifesto" with a certain amount of restraint, reserving it for central moments such as when national socialist parties are founded or refounded or in the series of foundational acts that constitute the different Internationals.

**Number
of Editions**

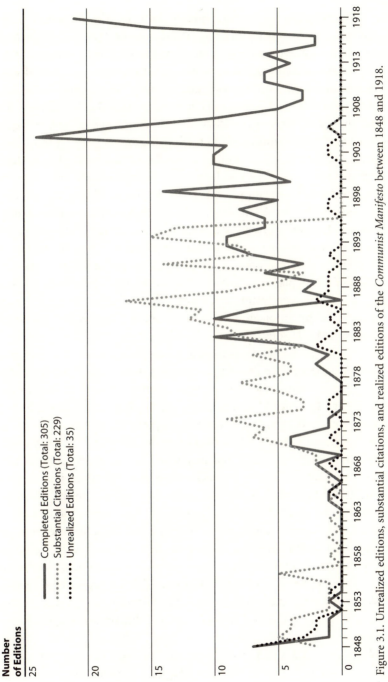

- Completed Editions (Total: 305)
- Substantial Citations (Total: 229)
- Unrealized Editions (Total: 35)

Figure 3.1. Unrealized editions, substantial citations, and realized editions of the *Communist Manifesto* between 1848 and 1918.

Restraint or evasion with respect to the genre title "manifesto" characterizes no text as clearly as Lenin's *What Is to Be Done?* (1902), which established the Communist Party as the avant-garde of the revolution, a concept that would become central to writers of art manifestos associated with the various avant-gardes of the twentieth century. Given Lenin's emphasis on theory, agitation, and propaganda, it is noteworthy that he sidesteps the genre of the manifesto as well as discussions of the *Manifesto*. Here we begin to see an anxiety about touching and revising the *Manifesto* by writing a new and presumably more adequate one. Instead, Lenin chooses to place his text, through its title, in a different and entirely Russian tradition. *What Is to Be Done?* borrows its title from Chernichevsky's 1863 novel, the all-time best seller of socialist fiction. A half-utopian, half-reformist novel with an explicitly antimelodramatic plot, this book combines Fourierist theories about the relation between the sexes with the communal ownership of the means of production.[6] Lenin's text, however, is the very opposite of a continuation of Chernichevsky's utopianism. Instead, Lenin writes under the direct influence of the *Manifesto*, demonstrating that the question "What is to be done?" must be answered not by a utopian novel but by a strategic and militant pamphlet that has learned is lessons from the *Manifesto*.

Avoiding the *Manifesto* for fear of displacing it turns out to be a frequent attitude taken by those most invested in this text's continued significance. In this sense, the dichotomy between the *Manifesto*'s originality and its historicity, which Marx and Engels had tried to manage through their prefaces, continued to make itself felt throughout the history of Marxism. On the one hand, using the genre defined by the *Manifesto* can mean reverence. On the other hand, each new manifesto also functions as an open or tacit challenge: apparently, the *Manifesto* failed to do the whole job. There is something else that needs to be done, there is something in the *Manifesto* that needs to be updated or otherwise adjusted. Even a return to Marx is a repetition that implies a minimum of difference, and this difference threatens the original. The *Manifesto* may well be the first and genre-defining manifesto, but this does not mean that it is this genre's best and ultimate instantiation. In this way, the genre of the manifesto itself develops over time, leaving the *Manifesto* further and further behind. The dilemma in which the Marxist tradition is caught is thus one of repetition and difference, of repeating the manifesto through prefaces, editions, and new manifestos in order to certify the *Manifesto* as origin and, at the same time, to know that each repetition, no matter how well-intentioned, inevitably brings with it some degree of difference that potentially undermines the *Manifesto*'s relevance.

The workings of repetition and difference characterize the series of foundational acts that inaugurated the several international associations of communists that followed the Communist League created by the *Manifesto*. Marx himself wrote the "Inaugural Address of the International Working Men's Association," but the only element he retained from his *Manifesto* was its concluding slogan: "Proletarians of all countries, unite!"[7] Evading the *Manifesto* was certainly a good strategy because Marx did not want to alienate rival groups, but the anxiety about the relation of this new text to the original *Manifesto* may have played a role as well. However, as the *Manifesto* increased its visibility throughout the seventies and eighties, it could no longer to be suppressed or spread secretly. More and more groups and associations had to take it into account, even if they did not subscribe to its principles, and national parties were being built whose manifestos deliberately refer to or even quote the *Manifesto*, such as William Morris and E. Belfort Bax's *Manifesto of the Socialist League* (1885). In the process of writing the *Manifesto of the French Communist Party*, Paul Lafargue even consulted Marx directly in July 1880.[8] The most powerful socialist party that considered the *Manifesto* as an important and foundational document was the German Socialist Party (SPD), which by the late nineteenth century had become the largest socialist party in the world. Even if many national and international associations could not agree on the content of the *Manifesto*, the *Manifesto* thus began to acquire an extraordinary status, and in proportion with this status it came to define what a proper manifesto should look like.

The need and desire to refer back to the *Manifesto* were nowhere as strong as during the efforts to revive or replace the Second International, which had suffered a spectacular defeat at the outbreak of World War I when all European socialist parties, with the exception of the Italian one, had violated the international ethos of the Second International and voted for war bonds and mobilization. Now the task of reorganizing an international communist association was seen once more as a question of returning to the original *Manifesto*. The Second Congress of the Third International issued the *Manifesto of the Communist International to the Workers of the World* (1920), written by Leon Trotsky, that openly declares to be written "in the form of a Manifesto." The choice of this form immediately opens the question of the *Manifesto*'s historicity and futurity: "Essentially the movement proceeded along the path indicated in advance by the *Communist Manifesto*. We Communists . . . feel and consider ourselves to be the heirs and consummators of the cause whose program was affirmed 72 years ago."[9] This reference to the *Manifesto* was meant to bolster the authority of the newly established Third International against the vestiges of the Second, which lingered

and was kept alive by various efforts, sometimes under the name of the 2 ½ International. But this reference, like all supplementations, both assured and threatened the continued influence of the *Manifesto*.

A similar dynamic made itself felt on a national level. In Germany at the end of the war, a radical group split from the discredited SPD under the name of Spartakus-Bund (Spartacus Association). When this association decided to constitute itself as a party, called the Communist Party of Germany (KPD), it did so through the so-called *Spartacus Manifesto*.[10] In her speech at the inaugural meeting of the Spartacus Association, Rosa Luxemburg developed the most extreme account of the dilemma of repetition and difference that characterizes all communist manifestos. The second sentence declares that a "new party" must be founded on a "new basis," but that this newness at the same time takes up the "thread begun seventy years ago by Marx and Engels in the *Communist Manifesto*."[11] So strong is Luxemburg's desire to return to the *Manifesto* that she is even bothered by the small revisions Marx and Engels had suggested in their own prefaces, including Marx and Engels's own comment, made in their 1872 preface, that some parts of their *Manifesto* had to be considered "partially outmoded" (*stellenweise veraltet*, 396). Luxemburg wants to go back further than these prefaces in order to arrive at the pure *Manifesto* itself, without commentary, adjustment, or qualification. Through a careful exegesis of the original "outmoded" passage, Luxemburg arrives at the thesis that far from being "outmoded," these suggestions are in fact the most pressing ones today.

This radical return, which asks us to ignore the very insights of Marx and Engels, is in need of justification; Luxemburg proposes one based on what she calls a "historical dialectic" (397) through which "that which was error then has become truth today." Luxemburg will end up claiming that even and especially Marx and Engels, were they alive today, would agree with her and take back their own qualifications. Today, Luxemburg says, "we are back at Marx, under his sign" (403). The *Manifesto*, which Luxemburg also calls a "contractual document" (*Urkunde*, 404), is the only thing that counts. Luxemburg calls for a return to the original manifesto, even against the words of Marx and Engels themselves. We need a new manifesto in order to confirm the old one, but for this confirmation to work, the new manifesto must erase itself and dwell humbly in the shadow of Marx.

This speech also demonstrates how deeply the question of history and historicity is bound up with the manifesto's desire for action. Returning to the original *Manifesto* means a return to action; once more, the revolution is imminent, approaching "with incredible *speed*" (425; Luxemburg's emphasis). Belatedness is transformed into immediacy, and the problem of

undoing Marx turns into an anxiety about missing the right moment for action. The manifesto's impatience with itself emerges with particular clarity at the end of the *Spartacus Manifesto* itself, at the seam between text and act: "The time for empty manifestoes, platonic resolutions, and high-sounding words has passed! The hour of action has struck for the International!"[12] The shorter the manifesto the better, this logic goes, but paradoxically, perhaps, this imperative cannot be taken to its extreme, namely, that the best manifesto is no manifesto at all. A minimum of manifesto is needed to articulate even this impatience and urgency, including the critique of all delays and all writing; a minimum of postponement is necessary to demand that action be no longer postponed.

What remains is the split second it takes to say "Act now" or "Let us speak no more" or "Now, after I finish this last sentence, there will be no more sentences; we will stop talking and writing and reading, and we will act, as soon as I have said the last now: now!" After this last "now" has been said, there is more postponement still in the form of an exclamation mark that both emphasizes the urgency to act and postpones the act itself once more. In its silent gesture, the exclamation mark even mimics the act; it is already some sort of act, but not the right one. The exclamation mark is one more seam between manifesto and revolution, one more mediation, more of an act than a text, perhaps, but not act enough. In this way, the manifesto is a genre that imagines itself to be on the verge of action, anticipating, preparing, organizing this action, and perhaps participating in it already, if only in a preliminary manner. The manifesto simply cannot wait for its own end so that real action, the only thing it cares about, can begin. It is a genre that is impatient with itself, that is eager to stop talking and to begin doing, even as it tries to make its own language part of that envisioned action. The history of communist manifestos, the fact that there exists a history of communist manifestos in the first place, is an index of postponements and failures, the failure of a final, all-transforming revolution. The absence of such a revolution makes for the melancholic tone that can be detected underneath these manifestos' aggressive surfaces. The history of political manifestos therefore has a tragic undertone, a history of disastrous postponements of the revolution, postponements to which all manifestos have contributed even as they have tried to do everything to bring them to an end.

As the twentieth century wore on, the dilemma of repetition and difference became increasingly pronounced. Following the foundational acts of the immediate post–World War I period, opposition to Joseph Stalin in the later thirties led to a second wave of alternative associations that tried

to derive their authority from the *Manifesto*. Prominent among them was the Fourth International, proclaimed by the *Manifesto of the Fourth International on the Imperialist War and the Proletarian World Revolution* (1940), written by Trotsky from exile in Mexico.[13] Just as the foundational manifesto of the Third International had been written against the Second, so the foundational manifesto of the Fourth was written against the Third. This manifesto, too, is written with a sense of urgency. It begins: "The Emergency Conference of the Fourth International, the World Party of the Socialist Revolution, convenes at the turning point of the second imperialist war" (183), and it refers to the manifesto's act of manifestation when it says, "The Fourth International considers that now is the time to say openly and clearly how it views this war and its participants."

The notion of openness and manifestation is particularly central here because it opposes the secrecy of the Hitler-Stalin Pact, which had shocked Europe's socialists. Indeed, As the people's commissar of foreign affairs, right after the Revolution, Trotsky had made it his business to expose the documents of the czar's secret diplomacy as a contrast to the openly declared and manifested foreign policy of the new Soviet state: "In revealing to all the world the work of the ruling classes as it is expressed in the secret documents of diplomacy, we address to the toiling masses the appeal which is the unalterable foundation of our foreign policy: 'Proletarians of all lands, unite.' "[14] But for the foundational document of the Fourth International, something more is required than a dedication to the open and the manifest. As in Trotsky's previous manifesto, a more direct negotiation with the *Manifesto* has to occur. Such a negotiation takes place a few pages into this new document: "Almost a hundred years ago when the national state still represented a relatively progressive factor, the *Communist Manifesto* proclaimed that the proletarians have no fatherland" (190); it is from this quotation that this new manifesto derives its authority and its central terms.

Just three years earlier, on the ninetieth anniversary of the *Manifesto*, Trotsky had sounded a similar note, declaring, "This pamphlet, displaying greater genius than any other in world literature, astounds us even today by its freshness."[15] But he places his own preface in the tradition of Marx and Engels's prefaces: "As early as their joint preface to the edition of 1872, Marx and Engels declared that despite the fact that certain secondary passages in the *Manifesto* were antiquated, they felt that they no longer had any right to alter the original text inasmuch as the *Manifesto* had already become a historical document, during the intervening period of twenty-five years" (18). While discussing those "secondary" passages that had become outmoded, Trotsky even defends the ten demands of the *Manifesto*, from

which Marx and Engels had distanced themselves in their 1872 preface (thus echoing Luxemburg): "The ten demands of the Manifesto, which appeared 'archaic' in an epoch of peaceful parliamentary activity, have today regained completely their true significance" (24). Subsequent manifestos and declarations must therefore "amplify" (26) the *Manifesto*, not deviate from it. And so Trotsky repeats what he had written in the manifesto of the Third International almost twenty years prior, namely, that he wants to be the "heir" (26) of the *Manifesto* itself. It did not escape Trotsky that his own writings thus form a history of repeated inaugurations, and he responded to this history in a note written shortly after his manifesto: "The party cannot preserve its tradition without periodic repetitions" (228).

Oscillations between preserving and supplementing the *Manifesto* mark the history of the socialist manifesto until today.[16] The late 1990s witnessed a resurgence of the manifesto in the debate about globalization, culminating in the millennial publication of Michael Hardt and Antonio Negri's *Empire*.[17] This book can be seen as the most recent symptom of the dilemma of repetition and difference. Although the authors themselves avoid the term "manifesto," the publisher boldly declares this book to be a new *Manifesto*. Indeed, *Empire* at least sets the scene for such a new manifesto in a section, early on in this lengthy book, that is written in cursive type and which takes as its subject Althusser's reading of *The Prince* as "utopian" manifesto. Inspired by Althusser's reading, the two authors ask: "How can a revolutionary political discourse be reactivated in this situation? How can it gain a new consistency and fill some eventual manifesto with a new materialist teleology?" (64). Mindful, perhaps, of Marx's caution about the poetry of the future revolution, they admit that "the form in which the political should be expressed as subjectivity today is not at all clear" (65), but they venture, at the end of the passage, a proposal:

> Today a manifesto, a political discourse, should aspire to fulfill a Spinozist prophetic function, the function of an immanent desire that organizes the multitude. There is not finally here any determinism or utopia: this is rather a radical counterpower, ontologically grounded not on any "vide pour le futur" but on the actual activity of the multitude, its creation, production, and power—a materialist teleology. (66)

This passage bespeaks a desire for a manifesto, avoiding the twin dangers of determinism and utopia, but its parameters are only paradoxes: prophetic (Spinoza) but actual (the actual activity of the multitude); nonfuturist (not "vide pour le futur") and yet teleological. This scenario, I think, describes

the product or effect of a manifesto, but not yet its theatrical and performative work. Any manifesto worth the title cannot be comfortably "ontologically grounded" in an actually existing activity of an actually existing multitude; it must produce this multitude as a subject in itself and for itself, must create the ground on which to stand.[18] I agree with Hardt and Negri that the form of a new manifesto is yet uncertain. With Marx, one might say that in *Empire*, the content of the new revolution is once more in excess of the form. But the real lesson to learn from the *Manifesto* is that the new form and the new content have to produce one another, if they want to truly shape and make the future.

4

The Geography of the *Communist Manifesto*

The *Communist Manifesto* and World Literature

The tension between updating the *Communist Manifesto* and preserving its original force, which characterizes the history of the socialist manifesto from Marx and Engels's prefaces to Hardt and Negri's *Empire*, has not been the only challenge faced by each manifesto after Marx. The other has been the geography on which the *Manifesto* is based. Engels's first revision of the *Manifesto* in 1852 was concerned not so much with the question of history as the question of geography: California and Australia had been neglected. The same type of adjustment happened in Marx and Engels's subsequent prefaces; the one for the 1882 Russian translation, for example, admits ruefully that "precisely Russia and the United States are missing here" (131). These remarks were but early warnings that there was something seriously wrong with the geography envisioned in the *Manifesto*. In fact, the entire history of communism belied the *Manifesto*'s industrio-centrist geography, for the great communist revolutions happened not in the most advanced industrial nations, such as Great Britain or Germany, but in "backward" ones, such as Russia or China and in the colonies. Indeed, everyone who struggled with the historicity of the *Manifesto*, from Marx and Engels through Lenin, Luxemburg, and Trotsky all the way to Hardt and Negri, struggled also with this geography. The history of the *Manifesto*'s rewritings and adaptations must therefore be complemented by an analysis of its geography.

Given the close connection between manifesto and modernity, the *Manifesto*'s geography also resonates with the geography of modernity. Mo-

dernity has often been seen as depending on temporal constructions such as progress as opposed to the spatial orientation of postmodernity. This temporal orientation of modernity found a particularly influential formulation in Hegel, for whom geography was but the passive recipient of history, an array of transient places occupied by the progress of the spirit in time.[1] While the temporal axis is marked by steady progress, the geographic plane is marked by gaps, white areas, and the graveyards of past cultures. Despite significant differences, Marx's conception of history is heavily indebted to this historically driven geography, and not just outside Europe but also within. For example, he dismissed Germany as a country without a political history, while insisting that the future of other European nations was to be sought in Great Britain. David Harvey has long advocated that we turn this "historical materialism" into a "historical-geographic materialism."[2] It is following such an imperative that I offer a geographic analysis of the *Manifesto* by examining not the (Hegelian) geographic understanding of capitalism the *Manifesto* presents but this text's own geographic practice. I will focus on three areas: (1) an analysis of how the *Manifesto* calculates its own translation, distribution, and readership; (2) the geographic circumstances of its composition; and (3) the actual translations and distribution of the *Manifesto*, the map of its diffusion.

Marx and Engels did not speak very much about how the *Manifesto* as a text and product fit into their understanding of capitalism, but the few places where they do are worth our attention. The first, and probably most important, mention occurs when the two authors address the question of world literature, a term that surely has ramifications for the *Manifesto* itself, which is nothing if not an example of world literature; indeed, it became one of the best-selling texts of all time. I quote from the translation by Samuel Moore, revised and edited by Engels for the edition of 1888:

> The bourgeoisie has through its exploitation of the world market given a cosmopolitan character to production and consumption in every country. To the great chagrin of Reactionists, it has drawn from under the feet of industry the national ground on which it stood. All old-established national industries have been destroyed or are daily being destroyed. They are dislodged by new industries, whose introduction becomes a life and death question for all civilized nations, by industries that no longer work up indigenous raw material but raw material drawn from the remotest zones; industries whose products are consumed, not only at home, but in every quarter of the globe. In place of

the old wants, satisfied by the production of the country, we find
new wants, requiring for their satisfaction the products of dis-
tant lands and climes. In place of the old local and national seclu-
sion and self-sufficiency, we have intercourse in every direction,
universal interdependence of nations. And as in material, so also
in intellectual production. The intellectual creations of individ-
ual nations become common property. National one-sidedness
and narrow-mindedness become more and more impossible,
and from the numerous national and local literatures there
arises a world literature. (93)

It is nowhere clearer how much Marx and Engels admire the bourgeoisie
than in this remark about bourgeois world literature, a world literature that
does its part in battering down the "Chinese walls" of national seclusion
which the authors mention a few sentences later. To what extent does the
Manifesto participate in this bourgeois, cosmopolitan world literature?

To answer this question, it is necessary to historicize the notion of
Weltliteratur, which had been coined just a few decades earlier by Johann
Wolfgang von Goethe, the very personification of the literary bourgeoisie.
Goethe's most famous remark, recorded by Johann Eckermann, considers
world literature to be not so much an accomplished fact as a project in the
making: "The epoch of world literature is at hand, and everyone must strive
to hasten its approach."[3] For Goethe, as for many later commentators, *Welt-
literatur* is in the process of developing, and the question is whether this
development should be supported or resisted.

What drives world literature, for Goethe, is translation. It is
through translation that the texts produced by the different nations are
made available to all and thus enhance their mutual understanding. The
other reason that translation is so central for Goethe is because it concerns
Germany's particular contribution to world literature: "Whoever knows and
studies German inhabits the market place where all nations offer their prod-
ucts [*Ware*]; he plays the translator even as he reaps profit [*sich bereichert*]."[4]
Goethe does not consider world literature to be something that concerns
the production of literature, but only its distribution and translation. In
other words, world literature is not written but made—made by a market-
place. One can recognize in this vision an effect of Goethe's particular loca-
tion on the semiperiphery of culture: while he cannot expect too much of
Germany in terms of original literary contribution, which is dominated by
France, he can expect much of talented German linguists and translators.
For this reason, perhaps, Goethe is singularly concerned with elevating the

value of translation and ends up making a startling declaration. After quoting from the Koran, "God gave each people a prophet in its own language," he concludes: "Each translator is a prophet for his people" (87). This is an astonishing conclusion to draw, since the quote Goethe offers means the opposite; it is the basis on which Islam has denounced translators and has kept translations of the Koran outlawed, even denying that such translations exist (instead, non-Arabic versions are called "The Meaning of the Koran"). So invested is Goethe in translation that he transforms the translator from blasphemer to prophet.

The translator is a prophet, but also a businessman. In fact, the marketplace and translation depend on one another. This interdependence leads Goethe, and has led many others, to connect world literature with a particular fear, namely, the fear of homogenization. While Goethe hails world literature for doing away with a narrow-minded fixation on national literatures, he nevertheless is concerned about preserving their distinctiveness: "I do not think that the nations should all think alike, they should simply become aware of one another and understand one another."[5] Goethe recognizes the fear of homogenization, but he dismisses it, surprisingly perhaps, with reference to the market in translation. It is the specificity of nations, he argues, not their similarity, that makes them valuable to others: "The peculiarities of each [nation] are like its languages and coins, they make commerce easier, in fact they make it possible in the first place" (86). World literature traffics not in sameness but in difference: it is difference and originality that is being marketed by German translators and, it is difference that makes national literatures circulate. Different languages guarantee the kind of specificity that circulates well, just like coins, provided that there are translators who ensure that they are translatable and thus exchangeable. No wonder that translation is such good business.

It is here that Marx can find a point of departure for his own conception of world literature. He no longer imagines the quaint, local market of talented German translators, but a global one that ends up turning against the very existence of the nation-state, a market that ultimately draws "from under the feet of national industries the national ground," leading to a "cosmopolitan" "world literature," marked by the "universal interdependence of nations." Transposed into the sphere of literature, this means that the national literatures no longer satisfy their own needs, and so a world literature emerges that spells the end of the national literatures altogether. Apparently, not only distribution but also production, "intellectual production" (*geistige Produktion*), now has the character of world literature. Where Goethe envisions a mercantile world literature dominated by the craft of

translation and captured by the image of circulating coins, Marx envisions a capitalist world literature dominated by the circulation of capital.

For a reader of Marx, the question of the production, distribution, and exchange of literature resonates with Marx's well-known distinction between use value and exchange value. Literature continues to be produced in some language, just as we can hypothesize about use value, but this does not matter, since the only thing that determines the value of a given commodity is its exchange value. Just as capital brings about the total exchangeability of commodities on which the world market is premised, so it brings about total exchangeability in the sphere of literature. Borrowing from *Das Kapital*, we can say that translation or translatability provides what Marx calls the "form of equivalence" (*Äquivalentform*), which is the condition and form of exchangeability.[6] World literature, in this view, sets the value of a given translation not according to its relation to the original text (use value) but according to the market of translation (exchange). Where Goethe leaves the production of literature to the national literatures and restricts world literature to their translation and exchange, for Marx this world of exchange and translation begins to encroach on production as well.

What, concretely, does it mean for translation to encroach on production, for a text to belong to this capitalist world literature? One way of addressing this question is by looking at the actual practice of Marx and Engels, and this means by analyzing the way they envision the circulation, translation, and publication of the *Manifesto*. Such an analysis unearths a startling notion of world literature based on a radically expanded concept of translation. At the end of the preamble, Marx and Engels demand that the *Manifesto* "be published in the English, French, German, Italian, Flemish and Danish languages." German here appears in the middle of a list of six languages, without any indication that it is the *Manifesto*'s original language. One might even say that Marx and Engels place German in the middle of this list to hide the fact that it is the *Manifesto*'s original language. And given the fact that the first editions of the *Manifesto* concealed the identity and thus the nationality of its two authors, one wonders whether they actually sought to obscure the fact that the *Manifesto* was written in a specific language at all, that there was an original language from which it then had to be translated into all the others. What seems to matter instead as the organizing principle of this enumeration of languages is their market share and geographic reach, with English and French ranging before Flemish and Danish. Indeed, the preamble leaves the question of authorship deliberately open, declaring vaguely that "Communists of various nationalities have assembled in London and sketched the following Manifesto." Who exactly has done

this "sketching" and who subsequently turned this sketch into a full text remains unclear. A multinational and multilingual assembly, a veritable Babel, has somehow given rise to a text, or at least to a sketch of one, that now can be published in as many languages.

Indeed, the *Manifesto* downplays and omits translation as a problem everywhere. The preamble speaks only of the simultaneous "publication" of the different versions in these six languages as if translation were a minor problem, not even worth mentioning. What emerges here is the dream of a new world literature: all editions of the *Manifesto* in all languages are equivalent so that the conception of an original language no longer matters. The 1888 preface reveals a similar desire by celebrating the fact that a French edition has been produced based not on the German edition but on the English one. Engels writes: "The German text had been, since 1850, reprinted several times in Switzerland, England and America. In 1872, it was translated into English in New York, where the translation was published in *Woodhull and Claflin's Weekly*. From this English version, a French one was made in *Le Socialiste* of New York" (135). Engels is more interested in the place and organ of publication, in geography, than in the original. Reference to the original, the bedrock of the concept of translation, has been replaced by a total translatability. This does not mean that Marx and Engels would deny that any text is written, for the first time, in a specific language and in a specific context. Rather, they seem to suggest that we do not have to accord this "first" formulation of a text in a given language the privileged status of an original invested with the aura of untranslatability, copyright, and authority.

Taking Goethe's notion of *Weltliteratur* as it is being refashioned by Marx and applying it to the *Manifesto* raises the question of what notion of literature is at work here. While Goethe's understanding of literature is largely confined to fiction, Marx and Engels, with their emphasis on "intellectual production," seem to revert to an older understanding of literature that includes all kinds of writing of a certain level of sophistication. It is this expanded notion of literature that allows the authors to develop their radical concept of translation, which seems to violate so egregiously the concept of the artistic original. Calling the *Manifesto* literature therefore does not mean to assign to it the status of an artwork. On the contrary, the two authors created a new mode of political articulation, a new genre. It was Brecht who most cunningly managed to foreground this distinction by translating the *Manifesto* back into the artistic and poetic form of the hexameter. Does the *Manifesto*, in this form, become art? Does it remain political? The question

is perhaps moot, since Brecht's verse *Manifesto* is virtually unknown. A fun exercise, this generic translation abandoned precisely the poetry that had turned this text into the first example of a new genre and into a principal example of world literature.

The worldwide success of the *Manifesto* has, to some extent, confirmed this text's extreme fantasy of world literature. The more the *Manifesto* actually became world literature, the more it was translated into other languages—and often not from the original German but from other translations—the more the conception of an original receded into the background. This is not to say that accurate translations have not dominated the *Manifesto*'s circulation in particular languages, for example, the "authorized" second English translation by Moore. The first translation, by Helen Macfarlane, is now ridiculed for translating the first sentence as "A frightful Hobgoblin stalks through Europe," which is, in fact, a more literal translation of what Marx and Engels had written.[7] In addition, the now outmoded word "hobgoblin" reads the *Manifesto* through the fairy-tale world of the Brothers Grimm (a little further on, the preamble announces that it will "meet the nursery tale of the Specter [or hobgoblin] of Communism with a Manifesto of the party itself" [87]). Nevertheless, when it comes to a text of world literature such as the *Manifesto*, reviving the opening of the Macfarlane translation would not make sense; "A specter is haunting Europe" has become the language of the *Manifesto* in English.

A second example is "All that is solid melts into air" (92), which has served Marshall Berman as the title of his famous study of modernity. What Marx and Engels had written in 1847 was "Alles Ständische und Stehende verdampft."[8] Marx engages in an intriguing wordplay that sounds outright Heideggerian. *Stehend* means "standing" or "fixed," while the preceding *Ständische*, which is etymologically derived from *stehend*, denotes a feudal or caste society, one in which the social classes are arranged in a fixed order or hierarchy. *Verdampft* simply means "to evaporate." After a rich and intriguing wordplay on "standing," Marx thus reverts to a strange special effect in the form of a mixed metaphor: something fixed and standing evaporates. This is a mixed metaphor because the solid first has to melt, and only then, as something liquid, can it evaporate into steam and air. A literal translation, preserving the mixed metaphor and replacing the stronger etymological resonance with an alliteration would be something like "Everything feudal and fixed evaporates." Moore's "All that is solid melts into air," however, intervenes more strongly. Instead of the solid somehow evaporating, he has it, correctly, melting away and even manages to preserve Marx's idea of steam by saying that the solid melts "into air." All this is an improve-

ment not only because it corrects, if that is the word, the chemistry of the passage but also because it renders it in the language of Shakespeare, referring to the famous concluding lines of the *The Tempest*: "Our revels now are ended. These our actors, / As I foretold you, were all spirits, and / Are melted into air, into thin air" (4.1.147). Moore works in the spirit of Marx, whose texts are full of quotations from Shakespeare, thus convincing by both precision and literary echo.

It is not so much a question here of evaluating translations as of demonstrating the autonomy of translation when it comes to a text of world literature such as the *Manifesto*. Reviving the opening of the Macfarlane translation, or remaking the "All that is solid melts into air" sentence would be entirely futile; these expressions have become the language of the *Manifesto* in English. In a way, thus, the *Manifesto*'s fantasy has actually come true: the original no longer really matters. The *Manifesto* no longer has an original language but only a first language, and even here it insists on a "simultaneous" publication in many languages. Even the conception of a first language is suppressed and replaced by simultaneity.

This is an astonishing, almost fantastic understanding of world literature, and one resonant with our contemporary debate about global literature. One way in which a radical conception of world literature has been imagined is by presuming the gradual withering away of the different national languages and the emergence instead of one single language, for example, global English. This is what Goethe cautions against—the fear of homogenization—and it is what continues to be a concern throughout the history of world literature. Such was, for example, Auerbach's pessimistic prediction of a world literature increasingly made homogeneous by what we would now call globalization.[9] In his recent book, *What Is World Literature?*, David Damrosch cites other examples of this fear of homogenization, the fear that the process of becoming world literature, the circulation of literature beyond its first context, will lead to a flattening out, assimilation, and homogenization for which the airport bookstore invariably stands as the figure.[10] Indeed, the book retailer Borders now classifies its small assortment of literature in languages other than English not as foreign literature but as "untranslated" literature, as if this literature is already waiting and destined to be translated into English. The truth is, however, that many more texts are being translated from English into the major other languages than into English. One consequence of this reluctance and resistance to translation is that many "world literature" authors have found their way into the global market through translations into French, not into English.

As stifling as the global dominance of a single language would be, one might nevertheless hope that such a dominant world language would be internally divided by dialects, sociolects, creolizations, and pidginizations, as well as by adaptations and transformations. Damrosch quotes, among others, Chinua Achebe, who claims, "I feel that English will be able to carry the weight of my African experience. But it will have to be a new English."[11] This is akin to what Deleuze and Guattari termed "minor literature," exemplified in Franz Kafka's peculiar use of Prague German.[12] This type of internal differentiation will not be enough for those who view languages as biological species, whose variety must be preserved from distinction at any cost. But it is, perhaps, a consolation for those to whom what matters most is the process of resisting homogenization and of ensuring differentiation in whatever form.

To return to the *Manifesto*, it is interesting to note that what Marx and Engels are doing is different and even more radical: they are totalizing translation to the point of eliminating the original language as a privileged point of reference entirely. One might say that they are trying to undo Babel (in what one might recognize as a version of the Pentecost miracle) and, in the process, comparative literature.[13] The conception of the original language and its translations informs not only the paradigm of national languages but almost all understandings of comparative literature, including that of Goethe but also that of George Steiner, whose main work on comparative literature is called *After Babel*.[14] This post-Babel state, the division of an ur-language into distinct languages among whom translation is always challenging and prone to failure, is the religious ground on which not only national literatures but also their comparative analyses stand. The difficulties, dangers, and problems, the necessary infelicities and losses of translation are such common complaints among theorists of translation that they hardly need to be articulated. They result, after all, from divine punishment and cannot, in this world, be undone.

At the same time, it is from the vestiges of the old comparative literature that a serious challenge to the fixation on the original is now being launched, whether through the practice of teaching literature in translation or through theories of translation based on circulation rather than on the original. One example is David Damrosch, whose definition of world literature includes "World literature is writing that *gains* in translation" (281; my emphasis). Damrosch foregrounds gains, not losses, opportunity not failure, formulating a conception of world literature that questions the authority of the original language. In fact, Damrosch envisions a type of world literature that overlaps with the one encoded in the *Manifesto*, namely, of a world

literature written not in some variant of global English but *for translation from the beginning*. It is a literature whose primary audience is not the one speaking the language in which it was first produced but a global audience defined by the international market, including international prizes, awards, and systems of distribution. Indeed, some of the defenders of the local against the world market, such as Steven Owen, articulate their objection precisely because they fear that translation will affect the original. World literature here creates "originals" that are already geared toward translation, marked in advance by translation, by the fact that they are going to be translated; they are works that, in Owen's words, "translate themselves."[15] Self-translation, global distribution—these are indeed the terms the *Manifesto* seems to embrace without qualification.

But is the *Manifesto* really nothing but a world literature under the sign of a capitalist market? If total translatability defines a bourgeois world literature driven by a global market, wouldn't the best way of resisting this bourgeois, capitalist world literature be to critique, as Owen does, this total translatability and to insist instead on the value of the original and on the irretrievable loss of this value in translation? Going back to Marx's critique of political economy, one might in fact assume that this would have been his strategy, for indeed, Marx hoped to restore the dominance of use value over exchange value. In a well-known argument, the early Jean Baudrillard criticized Marx's conception of the solid, unquestionable, natural conception of use and use value and argued that the originality of this use value is but an aftereffect of exchange.[16] In a world made up entirely of exchange, Marx projected the fantasy of a value prior to, more original and authentic than, the frantic exchanges of the marketplace.

It is remarkable that at least in the practice and vision of world literature that emerges from the *Manifesto*, Marx and Engels did not go that route, namely, of grounding a critique of bourgeois, capitalist world literature in the irreducible status of the original. Instead, they went the other way, pushing this capitalist world literature to an extreme, becoming more international than even the most international productions of bourgeois world literature by erasing the conception of the original altogether. According to Marx's understanding of capitalism, we can say that such a critique of the original is already implied in the workings of capitalism; but at the same time, in the sphere of literature and literary criticism, capitalist societies have shied away from this conclusion. Criticism in capitalist societies has tended toward preserving an older reverence for the sacred text by fetishizing the original as a value in and of itself. In this sense, literary criticism has remained ideologically precapitalist. It is no secret that liter-

ary studies, with its practice of hermeneutics, deep interpretation, and fetishistic attention to detail, has been shaped by the exegetical practices of religious texts inherited from long before the dawn of capitalism. It is only by reflecting critically on this heritage of literary exegesis that a new, modern, understanding of literature can arise, one based on circulation and translation.

Marx gives us a more precise way of formulating this precapitalist inheritance, and he also articulates a trajectory for leaving it behind. He does not advocate that we resist capitalism by fetishizing an original that is taken to be irreplaceable, untranslatable, unexchangeable. Rather, Marx demands that we accept the reality of translation and translatability not just as a something that happens to originals but as something that structures these originals as well. The possibility of translation affects all literature, even before it is actually translated, through what one might call the condition of translatability. Accepting this condition does not imply that translation is not difficult, that it might not run into problems, that it does not require extraordinary skill. Nor does translatability mean that we cannot or should not pay close attention to texts. It only means that we should not define an original by its categorical untranslatability and embellish this untranslatability with an aura of mystique derived from religious, revealed scripture. The law against translation, most clearly articulated by the Koran and so willfully ignored by Goethe, is only the most extreme form of this cult of the original.

There is one more lesson to be learned from Marx and Engels, namely, that we can accept translatability without being enslaved to capitalist exchange. One might think of this along the dialectical lines Marx suggests for all products of the bourgeoisie, including its world literature. The bourgeoisie will create the weapons of its own destruction, and one of these weapons is its world literature. The *Manifesto* participates in *Weltliteratur* in order to undermine it, to spoil it, to abolish it, and, most importantly, to outdo it. To put this in a slightly different way, the *Manifesto* wants to be the last and most successful example of *Weltliteratur*, and it also wants to be the first example of a different form of international literature.

Here we can understand better the complicated geographic dimension of the *Manifesto*'s performative practice. The task of intervention, which marks the entire *Manifesto*, becomes particularly pressing at the end, when the *Manifesto* is faced with the moment when it must trust its own intervention: "Proletarians of all countries, unite!" Of course, the proletariat—the "working men" in Moore's translation—is internally divided, even in the most advanced countries, not to speak of the so-called backward

countries, which may not yet have a proletariat, perhaps not even a bourgeoisie. What Marx and Engels are doing here is to create performatively the global addressee whose existence they at the same time presuppose. It is important to specify the sense in which the *Manifesto* thus creates the world proletariat, for according to its own theory the proletariat is created by industrial capitalism. The command to "unite!" indicates that this economic production is at least to some extent incomplete, that this class still must be united, and this means that it has yet to be created as a single, united class. The *Manifesto* thus speaks not from the position of dominant capitalist globalization but from its underside, the displaced position, which is the position of Marx and Engels as well as that of the proletariat. Written from the point of view of the international, countryless proletariat, the *Manifesto* hopes to create its addressee through its own international, literary practice. In much the same way, the *Manifesto* is the pinnacle of bourgeois world literature and wants to transform this world literature, performatively, into a different world literature, a new world literature in the making. This is the project of becoming international literature as Engels records it triumphantly in his preface to the English edition of 1888: "It [the *Manifesto*] is . . . the most international production of all Socialist literature" (135–136). International literature is not a status but a goal, an ongoing project. With Goethe, Engels is saying that the age of international socialist literature is at hand and that we "must strive to hasten its approach." This new form of world literature, which remains a thing of the future, is already on its way through none other than the *Manifesto* itself.

Marx returned to the topic of translation a few years after writing the *Manifesto*, in the *18th Brumaire*, where he ties it to the question of future and past, forgetting and memory. In the course of describing the burden of the past that must be cast off, he writes: "In like manner a beginner who has learnt a new language always translates it back into his mother tongue, but he has acquired the spirit of the new language . . . only when he moves in it without memory of the old."[17] The *18th Brumaire* is much more pessimistic, and it has the wisdom of hindsight, since it was written after the failure of the revolution of 1848 that the *Manifesto* had tried to inflame. But Marx's vision of a literature without original, translation without the burden of a native language still operates in the metaphors through which he wants to describe what it would mean to create a revolution that would derive its poetry from the future. Such a poetry can only arise once we do away with the memory of the old, with the dependence on the original, and only if we learn the language of the new.

The Geographic Production of the *Manifesto*

For Marx and Engels, translation was not just a theoretical or metaphorical issue but a practical one as well. It accompanied these two writers throughout their lives, as they were driven from one country to the next. If we want to take seriously Harvey's call for a historical-geographic materialism, we have to analyze not only the *Manifesto*'s own fantasies of world literature but also the actually existing geography of its composition. This type of investigation can additionally draw on Edward Said's notion of a "traveling theory" and James Clifford's analyses of travel and translation.[18] For, it will turn out, Marxism, in particular the *Manifesto*, is very much a "traveling theory," a theory on the move.

The *Manifesto* was written while the two authors were living and traveling between Brussels and London, where it was published first as a pamphlet of twenty-three pages and then serialized in the German-language newspaper *Deutsch-Londoner Zeitung* between March and July 1848. This moving back and forth was only the last in a whole series of exiles, expulsions, eviction orders, and temporary abodes, in particular for Marx. After losing the editorship of a radical newspaper due to government censorship, he had moved to Paris in 1843 to work for another newspaper, the *Vorwärts*. Two years later, France found itself under increasing diplomatic pressure to shut down the publication of the radical *Vorwärts*, which it did in 1845, serving expulsion orders to its editors and collaborators, including Marx. On February 3, 1845, Marx and his family moved to Brussels, where he had to swear to the suspicious police that he would not publish anything pertaining to the political situation in Belgium. It was here, and on travels to London, that Marx and Engels worked on the *Manifesto* (Engels and Marx visited one another in London and Brussels). At the same time, Marx was forced to give up his Prussian citizenship. From now on, he would be without nationality, and he never sought naturalization in any other country, not even in England.

These travels and moves were only to increase in speed, fueled by the great upheavals of 1848. On March 8, Marx received police orders to leave Brussels within twenty-four hours, and, after being arrested briefly, he did not even have time to take any of his belongings. Marx moved to Cologne to work on the *Neue Rheinische Zeitung*, but on May 16, 1849, he received orders to leave Prussia, being labeled a foreigner who was being relieved of the "hospitality he has so outrageously abused."[19] After a short stop in Frankfurt, Marx moved back to the now openly revolutionary Paris

in June. But things were not stable there either. On July 19 another expulsion order from Paris was threatened, then postponed, and then reinstated on August 23. Following Engels's invitation, on August 26 Marx finally arrived in London (his wife managed to get permission to stay behind with their second small child), where the reading room of the British Library became the closest, perhaps, he ever had to a home.[20]

The *Manifesto*'s internationalism was thus produced by the experience of exile on the part of the two authors, but it was written for an exile readership as well. As Anderson has observed, in 1848 there were thirty thousand German craftsmen in Paris, and the *Manifesto*'s immediate readers in London were German artisans living there.[21] The artisans, unlike the proletarians, were mobile and therefore had an experience of some form of internationalism (Anderson attributes the collapse of the Second International to the fact that it was dominated by a proletariat that was intensely immobile). When we now consider the *Manifesto*'s obsession with translation and distribution, its investment in erasing its language of origin, we can read these features as products of exile. Homelessness threatens communism, which may turn out to be a mere specter haunting Europe, and it is also what the *Manifesto* attributes to the working class: "The workingmen have no country" (109).

It is central, however, to recognize that Marx was not content with celebrating a particular form of exile or political diaspora. Just two years after completing the *Manifesto*, he and Engels wrote a scathing satire of exile revolutionaries, entitled *The Great Men of the Exile* (1852).[22] Although never published during their lifetimes, this substantial pamphlet is a crucial document in understanding the intersection of exile and the *Manifesto*. Its main targets are the German revolutionaries and pseudorevolutionaries exiled after the failure of the 1848 revolution. Their revolutionary poses, futile attempts to intervene in German affairs, their passion for associations, clubs, and parties, and finally their unending string of pamphlets, speeches, and manifestos earn nothing but the ridicule of the two authors. *The Great Men of the Exile* is a portrait of irrelevance and impotence, compensated for by an overproduction of manifestos, what the two authors call a "manifesto-mania" (*Manifestwuth*) (279) even a "diarrhea" (275).

It is not difficult to see that this general state of affairs was also very much true of Marx and Engels themselves. They, too, lived in and wrote for German exile circles; they, too, tried to intervene in German affairs; they, too, were involved in various leagues, associations, and parties; and they, too, had just written a manifesto. But this is not just a case of projecting anxiety onto others. Marx and Engels truly were more principled in their political stance,

more thorough in their analyses, sharper in their theory, and their manifesto was more than another vague declaration of principles. Nevertheless, *The Great Men of the Exile* characterizes the milieu from which Marx and Engels emerged and against which they struggled. They did so by crafting a new type of manifesto and by turning the experience of exile into something different, namely, a new internationalism. Communism should not remain homeless but, with the help of the *Manifesto*, turn the countrylessness of the proletariat into a new international association and class. When read in this light, the final sentence of the *Manifesto*—"Proletarians of all countries, unite!"—can be understood as an attempt at undoing the countrylessness of exile and turning it into a new communist internationalism.

One model of internationalism associated with movement and exile is that of cosmopolitanism. As much as Marx was the victim of police orders, diplomatic pressure, changing politics, and denunciations, his bourgeois background allowed him relative financial security, aided by the support of Engels. True, he was harassed constantly, but he had options, he was able to move at twenty-four hours' notice, and usually, though not always, with his entire household intact. For quite some time, the notion of cosmopolitanism has carried with it the negative connotation of class privilege, individualism, and lack of political engagement. It is only recently that this term has been resuscitated by the Left, in particular by Bruce Robbins.[23] Marx associated cosmopolitanism with the world market; indeed, the paragraph that ends with the notion of world literature begins with the claim, "The bourgeoisie has through its exploitation of the world market given a cosmopolitan character to production and consumption in every country" (93). But Marx's cosmopolitanism, like his experience of exile, is not simply negative; both are categories that the *Manifesto* uses as its point of departure to create a new form of internationalism. The context of the *Manifesto*'s production, while delimited by western and northern Europe, was one of displacement, and this original displacement can be seen as the catalyst for further displacements and circulation beyond this original exile. Marx and Engels were not "great men of the exile"; they wanted to be the promoters of a new internationalism accompanied and aided by a new poetry of international literature.

The Maps of the *Manifesto*

The internationalism of Marx and Engels can be found not only in the *Manifesto*'s own vision of world literature, nor simply in the circumstances of its

composition, but also in a third geographic dimension: the history of its distribution, the map of its border crossings. The *Manifesto*'s conception of its own translation and geographic distribution was different from what it had predicted—the dream of total translatability was confronted with harsh reality.

Again, it is the invaluable work of Andréas that can form the point of departure for a geographic analysis of the diffusion of the *Manifesto*. The first full publication in a language other than German was in Swedish, in 1848, followed by English in 1850. Unlike what the *Manifesto* had hoped and boldly announced, during the long years of the post-1852 reaction, there were no new translations of the *Manifesto* published (at least, no such publication could be verified), although there were translations planned, partially executed, or never published into Dutch, French, Spanish, Hungarian, Italian, and Danish in 1848, and one failed attempt to translate it into Polish in 1849. It was only in the late sixties and early seventies that further translations were realized, with a translation into Russian by Bakunin, two Serbian in 1871, French and Spanish in 1872 (a French one had been attempted in 1869), and Portuguese in 1873. The number of translations and foreign-language editions increased steeply in the eighties, with the first Czech in 1882, the first Polish in 1883, the first Danish in the following year, and the first Italian in 1889. The nineties witnessed the first Bulgarian (1891), Romanian (1892), Armenian (1894), and Georgian (1897), with Ukrainian following in 1902, Croatian in 1904, and Finnish in 1905.

This map captures the rapid movements of a text that was soon to acquire the status of world literature next to the Bible and the Koran (as Goethe might have been happy to see). However, this map of translation needs to be complemented by others, for example, a map of the places of publication. What emerges when one compares these two maps is the incongruity of language, nation, and readership. The first place of publication was, of course, London, but already in 1851, the *Manifesto* appeared in New York as well. Both editions are in German.[24] The first French edition also appeared in New York (in fact, the *Manifesto* was not printed in Paris in French until 1880), as did the first Czech one (the second Czech was printed in Vienna and only in 1898 was it printed in Pilsen). The first Russian one appeared in Geneva (only in 1883 was a Russian edition printed in St. Petersburg). Needless to say, the *Manifesto* had long been available in places such as South Africa in English editions produced in Great Britain and in Latin America in Spanish editions produced in Spain. Nevertheless, the first edition produced in Latin America appeared as early as 1888 in Mexico City, and the first African one in 1937, in South Africa. At the same time, the

manifesto made headway in East Asia with a first edition appearing in 1904, a translation into Japanese, to be followed in 1908 by one into Chinese.

This geographic pattern shows the multilingual character of cities such as London, Geneva, New York, and Chicago, as well as other cities in the United States (the fourth Swedish edition, for example, was published in Minneapolis). Here, too, one could expand Engels's observation about the indexical character of the *Manifesto* and say that its translations reflect not only the function of these cities as hubs for immigration and as places of branches of the First and Second Internationals but also the importance of English, Spanish, and French as colonial or ex-colonial languages; these displacements also sketch a map of censorship, forcing German and Russian editions to be published elsewhere in Europe or the United States. The chart thus shows yet another form of exile and countrylessness, driven by immigration patterns, censorship, and colonialism.

As the *Manifesto* was translated, it also fused with local traditions and created new versions of world literature and new visions of internationalism. Indeed, the history of communism is the history of different internationalisms, a history of mediations between the particular and the universal. The *Manifesto* contributes to these mediations and mirrors them; it mirrors them in particular in the many forms and adaptations of the genre of the manifesto. Andréas's data also could be used as a point of departure for analyzing how the manifestos that emerged in Russia, China, Latin America, and North Africa adapted and transformed this genre. Such a project cannot be the work of the single researcher. It would imply what Franco Moretti calls "distanced" reading, tracking changes and transformations of large numbers of texts over time and geographic areas.[25] In his analysis of the novel, Moretti found that, by and large, novels import foreign plot structures but insert into them local characters and present them through a local narrative voice. The manifesto, too, undergoes various adaptations and transformations, spanning from its content to its form and voice.[26]

The following brief case study of the Chinese writer Hu Shih exemplifies the adaptation and transformation of the manifesto and also anticipates the focus of the rest of my book, namely, the relations and rivalries between political manifestos and their twentieth-century by-product: avant-garde art manifestos. Hu borrows from political and art manifestos in a pamphlet that denounced the dominance of inherited styles in literature. This pamphlet adopts some formal features of political and art manifestos, for example, its eight succinct points, as well as its strident denunciation of traditional genres. Hu dismisses classical Chinese and advocates for a vernacular literature, *baihua*, based on the standardized spoken Mandarin.

	German	English	Russian	Swedish
1848	**London (4)**			Stockholm
1849	Kassel			
1850	**London-Hamburg**	London		
1851	**New York**			
1853	Berlin			
1864	**London**			
1866	**London-Berlin**			
1868	Vienna			
1869		London	**Geneva**	

Figure 4.1. Places and languages of publication of the *Communist Manifesto* between 1848 and 1869. Bold = foreign-language edition; shade = first publication in given language.

However, Hu's text still contains a residual reverence for tradition. Where Marx's and most subsequent avant-garde manifestos were written in the tone of utmost confidence, Hu feels compelled to present his immodest demands as "Some Modest Proposals for the Reform of Literature" (1917). He goes even further and pays homage to his elders and betters: "How am I, unlearned and unlettered, qualified to speak on the subject?" he writes, and concludes his revolutionary program with the words: "I must ask my learned elders . . . for their scrutiny and circumspection, there may well be places in need of severe rectification. . . . I have called them [the eight points] 'modest proposals' to underscore the sense of their incompleteness and to respectfully seek the redaction of my compatriots."[27] The voice of this manifesto is split thus between authoritative and prescriptive demands and self-deprecating gestures of submission. To be sure, the modesty of these phrases may well be seen as a mere facade, for Hu, who studied at Cornell and Columbia, slyly echoes Swift's ironic title. But the literary readership he was addressing demanded such gestures, however perfunctory, and thus caused the manifesto to be altered.

Even though Hu's modest manifesto is primarily concerned with literary style and form, it was embedded in a culture of increasing political agitation. It appeared in the magazine *New Youth*, founded by a number of Western-trained intellectuals and writers, which became one of the primary

	German	English	Russian	Swedish	French	Spanish	Czech	Polish	Danish	Italian	Bulgarian	Serbo-Croatian	Dutch	Yiddish	Rumanian
1871	**Chicago**	New York										Pancevo (Serbia) (2)			
1872	Leipzig (2)				**New York**	Madrid									
1873	Berlin					Lisbon									
1874	Vienna **Chicago** Leipzig														
1879					Lugano										
1880	**London**				Paris										
1881	**London**														
1882			Moscow **Geneva**				New York								
1883	**Chicago** Zürich	New York (2)	St. Petersb. (3) **Krakow** Moscow					Geneva							
1884	Zürich				Paris				Copenhagen						
1885			St. Petersburg Moscow Kazan		Paris Reims Montluçon Roubaix Roanne				Copenhagen						
1886		London	St. Petersburg	Stockholm	Paris	Madrid (2)			**Christiania (Oslo)**						
1888		London (2)				Mexico									
1889									Copenhagen	Cremona					
1890	**New York**	New York (2)	Moscow		Paris				Copenhagen					**London**	
1891	Berlin									Milan	Ruse				
1892	Bern							London		Milan			Amsterdam Hague		Iasi (2)

Figure 4.2. Places and languages of publication of the *Communist Manifesto* between 1871 and 1892.

conduits for translations of Marxist literature. Indeed, Hu's text coincided with the arrival of the *Manifesto* into China. While the publication of the full text, in a translation by Cheng Wangdo, did not occur until 1919, excerpts and summaries had been published as early as 1906. Although Hu, who later served as ambassador to the United States from 1938 to 1942, never formally sided with communism, he remained sympathetic to the movement, writing a telegram to Mao Tse-tung in 1945 urging him to build a peaceful party modeled on the British Labor Party.[28] Political manifestos and art manifestos were both imported forms, but they became quickly assimilated and adapted, with their form and voice adjusted to suit the purposes of a different readership.

As the example of Hu indicates, the history and geography of the *Manifesto* can serve as a point of departure for a second group of manifestos: avant-garde manifestos. Although not always directly linked to the *Manifesto*, the avant-garde manifesto is unthinkable without the genre-producing force of Marx and Engels's text, its translations and adaptations. The emergence and breathtaking proliferation of art manifestos rival the proliferation of the *Manifesto* itself. The rest of this study is devoted to analyzing the interactions of the political manifesto and the avant-garde manifesto, the one being the formative genre of political modernity and the other the formative genre of modernism and the avant-gardes.

PART TWO

The Futurism Effect

5

Marinetti and the Avant-Garde Manifesto

While the *Manifesto* continued to be revered, supplemented, and adapted to
new locales, there emerged texts, circulated in newspapers and magazines,
calling themselves manifestos even though they had less to do with socialism
or politics and more with literature and art. An art manifesto had split off
from the main branch of the political manifesto. Hundreds and thousands
of such art manifestos were printed in daily newspapers, often on the front
page, and in literary magazines, greeted the passerby on billboards and as
flyers, and were shouted at the audience in theaters, at street events, or over
the radio. We have lost a sense of how surprising the migration of the politi-
cal manifesto into the sphere of art really was because of the lasting impact
of this migration. After more than a century of art manifestos, these docu-
ments are more frequent and familiar than most socialist manifestos, even
though no one art manifesto has yet achieved the singular prominence of
the *Manifesto*.

 The effect of the political manifesto on the sphere of art can be
measured by comparing the new art manifesto to the forms of literary po-
lemic in the eighteenth and nineteenth centuries. William Wordsworth's
preface to the *Lyrical Ballads*, for example, shares with the manifesto the
desire to announce a new literary style, but this annunciation is phrased in
careful and measured sentences that present themselves as literary criticism
rather than as a political and revolutionary intervention. And far from seek-
ing to offend, the preface is eager to win over "the Reader," pleading that
the collection of poems be given a fair chance and recognized as a worthy
experiment. The fragments of Friedrich Schlegel and Ludwig Tieck are even
further removed from the pointed aggressions of the manifesto. Although
condensed, these fragments are open-ended and ruminating, often phrased

in an obscure and metaphysical language that is a far cry from the condensed attacks launched in manifestos. The difference between attack and defense distinguishes the manifesto from such texts as Percy Bysshe Shelley's "A Defense of Poetry." Although the "Defense" makes a general claim for the poet as legislator, this claim is grounded in a reverence for the past and articulated as an idealist aspiration, not as an intervention that seeks to change the power dynamic of the art world. Shelley's central term is "prophecy," and it is as prophecies that these romantic texts may echo some of the prophetic texts in the prehistory of the manifesto but not the active and calculated interventions of the modern political and art manifesto.[1]

These romantic prefaces, defenses, and fragments nevertheless provided the trunk onto which the new genre of the art manifesto could be grafted. The text that is often considered one of the first genuine art manifestos is Jean Moréas's so-called "Symbolist Manifesto" (1886). Collections of manifestos have tended to begin with this text or at least feature it as one of the first art manifestos.[2] Indeed, one can recognize in this text many of the familiar traits of the avant-garde manifesto. It belongs to a world in which art is produced collectively and where collective declarations invest much energy in labels such as naturalism, symbolism, decadence, naturism, and many lesser-known coinages. The "Symbolist Manifesto" situates itself in a battle between two isms, announcing the death of naturalism to pave the way for a "new art" called symbolism. Just as Marx and Engels had distanced themselves from "utopian socialism," so Moréas seeks to differentiate himself from rival "schools" and isms.[3] The battle of the isms is thus a product of an intense anxiety of influence. One reason the manifesto acquires such currency is because it makes for a good weapon in the struggles caused by this anxiety, differentiating one ism from the next.

The relation to one's predecessors is part of the larger question of literary history and tradition. Even though Moréas wants to break with the past to propel himself into the future, he cannot quite let go of the past entirely. To outflank naturalism, he calls for a "rejuvenation of the old metrics" (32), as if the new could not be imagined other than as a revival of what had previously been declared outdated. Like the *Manifesto*, Moréas's text is thus forced into a meditation on history, which it imagines to proceed through "cycles" and "evolutions" (31). All this anticipates the way in which the sphere of art would be organized in the twentieth century, when hundreds of movements and schools would rely on manifestos to denounce their predecessors and competitors for the purpose of rewriting the history of art. Even if many of the projects outlined in manifestos were never realized, what became firmly established was the act of declaring a new departure, of set-

ting one ism against the next, and of laying claim to the future at the expense of the past. What succeeded, in other words, was the revolutionary historiography dictated by the form of the manifesto.

The manifesto's historiography left its marks on many studies of the avant-garde, which often repeat the history of successions and ruptures fabricated by manifestos: symbolism broke with naturalism; futurism, with symbolism; vorticism, with futurism; dadaism, with futurism; surrealism, with dadaism; situationism, with surrealism; and so on ad infinitum.[4] The avant-garde history of succession and rupture seems inevitable in hindsight, but it must be recognized as a specific effect of the manifesto. Even the most sophisticated and influential theories of the avant-garde, including those of Poggioli and Bürger, use manifestos merely as documents that provide handy access to a movement's beliefs and intentions, without realizing that their theories were everywhere shaped by the formative impact of the manifesto's historiography. To analyze the genre that constructed this history of rupture in the first place, we must stop taking the manifesto at face value and instead analyze its formation.

For this undertaking I am able to build on the pioneering work of Claudio Abastado and Marjorie Perloff, who first moved the art manifesto as genre into the center of attention, as well as on a very recent conversation about manifestos that includes Lyon (1999) and Somigli (2003). Drawing on this critical tradition, I emphasize the nineteenth-century inheritance of the art manifesto, including its debt to the *Manifesto*, and the continued rivalry between art manifestos and political manifestos in the twentieth century. The manifesto is an exceptionally charged genre, poetically and politically, and therefore becomes the place where the most pressing issues and questions faced by twentieth-century art, including the relation to the audience, to society, to politics, indeed, the whole conception of what an artwork is or should be, are being dogmatically as well as symptomatically worked out. Finally, I will describe the formal (rather than doctrinaire) influence of different types of manifestos on artworks through the category of "manifesto art." Not only is the twentieth century a century of isms, as Mary Ann Caws has written, but the art of this century is an art under the sway, perhaps even in the shadow, of the manifesto.

The best indication that our literary and art histories have been under the sway of the manifesto is the fact that, as in the case of the Marxist tradition, critics tend to project the title "manifesto" back onto texts that did not label themselves that way. The so-called "Symbolist Manifesto" is a good example. I know of no critical study or anthology that does not call the text "Symbolist Manifesto." This, however, was not the name under which it

appeared in *Le Figaro* in 1886, where it was called simply "Le Symbolisme." The same retrospective labeling is true of most so-called manifestos written in the late nineteenth and early twentieth centuries.[5] The absence of the title "manifesto" does not mean that these programmatic texts did not contain some of the crucial features we now associate with the art manifesto. The practice of founding collective movements had existed for decades, and so had the polemical struggle among them. Indeed, these texts have clearly learned from the foundational force of the political manifestos, which were coming into their own at the same time.[6] Most often, however, the authors of these texts did not choose to signal that their programmatic and polemical texts belonged to the genre of the manifesto, with its particular inheritance and set of expectations.[7] All this would change, and the change becomes visible, when we begin to encounter texts that self-consciously entitle themselves "manifesto."

After the publication of Moréas's so-called "Symbolist Manifesto," it was another twenty-three years before programmatic art manifestos would announce themselves as such and thus openly embrace the foundational and revolutionary inheritance of the genre. The first person to systematically employ this title and to produce a large number of self-declared manifestos was the former symbolist poet Filippo Tommaso Marinetti, beginning with his *Manifesto of Futurism* (1909). Even here, however, the act of self-labeling occurred retrospectively. What has been called the *Foundation and Manifesto of Futurism*, *Manifesto of Futurism*, or *Initial Futurist Manifesto* did not present itself with any of these names in the original publication in *Le Figaro*. Like his more hesitant symbolist predecessors, Marinetti labeled his text simply with the term designating a new movement, a new ism: "Le Futurisme." It was only in subsequent publications that Marinetti would recognize the force of calling such texts manifesto and proceeded to employ the term liberally. Translated into Italian and reprinted many times in journals and as leaflets, "Le Futurisme" would now bear its former subtitle, namely, *Fondazione e Manifesto del Futurismo*, and later still appear as *First* or *Initial Futurist Manifesto*.[8] The ways in which Marinetti identifies himself through his signature are as numerous as the titles he employs. In the first *Figaro* edition, the author of the text is simply designated as one F. T. Marinetti. Subsequent editions are more elaborate, describing Marinetti as editor of the magazine *Poesia* and also as the leader of a movement called futurism: "Poète Futuriste Chef du Mouvement Futuriste." In addition, we now get a corporate address: "Direzione del Movimento Futurista, Corso Venezia, 61 Milano."[9] Now, there is an organization behind the manifesto, a movement, an address, and a system of distribution; not just an author, but authority.

You could write to this address and request a manifesto; in fact, subsequent editions would declare that manifestos could be obtained from this address free of charge.

The question of title and signature is more than a technicality; it registers the emergence of the manifesto as a self-conscious, manifest genre. The case of Marinetti demonstrates that even the first avant-garde manifesto reached full self-consciousness only retrospectively, that the power of the manifesto was not initially apparent even to Marinetti. As had been already visible in the *Manifesto* and its inheritors, a successful act of founding requires a mediation between past and future; naming something means ensuring that others will respect and follow an act of baptizing once it has occurred. Increasingly, it thus became clear that using the title "manifesto" bestowed the authority of baptizing onto the author, or at least it became the platform from which to lay claims to such authority. With futurism, at least, it worked beautifully. Once the self-authorizing power of the manifesto was launched, it became addictive. Hundreds of futurist manifestos suddenly appeared all over Europe, announcing the coming to itself of a new genre. Futurism taught everyone how the manifesto worked, and all subsequent movements would profit from this lesson.

A description of the retrospective gesture that led to the foundation of futurism does not yet explain why it was Marinetti, and not Moréas or the writer of decadent pamphlets, Anatole Baju, who discovered or invented the rules and functions of the manifesto.[10] What kept symbolism from discovering the power of the manifesto was its aesthetic doctrine, which is diametrically opposed to the language and form of the manifesto. This opposition is visible in "The Symbolism" itself. While Moréas understood the dynamic of the competing isms and their anxiety of influence, his manifesto suffers from the stark incongruity between the assertive language of the manifesto and the symbolist language this text seeks to promote. "The Symbolism" demands an "ambiguous" language, an "archetypal and complex style," "mysterious ellipses," and "daring and multiform tropes" (32). Other symbolists went even farther and declared symbolism to be at war with all forms of direct naming. Such a language of indirect suggestion concerned not only poetry but also literary expression; Stéphane Mallarmé, for example, extended it to prose, and his critical texts on verse, poetry, and language conspicuously avoided all naming and instead celebrated precisely the "mysterious ellipses" and "ambiguous" language of which Moréas speaks.

These programmatic terms, styles, and values that "The Symbolism" promulgates stand in stark contrast to the language in which they are articulated. "The Symbolism" wants to name something—in this case sym-

bolism—and does so through effective and pointed prose. The content of this manifesto celebrates ambiguity and obscurity, but this content is belied by its form, which is relatively unambiguous and not generally obscure. Like later manifestos, "The Symbolism" thus brings something of the hidden and the "mysterious" into the open, replacing specters with an official program. Moréas seeks to expose the new and to name it so as to leave no doubt about the faults of naturalism and the glories of symbolism. Unlike Mallarmé, whose suggestive prose texts are themselves examples of symbolist poetics, Moréas thus gets inextricably caught in the contradiction between what he preaches and the language he actually practices.

It was Marinetti who resolved the contradiction between the mysterious poetics of symbolism and the strategically explicit manifesto in favor of the latter. In contrast to his symbolist and decadent predecessors, whose work was marked by a dichotomy between the language of the manifesto and the poetry propagated in them, Marinetti brought the two to a point of convergence by creating a poetics that aspired to the condition of the manifesto. Direct naming, the striking noun, the perfect label, became even more important for his art manifestos than they had been for political manifestos. Most importantly, Marinetti applied these manifesto-like features to poetry, forging a poetry celebrating aggression, assertiveness, and confidence, a poetics of the name, the label, and the noun: "I fight against the precious and decorative aesthetic of Mallarmé, his search for the rare word, the unique and irreplaceable, elegant, suggestive, exquisite adjective. I don't want to suggest an idea or a sensation with grace or traditionalist affectation. I want to seize it brutally and throw it directly [*in pieno petto*] at the reader."[11] While Marinetti singles out directness and brutality, other, related, values return with predictable frequency as well, including speed, brevity, synthesis, aggressivity, the "typographical revolution" (77), and the dedication to the "absolute value of novelty" (120). These values, which putatively describe futurist poetry, are implemented nowhere as clearly as in Marientti's direct, aggressive, condensed, and brief manifestos themselves.

In her compelling book *The Futurist Moment*, to which my understanding of futurism is greatly indebted, Perloff argues for the affinity between futurist manifestos and futurist poetry.[12] In 1937, Kenneth Burke had taken an even more extreme stance, arguing, "Perhaps the most charitable thing we can say is that his [Marinetti's] manifestoes were themselves the works of art they proposed to herald."[13] Despite the critical edge of this comment, Burke here recognizes the manifesto's increasing centrality as a form of expression. Indeed, the new congruity between manifesto and poetry drives Marinetti to distill from the manifesto its pure gesture: the rup-

ture with the past and the invocation of the future. Where "The Symbolism" and even the *Manifesto* had been engaged in complicated negotiations with the past, Marinetti denounces not a particular past, be it naturalism or utopian socialism, but the past as such. And against this past, now labeled *passéisme* or *passatismo,* he sets not a particular future but the future as such: futurism. To put this, manifesto-like, into one neat formula: the form of the manifesto becomes the very content of futurism.

One consequence of this formula is that the manifesto must be regarded as the central genre of futurism. I believe this to be the case, although this was not explicitly acknowledged by most futurists. Even Marinetti seems to have held on to the idea that his futurist manifestos were only paving the way for a futurist art to come: "The manifestos and polemics are followed by facts: the works of poets" (27). But more and more, the values proclaimed in futurist manifestos were in fact epitomized in that genre and not in the works of poets, however much they may be following the tone and poetics of the manifesto. A gradual recognition of the centrality of the manifesto, if not a conclusive understanding of its dominance over art, finally emerged after several years of hectic manifesto writing among the futurists. For example, Marinetti not only began to encourage other futurists to write manifestos but also exerted direct influence over their formulation. In a letter from 1913, he lectured Gino Severini on the "*arte di far manifesti*" (art of making manifestos), insisting on the skill of finding the right names and labels, stressing the importance of brevity and economic tightness of expression, and demanding that the manifesto present its ideas in "full light, not in half light."[14] This remark, whose significance has been recognized and discussed by Perloff, does not yet capture all the attributes of the manifesto and does not acknowledge the extent to which the manifesto had become the master genre of futurism. But this remark does signal that Marinetti considered it worthwhile to impress on his followers the precise rules and purposes involved in writing manifestos and also to keep some type of control over how these manifestos were written. In the corrections he made on his own manuscripts and those of his friends, we can see the "*arte di far manifesti*" in action. He condenses, cuts, reduces, and highlights; he corrects the central titles and names, seeking at all times to insert his own key terms into the manifestos that are published under the name of futurism. In fact, Marinetti composes master lists of futurist words and concepts, a lexicon from which futurist manifestos could be made.[15]

From the beginning there existed a rivalry between manifesto and art, not, as in the case of symbolism, because they were diametrically opposed to one another but because they had become so much alike. Marinetti

did not go so far as to draw the radical conclusion of the situationists half a century later, that a poetics modeled on the manifesto implies that poetry should be abandoned in favor of manifestos. But he did have some idea of the consequences of what he was doing. An autograph manuscript of the first futurist manifesto, written on the letterhead of the Grand Hôtel Paris, includes a note that points to this rivalry: "We condemn all art insofar as it is realized and concern ourselves only with the preliminary state of the sketch. Art for us is simply one possibility of capturing the absolute."[16] This passage is crossed out and therefore does not appear in the manifesto, but we might take it, together with the fact of its having been crossed out, as a sign of the ambivalence with which Marinetti viewed his most consequential act: to have modeled an aesthetic on the manifesto so fully that the artistic realization of this program through the making of artworks became a secondary concern.

Fascism and Revolution

The history of the manifesto as a political genre makes it particularly important to analyze not only the manifesto's poetic but also its political coordinates. The *Manifesto* and other political manifestos cast a long, political shadow over the art manifestos of the twentieth century, which no art manifesto, no matter how seemingly detached from this political history, could escape. Because of the singular significance of the *Manifesto* and other socialist manifestos, the politics of the art manifesto must be examined with constant reference to this history of revolutionary writing from the Left. The continuing influence of the *Manifesto* and subsequent socialist manifestos has been neglected by most studies of art manifestos. It is, however, on this double history of the political manifesto and the art manifesto, on the assumption that the history of the art manifesto in the twentieth century must be written as part and parcel of a history of socialism, that my methodology is based.[17]

Claiming that the art manifesto remains calibrated to socialism does not imply that the writers of art manifestos are always identified with the cause of socialism, let alone its various national and international associations. To be sure, many writers of art manifestos, including those aligned with Russian futurism, Berlin dada, surrealism, and situationism, chose this genre precisely because of its association with Marx. Others, such as Marinetti, wanted to divert and redirect the revolutionary politics of this genre.[18]

But even Marinetti, Pound, Lewis, and other fascist-leaning writers of mani-
festos knew that the manifesto was a socialist genre and that they needed to
co-opt it just as they co-opted socialism more generally.

There existed a conduit for the manifesto to move from politics to
art: the notion of the avant-garde. Originally a military word, used to desig-
nate the advance corps of an army, the term "avant-garde" was appro-
priated in the early nineteenth century by what Marx called the utopian
socialists, in particular by the Saint Simonistes.[19] Here it designated a small
group of individuals who deemed themselves to be "advanced" in relation
to the majority of their contemporaries, one step closer to a utopia that lay
in the future but whose realization was already under way. This use of the
term presumes some unified historical axis along which humanity moves,
some being ahead and some being behind, the axis of progress that would
soon be internalized by the manifesto. When the term infiltrated the arts,
it meant that movements and schools began to style themselves as an ad-
vanced group, transporting the value of the new into art. A new move-
ment's claim to fame resided not in its intrinsic qualities but in the mere
fact of its being new and therefore ahead of the majority, which hopefully
would catch up in good time.

More, however, is implied here than simply a sense of progressive
advancement. In keeping with its military origin, "avant-garde" also suggests
a collective esprit de corps, a sense of the danger but also the privilege associ-
ated with being a member of a group so much ahead of everyone else. The
exposed position of the avant-garde requires not only individual daring and
recklessness but also some form of military discipline. In his *Mon coeur mis
à nu*, written in the early 1860s, Charles Baudelaire famously dismisses the
term precisely for these reasons: "To be added to military metaphors: poets
of combat. / Writers of the avant-garde. / These habits of creating military
metaphors bespeak not a military imagination but one made for discipline
and this means for conformity, an imagination born of servitude, of Belgian
character, that cannot think but in terms of collectivity."[20] Others, such as
Sainte-Beuve, echoed Baudelaire with a similar critique of avant-garde atti-
tudes in the sphere of art. Baudelaire's observation was in fact prophetic,
for party discipline would characterize the group formations of avant-garde
art, especially the surrealists and the situationists, who were more than ready
to expulse members for lack of conformity. While Baudelaire recognized the
issue of discipline at work in early avant-garde art groups, he did not address
the explicitly revolutionary ethos associated with many political and avant-
garde groups, particularly with the notion of the Communist Party as van-
guard articulated by Lenin.

That the term "avant-garde" extended from politics to art paved the way for the manifesto to span both spheres as well; indeed, the manifesto turned out to be an ideal tool for creating and then ensuring the collective identity and discipline of avant-garde movements. Even though the term had entered the sphere of art before the manifesto did, what we now call the avant-garde came into its own only when the two, manifesto and avant-garde, were joined, as they were tentatively with symbolism and more enduringly with futurism. Only then did the avant-garde have available the proper instrument to articulate its state of being advanced, its break with the past and affinity to the future, and only then did it speak succinctly and aggressively with a single collective voice. The emergence of the avant-garde thus prepared the arrival of the manifesto even as the entry of the manifesto into the sphere of art completed the creation of the avant-garde.

The conjunction of the avant-garde and the manifesto still does not explain why both concepts, charged with the socialism of Marx and Lenin, would end up in the hands of fascism. Here it is important to recognize that Marinetti, like most other fascists, including Benito Mussolini, started out as a socialist. Between 1912 and 1915, Mussolini was editor of the socialist journal *Avanti*, and Marinetti's own political position during the foundation of futurism in 1909 included several core socialist positions, such as the socialization of land, higher minimum wages, and attacks on parliamentarism, the institution of the family, and the Catholic Church. We can find a list of Marinetti's political demands in a document called *Manifesto of the Futurist Party of Italy* (1910), whose existence also demonstrates the extent to which the manifesto, even for Marinetti, was still a political genre, even if it had also become an artistic one. However, at the very moment when Marinetti added a political manifesto to his futurist art manifestos, he apparently felt the need to keep the two types distinct: "The political party of futurism which we are founding today . . . will be clearly distinct from the futurist art movement" (158). The difference between futurism as art movement and as political movement became even more pronounced after the fascists seized power in 1922. The new state accepted no competition in the sphere of politics and therefore forced futurism back into the sphere of art (a similar development occurred with Russian futurism in the early twenties, when the revolutionary state sought to subdue all avant-garde rivals). Defensively, Marinetti had to declare, "Futurism is an artistic and ideological movement. It intervenes in the political struggle only at moments when the nation is in great danger" (494). Even and especially when Marinetti was carrying the concept of the social revolution into art, the two had to remain conceptually distinct.

The forced separation between an artistic and a political futurism is indicative of an important feature, namely, the rivalry or tension between political manifestos and art manifestos. Just because so many figures in the avant-garde harbored social and political ambitions does not mean that they wanted to eliminate all differences between the two spheres. As Pierre Bourdieu has argued convincingly, it was the emergence of art as an autonomous sphere in the nineteenth century that enabled a writer such as Émile Zola to intervene in politics, which he did in the form of an open letter entitled "J'accuse."[21] Zola could claim to address the issue of Alfred Dreyfus with authority only because he had made a name in literature, which was seen as shielded from the interests of politics.[22] The two distinct genres Zola chose, namely, his literary "manifestos" on naturalism (none of them were actually labeled manifesto) and his political attacks, depended on the difference between literary and political manifestos, which even Marinetti would maintain.[23] This is perhaps the moment to take to task the theory of the avant-garde put forth by Bürger, which is premised on a Hegelian sublation of art and life, art and politics.[24] True, the manifesto's double existence in politics and art indicates a close relation between the two spheres and means that the history of the one cannot be written without the history of the other. But the mere fact that political and art manifestos were related to one another does not mean that they wanted to or managed to create a total fusion of the two domains. Instead, the manifesto, now situated both in politics and in art, became a genre through which art and politics could communicate, a kind of membrane that allowed for exchange between them even as it also kept them apart.

From Revolution to War

What motivated Marinetti's continued dedication to the manifesto, despite its socialist heritage, was his dedication to the project of a revolution, the notion with which the manifesto remained most intimately aligned. This belief in the revolution was something Marinetti shared with many fascists, including Mussolini, who declared, "For a revolution to be great . . . it must be a social revolution. If you look into things deeply you will observe that the French Revolution was eminently social."[25] Many fascists admired not only the French Revolution but also the October Revolution, even though they were violently opposed to the official Communist Party of Italy (PCI). By the same token, several communists, among them Gramsci, attested that

Marinetti was a genuine, if perhaps misguided, revolutionary.[26] Marinetti oscillated between a fascination with the communist revolution, an adherence to several key socialist demands, and a strong desire for a special Italian solution to the so-called crisis of parliamentarism. Even when Marinetti found himself under attack for his belief in a social revolution by culturally conservative fascists favoring Roman classicism, he responded not by giving up entirely on the concept of the revolution but by calling for a specifically Italian revolution: "We have to make our own revolution" (481), one that was supposed to go "beyond" (482) the horizon of the October Revolution.

Even though fascism accepted some sort of revolution, and thus was ready to use some sort of revolutionary manifesto, the concept of the revolution was increasingly framed and mediated by war. The *Manifesto of Futurism* had declared, "We want to glorify the war—the only hygiene of the world" (11), and the *Manifesto of the Futurist Party of Italy* placed war and revolution in a parallel position: "Everything must be ready, without any delay, for an eventual war or an eventual revolution" (155). While in 1910 the two, war and revolution, were still of equal importance, the balance soon shifted in favor of war. In 1915, Marinetti published a pamphlet named after the war passage in the *Manifesto of Futurism*, namely, *War the Only Hygiene of the World*. Even here the concept of the revolution has not disappeared entirely. The text's retroactive account of early futurist agitation still calls the *Manifesto of Futurism* a "Revolutionary Cry" (236), but the revolution becomes an adjective modifying war. Now, the "young revolutionaries" (291) are assembled for the purpose of the war, and the war, not the revolution, becomes the central figure of futurism, to the point where Marinetti declares, in the same text, that "the current war is the most beautiful futurist poem" (333) and defines war as "intensified Futurism" (335).

The best indication for the change from revolution to war as the guiding figure of futurism can be found in the changed concept of the avant-garde, which both Marinetti and Mussolini took from the socialist and bohemian traditions of the nineteenth century and remilitarized. One precursor of the Fascist Party called itself Avanguardie Studentesca dei Fasci di Combattimento (1920); the ideological center of this avant-garde was an assault troupe I Arditi, with whom, for example, the novelist Gabriele d'Annunzio occupied the small port city of Fiume—today Rijeka in Croatia—to reclaim it from international protection. This remilitarization of the avant-garde was easy, for it meant only a return to the term's original usage. Baudelaire's fear of a military avant-garde art was finally borne out: Marinetti strategically used the term for both military and art matters to bring the two closer together. One example is his pamphlet *Democrazia Futurista: Dinamismo*

politico (1919), which is dedicated to both the "political futurist fascists" and the "Association of Arditi," and which addresses the Arditi as the "avanguardia della Nazione" (465). While Lenin had used the term "avant-garde" for the purposes of the revolution, Marinetti (and Mussolini) used it for that of war.

What were the implications of this inversion between warlike revolution and revolutionary war? Hannah Arendt begins her magisterial *On Revolution* (1963) with a meditation on the relation between war and revolution.[27] Even though the two are diametrically opposed, the one tending toward annihilation, the other toward emancipation, Arendt notes an unsettling connection between them. Wars have historically tended to trigger revolutions: the Franco-Prussian War, the Paris Commune of 1870; the Russo-Japanese War, the Russian Revolution of 1905; and of course World War I, the Russian October Revolution, as well as a number of more short-lived revolutions in central Europe, including the German November Revolution of 1918. In fact, no country that found itself on the losing side of the Great War was able to avoid a revolutionary change of regime.

After observing this historical correlation, Arendt moves on to a second, and more disturbing, link between war and revolution. War, she recognizes, not only functioned as an external trigger for revolutions but also performed a constitutive, necessary, and foundational act of violence in revolutions: "That such a beginning must be intimately connected with violence seems to be vouched for by the legendary beginnings of our history as both biblical and classical antiquity report it: Cain slew Abel, and Romolus slew Remus; violence was the beginning and, by the same token, no beginning could be made without violence, without violating" (20). Marinetti's enthusiasm for war can be partially explained by the connection Arendt draws between war and revolution. War, for Marinetti, is a great revolutionary force, destroying the old Italy he reviled so much; the "hygienic" effects of the war reside in sweeping away the centuries of history that are blocking Italy's passage into the future. But the war, for Marinetti, is more than a moment of initial, foundational violence. It becomes an end in itself.

It is this shift from means to end that marks Marinetti's departure from socialism. Marinetti, Mussolini, and most other future fascists made their final break with socialism through their agitation on behalf of Italy's entry into World War I. While all other socialist parties of Europe had been caught up in the nationalistic rhetoric of the Great War, thus bringing the Second International to a sudden death, the PCI alone resisted this tendency and adopted a strictly pacifist stance. It was this stance that finally triggered the split between the future fascists and the PCI, committing fascism to the

cause of war in all its forms. This split, caused by nationalism, was an effect of the extreme national agitation that resulted from Italy's late, or belated, national unification, anticipating a similar extremism in Germany only a few years later. Indeed, Marinetti's writings are textbook examples of a national inferiority complex. Everything must be done to elevate Italy's standing in the eyes of the world; Marinetti even boasts how much his own futurist agitation, in particular his "millions of manifestos" (338), contributed to the fame of Italy everywhere.

Marinetti broke not only with the PCI but also with the mode and tradition of socialist theory. Even though Marx had tried to turn philosophy into practice, there was never any doubt about the constitutive role of theory for Marxism. Far from demanding that theory had to be abolished in favor of praxis, Marx had insisted that the two become intertwined. Most Marxists in the twentieth century, from Lenin to Mao, never retreated from this belief in the importance of theory, ensuring that communism remained an intensely intellectual and theoretical project even as it considered traditional philosophy with suspicion. This dedication to theory had several consequences, such as the formation of a tradition of high socialist theory, which continues today, and at the same time an unprecedented effort in creating a popular pedagogy often called by the now suspect word "propaganda."[28]

Italian fascists as well as many other contemporary writers responded to this Marxist dedication to theory by celebrating the notion of action, an action untainted by reflection or theory. The name most closely associated with this development was Georges Sorel, a socialist who, shortly before his death in 1922, went so far as to endorse Mussolini's coup d'état. In a series of essays, published in *Le Mouvement Socialiste*, a journal founded in 1899 to disseminate syndicalist ideas, Sorel represented the most antitheoretical, anti-intellectual communist revisionism imaginable. Instead of theory, history, and pedagogy, Sorel advocated what he called a "myth," namely, the myth of the general strike. The general strike names a moment of ultimate action, the rupture with capitalism, the event that will bring about the new order. And like Arendt, Sorel knows that this foundational rupture will require an act of violence. Unlike Arendt, however, who is deeply disturbed by the thought of violence constituting a necessary part of the revolution, Sorel celebrates this violence with great enthusiasm. Violence is Sorel's name for pure action, the type of action based on myth and not on theory. His influential collection of essays, entitled *Reflections on Violence*, is an unrelenting glorification of revolutionary violence.[29]

Sorel's master figure for revolutionary violence is war, but this war continued to be calibrated to some kind of revolution: "That party will pos-

sess the future which can most skillfully manipulate the spectre of revolution" (58). But more and more what Sorel focuses on, the language in which he glorifies revolutionary violence, is that of war. The promise of the revolution is something that is evoked, but only as an ultimate goal. His heart is really in war. It may be worth quoting Sorel at some length:

> War may be considered from its noble side, i.e. as it has been considered by poets celebrating armies which have been particularly illustrious; proceeding thus we find in war:
>
> 1. The idea that the profession of arms cannot compare to any other profession—that it puts the man who adopts this profession in a class which is superior to the ordinary conditions of life,—that history is based entirely on the adventures of warriors, so that the economic life only existed to maintain them.
> 2. The sentiment of glory which Renan so justly looked upon as one of the most singular and the most powerful creations of human genius, and which has been of such incomparable value in history.
> 3. The ardent desire to try one's strength in great battles, to submit to the test which gives the military calling its claim to superiority, and to conquer glory at the peril of one's life. (188)

The passage continues in a similar manner with references to Greek literature, philosophy, and art, which are all born, we are told, from the spirit of war. While acknowledging that there are equally prominent critiques of war, Sorel contends that in those cases, "The object of war is no longer war itself" (189). As long as war is pursued as an end in itself, it retains all the glories specified by Sorel. Even though Sorel is still putatively using war as a metaphor to characterize the violence of the general strike, the metaphor is beginning to take over.

There is only one thing that keeps Sorel from abandoning the revolution in favor of war and violence entirely, and that is his continued belief in Marxian dialectics, his conviction that an initial act of violence will inevitably lead to a revolutionary upheaval: "Proletarian violence . . . makes the future revolution certain" (90). Through this causality, the language of war retains the semblance of being only a means toward a revolutionary end even though all revolutionary energy is now invested in the first spark; the revolution will then take care of itself. This belief must seem surprising in a writer who was ready to charge Marx with blindness, oversight, and miscalculation, and it also seems to be at odds with the history of socialism

Sorel evoked to justify his revision of Marx. British Fabianism, the German Socialist Party, and the French Communist Party had given up on the assumption that the class antagonisms would increase over time, a theory that simply failed to describe industrialized Europe at the end of the nineteenth century. It would seem that more, rather than less, socialist theory and analysis was needed to show that underneath all these changes the simple class antagonism of early industrial Britain was still intact.

Sorel, however, went exactly in the opposite direction, by holding on to the Marxian class struggle, which alone could justify his belief in the dialectics of the general strike. Instead of theory, Sorel opted for violence. An act of proletarian violence would force the producers to give up their disguise, to appear as nothing but producers and thus reveal the class antagonism that might otherwise remain concealed: "Proletarian violence confines employers to their rôle of producers, and tends to restore the separation of the classes, just when they seemed on the point of intermingling in the democratic marsh" (90). At a time when many socialist leaders reacted to new social conditions by preaching gradual change through the democratic institutions, Sorel trusted violence to reopen the class antagonism on which its dialectical justification was premised. Sorel can thus be seen as the transitional figure between the communist revolution and Marinetti's celebration of war in the sense that Marinetti's position might be defined as Sorelian violence minus Marxian dialectics. While for Sorel, the revolution had been rhetorically and strategically replaced by war, the conceptual end of this war was still the revolution. For Marinetti, this end has disappeared almost entirely and become nothing but an attribute of war: Sorel's warlike revolution becomes Marinetti's revolutionary war. What counted now was not a series of theory-inspired speech acts through which the revolution was to be brought about but an antitheory celebration of pure and violent action.

Action, Speech, and Theater

Sorel's doctrine of untheorized action fueled futurist and fascist attacks on the university, intellectuals, and philosophers, and the fascist fixation on the "deed" could have been, and sometimes was, lifted directly from Sorel. In fact Mussolini declared, "What I am I owe to Georges Sorel."[30] For fascism, the Sorelian-futurist attack on theory helped to cover up just how heterogeneous the alliance of war veterans, futurists, and a diverse antiparty and antiparliamentary coalition really was. Born without coherence or program,

fascism used the antitheory and pro-action rhetoric of Sorel and Marinetti to turn a deficiency into an asset. This strategy did not even change after the Fascist Party had begun to rule and was thus forced to make policy. In 1924, after fascism has been firmly established in power, Sergio Panunzio still claimed that it could never be defined and was still unfolding.[31] In 1932, the official historian of fascism, Gioacchimo Volpe, to emphasize fascism's continued antitheoretical nature, quotes reverently Adriano Tilgher's famous declaration that fascism was "absolute activism transplanted into the field of politics."[32] The texts by these authors and by other so-called theorists of fascism, for example, by Mario Rocco, Giovanni Gentile, the earliest philosopher of fascism, and Mario Palmieri, author of *The Philosophy of Fascism* (1936), are not so much theoretical accounts of fascism as defenses of a lack of fascist theory and an aggressive celebration of action. All this is perhaps best summed up in Mussolini's insistence on a "doctrine of action."[33] This antitheoretical stance also served the purpose of differentiating fascism from the official (non-Sorelian) socialism of the Second International, a socialism that had become the unchallenged, if internally divided, owner of revolutionary theory. Fascism famously presented itself as a bulwark against communism, as a "damming of the Bolshevik flood," as many fascist writers, such as Volpe, put it.[34] Indeed, the celebration of war was a means of co-opting the socialist revolution.[35]

The shift from revolution to war also precipitated a notorious feature of futurism, namely, its misogyny. The celebration of war demanded "masculine" virtues, such as the ones enumerated by Sorel, and thus the denigration of "feminine" ones. This gendered opposition was so ingrained that it was kept in place even by the few attempts made by women to acquire a voice within futurism. Prominent among those was Valentine de Saint-Point, whose *Manifesto of the Futurist Woman* presents itself as a "response to F. T. Marinetti."[36] Yet even here the gendered opposition is not entirely overthrown. While on the level of biology, the gender division is denied—"It is absurd to divide humanity into men and women"—the very next sentence reinscribes it on the level of value: "It is composed only of femininity and masculinity" (14). On this level, everything is left as it was: "What is most lacking in women as in men is virility." Misogyny is thus both critiqued and displaced to a different level, where it continues to work as it had before. The widespread misogyny of futurism has led many, including Lyon and Avital Ronell, to argue that the manifesto itself was a masculinist genre. This claim is certainly true of futurism, which makes it all the more surprising that later feminists, such as Valerie Solanas, felt free to adopt this genre for their own purposes. *as we'll see*

The change from revolutionary theory to the war rhetoric of pure action had significant implications for the manifesto, which had, until then, served as the conduit for socialist theory. This development was prepared for by Sorel as well. Attacking the *Manifesto* for trying to predict the future on the basis of a theory of history, he ridiculed Marx and Engels's subsequent prefaces as failed attempts to correct the false predictions driven by an over-confidence in theoretical discourse. The *Manifesto*, in his opinion, had never really broken with the utopian socialists, and he saw it as nothing but a revised version of its generic predecessor, Considérant's *Manifesto of Democracy*, with which Marx and Engels's text had in fact little in common.[37] What Sorel calls the "decomposition of Marxism" is therefore also a decomposition of the manifesto as a genre combining theory and practice. Instead of theory, we have the myth of the general strike, and instead of a poetry of the revolution, we have a poetry of war. Sorel thus supplied precisely the critique of the manifesto Marinetti needed to break with the socialist manifesto.

With the help of Sorel, Marinetti wrested the manifesto from the hands of the theorizing socialist tradition of the revolution and turned it into an antitheoretical organ of war-inspired action speech. To be sure, action speech had been part of the *Manifesto* as well. But Marx and Engels had balanced action speech with a grand historical narrative and a scientific, ana-lytic, and theoretical discourse. The countless futurist manifestos preaching war are themselves infused with attributes of war: aggression, agitation, rup-ture, violence. What Marinetti did to the manifesto was to purge its historical and theoretical voice and to reduce it to its most impatient speech acts.

The futurist manifesto was shaped by another consequence of fas-cism's dismissal of theory and embrace of action: a theory of live, performed declamation. Dismissing the written word as being part of theory and re-flection, the fascists turned to spoken speech as their alternative. The official historian of fascism, Volpe, detailed that the futurist celebration of speech was meant to turn language into action. Mussolini's speech, he says, is "nearly synonymous with action" and pertains to a specifically fascist ora-tory "that is reduced to its bare bones, biting, sincere, and firm."[38] German fascism pushed this valuation of speech over the written manifesto to an extreme. Adolf Hitler bemoaned, in *Mein Kampf*, communism's advantage in the sphere of theory, although he argued that the success of Marxism was due not "to the literary work of Marxist patriotic writers" but to "agita-tors."[39] Indeed, Hitler even mentions "Dadaistic 'experiences' " (353–54). In reaction, he formulated a fascist alternative, based on the privileging of pub-licly declaimed speech, the actionlike qualities of the spoken word, over the textual manifesto. Drawing on Gustave Le Bon, whom Italian fascists also

admired, Hitler sought to counter socialist theory and pamphlet culture—
including manifestos—with the live, aggressive, theatrically spoken word.
Even the French Revolution, he claims, was prepared not by the writings of
the philosophes but by the spoken words of agitators in the streets. While
the *Manifesto* can be understood as the continuation of the Enlightenment
by other means, fascist speech belongs to the sphere of mass rallies, the
reritualization of politics, the charismatic leader that played such a crucial
role in what George L. Mosse called the "nationalization of the masses."[40]

While the fascists largely gave up on the manifesto and opted for
spoken speech, Marinetti drew a different conclusion: just as he had let the
fascist antitheory doctrine shape the poetics of his futurist manifestos, so he
applied this ideology of pure speech to the manifesto by turning the mani-
festo into a genre that was spoken and declaimed on a stage. Many futurist
manifestos were performed before they were printed, and even when they
appeared only in print, their layout sought to suggest the spoken, or shouted,
word. To ally the spoken word more closely to action, Marinetti grounds it
in a new art, which he called "dynamic and synoptic declamation" (122).
This declamation foregrounds gesture and facial expression. Opposing tra-
ditional oratory and its relegation of gestures to a purely decorative, subser-
vient function, Marinetti calls for a futurist art of declamation involving not
only arms but also legs, resulting in a "lyrical sport" (124). Instead of a
largely "static" declamation, Marinetti demands a "total dynamism"; the
agitated gesturing that is to drive this dynamism, however, must be not
organic but "geometrical," just as the voice must be "metallisized, liquefied,
vegetalized, petrified, and electrified" (125). The futurist declamation draws
on the depersonalized and dehumanized futurist theater, a theater of ma-
chines, electric lights, and props from which the human body is largely
absent; indeed, many of the futurist manifestos were declaimed as part of
theater performances during tours in provincial theaters.[41] Marinetti's
conception of a specifically futurist declamation gives us further hints about
the poetics of his manifestos. Opposing stasis, the manifesto uses dynamism;
rather than studious elaborations, we have a short, "synoptic" concentration
of words; and instead of continual discourse, Marinetti privileges the wild
gesturing of arms and legs. We can see here the importance of futurist per-
formances, during which words as well as tomatoes and eggs were thrown
back and forth, for the tone of futurist manifestos. These manifestos' advers-
arial attitude toward the reader was made tangible in the heated atmosphere
of futurist theater events.

Marinetti's art of declaiming manifestos was part of a more general
program of theatricalization that affected all avant-garde forms of expression.

The signal for this move came from Marinetti, who declared that "everything of any value is theatrical" (117). Thanks to Giovanni Lista's and Günter Berghaus's careful and comprehensive reconstructions of futurism's theatrical activities, it is now possible to recognize the extent to which various forms of theatricality, from the cabaret to street agitation, defined different phases of futurism.[42] One example of theatricalization is futurist poetry, especially the *parole in libertà*, a form that, along with the "acted out poem" (121), was conceived explicitly as a poetics for the stage. The performed manifesto, the theatrically exposed painting, the music calibrated toward theatrical effects are other examples of the pervasive theatricalization of the arts. The distribution of manifestos was theatrical as well. While Marinetti preferred to throw manifestos out of a racing car, other futurists threw them at passersby in all manners, including from the Clock Tower on Piazza San Marco in Venice. I am not sure how many futurist manifestos were thrown out of airplanes, but Fedele Azari, the self-proclaimed futurist aviator, turned the airplane into a vehicle for futurist art in his Futurist Aerial Theater. *20s - 30s*

To assess the implications of this theatricality for the avant-garde, it may be useful to remember the antitheatrical polemic of high modernism. The avant-garde shared the modernist suspicion that the theater was not simply one form of art among others but a condition or mode that could be applied to all arts. While modernism considered this theatrical condition a threat to art and therefore sought to exorcise theatricality so that a true *Greenberg* and pure art might be preserved, the avant-garde embraced this threat to art and therefore sought to theatricalize art in order to thoroughly change, deform, and even destroy it.[43] Futurism is an early manifestation of the theatricalization of art, which became an important feature of all subsequent avant-garde movements, changing art beyond recognition. *key*

Futurism not only performed manifestos but also produced several manifestos about theatrical performance, including one on the Futurist Variety Theater and one on the Futurist Synthetic Theater. Whereas the Variety Theater emphasized quick transitions, burlesque modes, and irreverent topics, the Synthetic Theater demanded extreme compression to the point where single pieces, labeled *sintesi*, or syntheses, lasted no more than a few seconds. Both types of futurist theater do their utmost to distance themselves from the bourgeois institution of theater and instead envision a theater based on what Marinetti calls *fisicofollia*, or body-madness. In addition, they reiterate and promulgate such values as speed, constant transformation, electricity, condensation, and the "absolute value of novelty" (120). It is significant, however, that given the frequency with which futurist manifestos were performed in theaters, neither of the two major theater manifestos

thematizes the futurist *serate*, evenings of declamation and recitation, as examples of the kind of theater they envision.[44] Nevertheless, several features of manifesto performances do resonate with the theaters envisioned by the futurists: the wildly gesticulating declamation invokes the "body-madness" recommended for the futurist theater; the compressed brevity of the manifesto is akin to the compression achieved in the brief *sintesi* performed on the futurist stage; and the lack of transition between different points and demands made in manifestos echoes the abrupt changes advocated in the variety theater.

More important than these resonances between manifestos and futurist theaters is the fact that the futurist manifesto is infused with a particular form of theatricality. The manifesto had always been a genre singularly intent on theatrical posing, on claiming an authority it did not yet possess, but the art manifesto takes this theatricality to an extreme. Where the political manifesto sought to subordinate theatricality to performativity, intending to turn the pose into the real thing, the art manifesto inverts this hierarchy, admitting frankly to a dominance of theatrics over authorized speech acts. Once a manifesto is framed by a stage, even by a street event or demonstration, its theatricality is unleashed without restraint. One might say that the theatricality at work in all manifestos here returns to the actual stage and is allowed to develop its full force.

Who could have predicted that sixty years after Marx turned the manifesto into a theoretical and political instrument, it would end up in the theatrical evenings, *serate*, of early futurism, shaping the aesthetics and poetics of the first avant-garde movement while also being shaped by it? Several mediations were necessary for this transition to take place: the tentative appropriation of the manifesto by symbolism; the entry of the avant-garde into the sphere of art; the rivalry between revolution and war as central figures of change; and the antitheoretical (and protofascist) tradition of Marxism advocated by Sorel and continued by Marinetti and Mussolini. These factors helped Marinetti reinvent the socialist manifesto as an avant-garde manifesto, a genre that exerted a profound influence on the art of futurism, its poetry, collages, and theatrical performances.

Manifesto Art

What distinguishes futurism from its predecessors such as symbolism but also from the fragments, defenses, and prefaces of romanticism is its willing-

ness to allow the manifesto not only a thematic influence on the making of futurist art but a formal one as well. To gauge this influence, we must return to Marinetti's favorite theme, namely, the war, which shaped his art as much as his manifestos. As early as 1909, Marinetti had declared: "Today more than ever, don't do in art what you don't do in war" (28). For Marinetti, war was never a metaphor. The futurists sought the war, enlisted in the war, and stuck to their dedication even through the horrors of World War I trench warfare. In *Blast II*, Lewis denounced Marinetti for this pro-war stance: "There is one man in Europe now who must be in the seventh heaven: that is Marinetti. From every direction come to him sound and rumours of conflict. He must be torn in mind, as to which point of the compass to rush to and drink up the booming and banging, lap up the blood! He must be a radiant figure now!"[45] Lewis is trying to distance himself from Marinetti's war rhetoric, even though Lewis's own "blasts" borrow from warlike violence as well. What is more important here, however, is his reference to the "sound" and the "rumours" of war, the "booming" and "banging," which are part of Marinetti's attempt to attune his poetry to the sounds of war.

Marinetti's most elaborate poem was *Zang Tumb Tuuum* (1914), which is an attempt to render the sounds of the war, the battle of Adrianopolis in 1912, onomatopoetically. The title words "Tumb Tuuumb," for example, refer to the specific sound of a shrapnel.[46] This technique of using groups of letters to create particular vocal and visual effects is a direct result of Marinetti's doctrine of the *parole in libertà* (words in freedom), of freeing words, or rather letters, from the constraints of the lexicon and grammar. But the poem is more than an onomatopoetic collage of sounds. It seeks to capture different aspects of war through sections called "Mobilization," "War Correspondence," and "Battle." The whole poem culminates in a section called "Bombardment." Dynamite is celebrated for its explosive power; trains and airplanes for their speed; and troop movements for their geometric formations. Since, according to Marinetti, the war was the greatest futurist poem, it was only natural that he would try to prove this claim by writing his own greatest poem in the idiom of war.

Zang Tumb Tuuum is written not only to represent the war but also to exemplify Marinetti's war manifestos. Scrupulously obeying the poetics outlined in various futurist manifestos, it uses mathematical signs such as "=" and "+," omits adjectives and adverbs, and presents most of its verbs in the infinitive. It favors brevity and telescoped synthesis over continuous narrative and enacts the "typographical revolution" advocated in various futurist manifestos by enlarging letters and words for heightened effect. In

fact, there is something dutiful in just how carefully *Zang Tumb Tuuum* follows the poetics outlined in futurist manifestos, as if to demonstrate at all cost how compelling this poetics can be in practice. So excessive is this poem's adherence to the futurist manifestos, so close its attention to their every word, that it not only keeps recycling the favorite topics of futurism— war, airplanes, fast cars—but also incorporates the technical and theoretical vocabulary of these manifestos. At times, *Zang Tumb Tuuum* thus quotes from manifestos, as it does, for example, in its opening lines:

> No poetry before us
> with our wireless imagination words
> in freedom loooong liiiiive Futurism (643)

The slogan "Long live futurism" can be found in many futurist manifestos. The phrase "wireless imagination" (*immaginazione senza fili*) is the subtitle of one of Marinetti's most well known manifestos, and the label "words in freedom" (*parole in libertà*) is the name of the new poetics *Zang Tumb Tuuumb* is supposed to exemplify. And not only do the terms of these manifestos appear here, but they function in the same way as they do in manifestos, namely, to differentiate futurism from its predecessors and rivals: "No poetry before us." *Zang Tumb Tuuum* here reenacts the creation of a point zero, a new departure, to which all manifestos aspire.

The programmatic opening sets the tone for the entire poem, which is saturated with the key words of futurism. On the very next page we read, "Totality simultaneity absolute synthesis = superiority of my poetry over all the others stop" (644). What is being wired here—one of Marinetti's favorite means of communication—is a list of futurist slogans in the overconfident tone of the manifesto. Manifestos have infiltrated this poem, which therefore ceases to function simply as a poem and becomes an extension of these manifestos.

So much does Marinetti think of his manifestos in the process of writing *Zang Tumb Tuuum* that sooner or later a manifesto, as theme and topic, was bound to show up in the poem itself. The manifesto makes its appearance through Marinetti's favorite form of distribution: it is being thrown out of an airplane. This manifesto is a true war manifesto, a propaganda manifesto, which begins: "We Bulgarians make war against the Ottoman government which is incapable of governing appropriately" (712). Nothing could have appealed more to Marinetti than a war manifesto, in the middle of a war poem that is dependent on manifestos. *Zang Tumb Tuuum* could be used as a cautionary tale, warning poets not to give up their generic autonomy, but it is a tale whose moral was lost on much avant-

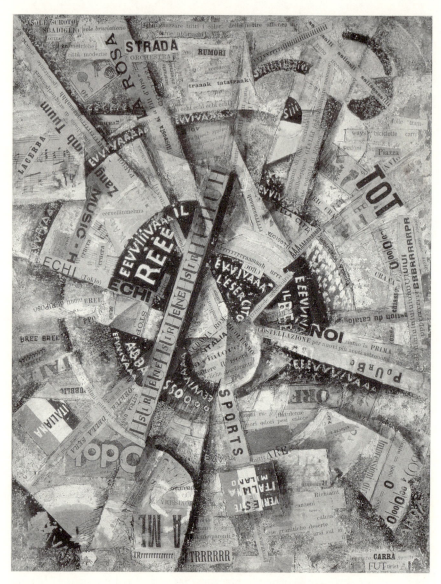

Figure 5.1. Carlo Carrà, *Manifestazione Interventista*, 1914. Collection Gianni Mattioli, Guggenheim Collection, Venice. Photograph: David Heald. ARS, N.Y.

garde poetry, which has sought a close alliance with the manifesto through-out. If manifestos constitute a danger for poems, it is a danger avant-garde poets seek out systematically, even if this means that they stop writing poems and begin writing something closer to manifestos. The futurist master genre thus turns art into a mixture of art and manifesto, what one could call manifesto art.

The work of art that epitomizes this category of manifesto art most succinctly is a collage by Carlo Carrà called *Manifestazione Interventista* (1914).[47] Also published in *Lacerba*, a futurist journal advocating Italy's entry into the World War I, this collage is organized around a vortex that looks like a megaphone whose cone gathers words and letters and com-presses them into one big outcry. These words and letters are taken from newspapers and *parole in libertà* as well as from manifestos. Their arrange-ment, too, signals a kinship with the manifesto, a genre to which Carrà also alludes in his title, "Interventionist Manifestation." The manifesto, here, is identified with its most characteristic feature, namely, the desire to engage in a political intervention, in this case the intervention of Italy in World War I. Surrounded by countless artistic and political manifestos, Carrà's piece has itself become something of a manifesto, a collage of material organized around a single center and a single issue. *Manifestazione* can be seen as a study in what happens to art in an era dominated by manifestos: it is turned into an interventionist manifestation.[48]

Not all artworks produced by futurism correspond neatly to the category of manifesto art. But we can see that the nature of art and of an art movement has changed with futurism, and it has changed in a way that anticipates the further course of what is conventionally, though not unprob-lematically, called the historical avant-garde and the neo-avant-garde. Sub-sequent movements, such as vorticism, dadaism, or surrealism, or the situa-tionists produced different combinations of manifestos and artworks, but they all share with futurism what should be considered futurism's heritage, namely, the centrality of the manifesto. It is this that I am calling the futur-ism effect.

Russian Futurism and the Soviet State

The Future in the Periphery

In launching futurism, Marinetti had made three crucial decisions: that the language in which to found an avant-garde movement was French; that the best place to do so was Paris; and that the best venue was *Le Figaro*, the preferred journal for the artist declarations of the Belle Epoque. In 1909, Paris was still the unrivaled center of the artistic avant-garde, attracting everyone from Pablo Picasso to James Joyce and much of the so-called Lost Generation of U.S. writers. And if Paris was the place to be for painters and writers, it was even more so for those experimenting with the newest avant-garde form, the manifesto. It was in Paris that the world sought the dernier cri in art and Paris that possessed the infrastructure for inaugurating new programs, including a host of small magazines as well as major daily newspapers, such as *Le Figaro*, willing to publish artistic manifestos on the front page. Those harboring ambitions of launching manifestos and attracting attention were thus drawn to Paris, the Romanian Tzara (one of the founders of dadaism) and the Chilean Huidobro (founder of creationism) among them.

But while futurism had confirmed Paris as the center where successful acts of naming and labeling should be performed, it also demonstrated that the avant-garde was becoming an international phenomenon. Almost as soon as the movement had received its baptism in the French capital, Marinetti took it to Italy and charged it with a nationalist rhetoric. It was from the relatively backward Italy that the new type of avant-garde was operating, but it nevertheless was capable of projecting its influence across

Europe as well as to the Americas. This instant geographic diffusion of futurism indicates the force of the futurism effect, a force channeled, articulated, and also catalyzed by manifestos.

The geographic pattern of the futurism effect, namely, that it made itself felt more lastingly in the southern and eastern periphery of Europe as well as in Latin America, corresponds to the distribution of the *Manifesto*, even though it contradicted the geography theorized within this text itself. Notoriously, it had been with respect to the semiperiphery of industrialization that Marx and Engels had been most fatefully wrong, predicting that the contradictions of capitalism would make themselves felt first and foremost in the most advanced nations, such as Great Britain. Even after it had been proved wrong by the Russian Revolution, this theory survived to the early twenties, with Russia looking toward Germany for the sparks of the world revolution. Communism, however, was moving to the periphery, a trend that continued throughout the twentieth century, leading to the powerful confluence of communism and anticolonial struggles.[1] The best conditions for communism could be found precisely in countries such as Russia and Mexico, countries marked by extreme tensions between a predominantly rural population with vestiges of feudalism and centers of belated and therefore rapid-paced modernization and industrialization. One indicator for the geography of communism is the map of the translation and distribution of the *Manifesto*, which greatly increased in Russia at the turn of the century. In 1899, for example, there were as many as ten Russian editions of the *Manifesto*; a second peak was reached in 1905 with thirteen editions, and then again in 1917 with another ten. By comparison, in the same period there was only one German edition in 1899 and no English, French, or Spanish at all, and only a single one in English and German, respectively, in 1905 (see the charts in chapter 4).[2]

The geography of communism in general and the *Manifesto* in particular can give us valuable clues for understanding the geography of the avant-garde, for example, how it, too, received significant impulses from the periphery of industrialization, both the periphery of Europe, such as Italy and Russia, and outside Europe, such as Latin America. Belated industrialization often created more extreme resistance, but also more extreme advocacy, and it was precisely the clashes between resistance and advocacy, the crisis of modernization resulting from them, that many avant-gardes epitomized.

It was, perhaps, because communism and the avant-garde shared a common root that Russian communists were most attuned to the geography of futurism. Writing about the rapid spread of futurism from Italy to Russia, Trotsky argued:

A phenomenon was observed which has been repeated in history more than once, namely, that the backward countries . . . reflected in their ideology the achievements of the advanced countries more brilliantly and strongly. In this way, German thought of the Eighteenth and Nineteenth Centuries reflected the economic achievements of England and the political achievements of France. In the same way, Futurism obtained its most brilliant expression, not in America and not in Germany, but in Italy and in Russia.[3]

One might compare this observation to Engels's insistence that the *Manifesto* could serve as an index not only of the spread of communism but also of industrialization. Trotsky adds one twist to this idea by arguing that the avant-gardes serve as indexes not so much of industrial modernity but of its ideology.

Trotsky's analysis can be extended to avant-garde manifestos, which remained tied to the *Manifesto*, even as they also sought to maintain their distance from this imposing document. Indeed, Trotsky's geographic hypothesis has informed, often tacitly, theories of the postmodern such as those of Anderson and Jameson. For them, too, modernism and avant-garde art mark not so much the triumph of industrialization as the collision, within the cultural sphere, between industrialization and older aristocratic and agrarian modes.[4] The complete triumph of industrialization and capitalism, the successful elimination of everything that stands in its way, thus means not the height of modernism but its transition to postmodernism. Anderson writes: "Where modernism drew its purpose and energies from the persistence of what was not yet modern, the legacy of a still preindustrial past, postmodernism signifies the closure of that distance, the saturation of every pore of the world in the serum of capital."[5] The totalizing concept behind the phrase "every pore of the world" presumes the possibility of saturation, that capitalism would at one point simply have saturated the world once and for all. Instead, one might think of different waves of modernization, exerting their disruptive force in places that had already been subject to previous forms of industrialization. In any case, what matters here are not the claims about the postmodern but the views of modernism they imply. Anderson's temporal-economic scheme of the crisis of modernization can be projected onto a geographic plane, generating a theory of uneven development according to which modernism will appear at different times in different places, depending on the dominant economic mode of production.

This rather general scheme, however, has some difficulties accounting for the extreme differences, including the political differences, between various forms of avant-gardes. Whereas in Italy futurism emerged from the extreme fringes of syndicalism and quickly turned fascist, in Russia it rode the waves of the Bolshevik revolution and was thus much more directly related to the socialist tradition of the manifesto. This relation, however, turned out to be less than a blessing. While Mussolini forced Marinetti to tone down his political manifestos because they were seen as too close to socialist ones, in Russia the futurists were forced to tone down theirs because they were seen as not socialist enough. Even though the political vectors of Italian and Russian futurist manifestos thus point in different directions, in both cases an avant-garde culture based on the manifesto collided with a political regime that had had to form its own relation to the history of this genre. The debates about the politics of the avant-garde manifesto demonstrate that these manifestos were not simply the articulation of the crisis and ideology of modernization, but that this genre was charged with its own particular political and poetic history.

Manifestos in Russia

There can be no doubt that Russian futurism was directly influenced by Italian futurism and that it therefore constitutes part of the futurism effect. Just how this effect worked, however, has been the subject of a heated debate began by the Russian futurists themselves. The only group that paid direct homage to Marinetti was also the one that introduced the word "futurism" to the Russian literary scene: a collective called ego-futurism. As early as 1911, one of its members, Igor Lotarev (then writing under the pseudonym Igor Severyanin), had used the word "futurism" in a small volume of poems.[6] However, the second, and more influential, group associated with Russian futurism, cubo-futurism, was much more eager to evade Marinetti by emphasizing its roots in an earlier group of experimental poets, the Hylaea group, which came before the emergence of Italian futurism. The vehemence with which cubo-futurism tried to downplay Marinetti's influence may be fathomed from its futile attempt to predate retroactively some of its publications to a period before Marinetti's first manifesto. In their 1913 short text "The Word as Such," Aleksei Kruchenykh and Velimir Khlebnikov even tried to reverse the vectors of influence, claiming, "The Italians inhaled

the Russian air and started producing crib notes on art, word-for-word translations."[7]

All this lingering anxiety of influence erupted when Marinetti traveled to Moscow in early 1914. Marinetti's visit was widely reported in the press, and some Moscow futurists tried to make a good impression on the bellicose Italian by giving him occasions to declaim his work and engaging him in discussions about different types of futurism. Others, however, especially Khlebnikov, treated Marinetti with open hostility.[8] It is difficult to determine where these squabbles were due to personal pride and where a more serious struggle about different futurisms was at work. There is certainly a kinship between the Russian attempt to find an original sound language, called *zaum* (transrational language) and Marinetti's *parole in libertà* (words in freedom), and many, if not all, Russian futurists were infatuated at some point or another with Marinetti's arsenal of topoi, ranging from skyscrapers and automobiles to war and violence.[9] At the same time, the Russian futurists undeniably developed their own specific style and traditions of avant-garde poetry that were only partially borrowed from Italian futurism.

The debate about Marinetti's influence has focused almost exclusively on poetry. Most participants and later critics eager to maintain the independence of Russian futurism celebrated the undeniable originality of Russian futurist poets and dramatists, especially of Vladimir Mayakovsky. Kruchenykh and Khlebnikov, for example, based their dismissal of Marinetti on the claim that "they [the Italians] made no verbal artifacts until 1912 (the year their big collection was issued), or later."[10] The emphasis on the poetic work was reinforced by the extraordinary collaboration between Russian futurists and formalist criticism. Russian futurism profited greatly from formalist theorists and interpreters such as Victor Shklovsky, whose support and interest helped it gain recognition and cachet. The futurist technique of taking everyday language and decomposing it into single units only to recompose them in novel and startling ways corresponded to some of the methods and theories advocated by formalism. The singularity, originality, and purity of the poetic word were shared concerns of futurists and formalists alike. And it was futurism that helped shape the formalist theory of estrangement.

What this investment in the purity of the poetic word has obscured is that Marinetti's most important genre, the one almost singularly responsible for the futurism effect, was not poetry but the manifesto, and that it was the manifesto that became a central genre for Russian futurism as well. Rather than compare the "words in freedom" with Russian *zaum* poems, or

count how often automobiles appear in this or that poem, we should therefore focus on the manner in which Russian futurism learned from Marinetti the art of making and distributing manifestos. Indeed, the confluence of futurism and formalism is one reason that the manifestos of the Russian futurists are rarely discussed, for they could not have been further from the emphasis on "poeticity" and "literariness" advocated by formalism. Echoing Moréas's celebration of obscure language in "The Symbolism" and the long tradition of symbolism in Russia, Shklovsky writes about futurist poetry: "This is an incomprehensible and a difficult language; one cannot read it as one reads a newspaper, but our demand that poetic language be understandable is too much a habit."[11] "Incomprehensible" and "difficult" are qualities of a specifically "poetic" language that challenges our habitual expectation to understand written utterances immediately and without effort. These qualities are at odds with the type of writing that characterizes the manifesto, which is geared toward the "newspaper" and is supposed to be an easy, if not always predictable, read. This type of dismissal was repeated by Roman Jakobson, who was not willing to attribute to the manifesto any value of its own, considering it part of neither poetry nor literary studies: "No manifesto . . . can serve as a substitute for an objective scholarly analysis of verbal art."[12] The manifesto thus escaped the notice of most formalists who sought to cement, rather than erode, the difference between the poetic and the everyday, and between objective analysis and normative opinion.

However, it was the manifesto that was primarily responsible for the futurism effect. Marinetti's manifestos were the first of his texts to make it to Russia; they were immediately excerpted by journals and magazines reporting the latest trends in western Europe, in particular Paris, and then quickly translated in their entirety. As Vladimir Markov argues in his magisterial study of Russian futurism, Marinetti's poetry was little discussed and, for the most part, not available in translation.[13] That Marinetti would exert his influence through manifestos and not through his poetry is due to the fact that the manifesto is uniquely geared toward making an impression and producing effects, not only immediate and local but also long-distance effects. The manifesto presents itself as instant news, and its slogans and compressions demand to be reported and circulated. These slogans are presented in a language that may be extreme, condensed, and elliptical, but that nevertheless remains dedicated to functioning, if at times violent, communication. Even journalists can translate these slogans with relative ease. While "words in freedom" defy any attempt at translation (although one might argue that they do not need to be translated), the language of the manifesto invites translation as well as excerpting and reporting. In this way, the futur-

ism effect was caused by projections of the manifesto across space, and not just in Russia but also in such places as England and Latin America.

Marinetti himself was very aware of these effects. Prior to his arrival in Moscow he had personally sent many of his manifestos ahead for the Russians' perusal,[14] and he eagerly followed the various translations of his manifestos:

> It is without question that the term *futurismo* (and futurist) appeared in Russia after my first manifesto was published in *Figaro* and then translated by the most important newspapers of the world, and naturally also by Russian newspapers and reviews.
>
> It is without doubt that the theory of futurism, created by me and my friends, spread in Russia with extraordinary rapidity, thanks to the literary success of my book *Le Futurisme*, which, as my editor Sansot informed me, sold more copies in Russia than in any other part of the world.[15]

Like Marx and Engels in their *Manifesto*, Marinetti wants to claim that his *Le Futurisme*, a collection dominated by manifestos, has the status of world literature. Although it could never rival the *Manifesto*, its history of publication was indeed international, with the book appearing in Russia as *Futurizm* (1914) even before it was published in Italian under the title *Guerra sola igiene del mondo* (1915) and in Spanish as *El Futurismo* (1916).[16] *Le Futurisme* responds to a need that emerged soon after the manifesto had become widely used among futurists. Manifestos are ephemeral texts; some of them were printed in journals, while others were distributed as flyers or declaimed from the stage. Thus, they now had to be collected and transformed into a more durable and marketable form. Similar attempts at self-anthologizing were undertaken by other avant-garde writers and impressarios, including Tzara and Huidobro. What we see here is the entry of the manifesto into the domain of book publishing.

Le Futurisme, however, was not the first appearance of futurist manifestos in Russia. The "extraordinary rapidity" that stunned Marinetti characterized the transmission and reception of futurism in Russia even before his collection appeared there. Within a month of the publication of Marinetti's first manifesto in *Le Figaro*, a Russian daily published an article informing its readers that yet another school had been founded in the "usual place for such proclamations," namely, *Le Figaro* of Paris.[17] Under the nom de plume "Panda," written in the Westernizing Latin alphabet, the anonymous author quotes all eleven points of the manifesto, thus introducing the part that was originally called "manifesto" to Russian readers. Panda's is

followed by a number of articles devoted to futurism, as well as by several translations of futurist manifestos over the next few years.[18] Contrary to many denials, there can be no doubt that the name, the slogans, and, most importantly, the forms of futurist manifestos were available in Russia before the emergence of a specifically Russian type of futurism.

Marinetti's manifestos exported not only his aesthetic doctrine but also the avant-garde manifesto as a literary form. This form was taken up by the Russian futurists instantaneously, for it provided an intriguing alternative to the various symbolist and imagist declarations that had hitherto appeared in Russia. Even and especially the manifestos published by cubofuturism, the group that most adamantly denied Marinetti's influence, are indebted to his new type of manifesto. The first cubo-futurist manifesto, "Slap in the Face of Public Taste" (1912), begins with a dismissal of the past *tout court*, "The past is too tight" (51), before it turns against the entire Russian literary tradition: "Throw Pushkin, Dostoevsky, Tolstoy, etc., etc. overboard from the Ship of Modernity"; and it refers to the "skyscrapers" from which the futurists are gazing at the insignificance of their symbolist predecessors. Their form is clearly borrowed from Marinetti as well, in particular the aggressiveness with which they attacked the "filthy slime of the books written by those countless Leonid Andreyevs." And the title, "Slap in the Face of Public Taste," creates an adversarial relation between the text and its audience, a speech act dreaming of physical combat.

There is one more measure by which we can gauge the influence of Marinetti on Russian manifestos, namely, the manner in which they were distributed. Ego-futurism, the faction most friendly to Marinetti, adopted, for example, his style of distributing manifestos as leaflets and flyers.[19] More surprising, however, is the fact that even cubo-futurism, which denied Marinetti's influence, adopted his style of distribution even as it also experimented with alternatives. Kruchenykh's famous "Declaration of the Word as Such" (1913), for example, appeared as a leaflet, and Mayakovsky's "We, Too, Want Meat" was prominently placed in a newspaper, the Moscow *Virgin Soil*. But not all manifestos were distributed this way. "The Trumpet of the Martians," for example, was printed, in an archaic and nonfuturist gesture, on a scroll.[20] Cubo-futurism also borrowed from Marinetti the habit of declaiming manifestos from a stage. Beginning in 1913, the cubo-futurists toured Russia with the equivalent of Marinetti's theatrical evenings, staging events that included declaimed manifestos among other theatricalized forms.[21] Here, as in futurism and later in dadaism, the appeal of the theater was the possibility of directly confronting the audience, of turning the rhetorical "Slap in the Face of Public Taste" into reality. How much these perfor-

mances were indebted to Marinetti became clear during his visit to Moscow, when those seeking to please their visitor arranged for Marinetti to appear in one of their cabarets.

While both the content and the form of Russian futurist manifestos clearly betray Marinetti's signature, these manifestos did not occupy the same role within the field of literature. "Slap in the Face of Public Taste," like the majority of Russian manifestos, appeared as the introductory text to an anthology carrying the same title. In fact, most futurist groups in Russia, including Hylaea, the Centrifuge, the Mezzanine of Poetry, Company 41, and cubo-futurism, presented themselves through anthologies framed by programmatic manifestos.[22] Whereas in Italy, the manifesto was beginning to acquire the status of an independent literary form, in Russia manifestos functioned primarily as a frame for collections of poetry. One reason for the manifesto's servitude to poetry was the need for Russian avant-garde writers to legitimize themselves as artists and therefore to prove themselves in the genre that stood highest in the hierarchy of the arts (a similar tendency can be observed among Latin American writers of manifestos). Russian manifesto writers therefore did not want to or could not go quite as far as Marinetti in betting their reputation on the ambiguously positioned genre of the manifesto.

So strong was the dependence of the manifesto on poetry that many Russian manifestos quote from the poems composed in the spirit of the theories laid out. In a fifteen-page booklet entitled *The Word as Such*, Kruchenykh and Khlebnikov alternate between the condensed but quite comprehensible demands typical of the manifesto and fragments of rather incomprehensible poetry that are identified as "examples." This manifesto cannot resist offering commentaries on these examples: "While in the works of the first type the similes are usually limited to one word, in the second type they extend to several lines and consist mainly of nouns, in this way ultimately effective in 'roughing up' the language."[23] The manifesto retreats behind the poem and functions as its explanation in what almost reads like a piece of formalist analysis. This intrusion of the manifesto into the domain of literary analysis was perhaps one reason Jakobson felt the need to defend "scientific," that is, formalist, literary analysis against critical "manifestos."[24] The internal scission between interpretative manifesto and poetic example nevertheless remained one of the specific features of the Russian manifesto.

At the same time, however, one might recognize in the mixture of manifesto and poem a different tendency, a hesitant form of what I call manifesto art: mixtures of artworks and manifestos. Some contemporary critics recognized that the manifesto was affecting not so much literary criti-

cism as poetic practice. Trotsky, finding himself in agreement with the formalists whom he otherwise attacked, warned, that, "Monumental proletarian styles cannot be created by means of manifestos."[25] What is remarkable about this warning is that it was written by one of the most avid writers of political manifestos. It is tempting, therefore, to detect here an anxiety on the part of the older tradition of the socialist manifesto with respect to the newer avant-garde manifesto that seemed to be stealing the show. Much later, however, Trotsky himself would drift toward the avant-garde manifesto when he coauthored with two avant-garde figures, André Breton and Diego Rivera, "Manifesto: Towards a Free Revolutionary Art," which tried to mediate between socialism and the avant-garde.

Futurism and the Revolutionary State

The event that brought the debates surrounding Russian futurism to a point of crisis was the Russian Revolution. Much more so than Italian futurism, Russian futurism had always presented itself in terms of revolution: the revolution of poetry, of language, of art, of the society that had created *passéiste* art. To this end, it had appropriated from Marinetti the revolutionary genre as such: the manifesto. Now, however, this revolutionary form had to face the political and social revolution that was happening all around the futurists. Just as there had been a fierce competition between the artistic and political manifestos in Italy, so there came to be a competition between political and artistic manifestos in Russia. Indeed, in Russia these two strands collided much more directly. Whereas in Italy fascist politics had more or less retreated from the genre of the manifesto and thus left Marinetti to exploit the genre at his leisure (at least as long as these manifestos did not claim to be political), in Russia there now existed a state that derived its own legitimacy from the *Manifesto*, the most important point of reference for all manifestos.

At first, this common heritage of political and art manifestos seemed to predestine them for a perfect match. Futurism's dream of taking art to the streets was within reach. Russian futurists wrote openly propagandistic poetry and plays, such as Mayakovsky's *Mystery-Bouffe*. They also devoted considerable energies to poster art and even transformed the entire town of Vitebsk, in Belarus, into a futurist spectacle. Futurism wanted to become the art of the revolutionary state and tried to shore up its revolutionary credentials wherever it could: "We did not indulge in aestheticism, pro-

ducing things for self-gratification. We applied our acquired skills to the agitational-artistic work required by the Revolution [the ROSTA posters, newspaper feuilletons, etc.]." The futurists referred to Vsevolod Meyerhold's production of Mayakovsky's *Mystery-Bouffe* as one of the first examples of genuinely "revolutionary" art.[26] Indeed, the purpose of all these diverse futurist activities was political agitation: "We will agitate the masses with our art" (194). The first issue of the most lasting avant-garde journal, *Lef* (Left Front of the Arts; 1923), exclaimed confidently: "Futurism became the left front of the art. 'We' became it" (192).

Mindful, perhaps, of formalism's contempt for "slogans," one writer is almost defensive about the extent to which the futurists had engaged in agitation: "The Futurists could not wait for their declarations and new poetic forms *by themselves*, gradually and unobtrusively, to breach the thickness of bourgeois consciousness. . . . There was concern only about the device's effectiveness . . . In order to make ears turn you have to call out loud."[27] However, the more the futurists tried to prove their revolutionary credentials through manifestos and propaganda art, the more they collided with the manifestos and propaganda controlled by the emerging state. The futurists were told that they had to limit themselves to the writing of art; agitation, revolutionary "effectiveness," "calling out loud" would be the sole prerogative of the Soviet state. (At the same time, Marinetti was experiencing a similar problem in fascist Italy: he, too, was forced to retreat into the sphere of art against which he had rebelled by means of manifestos and manifesto art.) From the perspective of the state, futurist "effectiveness" had always retained some of the theatricality of the Italians, and the Russian futurists were therefore accused of being "charlatan-advertisers." Marinetti's art of posing, echoed in Mayakovsky's notorious yellow trousers, now became an emblem of weakness. The Russian futurists thus found themselves in a no-win situation: when they were partially effective in their propaganda art and manifestos, they were punished as a threat; when they celebrated theatricality, they were mocked for being ineffective.

The dividing line between avant-garde art and the political vanguard was increasingly defended as the twenties wore on. At first, the futurists were still able to secure official support, but this support became more ambivalent and infrequent. One of their protectors was Anatoly Lunacharsky, commissar for enlightenment, the equivalent of a minister of culture, who defended Russian futurism, for example, by quoting Gramsci's declaration that Marinetti was a genuine revolutionary artist.[28] The most articulate support, however, came from Trotsky, but only after he had been forced out of his party and governmental posts. His *Literature and Revolution* (1924)

recognizes a genuinely revolutionary desire on the part of the Russian futurists, who are credited with attacking not only the old bourgeois aesthetic but also the society that had given rise to it. At the same time, Trotsky questions the futurists' claim on the revolution. Arguing that it was the Russian Revolution that had turned the futurists into revolutionaries, he ends up questioning the revolutionary nature of futurism altogether: "A bohemian nihilism exists in the exaggerated Futurist rejection of the past, but not a proletarian revolutionism" (131). The rivalry between futurism and communism with respect to the revolution becomes clear when Trotsky begins to put the word "revolution" in quotation marks when speaking of the futurists (142). At the same time, he relegates all art to the rear guard: "The place of art is in the rear of the historic advance" (236). It is in the course of this argument that Trotsky echoes Marx's notion, from the *18th Brumaire*, of the poetry of the revolution: "Out of the revolution grew the materialist method. . . . This is the greatest fulfillment of the Revolution and in this lies its highest poetry" (100). Art is situated in the rear, while the materialistic method, the instrument of the revolution, is in the front. Just as futurist manifestos competed with Trotsky's own manifestos, so the futurist artwork competed with the revolution. For Trotsky, this meant that the futurists needed to stop writing manifestos and confine themselves to the production of art, without being able to claim that their art could ever become the true poetry of the revolution.

Trotsky's critique was benevolent in comparison to the attacks that were being launched against the futurists on the part of those advocating a strictly proletarian art, in particular the Russian Association of Proletarian Artists (RAPKh). For them, the futurists were merely a waste product of the decaying bourgeois culture, forever severed from the proletariat. Now the question of how directly Russian futurism was derived from Italian futurism became a matter not only of artistic originality but also of political survival. Consequently, the futurists had to deny that Marinetti had ever had the slightest influence on them: "The Russian *Futurists broke off definitively* with the poetic *imperialism* of Marinetti, whom they had already booed at the time of his visit to Moscow" (1913).[29] But despite all denials, their association with Marinetti would haunt them to the bitter end, prompting Osip Brik to parody the logic of his detractors in 1927: "What is Lef? Futurists. What are Futurists? Marinetti. Who is Marinetti? An Italian Fascist. Consequently . . . the conclusion is clear. All of this is pure rubbish, since the Russian Futurists arose long before Marinetti became well known in Russia."[30] Despite Brik's protests, it was precisely this logic that ultimately gained the upper hand, thus depriving the Russian futurists of any official support.

Mayakovsky's eventual suicide in 1930 epitomized for many the death of Russian futurism and of the Russian avant-garde more generally.

As the Russian futurists were put on the defensive and forced underground, many acknowledged that their revolution had little to do with the Bolshevist state, just as their manifestos had been different from those of Lenin and Trotsky. Now they claimed that the official revolution had fallen short of its promises and that the futurists had to press for a spiritual revolution to complete the material one that had already taken place. This change in direction also affected their attitude toward art. Vladimir Tatlin, for example, staged Khlebnikov's *Zangezi*, which was called a "prophecy in dramatic form"; one might consider this prophecy to be a move back to the origins of the apocalyptic manifesto of the Renaissance or to its romantic variants. Most emblematic, perhaps, was Mayakovsky's poem "Fifth International." The poem was originally entitled "Fourth International," but Mayakovsky decided to add one more number, thus moving it even further into the future. This turned out to have been a wise decision, for soon Trotsky would actually found a Fourth International after having been sent into exile by the official Third. Upon the poem's publication, Mayakovsky sent a telegram to Einstein: "From the art of the future to the science of the future." The art or poetry of the future could not make peace with the official revolution. While the Soviet state was building the present, the futurists wanted to continue deriving their poetry from the future.

7

The Rear Guard of British Modernism

Trotsky's observation that the periphery articulates the ideology of progress more clearly than the center helps explain why the futurist manifesto would emerge in Italy and then move to Russia. Futurism reflected the ideology of the advanced industrial nations not just by worshiping machinery and production processes but by capturing the temporality of modernity, the value of the new for its own sake. However, while the rapid proliferation of the manifesto from Italy to Russia adheres to Trotsky's paradigm, we now have to ask what happens when the genre that captures the ideology of progress like no other returns to the center of industrialization: England.

Those among the Anglo-American modernists most attuned to the Continent reacted to the latest, manifesto-driven modernism with a combination of desire and resistance. Reaction is an operative term here, for those who responded most directly to the manifesto in England, Lewis and Pound, were reactionaries in the political sense as well. The notion of reaction, however, can be developed further to capture the contradictions of their positions and even their artworks: their obsession with communism and their concern with the individual artist; their fascist allegiances and defensive art; their simultaneous denunciation of modernism, the avant-garde, bohemia, and academic art. Marked by belatedness in relation to the Continental avant-gardes, London's international modernists sought to catch up with the extreme modernism of the semiperiphery but also to redirect its impulse. Without wanting to go back and without wanting to embrace some utopian future, the only attitude that was left for them was that of a defensive battle on all fronts, a reactive form of avant-garde, even a reaction *to and against* the various avant-gardes, what I will call a rearguard action against every major force and movement of the time.

When looking back, in *Blasting and Bombarding* (1937), to the immediate postwar period, Lewis used the term "rear-guard" in a throwaway line: "Apart from the gallant *rear-guard actions* spasmodically undertaken in the British Isles by literary sharpshooters steeped in the heroic 'abstract' tradition, usually still termed 'avant-garde' for want of a more appropriate word . . . the movement to which, historically, I belong will be as remote as pre-dynastic Egyptian statuary [my emphasis]."[1] He adds, paradoxically, "The rear-guard presses forward." The notion of the rear guard, I argue, can be used to describe Lewis's aesthetic and political position with respect to the Continental avant-gardes in general. The way I propose to use the notion of a reactive avant-garde or rear guard is distinct from a mere nostalgia for the premodern world; it is coextensive neither with the tradition-bound conservatism of a T. S. Eliot nor with the religion-inflected modernity advocated by the nonconformist Catholic Charles Péguy (though Péguy did use the word *arrière-garde* as well). Rear-guardism, which culminates in Lewis but includes a wider range of figures, is a defensive formation that places itself within the field of advancement but is skeptical of its most extreme practitioners; it seeks to correct and contain the avant-garde's excess without falling behind and losing touch with it entirely.[2] Caught between advancing and retreating, the rear guard lacks room to move and thus engages in an endless and disoriented back-and-forth, in sideways maneuvers and feints, often breaking off from the main corps to find itself alone and surrounded by enemies everywhere.

The first and foremost defensive posture the rear guard takes is in relation to the manifesto. In their skepticism, Lewis and Pound were not alone. As the manifesto swept across peripheral locales, such as Russia and Latin America, and then turned to the most industrialized countries, there formed a chorus of artists, journalists, and politicians, including Trotsky, Jakobson, Picabia, Artaud, and German expressionists who denounced the manifesto as being variously bad: bad theory, bad form, bad manners, and bad art.[3] The prevalence of this complaint in the early twentieth century is overwhelming, an index of the prominence of this new genre and also of the impression that it might have a bad influence on the status of the work of art. The manifesto violated almost all values associated with high modernism by privileging the explicit rather than implicit, easy slogans rather than complex structures, shrill ruptures rather than subtle epiphanies, direct address of the audience rather than unreliable narrators, political interventionism rather than aesthetic autonomy, and finally revolution rather than transcendence. Manifestos openly competed with advertising, propaganda, newspapers, and political speech, and they disregarded many sanctioned

forms of art; they were written for immediate consumption and maximal effect, not for arduous and contemplative reading and exegesis. Not only was there no movement that did not articulate itself through manifestos, but more and more contemporary observers sensed that writing manifestos had become many artists' primary activity.

What is striking about these diverse critics of the manifesto is that they themselves were drawn into the manifesto craze and ended up becoming prominent writers of manifestos.[4] Expressionism, for example, produced a number of veritable antimanifesto manifestos, for example, Oskar Kanehl's "Futurism: A Sober Manifesto," which criticizes the irresponsible exaggerations of the futurists, and August Stech's ironic "A Call for a Manifestantism," which protests against the explosion of manifestos after 1909. Even those who wrote against the bad influence of manifestos on art found that the most effective genre in which to voice these complaints was none other than the manifesto itself.[5] While some of these skeptics of the manifesto, such as Picabia and Artaud, were soon converted, others remained skeptical and used the manifesto only as a weapon against itself. But whether these writers were for or against manifestos, rear-guardists or avant-gardists, they found themselves forced to take a stance toward this genre. By causing either rejection or embrace, the manifesto managed to polarize the cultural field like a magnet, reorienting other forms of writing around it.

Britain's relation to the Continental avant-gardes and their manifestos was shaped by its own history of socialist writing. In some sense, of course, London was the birthplace of the genre, since the *Manifesto* had first been published there, albeit in German, and English was one of the first languages into which this text had been translated. But socialism in Britain had its own particular history that intersected with, but was not primarily driven by, the *Manifesto*. Chartism and the women's suffrage movement were much more dominant here than elsewhere in Europe, and unlike the Socialist Party of Germany and other national branches of the Second International, the Labour Party never presented itself as a direct heir of Marx or his *Manifesto*. Until the early twentieth century, socialist writing inspired by Marx was confined to small groups such as the Fabian Society. And even the Fabians were committed to a gradual, evolutionary socialism that evaded precisely the notion of the revolution so intimately tied to the form of the manifesto. Indeed, in Britain the word "manifesto" means primarily party platform.

Most political pamphlets, such as the ones issued by suffragists, remained firmly within the sphere of politics and did not, as Marinetti's manifestos had done, attempt to fuse political pamphleteering and literary

expression. There were, however, some exceptions to this rule. George Bernard Shaw shamelessly integrated his political pamphlets into his plays. *Man and Superman*, for example, not only revolves around the question of technological, social, and revolutionary modernity but also includes a "Revolutionist's Handbook" as an appendix to the play.[6] And like the Italian futurists working with the manifesto, Shaw was accused of mixing propaganda with art. However, Shaw's dialogues and handbooks, essays and aphorisms never coalesced into the generic form of the manifesto, with all the history and difficulties associated with it. And, significantly, Shaw seemed unaware of and undisturbed by the manifesto explosion that was taking place on the Continent.

The other feature that was missing in England was the formation of self-declared artistic groups, whose programs then would lend themselves to being presented in something resembling a manifesto. Shaw's activities in group formation were confined to politics, where he happily became a public spokesperson for the Fabian Society, and never extended into the sphere of art. Although he strongly and polemically advocated for the New Drama, he pursued this project largely as an individual voice. The one exception was Bloomsbury. In its formation and organization, this group, however, was a far cry from the much more tightly knit Continental movements. Bloomsbury had emerged from a Cambridge club at the turn of the century and remained more a clique than a group, let alone a full-fledged movement. Bloomsbury also never defined itself in opposition to rival avant-garde groups; indeed, it was a rather insular phenomenon. The only country its members visited with regularity was France, and their interest even in the French avant-garde was largely restricted to painting and rarely extended to poetry, theatrical performances, or manifestos.

Given this relative isolation, it is not surprising that only the most international of the modernists working in England, Pound and Lewis, caught wind of what was happening on the Continent. Before 1914, however, even they could not quite bring themselves to form groups, write manifestos, and do all the other things avant-garde groups were now supposed to do, such as engaging in highly visible public stunts and provocations. Pound had picked up the currents of the Continental avant-gardes as early as 1912, but all he did then was coin, very halfheartedly, something called "imagism." Despite his desire to participate in the field of isms and their manifestos, his "A Few Don'ts by an Imagiste" falls short of being a full-blown manifesto: while the manifesto signals a claim to totality, toward the absolute, the cautious or even coy "A Few Don'ts" deliberately renounces any such grandiose aspiration. It is almost as if Pound were attracted to the

manifesto without wanting to own up to its more extreme consequences. Pound's later "ABC's" and his "How To" texts may be somewhat less modest, but they likewise circumvent the manifesto by being modeled on another down-market genre, namely, the user's manual or introductory guide.[7] However, the elaborate humility of these titles—the texts themselves are quite confident—are without doubt calibrated toward the manifesto. They must be understood in the context of the authoritative and programmatic manifestos that had begun to circulate through newspapers, magazines, and leaflets everywhere around Pound and with which, as Lyon has very convincingly argued, Pound had to struggle and compete.[8] For example, Pound had made sure that the name for his first ism, imagism, would be entirely novel and not already in use by some obscure French movement. He thus fully participated in the differential logic of the Continental avant-gardes, each trying to stake out its own territory by emphasizing its distinctiveness— often minimal enough—with respect to rival movements.[9]

Pound's imagism was only a hesitant rehearsal of how to launch a movement, lacking, as it did, a central organ of publication and a manifesto. As in the case of Russia, it was through Marinetti himself that the manifesto entered Britain. Marinetti's first manifesto had been translated into English soon after its publication, and Marinetti himself made several appearances there. Somigli has detailed the gradual infiltration of futurism into England before the well-known and also well-publicized third visit in 1914.[10] It was this visit, however, that would prove to be instrumental in the formation of a British rear guard. Marinetti's visit, extensively covered in the press, fit the pattern of many similar visits across Europe. He gave well-attended lectures and readings and, unavoidably, coauthored the *English Futurist Manifesto*.

The mistake he made, if indeed a mistake it was and not a cunning strategy for sowing dissent, was to print this manifesto on the stationery of the Rebel Art Centre. The center's autonomy was jealously guarded by Lewis, who had set it up against Bloomsbury, from which he felt systematically excluded. Lewis, who was not going to let this laboriously acquired independence be hijacked by his Italian competitor, prepared a series of defensive measures, many of them quite in keeping with the techniques of public disruption adopted by the futurists. He gathered some friends and interrupted Marinetti's lecture at the Dore Galleries. In the next *Observer* on June 14, the rebels promptly explained their opposition to the man whom the press liked to call "the caffeine of Europe": "We the undersigned . . . beg to dissociate ourselves from the 'futurist' manifesto which appeared in the pages of the *Observer* of Sunday, June 7th."[11] Critics have tended to emphasize the differences in style and aesthetic doctrine, with futurism favoring

dynamism and movement while Lewis was attached to a kind of modernist classicism based on distinct forms and shapes. More recently, Lawrence Rainey and Lyon have emphasized that the confrontation between Lewis and Marinetti was less about aesthetics than about publicity.[12] It is this latter understanding that feeds into my argument, namely, that Marinetti's success in London, like his success everywhere else, was a carefully orchestrated publicity stunt that demonstrated, above all, the effectiveness of his primary advertising instrument: the manifesto.

Lewis did not leave it at attacking Marinetti. He began to realize that he could stop Marinetti from winning followers in England only by coming up with something like a Continental avant-garde movement of his own, including a proper membership, a program, a journal, and, most important, a manifesto. The result was a movement called "vorticism" and the journal *Blast*, which lasted from 1914 to 1915, edited by Lewis with the help of Pound.

Blast, 1914

Blast is marked by a typical avant-garde desire for differentiation, functioning as an attempt to counter the advanced Italian futurism with a British ism, to meet the Italian invader with a homegrown product.[13] But this national struggle, heightened by the rhetoric of the imminent war, was also and more significantly a generic struggle, a struggle about different modernisms, for *Blast* viewed the new avant-garde repertoire of manifestos and isms with ambivalence. This ambivalent and conflicted use of the manifesto is visible in the manifestos of *Blast* themselves. Vorticist manifestos attack almost randomly long lists of individuals, as well as "the post *office*" (21), "aperitifs" (13), "sport" (17), and "humour" (17), and it is difficult to extract from them even a halfway consistent position. Sometimes these manifestos have been described as mere parodies, suggesting that they need not be taken seriously and were of little consequence. It is important to recognize, however, that only once the manifesto was recognized as an established genre could it be opposed or embraced, but also quoted, parodied, and alluded to in a variety of ways. In fact, a playful use of the manifesto can be found in many of the Continental avant-garde movements, such as dadaism, which created masterpieces of parodic metamanifestos.[14] Even though the vorticist "Manifesto" is not, simply, serious, it nevertheless serves a serious purpose, for it must be regarded as the first line of defense against Marinetti.

Instead of parody, one might think of it in terms of satire, a concept Lewis would use to describe the particular aesthetic and political mixture that characterizes his later work. Speaking on Radio Rome in 1940, Pound made a similar point: "The stinking old Manchester Guardian took six months to discover that Blast was satiric."[15] Satire in fact became the rearguard style par excellence, a way of using and co-opting avant-garde strategies without subscribing to their aesthetic and political implications.

Even as it satirizes some aspects of the manifesto, *Blast* participates in the bad-mannered mode of speech that characterizes this genre. In particular two texts, called "Manifesto I" and "Manifesto II," take to an extreme the manifesto's polarization between condemnation and praise, its staccato style of enumerating apodictic demands, hostility toward the audience, aggressively enlarged letters, and hypertrophic speech acts. *Blast* announces, for example, its eagerness to reach a large public: "Blast sets out to be an avenue for all those vivid and violent ideas that could reach the Public in no other way."[16] The communication of such "violent" ideas echoes modernist techniques such as rupture or suddenness,[17] but it is best described as a poetics of action as it was envisioned by Burke and later by Austin, a poetics that culminates in two quintessential speech acts, satirically exposed: cursing and blessing.[18] The "curse" and the "blessing" belong to a type of speech act whose utterance is coextensive with its effects; they are speech acts defined by their effects on an addressee. However, this juxtaposition of curses and blessings also constitutes a stark, overdrawn picture that is far, for example, from the playful metamanifestos of dadaism. Even though the speech acts of *Blast* are thus infused with violent irony, they continue to participate in what they ironize and continue to be deployed for the serious business of reacting to the Continental avant-garde. Relying on the manifesto's performative and foundational power, Pound and Lewis tried to erect with it a bulwark called vorticism for the paradoxical purpose of containing the influence of Marinetti's manifestos and manifesto-inspired practices. It is thus misleading to say either that Lewis and Pound simply made fun of the manifesto or, alternatively, that they simply took it seriously. What they did was to redirect and adapt it for their own purposes.

Pound's and Lewis's ambivalence with regard to the manifesto was based on two anxieties, each of which corresponded to one of their assumptions about art: their fear that the influence of the manifesto would turn the artwork into nothing but theory-laden propaganda art and that the manifesto's collective authorship would undermine the autonomy of the individual artist. Given the fact that the manifesto was pressed upon Pound and Lewis by Marinetti, it is not surprising that they would identify its bad influence

CURSE $\boxed{3}$

WITH EXPLETIVE OF WHIRLWIND

THE BRITANNIC ÆSTHETE

CREAM OF THE SNOBBISH EARTH

ROSE OF SHARON OF GOD-PRIG

OF SIMIAN VANITY

SNEAK AND SWOT OF THE SCHOOL-ROOM

IMBERB (or Berbed when in Belsize)-**PEDANT**

> **PRACTICAL JOKER**
> **DANDY**
> **CURATE**

BLAST all products of phlegmatic cold
Life of **LOOKER-ON.**

CURSE **SNOBBERY**
(disease of femininity)
FEAR OF RIDICULE
(arch vice of inactive, sleepy)
PLAY
STYLISM
SINS AND PLAGUES
of this **LYMPHATIC** finished
(we admit in every sense
finished)
VEGETABLE HUMANITY.

15

Figure 7.1. From "Manifesto I," in *Blast I*, 1914, 15. Kroch Rare Books and Manuscripts Library, Cornell University.

on the artwork primarily with that movement, accusing the futurists of creating too much "propaganda" (*Blast II*, 42) and not enough great works of art. A similar attitude also emerges at the end of *Blast I*, which culminates not with the call to arms typical of the manifesto but with a word of caution directed at the violent wing of the women's suffrage movement: "To Suffragettes. / A word of advice. / In destruction, as in other things, / stick to what you understand. / We make you a present of our votes. / Only leave works of art alone. / You might some day destroy a good picture by accident" (151). The fear that a single "good picture" might be destroyed in the course of a revolutionary struggle responds to the well-publicized destruction of paintings by British suffragists, but it also registers the extent to which Pound and Lewis sought to preserve the artwork by any means necessary.[19] Underneath the patronizing tone of this note we can thus perceive a thinly concealed fear about the relation between art and revolution, a fear about the value of the artwork.[20] Pound and Lewis felt a certain amount of gratitude toward the radical magazine the *Egoist*, which had run the ads for the first issue of *Blast*. And as Lyon and others have pointed out, suffragism represented one of the British traditions of manifesto-driven agitation that Lewis and Pound felt increasingly compelled to imitate.[21] But political struggles of emancipation are questions of "votes" and not of "art," and *Blast* here signals a desire to keep art and politics—and this also means art and manifesto—apart.[22]

The association, however uneasy, between vorticism and the women's suffrage movement also offered an additional way in which Lewis and Pound could distance themselves from Marinetti and the futurists. Not only did futurism present itself in a hypermasculinist language, Marinetti's manifesto itself has been described as a masculinist genre. The subsequent history of various feminist rewritings of the manifesto further elaborated, critiqued, and revised the recurring misogyny of the manifesto, especially those feminist manifestos analyzed by Lyon, but also the more oblique negotiations with this genre visible in such texts as Virginia Woolf's *Three Guineas*.[23] Lewis's satirical manifestos may not necessarily seem much more attractive than Marinetti's, but they did recommend themselves by their lesser degree of warmongering and by a form of misogyny that was certainly virulent but perhaps less ideologically founded and ingrained. But while the vorticists' dependence on women patrons, on magazines run by women, and on the tradition of women's suffrage writing made Marinetti-style machine machismo impossible, this dependence also led to the aggression visible in the defense of the artwork against suffragist politics. In other words, what the

suffragists represent here is the intrusion of politics, manifesto-driven politics, into art.

However, the vorticists' defense of art does not imply a return to or continuation of turn-of-the-century aestheticism.[24] Lewis declared outright, "There is nothing mysterious about Fine Arts. . . . Art is as transparent and straightforward a proceeding as is animal life itself. . . . The pretentions of art, I take it, do not point to anything beyond the thresholds of life."[25] His attempt to separate the frauds from the genuine artists and his anxiety about the destruction of the aesthetic sphere might sound similar to aestheticism, but for Lewis these concepts have acquired a different function within the system of art.[26] Instead of differentiating art from the social utility of the realist and reformist novel, they are opposed to a much more recent form of modernism and avant-garde art, whose putative attempt to merge art and life Lewis rejects vehemently: "[Art] is not a way of life."[27] Indeed, his most outrageous attacks are directed not only at the high modernists but also at the tendency to turn this art into a lifestyle. Bloomsbury, for Lewis, represented the pinnacle of Britain's avant-garde bohemia, and it therefore became the target of his venomous satire, *The Apes of God.*

Instead of indulging in either the aestheticist cult of art or the avant-garde cult of life, Lewis undertakes a rearguard action against the manifesto and its assault on art, here represented in the figure of violent suffragists who are greeted not with a call to arms but with a call to disarm. *Blast* is only the first step in a whole series of such reactions, which would span Lewis's entire lifetime and mark him, as Jameson has said of Lewis more generally, as the primary reactionary of British modernism.[28] It was only much later, in *Blasting and Bombarding*, that Lewis admitted to the political dimension of his aesthetic rear-guardism: "I might have been at the head of a social revolution, instead of merely being the prophet of a new fashion in art. . . . Really all this organized disturbance was Art behaving as if it were Politics. But I swear I did not know it, it may in fact have been politics. I see that now" (32). Even though the two, art and politics, are still set apart, Lewis here acknowledges a porousness between them he had previously denied.

Blast's rearguard action against manifesto modernism is not just a defense of the value of the artwork against a politics articulated in manifestos but also a reaction to a second feature of the manifesto, namely, its role in creating collective movements. The declaration "Blast presents an art of individuals" (80) echoes the subtitle of the *Egoist*, which calls itself "An Individualist Review."[29] The *Egoist* had adopted this title from the anarchist Max Stirner, who had been one of the targets of Marx and Engels's *Manifesto*

and who therefore lent himself well as a name for an anti-Marxist journal. In keeping with this individualist attitude, several contributors did not sign the vorticist manifestos, including Rebecca West, whose story "Indissoluble Matrimony" can be read as a send-up of the term "vorticism" itself.[30] The emphasis on individuality was also part of Lewis's campaign against Bloomsbury, which he saw as a closely knit group that had specifically excluded him. "I and the people about whom I am writing are of course not a herd or flock, however small, in the sense of the French cenacle or the London 'Bloomsburies.' Inded [sic] that sort of grouping necessarily implies that the people composing it are of far more interest together than they are apart."[31] In actuality, however, it was vorticism, not Bloomsbury, that had presented itself through a collectively signed manifesto, a collective program, and a collective name. Indeed, it is through this rivalry between vorticism and Bloomsbury that the art scene in London was beginning to resemble the competition among the different Continental isms and groups. Perhaps it was this foray into the culture of Continental-style movements that prompted Lewis to backpedal and deny that such a move had been made. It is a typical feature of the rear guard to use avant-garde techniques but to reject the values that underpin them.

Blast was thus engaged in a battle with and against these modes and formations, using a homeopathic method, if you will, of keeping the manifesto at bay. Using a little bit of manifesto to immunize England from the grand manifesto onslaught was a tempting strategy, and it seems to have worked: manifestos and avant-garde collectives remained a relatively rare phenomenon in British modernism. But no matter how successful this immunization, it nonetheless meant that now some form of manifesto had entered the system of art in England, was exerting its influence, and therefore had to be contained. After Blast, it is no longer possible to write the history of British modernism without taking the manifesto into account.

Lewis's *Enemy of the Stars*

Blast's homeopathic strategy with respect to the manifesto thus had consequences. The phenomenon that characterized futurism, namely, the mixture of manifesto and artwork, was beginning to make itself felt in England as well, and nowhere as clearly as in Blast, where manifestos and artworks were forced together. The manifesto, no matter how ambivalently used, began to inform art, leading to combinations of art and manifesto in various shapes.

The uneasy alliance between manifesto and art characterizes nothing so much as the work in which *Blast* culminates: a particularly strange kind of play written by Lewis himself, *Enemy of the Stars*.[32] *Enemy* is not a successful play by any stretch of the imagination. Its most characteristic feature, I will argue, is its dependence on the manifestos by which it is framed and that invade it in various ways. This condition makes *Enemy* an example of manifesto art, a play that is under the sway of the manifesto. Given the "dramatistic" (Burke) nature of the manifesto, it should perhaps not come as a surprise to find a particular affinity at work between manifesto and drama. While futurist manifestos were performed in theaters, for vorticism this theatrical tendency took the form of a satirical manifesto drama. This characterization can be tested against a second version of the play, written before *Blast* but not published until the thirties, which is much longer and more narrative but also less abrupt, aggressive, and abstract. This version lacks many of the shorter version's failures precisely because it was removed from the context of the manifestos and intended to stand alone.

What is striking from the very outset about *Enemy* is that this dramatic text does not seem to be conceived for the theater at all; it is characterized by a total lack of theatrical—objective—correlatives. The stage directions can barely recall the fact that we are supposed to be on a theatrical stage or in a circus. We read, for example, "A human bull rushes into the circus" before it "rushes off, into the earth" (59). As if this description had realized that rushing "into the earth" might be a little difficult to represent in a theater, it adds, helpfully, that there is a "gangway into the ground at one side," an instruction that is little more than a gesture toward stageability. The other stage directions are equally unspecific, demanding, for example, that the "hut of second scene is suggested by characters taking up their position at opening of shaft leading down into mines quarters" (60). The disinterest in the requirements of staging places *Enemy* within the tradition of the modernist, antitheatrical closet drama, a tradition ranging from Mallarmé's closet dramas to the "Circe" chapter in *Ulysses*, a tradition marked by an active resistance to the theater.[33] Indeed, Lewis would later claim that James Joyce got his idea for the "Circe" chapter from *Enemy*. Just as Lewis had abused rather than simply used the manifesto, so here he abuses rather than uses the theater.

Lewis's attitude toward the theater was bound up with the theatricality of futurism and in particular its manifestos. Indeed, just as he had created a defensive form of manifesto, so he created a defensive form of drama that withdrew from and reacted against the theater. Lewis's closet drama, however, is markedly different from those of many other modernists.

What takes over the work of staging this play are not only stage directions and the imagination of the reader but a number of paintings Lewis inserted between the opening description of the play and the text of the dialogue.[34] Some of Lewis's paintings, such as *Plan of War* and *Slow Attack*, pick up the bellicose tone of both his manifestos and his play; *Timon of Athens* refers directly to another play, and the final illustration sets the scene for the ensuing play, whose title it bears: *The Enemy of the Stars*.[35] Indeed, the grotesque, stark, and overdrawn quality of these works echoes Lewis's technique of satire. While the text of the play is too entangled in its programmatic function and aggressive tone to bother with the stage, Lewis's illustrations supply some form of visual setting, one that is directed not at a hypothetical stage director but at the reader of *Blast*.

The emphasis on visuality indicates the transitional position *Enemy* occupies in Lewis's career: prior to *Blast*, he had been primarily a painter, not an editor and writer. Many of his contributions to *Blast I* and *Blast II*, in particular his survey of futurism, impressionism, and imagism, centered almost exclusively on these movements' productions in the visual arts. Even when he turned to literature, he explicitly wanted to import into it a visual aesthetic. For Lewis, this meant an aesthetic of surface, of the image, of juxtaposition and, at the same time, a rejection of in-depth characterization and linear narrative. Lewis chose drama as his first major literary form because it was intimately connected to visuality, even if he transposed this visuality to the printed text.

One additional feature Lewis derives from painting and uses against the theater is abstraction. Instead of settings and characters, Lewis's play is populated by abstractions taken from his pamphlets and manifestos. *Enemy* is conceived for a *theatrum mundi* in which rages a battle of cosmic dimensions and abstract ideas. The entire text is saturated with such abstract terms as "humanity," "death," "life," and "God," and the characters seem like marionettes, pulled about by these abstractions that invade the play from the manifestos surrounding it. The yoking of abstraction and embodiment has led some commentators to read the play as an allegory in which characters are supposed to embody the abstractions that surround them. But no fixed allegorical meaning can actually be construed. The failure of allegory is linked to Lewis's painterly aesthetics of the pure surface, which also implies a rejection of depth and thus of hermeneutics, even of interpretation as such.

To facilitate the reading of this text, Lewis included a narrative commentary that tries to connect the action of the protagonists and the battle of ideas. The play opens, for example, with the following description of one

of the two characters: "One is in immense collapse of chronic philosophy" (59). We read a little later on that this character "lies like human strata of infernal biologies" (61), only to learn further on, in a more narrative mode: "He was strong and insolent with consciousness stuffed in him in anonymous form of vastness of Humanity" (71). The narrator's voice seems to address the reader directly, eager to communicate what the play itself, with its own repertoire of representation, is apparently unable to convey. One might recognize in this narrative technique a feature that appears in many closet dramas and that I have called the "diegetic theater."[36] However, rather than controlling the scene through descriptive passages and stage directions, this narrator compensates for his failure to do so by bursting out in slogans, maxims, and far-fetched metaphors. *Enemy* is not so much a diegetic theater as the failure of one.

Instead of reading *Enemy* as a failed play, however, one can read it as a particular confused and symptomatic instance of manifesto art, for some of the play's dramatic failures can be attributed to the influence of the manifesto. Far from seeking to advance the genre of drama, this text participates in a programmatic and polemical project, namely, that of advancing a new movement called vorticism.[37] It is in this project, fueled by manifestos, that one can recognize what Fredric Jameson called Lewis's "fables of aggression."[38] For these aggressions are born from the manifestos that are grouped around this dramatic text. *Enemy* is directly under the sway of the journal's programmatic propaganda, the manifesto-like, uneven layout, the montagelike changes, uneasily hovering between theory and art. Both its failure and its appeal are products of the collision between the literary form of drama and the genre of the manifesto.

The Aftershocks of *Blast*

On the whole, *Blast I* worked well enough as a rearguard action against Marinetti. But Lewis's satirical strategy soon encountered a major obstacle, namely, the outbreak of World War I. While Marinetti welcomed the apparent convergence of his war rhetoric with the actual war, Lewis and the vorticists found themselves unable to defend their own, satirical, language of blasting and bombarding: "All Europe was at war and a bigger *Blast* than mine had rather taken the wind out of my sails."[39] Although a second, final, "War Number" appeared, the war can be said to have called Lewis's bluff.

Despite this defeat, the two issues of *Blast* had a surprising afterlife. Even though *Blast* had satirized the manifesto, it also established it, however ambiguously, in England. A significant number of figures in literature and the visual arts were now associated with an ism and a series of manifestos, whether or not they had officially signed on to them. It was as a conduit of the Continental avant-garde that *Blast* influenced the whole system of literature and art after 1914. One example is impressionism, as represented by Ford Madox Ford. Unlike futurism or vorticism, impressionism had been originally coined not by a group of artists gathering around one dogma but as a critical slur directed at a heterogeneous group of painters violating the academy style. The term was slowly accepted by the painters so labeled, and only after it had found a place in the visual arts did it gain any currency in literature.[40] Given this history, it is not surprising that none of the programmatic statements around literary impressionism have the foundational fervor of futurist and vorticist manifestos. There is no foundational manifesto of impressionism, but only a history of gradual emergence and adaptation.

All this changed once Marinetti and his type of manifesto had been established in England. Now, those who had been happily using the term "impressionism" for decades suddenly felt compelled to write manifestos. Ford's "On Impressionism" (1914) is such a belated, retroactive quasi manifesto of impressionism, written after Marinetti's third visit to London and just after *Blast I* had come out. Ford was closely associated with *Blast*, to which he had given the first installment of what ended up being his most famous novel: *The Good Soldier*. Indeed, Ford—or Hueffer, as he was then still called—had been *Blast*'s most widely known and most seasoned contributor. He often assumed a slightly paternalistic attitude toward the editors and contributors of *Blast*, even as he also genuinely wanted to help the young generation with their venture, however extreme and over-the-top. In the dedicatory letter to a new edition of *The Good Soldier*, written ten years later, Ford evokes the "passionate days of the literary Cubists, Vorticists, *Imagistes* and the rest of the *tapageux* and riotous *Jeunes* of that young decade."[41] But this whole heated scene is described in the past tense and reveals a rivalry with this new generation; almost triumphantly, Ford notes that his "good friends . . . Ezra, Eliot, Wyndham Lewis, H.D." were drowned out by the war and that their riotous ways did not survive it. It is as if Ford wanted to participate in the new manifesto mode by inserting impressionism into the concert of avant-garde movements and then, later, show that his older ism outlasted them all.

"On Impressionism" is a belated and retroactive manifesto, but it oscillates ambivalently between understatement and dogmatism.[42] Opening

with the sentence, "These are merely some notes towards a working guide to Impressionism as a literary method," it continues: "I do not know why I should have been especially asked to write about Impressionism; even as far as literary Impressionism goes I claim no Papacy in the matter." After such denials—the denial of "Papacy" resonates with the anti-Catholic rhetoric of *The Good Soldier*—Ford slowly begins to warm to the idea that impressionism is an ism, an aesthetic, a method that is firmly connected with his name. "I have a certain number of maxims, gained mostly in conversation with Mr. Conrad, which form my working stock-in-trade" (261). Even though the emphasis here is on conversation and practice, Ford now admits that there are indeed maxims of impressionism that he has employed, perhaps even invented. This turn to a more dogmatic position is confirmed in the structure of the text, which is divided into "articles," which are again divided into parts designated by roman numerals. Finally, in the course of writing the second article, Ford claims, "I have spent the greater portion of my working life in preaching that particular doctrine," (265) and begins to sound, if not like the pope of impressionism, at least like one of its more outspoken preachers defending the high doctrine of the faith.

Just how much "On Impressionism" was written with futurist manifestos in mind can be fathomed from the fact that it presents itself not as a dialogue with the fellow impressionist, Mr. Conrad, but as a defense against a Mr. Futurist: "My futurist friend again visited me yesterday, and we discussed this very question of audiences" (270). This question of the audience is central also to Ford's own text, which is addressed not to the like-minded impressionists but to a skeptical if not openly hostile audience. In this, too, he was drawn into the manifesto mode and the battle of the isms. At the same time, he participated in it by way of a defensive dialogue, a dialogue with and defense against futurism as a doctrine and as something transported through manifestos. Even though Ford was not a reactionary in the political sense, and even though his style was formed before the full-blown emergence of the manifesto, he can be considered a temporary and retroactive rear-guardist, at least in an aesthetic sense, just as he was a hesitant and belated user of the manifesto.

The aftershocks of *Blast* made themselves felt not only in such retroactive quasi manifestos as Ford's "On Impressionism" but also in the subsequent work of the main vorticists, whose works continued to be influenced by the manifesto even when they no longer made use of this genre directly. Lewis's *Tarr*, for example, which has been read as a battle between modernism and the avant-garde, is prefaced by a text that looks very similar to a manifesto. Adopting the collective voice of the manifesto, Lewis writes: "The

artists of this country make a plain and pressing appeal to their fellow-citizens. It is as follows: The appeal."[43] What follows is a five-point program, which Lewis calls an "onslaught on Humour." This is a theme from *Blast*, whose manifestos targeted British humor in particular, and both the theme and its manifesto-like deployment are carried over into the novel. Unsurprisingly, the implied audience is not only the humorous Brits but, once more, "the Italian futurist 'littérateur,' the Russian revolutionary" (13). Lewis, like D. H. Lawrence, who included vaguely futurist figures in his novels, felt the need to negotiate his relation to Marinetti.

But the novel was not the only genre to register the reverberations of *Blast* and its manifestos. More directly attuned to them was Pound's *Gaudier-Brzeska: A Memoir*, a memoir of the French sculptor who had been prominently featured in both issues of *Blast* and who died just before the publication of *Blast II*.[44] "Mort pour la patrie. Henri Gaudier-Brzeska: after months of fighting and two promotions for gallantry, Henri Gaudier-Brzeska was killed in a charge at Neuville St. Vaast, on June 5th, 1915" (*Blast II*, 34); this was a boxed announcement, a rare moment of sentimentalism in an otherwise most unsentimental journal. The *Memoir*, which appeared in 1916 and with added material again in 1970, starts with a reproduction of this original death announcement. But reproduction, or quotation, also becomes the primary technique of the entire text, which is an attempt to gather the literary and sculptural bequest of Pound's young friend. Prominent among the materials used are the manifestos Gaudier had written and published in *Blast*. The "Gaudier-Brzeska Vortex," for example, is reproduced in its entirety, as is a second "Vortex," written "from the trenches," which precedes the death notice in *Blast II*. Here Pound reuses the manifesto by integrating it into a collage of material surrounding the dead friend.

Pound quotes letters and newspaper articles, reproduces photographs of sculptures, and tries to reconstruct some of the events in Gaudier's young life. The result is a primary example of Pound's style: the arrangement, without transition, of found material in the manner of a collage. We can also see a certain family resemblance between Pound's choppy collage style and the manifesto. Just like Gaudier's manifestos, Pound's *Memoir* is abrupt, condensed, and synthesized. Like these manifestos, it does not bother with transitions and explanations, proceeding in a paratactic order. Instead of depth, it arranges the terms and thoughts that chase one another in a rapid-fire succession, on a broken surface.

Pound's reproduction and imitation of Gaudier's manifestos, however, are in the service of a particular project, namely, of assembling the remains of a dead comrade, even though Pound knows that his dead friend

cannot be made whole again. As much as Pound is engaged in this memorial work, he refuses to focus his *Memoir* on a center, following instead different scraps of material no matter how small their significance might be and losing sight of his putative subject more than once. At the beginning, he informs the reader, "I should in any case have written some sort of book upon vorticism, and in that book he [Gaudier] would have filled certain chapters" (19). Indeed, the *Memoir* contains long depositions on vorticism, its relation to impressionism, futurism, and cubism. This entire text, then, is as much a memoir of vorticism as a memoir of Gaudier. From this perspective, the extensive reproductions of manifestos acquire particular significance. The vorticist manifestos are reproduced but also framed; they are saved from oblivion but also integrated into a different genre, the memoir, that preserves their futurism in an act of remembrance. This is perhaps Pound's slyest rearguard strategy with respect to the manifesto: making it part of an archaeology, a history, a memoir that keeps it safely in the past. The manifesto's futurism is reversed and turned into history, becoming the chief ingredient of the funeral of the future.

The Politics of the Rear Guard

The rearguard containment of the manifesto is not a question just of literary form but also of political and ideological conviction; indeed, it is bound up with the most charged political questions of the time, namely, communism, Bolshevism, and fascism as they inform the thought and writing of those around Lewis and Pound, including Mussolini, Hitler, Sorel, T. E. Hulme, and Marinetti. In an important essay, Anderson has argued that the notion of revolution constitutes the horizon of modernism.[45] This is nowhere as true as in the case of *Blast* and its aftermath, but nowhere is it more difficult to disentangle the different strands—political, social, aesthetic, ideological—held together by this one concept of the revolution. It is to the political dimensions of modernism, of the futurist avant-garde and the vorticist rear guard, that we must turn to understand the ideological underpinnings of rear-guardism. They, too, are registered with particular clarity in the various uses and abuses of the manifesto, this most openly ideological and political form of the early twentieth century.

The political and ideological charge of the manifesto comes into view when we recognize how surprising the transition from the *Manifesto* to the avant-garde manifesto really was, surprising because it implied also a

transition from a genre firmly in the hands of socialism to a genre used by a protofascist such as Marinetti. Ezra Pound, for example, not only embraced fascism as a political doctrine but also followed Mussolini's art of action speech and violent declamation; Pound's rants on Radio Rome (in one of them, he returns to *Blast* and calls it half condescendingly, a "magazine or manifesto")[46] are case studies in agitational speech.[47] Lewis had called Pound, "a born revolutionary, a Trotsky of the written word."[48] In fact, Pound theorized a type of agitated declamation, one that would be a perfect synthesis of speech and action, in his most notorious pamphlet, written in 1935 in Italy: *Jefferson and/or Mussolini: L'Idea Statale, Fascism as I Have Seen It, by Ezra Pound, Volitionist Economics.*[49] This pamphlet is primarily an attempt to sell fascist Italy to America through the juxtaposition of the two names that appear in its title. Although putatively arguing for a cross-historical kinship between Jefferson and Mussolini, this pamphlet is a study in comparative revolution formed by the triangle of the American, Russian, and fascist revolutions, with some Confucius thrown in at the end. These three revolutions, Pound claims, were not interested in erecting a state or running a bureaucracy, in governing in the technical sense, but only in the revolutionary overthrow of existing structures.

As important as this text's content is its form. Like the *Cantos* and the *Memoir, Jefferson and/or Mussolini* is a paratactic collage; Pound himself admitted: "I am not putting these sentences in monolinear syllogistic arrangement" (28). *Jefferson and/or Mussolini* also contains a meditation on the speech acts of manifestos. Pound sees Jefferson as the central author of the Declaration of Independence and credits him with having created the kind of action speech that uses "verbal formulations as tools" (62). All three revolutions, Pound claims, are motivated by the ideal of "DIRECT action" and articulated in a language that participates in this action. Such an action speech, according to Pound, can take different forms. It includes fascist agitation but also Jefferson's way of using words as tools, a mode, according to Pound, that also characterizes the Declaration. Finally, action speech found another expression in Lenin's revolutionary rhetoric. All three figures and forms of action speech, Pound insists, are genuinely revolutionary, and each instigated the revolution that was right for its own time and place; Mussolini did for Italy what Jefferson had done for America, and Lenin for Russia. Indeed, the formulation "and/or" marks an equivalence rather than an opposition; the suggestion of a choice among similarly valid paths determined not by some universal standard but by local requirements. "And/or" can be taken as the fascist formula par excellence, the pretense of equally available solutions to the crisis of parliamentarism, solutions whose differences were

putatively dictated not so much by matters of ideology but only by regional and national peculiarities.

During the two decades following the Great War, Lewis articulated the politics of his aesthetic rear-guardism in a manner reminiscent of Pound's either/or. The most notorious and most clearly fascist statements can undoubtedly be found in his book *Hitler*, which presents itself as a balanced account of a charismatic leader whose politics, while perhaps not directly applicable to Britain, nevertheless deserve respect. The Hitler book, which Lewis regretted almost as soon as it was published, is only the tip of the iceberg of a long series of political writings, none of which Lewis ever felt the need to retract. It is in these texts, including *Time and Western Man* (1927) and *The Art of Being Ruled* (1926), that the political coordinates of the rear guard reveal themselves most clearly.[50]

Like Pound, Lewis recognizes the revolution as the inevitable horizon of modernity—"All serious politics today are revolutionary" (17)—and furthermore identifies the Bolshevik revolution as its paradigm: "In the abstract I believe the sovietic system to be the best. It has spectacularly broken with all the past of Europe" (320). In the same vein, Lewis quotes, often approvingly, from socialist theory, including Marx, Karl Kautsky, Lenin, Shaw, and Bertrand Russell, concluding from these studies that "any revolution today . . . must to some extent start from and be modeled on socialist practice. This applies as much to a fascist movement or putsch, as to anything else" (18).[51] At the same time, Lewis searches for an alternative to Bolshevism based on some vague combination of Marinetti, Mussolini, and Marxism: "*Fascismo* is merely a spectacular marinettian flourish put onto the tail, or, if you like, the head, of marxism. . . . And that is the sort of socialism that this essay would indicate as the most suitable for anglo-saxon countries or colonies" (321). Again, it is the and/or formula that constitutes the calculus of fascism.

As had been the case with Marinetti and Mussolini, Lewis's move from socialism to fascism was facilitated by Sorel. The "key to all contemporary political thought," Lewis insists, is "George [*sic*] Sorel" (119), transmitted to him through the translations of the theorist behind *Blast*, T. E. Hulme. Hulme, greatly revered by most members of *Blast*, was instrumental in translating and transmitting Continental aesthetics, politics, and philosophy to England, especially the writings of Henri Bergson and Wilhelm Worringer, whose *Empathy and Abstraction* had become the touchstone for abstract art. Many of the aesthetic doctrines expressed in *Blast* can be traced directly to Worringer and to Hulme's critique of Bergson. This aesthetic influence was more than matched in importance by the political, and this

means protofascist, ideas that Hulme transported as well, primarily through his translation of Sorel's *Reflections on Violence* and his involvement with the French fascist and protofascist press.

Like Continental fascists, Lewis placed himself within revolutionary modernism, but like them he sought to reduce and contain the consequences of this revolutionary modernity wherever he could. This containment took the paradoxical form of an oligarchic revolution: "Revolution . . . is not the work of the majority of people" (120), he observed, claiming that "a small number of inventive, creative men are responsible for the entire spectacular ferment of the modern world." Still in awe of revolutionary modernity, the "ferment of the modern world," Lewis denies the most central elements of this ferment, the unleashing of social revolution, mass democracy, and industrialization; instead, he restricts the true revolution to some neatly confined elite. In a more Machiavellian register, he concludes that most people want to and need to be ruled, rather than be rulers of their own fate. This is true, in Lewis's view, of the Bolshevik revolution as much as of Mussolini's march on Rome. Lenin and Mussolini are both members of the revolutionary few, whether they present themselves as the spearhead of the avant-garde or simply as Il Duce. This aristocratic revolution of the few can be seen as the political face of Lewis's artistic individualism expressed in *Blast*.

Everywhere Lewis found himself confronted with what José Ortega y Gasset called "the revolt of the masses": mass democracy, mass war, mass revolution, collective art movements.[52] And everywhere Lewis presented himself as the single and solitary reaction to all those masses. At this point, another view on the difference between Lewis's rear-guardism and aestheticism emerges. Like Lewis, most aestheticists from Mallarmé to Wilde positioned their delicate works against the masses. For them, however, this meant shunning widely circulating artworks such as serialized novels and journalism. For Lewis, by contrast, the notion of the mass is newly charged with everything from the Bolshevist mass revolution to the mass slaughter of the World War I. Rather than an aestheticist leftover, Lewis's text is formed in direct reaction to early twentieth-century masses, which Lewis wanted to rule through the exceptional individual, the single artist or political ruler.

While Lewis was thus restricting the notion of revolution, he began to cool to a philosophy and aesthetic based on action. While Marinetti, despite his political affinity to fascism, held on to a progress- and future-oriented avant-garde, Lewis did everything to stop and block any such advance, to slow down and derail such progress. Just as Mussolini accepted the concept of the revolution for the purpose of containing its effects, so Lewis adopted the genre of the revolution, the manifesto, to contain its consequences.

Satire in the Extramoral Sense

Lewis's writings of the twenties and thirties elaborate and extend his rear-guard stance to modernist literature through a serious of abstract and capacious terms and theories. *Time and Western Man* (1927) takes on almost all of the representatives of "good" modernism in the sense of the canonized "high" modernists, including Joyce, Stein, Pound, Eliot, Proust, Lawrence, and Hemingway.[53] The operative term here is "time," the "time cult," or the "time mind," and the range of phenomena subsumed under this one category is truly astonishing: the obsession with memory in such novelists as Proust; Pound's "antiquarian and romantic tendencies" (38); and Joyce's unending stream of words, "fluid material gushing of undisciplined life" (112). "Time mind" refers not only to an obsession with memory but to everything having to do with processes, transformations, instability, shapelessness, and flux. This aesthetic side of the time mind, defined by a lack of formal discipline, finds its counterpart in the philosophies of Russell and Spengler, who in turn borrow from scientific theories of the unstable and the fluid, including Darwin's evolutionism and Einstein's theory of relativity. The time mind is epitomized, however, by a figure that bridges philosophy and art, namely, Bergson, whose notion of creative evolution revolves around such notions as relativity, subjectivity, flux, and memory. Here we begin to approach the true function of this convoluted and synthetic text, namely, the fact that "time" really stands for the idea of progress or progressive time as it organizes modernity: "No doctrine, so much as the Time-doctrine, lends itself to the purpose of the millennial politics of revolutionary human change, and endless 'Progress' " (422). Now, even Sorel and Mussolini are denounced as "*pur-sang* bergsonian" (201), and the "time mind" extends all the way from literary modernism to the futurist, progressive millennialism of modernity.

What is more important than the far-fetched arguments with which Lewis wants to make us believe that Stein and Spengler, Chaplin and Proust, Joyce and Russell, Einstein and Mussolini all share the "time mind" is the very abstraction of the category "time" itself. It presents a shield with which Lewis wants to contain the consequences of radical modernism and modernity. The notion of the rear guard helps us understand the all-encompassing nature of the "time mind," why Lewis would create a term of critique so general that it ends up including almost all of modernity and modernism at once. Tyrus Miller has described Lewis's works as "late modernism."[54] I would like to take this notion of lateness or belatedness as one feature of

what I call the rear guard, which is not only behind, deliberately in the back, but also occupies the role of a defensive aggression.

This argument can be made with particular clarity when it comes to the notion of satire, which is at the heart of Miller's argument and which, I suggest, constitutes the center of Lewis's rear-guardism in the sphere of art. After the paradoxical experiments of *Blast*, Lewis rethought his literary practice and formulated a full-blown literary program for rearguard art, in his *Men without Art* (1934), under the name of satire. Lewis's definition of satire has little in common with the usual meaning of that genre and makes sense only within his own political and aesthetic universe. Satire articulates, against the progressive, millennial-modernist paradigm, an antiaction art that reacts point for point to the formation of modernity, manifesto, and revolution: "We may describe this book as a defence of contemporary art" (13). Even though Lewis's so-called satires include some of the features generally associated with this genre—exposing grotesque aberrations; exaggerating flaws and features; projecting these stark portraits against a tacit understanding of common sense and the normal—his satire is a general name for rearguard art as such. Satire gathers the different components of Lewis's rear-guardism into one literary form.

As a defense formation, satire is thus embedded in a host of expressions and formulations surrounding the question of value judgment. Lewis sees aestheticism, from Pater through Wilde to Gide, as "three consecutive generations of moralists—of moralists-gone-wrong" (145). But moralism extends to more than just aestheticism; it includes manifesto-driven modernism as well. Imagining a historian of the future, Lewis presents literary history as a sequence of different types of moralism, a naughty or "bad" moralism and a dutiful or good moralism: "He [the historian of the future] will see the trial of Wilde as the grand finale of the 'naughty' decade—then fourteen humdrum years of Socialist tract-writing—then war—and then *more* 'naughtiness.' He will perhaps meditate—'here was a people, moralist to the core, who only possessed two modes of expression, one childishly rebellious, the other dully dutiful!' " (148). Both aestheticism and the manifesto—or "tract-writing"—are moralizing, bound up in the endless oscillation between the "naughty" and the "dutiful," good and bad. At other times, Lewis would accuse Marxism of breeding an art so bad that he feels compelled to call it "anti-art." Particular values have shifted—"our *bad* has not been quite their *bad*" he observes at one point—but badness and moral value dominate both to the detriment of art itself.

Hence Lewis's desire to dissociate entirely satire from value in the moral and political senses. This is surely Lewis's most counterintuitive strat-

egy, since the word "satire" is traditionally infused with implicit and explicit value judgments and morality. His "Is Satire Real?" opens with the statement "That the moralist—in whatever disguise—can give us as much trouble as the politician—in whatever disguise—is certain" (107) and concludes with the observation "So today Satire can be judged good or bad upon no familiar or traditional pattern of ethical codification" (111). Satire, and with it modernist art, must be entirely divorced from the question of judgment and moral value and become hard, objective, static, abstract—value free. Lewis proposes the term "metaphysical satire" (232), but one should call it more properly "satire in the extra-moral sense." This metaphysical sphere of art beyond value, and Lewis thinks of this very explicitly in Nietzschean terms, is the last and final place of retreat from the chaos of moral "naughtiness" and political moralism, fascist and socialist revolutions, collective avant-gardes, and the influx of socialist tracts and manifestos. This notion of "beyond good and bad" returns frequently in the last sections of *The Art of Being Ruled*, in the form of a chapter title "Beyond Action and Reaction," in which Lewis defines his own aspiration, with a Nietzschean dash, as that of becoming "neither a 'good European' nor a 'bad European'—but, in short, a 'beyond-the-good-and-the-bad European' " (359). This metaphysical or beyond-good-and-bad position is the place from which he hopes to take on high modernism as much as manifesto modernism; satire, in other words, is a term that claims to have overcome what we might now call the "grand récit" of modernity and therefore constitutes Lewis's ultimate rearguard concoction.

Lewis is a limit case of modernism in part because he himself was so engaged with delimiting modernism and its influence, because he, as a late and rearguard modernist, was primarily interested in bringing modernism to an end. What is important for us is not the question of whether he was right in drawing this limit but his very attempt to do so. Lewis makes for a useful case study, also, for multiplying the term "modernism," not so much by presenting a happy plurality of modernisms but by outlining a struggle among them, including "good" or "high" modernism and "bad" or manifesto modernism. To these two, a third term should be added, that of a rearguard modernism, which wants to present itself as an "and/or" and, at the same time, as a "beyond" or "neither"—as a good and bad modernism or as a beyond-good-and-bad modernism.

To us, however, Lewis's satire may appear not so much a solution to the question of good and bad as something altogether worse and beyond the pale, full of grotesque distortions, offensive clichés, racist portraits, pa-

tronizing characterizations, sexist obsessions, and tiresome repetitions. Perhaps it was Lewis's attempt to go beyond value that led from bad modernism to worse. Lewis did not overcome the good and the bad, but he managed to create something ugly: a truly nasty modernism whose value might lie in the fact that it makes *Blast* and its homeopathic rear-guardism seem, retrospectively, not all that bad.

The Avant-Garde at Large

8

Dada and the Internationalism

of the Avant-Garde

The Great War had two divergent effects on the European avant-garde. On the one hand, it intensified the nationalist identifications of Italian and Russian futurism, German expressionism, and English vorticism. Futurist agitation for Italy's entry into the war was probably the most extreme case of an avant-garde coinciding with war propaganda, but German expressionism and British vorticism were drawn into the war's nationalism as well. *Der Sturm*, the primary expressionist journal, supported the war effort in Berlin, and the war issue of *Blast*, while shying away from simplistic propaganda, was saturated with nationalist and stereotypical labels and phrases.[1] On the other hand, the Great War also gave rise to movements explicitly devoted to resisting this nationalization. The most non- or antinational movement of the time was probably dada. The American dadaist Walter Conrad Arensberg declared dada to be American, Russian, Spanish, Swiss, German, French, Belgian, Norwegian, Swedish, Monegassian;[2] and the Dutch dadaist Theo van Doesburg wrote, "In its essence, Dada is the same everywhere, but different in its manifestations. In France . . . Dada is the most contemplative. In Germany . . . it is more political, in America more practical and constructive."[3] Most nondadaists, however, chose to see this internationalism through national eyes. In Paris, dada was seen as either German or American, in America it was perceived as French, in Berlin it was seen as Swiss, in Switzerland it was seen as a mixture of French, Romanian, and German— the only attribute that seems to have remained stable was that of being imported, nonnative, and foreign.

These cross-national confusions, however, barely scratch the surface of the complicated web of cities and people that make up the elusive phenomenon called dada. Dada journals and publications were produced in Zagreb, Zurich, Warsaw, Weimar, Vienna, Triest, The Hague, Tarrenz, Tiflis, Tokyo, São Paulo, Santiago de Chile, Rome, Prague, Paris, Okayama, New York, Munich, Madrid, Mantua, Leiden, Ljubliana, Kraków, Hanover, Geneva, Florence, Cologne, Bucharest, Buenos Aires, Brussels, Berlin, Barcelona, and Antwerp, a network spanning North and South America, East Asia, and Europe.[4] Dada is always elsewhere, imported and transient, redirecting the print cultures that had created the imagined community of the nation-state into a multilingual and nonnational direction.[5] The entire program of what one might call denationalization is epitomized in dada's very name. A word emerging from the gray area of the prelinguistic, dada is something between pure sound and articulate language, prefiguring the dadaist interest in a "pure" sound poetry not yet appropriated by a linguistic code.[6] As different dadaists never tired of pointing out, dada has meanings in Romanian, Russian, French, German, and Italian. The best thing about "dada," however, is that it has no central meaning in any language: it is a nonsense word that travels in the margins of different languages without firmly belonging to any one of them.

Dada's uneasy relation to nationality means that a comparative study, which makes sense for relating Italian and Russian futurism and British vorticism, will necessarily miss the mark here. Comparing, say, dada America and dada Slovenia or dada Germany and dada Japan may yield some interesting insights, but it makes little sense as a general methodology because the phenomenon under investigation is not constituted by national identifications. Nor is dada's internationalism just a negative category floating above a ground map covered with the color-coded patches of the nation-states. Dada sought to establish an internationalism best described by the figure of the network, a web organized not by nation-states or languages but by connections among cities. The figure of the network also indicates that it is difficult, even futile, to search for dada's origin or center. The dadaists themselves could never agree on who came up with the term and when it was coined, and the strategic refusal of most dadaists to ever define the movement has led to multiple narratives of its origin, which include New York, Santiago, Bucharest, Paris, and Zurich among the primary contenders.[7] What is required, therefore, is a method that captures dada's theory and practice of internationalism, its peculiar modes of establishing networks that cross national borders. Although this structure would today be called "transnationalism," since it establishes not connections be-

tween existing nation-states but a network that crisscrosses them, I will continue to employ the term "internationalism," because it was used, for lack of a better one, by the various socialist Internationals and also by the dadaists themselves.

391—A Journal on the Move

The history of Francis Picabia's journal *391* is representative of dada's far-flung geographic practice, a case study in how dada created the connections and nodes through which it emerged as an international movement. Born to Cuban and French parents, Picabia could have evaded the draft in France due to his Cuban citizenship, but he decided to enlist to take the rather privileged position as a chauffeur to General de Boissons (this job and Picabia's qualifications as a mechanic anticipate his later interest in the aesthetics of machines). When he was about to be transferred to an infantry regiment heading for the thick of the war at Ypres, his well-connected wife managed to secure him an assignment to purchase sugar for the French army in the Caribbean. Picabia never completed his mission and instead disembarked in New York. It was not his first visit there. As one of the wealthiest dadaists, he had been among the few French participants to travel to the original Armory Show in 1913, where he had received a warm reception by the emerging avant-garde group around Arensberg and Alfred Stieglitz, who treated him like a French cultural ambassador.[8] Now back in New York, he picked up these old ties and started to publish in the avant-garde magazine *291*, founded by Stieglitz and named after his gallery address at 291 Fifth Avenue. Soon, however, publishing in *291* no longer satisfied Picabia's ambitions, and he decided to publish a journal of his own, modeled on *291* and yet exceeding it, an aspiration captured in its title, *391*.[9]

Unlike *291*, *391* cannot be described simply as a New York journal; rather, it is what Tzara called a *revue en voyage*, a traveling journal, which both helped establish and exemplified the dada network by moving from city to city.[10] Its first four issues were produced in Barcelona, where Picabia had gone to recover from a nervous illness. Several members of the New York circle, for example, Albert Gleizes, the propagandist of cubism, had gone there as well, trying to establish another node in the network. Soon, however, Picabia went back to New York, where the next three issues of *391* appeared. Despite the immense attraction New York had for him, Picabia did not remain there and soon crossed the Atlantic again, although he still

did not dare to enter France before he had cleared his status with the army. Only when his wife managed to secure a laissez-passer to Paris in November 1917 did he return to Paris. As much as he had been looking forward to Paris, however, the city did not keep him for long. He ended up spending most of 1918 at various Swiss towns and resorts. In one of them, he received a letter from Tristan Tzara, the most vocal of the Zurich dadaists, inviting him to visit the town. Picabia's decision to follow this invitation proved consequential, for it led to a Zurich issue that significantly altered the style of *391*, whose layout and content began to look more and more like a collage. In fact, all these moves and locations left their marks on the look and nature of *391*. While this journal had acquired its machine aesthetic in New York, its chaotic layout emerged in Zurich. In addition, Zurich marks *391*'s conversion to manifestos, the first of which, entitled "Small Manifesto," was written by Picabia's wife, Gabrielle Buffet. Indeed, *391*'s particular mode of circulation also left its marks on the manifestos it printed. These manifestos, too, became increasingly collagelike, communicating visually and typographically across languages. Finally, Picabia returned *391* to Paris, where the journal would appear over the next couple of years. (The move to Paris also paved the way for Tristan Tzara to follow Picabia at his invitation.)

While moving across the Atlantic and around Europe, Picabia left a trail of dadaist activities. Picabia translated and published texts in French, English, German, Spanish, and Italian, a limited set of languages, to be sure, but one that had a large, specifically a transatlantic, reach. Translation, in fact, presented no major difficulty for dada's internationalism. Most of its publications were multilingual, providing contributions in a variety of languages, often without bothering about translation at all. Translation was a problem for modernism, with its intricate, subtle, and difficult style, but not for dada. In fact, a good portion of dada literature seems to require no translation at all, namely, the sound poetry and nonsense rhymes that are among the most well-known literary products of this movement. One might say that dada continued what was begun in the *Manifesto*, namely, a literary practice in which translation could somehow be circumvented or even abolished.

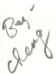

The journal's form of internationalism was marked by its travels. The third issue, for example, addresses itself to readers in "both hemispheres" and includes reports about dada activities in Paris, Barcelona, New York, Geneva, Metis City, and Haiphong. The fifth issue continues this orientation, although it limits such reports to the three major nodes, Paris, Barcelona, and New York. Beginning with the eighth issue, Zurich is added to this list. Not only does *391* feature vignettes about dada events taking place in other cities, but each place of publication informs the journal's

vision of the previous location, creating a particular version of what Appa-durai has called "global imagination," an internationalism directed at a small but global audience.[11]

Anecdotes about leaving and arriving permeate dada's history and point to the consequences of its being a traveling movement. In 1919, for example, as Duchamp was in the midst of moving back to New York, Picabia noticed among the suitcases and the chaos of Duchamp's apartment an odd-looking postcard that was about to be packed away. It was none other than a postcard of Mona Lisa with a mustache and entitled with the pun "L. H. O. O. Q." (when sounded out in French, one can hear, "elle a chaud au cule," she has a hot ass). Picabia took the postcard, copied it (no concern about the original here), and published it on the front cover of the next issue, creating one of dadaism's most well-known icons. Packing and unpacking, moving, translating, worrying about customs, visas, laissez-passer, and pass-ports, as well as sending things in the mail or through the wireless, are the consequences of dada's networked existence.[12] Picabia exclaimed, "One must be a nomad, pass through ideas as one passes through countries and cities"[13]—passing through becomes the condition of dadaism par excellence.

Some of these travels can be attributed to the war. While war re-duces tourism, it causes an immense mobilization of people and goods. Without his army assignment, Picabia would not have gone to New York in 1915. Another type of movement precipitated by war was draft evasion and the general desire to abandon the hypernationalist rhetoric of nations par-ticipating in World War I, prompting many dadaists to relocate to neutral Zurich. New York, too, became a destination for those seeking to leave war-ravaged Europe behind. But even though Picabia participated in both types of travel occasioned by the Great War, his many movements back and forth across the Atlantic were not caused by the war alone. His first visit to New York had been partly for tourism and partly for business, prompted by the international exhibition circuit. These types of travel—exile, tourism, exhi-bitions—were followed by others. Picabia went to Barcelona because of his health and also to Switzerland; his extravagant spa vacations testify to the class privileges associated with such trips and their particular form of avant-garde cosmopolitanism (another international vanguardist, the Chilean Vi-cente Huidobro, enjoyed an even more privileged background, which facili-tated his travels back and forth between Latin America and Europe). And Picabia's return to Europe was motivated by his desire to connect to the emerging avant-garde scene there. All these motivations and modes of travel coexisted and contributed to the multifaceted internationalist network es-tablished by such journals as *391*, a journal on the move.[14]

Dada's Internationalisms

Internationalism, however, is not just a description of what dada did but also the centerpiece of a program it sought to pursue, a myth it wanted to create, a value. Most dada journals and many other dada activities bore the adjective "international." When dada arrived in Berlin, for example, the first thing its members organized was the First International Dada Exposition, and most dada activities and events either took place under the explicit heading of internationalism—beginning with the magazine *Cabaret Voltaire*, which was called an "international journal"—or were described as international, retrospectively. Dada magazines eagerly published clippings from "all newspapers of the world," and, like *391*, many provided long lists of cities that were actually or allegedly part of the dada network.[15]

If the motivation for this internationalism was first and foremost the opposition to the nationalizing war and its aftermath, dada also sought out actual practices and theories of internationalism on which to model its own aspirations. The first such model was capitalism and specifically the multinational corporation. The Berlin dada office was regularly referred to as "world headquarters," and Grosz and Heartfield used letterhead that read "Grosz-Heartfield-Works—Berlin, London, New York." Dada even imitated the very language of this capitalist internationalism, namely, finance capital: "Invest your money in Dada" is one such preferred slogan; another manifesto assures the reader, "The orders of the Dada bank are accepted all over the world."[16] Indeed, dada pursued the concept of international capitalism to its bitter end by revealing its imperialist violence. In an elaborate account of a "Dada expedition" resulting in the foundation of "Dada colonies," the dadaists parodied the consequence of the global flow of capital as theorized by Lenin.[17] And the *Dada Almanach* identifies the German dadaist Walter Mehring as the chief propagandist of dadaism in Japan and China, as if he were a scout sent there to pave the way for dada's new colonial ventures.[18] It is easy to dismiss such references as the satires and theatrical poses they certainly are. Nevertheless, dada sought out this multinational language because it provided a model of internationalism that dada did not fully accept but nonetheless used to forge its own, quite different, transnational project.

There is another twist to this frame of reference, and that is dada's infatuation with the country that was routinely seen as the place of or at least the placeholder for international capitalism: America.[19] The two authors of the "Grosz-Heartfield-Works—Berlin, London, New York" had American-

ized their names, Grosz by changing his first name from the Germanic Georg to George, and Johann Herzfelde by changing his names to John Heartfield (indeed, Grosz, like several other dadaists, would end up emigrating to the United States). These two were also responsible for the creation of the collage *Dada-merika*. In addition, many of Grosz's most stunning drawings, collages, and paintings of city scenes, such as *Leben und Treiben in Universal City um 12 Uhr 05 mittags* (Life in the Universal City at 12:05 P.M.; 1919), are set in some imaginary U.S. city. Like "internationalization," "Americanization" became something of an aesthetic maxim. In a note about Hans Arp, who had de-Germanized his name to Jean Arp, Hugo Ball writes: "Whatever art can absorb into its principles from Americanism [Amerikanismus], it must not frown upon. Otherwise it will remain stuck in sentimental Romanticism."[20] This identification of dada with America was not only a European projection, although it was that as well. The American dadaist Arensberg, for example, wrote a manifesto entitled "Dada Is American."[21] Huelsenbeck, who would later change his name to Charles D. Hulbeck and who ended up practicing as a psychoanalyst in New York (through the personal intervention of Albert Einstein, he managed to get his medical accreditation without having to submit to the necessary exams), wrote more enigmatically: "Dada is the American side of Buddhism."[22] Antisentimentalism, chaotic activity, capitalist deracination—these are key words associated with modernity and progress. But dada did not simply dance to the melody of progress; it was specifically attuned to the internationalism of this gigantic capitalist circulation of goods, capital, people, and signs. "America," "Americanism," and "Americanization" then—as now—served as the geographic markers, the topographic names, for stateless capitalism.

World War I marks a crucial moment in what Deleuze and Guattari call the reterritorialization—or renationalization—of stateless capital.[23] Even though capitalism—as Marx and Engels had observed in their *Manifesto*—had battered down the Chinese walls of the national state, it could, at the same time, pit one capitalist nation against the other in a struggle for colonies, territories, trade routes, and markets. This paradox did not escape the dadaists, who consequently oriented themselves toward a second, and in some ways more attractive, model of internationalism, one that had the additional advantage of having predicted and theorized the oscillation of capitalism between nationalism and internationalism, namely, communism.

From the beginning, communism had positioned itself as an alternative to capitalism's internationalism, seizing capitalism's own deterritorializing effects and pursuing them to their logical extreme or rather to the point at which they would be, dialectically, turned into some new and true

form of internationalism. However, even though communism was rigorously international in its theory, the Second International was itself caught in the nationalizing effect of the war. Most socialist parties in Europe, especially the German socialists, had aligned themselves with their government's war efforts by voting for war bonds and supporting mobilization.[24] The Great War had thus managed to reterritorialize and renationalize the Second International as well. But even with the Second International in crisis, dada could use its vestiges as a point of reference through which and against which to establish its own practice of internationalism.

The *Manifesto* and the Communist (or Third) International at various points would become more serious models for dada activities, in particular in Berlin, where dada quickly joined the communist Spartacus revolution in the postwar Germany of 1918. In Berlin, we also find numerous pamphlets signed by the Dada Revolutionary Central Committee.[25] As in the case of capitalism and its "Americanization," this international orientation is translated into aesthetic terms, this time as the process of the "bolshevization" of art. Whether meant as slur or as validation, this phrase indicates the extent to which dada's internationalism borrowed from communism.

In a diary entry of 1917, Hugo Ball, one of the founders of dadaism, addresses the relation between dadaism and communism explicitly without coming to a clear conclusion:

> Strange events: while we had our cabaret in Zurich, Spiegelgasse 1, Mr. Ulianow-Lenin, if I am not mistaken, lived across the street in the same Spiegelgasse, no. 6. He must have heard every evening our music and tirades, I wonder whether with pleasure and profit. And while we opened our gallery in the Bahnhofstraße, the Russians traveled to St. Petersburg to start the revolution. Is Dadaism in the end as sign and gesture the counter-part to Bolshevism? Does Dadaism confront destruction and absolute calculation with the completely quixotic, purposeless, and incomprehensible world? It will be interesting to see what happens there and here. (163)

While Lenin, who sought to preserve the international character of communism, proceeds by the dictates of political efficacy, dadaism invites the incalculable, noninstrumental, and "quixotic." But this difference is a dialectical one, in Ball's speculation, for dadaism becomes the "counter-part" to bolshevism by "gesturing" to that which bolshevism must necessarily suppress in order to get the revolution going. Dada's chaotic "signs and gestures" do not signify revolutionary impotence or bourgeois decadence but a necessary

corrective, one called for by the bolshevist insistence on efficient strategy. Just as the bourgeoisie produces the proletariat that was to be its destruction, Lenin's instrumental reason breeds dada's chaos. New versions of Ball's strange dialectic would emerge in the struggle between the surrealists and the Third International and between the revolutionaries of the high sixties and Cominform.

Internationalism Localized (Zurich)

Ball's "strange" dialectic is worth pursuing further because what holds these two, Lenin and dada, together is their geographic position, Zurich, and on an even smaller level, one street; one might be tempted to subsume dada and Lenin under some category of an internationalism of Spiegelgasse 1–6. For internationalism, as totalizing and universalizing as it is in its aspiration, is certainly also influenced by local culture, and so we should subject both Lenin's international socialism and international dadaism to a geographic analysis. Zurich was a safe haven for refugees, emigrants, pacifists, and draft evaders, as well as smugglers and spies—on several occasions dadaists, frequently moving back and forth between different cities and countries, were suspected of being spies.[26] Emmy Hennings, Hugo Ball's wife and the most gifted of the Cabaret Voltaire performers, reminisced that during the war, "[Zurich] was the most international [place] imaginable."[27]

This internationalism was made possible, in part, by a long tradition of the freedom of the press in Switzerland. Between 1835 and 1923, 130 labor-oriented journals were founded, of which 25 managed to survive for considerable lengths of time.[28] Switzerland and specifically Zurich allowed for a kind of internationalism that seemed impossible in a Europe ravaged and reterritorialized by the Great War. At the same time, Zurich was not simply a refuge for an endangered internationalism. Despite or rather because of Swiss neutrality, the war parties founded more than forty press and propaganda offices there.[29] Besides being a place to evade the war, Switzerland thus became the staging area for extensive and well-financed war propaganda and agitation. Zurich thus constituted a place where internationalism and nationalism collided. Dadaism was particularly attuned to the cacophony that resulted from this collision.

This is an important local context, although the concept of the local context needs to be handled with care. In many respects, dada had little to do with Zurich or Switzerland, including Switzerland's own socialist parties

and revolutionary endeavors. The dadaist Hans Richter even claimed that some dadaists ended up in Zurich as a fluke.[30] Huelsenbeck, for example, went to Zurich to work with Ball, whom he admired greatly, and several other dadaists seemed to have gone there for various personal reasons as well.[31] No matter what had motivated their moves, however, all the dadaists had come from elsewhere; there was not a single Swiss among them, and they remained deliberately foreign and detached from local affairs.[32]

While dadaism developed its own form of internationalism, Lenin not only plotted the revolution but also theorized the international reach of capitalism. What Lenin was scribbling while listening to the "music and tirades" in the Cabaret Voltaire was his most consequential work, *Imperialism, the Highest Stage of Capitalism* (1917), his attempt to locate the causes of the war in the process of capital accumulation. Capital, Lenin argued, did not itself believe in the nationalisms it promoted for the purposes of war but only used them as a weapon against the international proletariat. In truth, capital depended on expansion, on creating equivalences and translatability, as Marx had already noted. Lenin's *Imperialism* presents itself as a sequel, detailing the particular form of imperialism that had developed since the writing of the *Manifesto*. Just as dada used capitalism as one model for its own international counterproject, so Lenin emphasized the international nature of capitalism to use it as a stepping-stone for his own attempts to renew the Second International.

Lenin was not alone. Prompted by the Communist Party of Italy, the only national branch of the Second International to stick to a pacifist internationalism, scattered internationalist socialists determined to resist the nationalist co-optation of the labor movement gathered in Switzerland and authored the famous *Zimmerwald Manifesto* of 1915, which directly addressed the nationalizing effect of the war on the Left.[33] Lenin and a number of Bolshevik representatives supported a resolution written by Karl Radek, a staunch supporter of internationalism. Even though this internationalist wing did not fully prevail at the conference, the *Zimmerwald Manifesto* was the basis for the foundation of the Third International in 1919. The manifesto echoes Lenin's analysis of the war as being an "imperialist war" that disguises its own global aspiration through a nationalist mask:

> The World War, which has been devastating Europe for the last year, is an imperialist war waged for the political and economic exploitation of the world, export markets, sources of raw material, spheres of capitalist investment, etc. It is a product of capitalist development which connects the entire world in a world

economy but at the same time permits the existence of national state capitalist groups with opposing interests. If the bourgeoisie and the governments seek to conceal this character of the World War by asserting that it is a question of a forced struggle for *national independence*, it is only to mislead the *proletariat*.[34]

What becomes clear in these lines is that communism imagines itself to be engaged in a struggle with an equally international capitalism, one, however, that cunningly disguises its own internationalism through the war. Switzerland, which Richter considered the dead center of the war, provided the milieu that allowed Lenin to perceive the international essence of capitalism and to envision an international response to it.[35]

At the end of the war, left internationalism faced two difficulties: not only had the Second International failed dismally, but socialist internationalism had to compete with a second, powerful quasi manifesto that promised to solve the root causes of the war as well, namely, Wilson's Fourteen Points. While Lenin and others were agitating for a new International, many Europeans were projecting onto Wilson's Fourteen Points the power to deliver them from the ravages of the war. In his novel *Nineteen Nineteen*, John Dos Passos relates the Fourteen Points explicitly to the prehistory of the *Manifesto* in a parenthetical remark: "(Did Meester Veelson know that the people of Europe spelled a challenge to oppression out of the Fourteen Points, as centuries before they had spelled a challenge to oppression out of the ninety five articles Martin Luther nailed to the churchdoor in Wittenberg?)."[36] Indeed, the Second International, broken but not yet extinct, went so far as to officially endorse Wilson's Fourteen Points. By the end of the peace conference, in the summer of 1919, however, it had become clear to Europe that the high promise of this quasi manifesto had failed. It had done so, as John Maynard Keynes wrote in his prophetic pamphlet, *The Economic Consequences of the Peace* (1919), because Wilson had been seduced, like a Jamesian heroine, in the theatrical glitter of the hall of mirrors at Versailles and the subtle treacheries of Europe; or, as Margaret MacMillan has suggested recently, because Europe was so divided that even an honest and able broker such as Wilson could not remake it from scratch.[37] While the immense cachet of the Fourteen Points lasted for only a few years, this text represented a powerful articulation of nationalism as the solution to war, codified in the League of Nations. Internationalism, especially the internationalism derived from the *Manifesto* now invigorated by the Russian Revolution, was competing with a nationalist internationalism.

Manifestos on the Stage

The strange dialectic between international dadaism and international socialism played itself out nowhere as clearly as in their respective manifestos. The first address made by Huelsenbeck in the dadaist Cabaret Voltaire, for example, riffs on the internationalism of the *Manifesto*: "Respected citizens of Zurich, students, artisans, workers, vagabonds, drifters of all countries, unite!"[38] Indeed, dada developed a particularly international practice of the manifesto, one that was different from Lenin and Wilson but also from the movements that were part of the futurism effect. In contrast to Marinetti's nationalistic rhetoric of aggression, Lewis's grim satires, or Russian poetic manifestos, dada manifestos seem more playful and experimental, more aware of the fact that the avant-garde manifesto had become a genre that could be variously used and altered. All these features are driven by a single overwhelming tendency: dada manifestos were born from the spirit of the theater. True, both the Italian and Russian futurists as well as Lewis had sought out drama and the theater at various points, but no movement was as fully at home in the theater as dada.

The Cabaret Voltaire was formed by a mixed group of artists from a half dozen countries who managed to convince the owner of a local bar to let them open a cabaret, suggesting that their activities would increase his sales, which they did, at least for a couple of months. From this perspective, the Cabaret Voltaire was a properly capitalist venture, a way of attracting the attention of patrons, in short, a form of advertising. The founders released the following note to the press: "Cabaret Voltaire: Under this name, a group of young artists and writers has been established, whose goal it is to create a center for artistic entertainment."[39] Neither revolution nor socialism, but entertainment, is the expressed goal here.

The Cabaret Voltaire was extremely heterogeneous in its selection. It had no program, no aesthetic, no label—the evenings freely combined plays by Wassily Kandinsky and Oskar Kokoschka, music by Arnold Schoenberg, and poems by Stéphane Mallarmé, the Comte de Lautréamont and the performers themselves. This mixture is noteworthy because it cuts across the modernism/avant-garde divide, alternating between extremely demanding and highly structured works of "high" modernism, such as those of Schoenberg and Mallarmé, and the childish pranks and performances more often associated with dada soirees. The dada stage served as a platform for everything from the exhibition of paintings and the recitation of poems to the performance of dances, plays, and declarations. In March 1916,

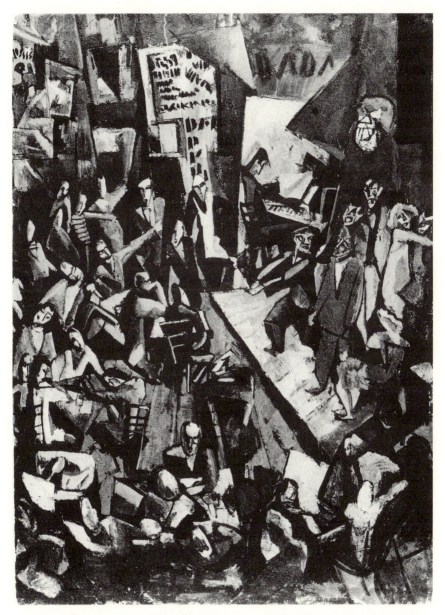

Figure 8.1. Marcel Janco, *Cabaret Voltaire*, 1916. Kunsthaus Zürich. ARS, N.Y.

Hugo Ball notes in his diary: "All the styles of the last twenty years had a rendezvous yesterday evening."[40] This heterogeneous mixture, however, was not pure chaos; it was held together by the frame of the stage. By using the theater as a place for this "rendezvous" of different genres and styles, Ball and his friends recognized a particular feature of the theater, namely, that it is not only a specific art form but also a mode of bringing together all the other ones, a space in which the different genres and art forms can be gathered.

This understanding of the theater harks back to the notion of the *Gesamtkunstwerk*. Among the many dadaists with a background in theater, Ball was the most explicitly interested in rethinking the theater as a total work of art: "Expressionist theater, this is my thesis, attempts the festival theater and contains a new understanding of the Gesamtkunstwerk."[41] All this still sounds very Wagnerian, and Ball was influenced by Kandinsky and others who sought to re-create and outdo Wagner's original conception of the total work of art.[42] Soon, however, a different understanding of total theater emerged, one closer to that of Erwin Piscator (and Brecht), who imagined a total but heterogeneous work of art, anticipating Sergei Eisenstein's "montage of attractions" that emphasized the collision rather than unification of elements. This aesthetic question of whether to unify the arts or to have them collide has always been an immensely political problem, for Wagner's unity also implied the unification of the *Volk*, while Piscator's and Brecht's disunity envisioned a critical or revolutionary effect. This was precisely the motivation for Ball's reorientation, for his main interest in a fractured total theater was its capacity to stir up social dissent: "Only the theater is capable of forming a new society."[43] There is no more question of unification and harmony, no more quasi-sacred, festival-like Bayreuth where the mystical unity of the arts leads to the unity of the *Volk*, but only montage, juxtaposition, and struggle among various elements and forms that some-how exert their revolutionizing influence on the audience and from there to society at large.

In its dedication to a revolutionary theatricality, the Cabaret Voltaire participates in the peculiar affinity between avant-garde and theater. It was Marinetti who had declared that "everything of any value is theatrical" (117), but it was dada that put that ideal fully into practice. Huelsenbeck would go so far as to speak of the world as a dadaist cabaret: "Just as Dada is the cabaret of the world, so the world is the cabaret Dada."[44] Theatricality was a driving force for many early dada styles, giving rise, for example, to the simultaneous poem, inheritor of the equally theatrical and performance-driven futurist *parole in libertà*: the stage provided the frame within which

the recitation of simultaneous poetry could occur. The Cabaret Voltaire put all the arts, from poetry to painting, on the stage, subjecting them to the dictates of the theater. This operation of theatricalizing the arts was applied with particular glee to the first avant-garde movement, cubism, so that the dadaists could claim triumphantly that "[dadaism] turned cubism into a dance on a stage."[45] This theatricalization also constitutes the difference between dada and the high modernist works it presented, including those of Mallarmé and Schoenberg: dada neither rejected nor accepted high modernism but instead theatricalized it.

The process of theatricalization obtained its particular character from the fact that the dadaists rehabilitated a specific theatrical form: the cabaret. Peter Jelavich has spoken of a "cabaretic modernism," of which the Cabaret Voltaire is a prime example.[46] The cabaret has always been openly political and impolite, provoking the audience to spontaneous reactions and favoring brief interludes and revue-style episodes—all qualities celebrated by dadaism just as they had been by celebrated by futurism.[47] Even architecturally, as Manfredo Tafuri has shown, the cabaret undoes the bourgeois stage, for example, in the work of such reformers as Georg Fuchs and Kurt Hiller, whose manifesto on the Neophathetisches Cabaret envisions a cabaret resounding with "Nietzschean laughter."[48] Most importantly, the cabaret treated the other arts with utter irreverence. In his novel *Stilpe* (1897), Otto Julius Bierbaum includes a pamphlet—a recent anthology calls it a "manifesto"—for a new cabaret: "all art ... to be reborn, by way of the music hall! ... We'll drag everything into our net: painting, versifying, singing, everything that has beauty and the joy of life in it."[49] The cabaret becomes a net that catches all the other arts and drags them onto the stage, where they are rejuvenated and reborn.

One feature of the cabaret was of particular interest to dada, namely, the interaction between stage and audience. In the cabaret not only the arts onstage but also the audience is theatricalized. Countless accounts of dada evenings boast of the scandals these evenings caused, of how often the police had to come, and of the violent reactions the performers were able to elicit from the audience. These accounts of scandal are an integral part of the historiography of modern drama more generally, beginning with the riots triggered by Victor Hugo's *Hernani* and extending all the way to the éclats caused by the plays of Ibsen and Jarry. Modern drama authenticated itself through its adversarial relation to the audience, an attitude distilled belatedly in Peter Handke's play *Offending the Audience* (1966). At the same time, however, provocation was always balanced by a second demand, also operative in the case of the Cabaret Voltaire, namely, that of entertain-

ment.[50] The Cabaret Voltaire should therefore not be understood, as it sometimes has been, as an attempt to simply confront the audience with outright hostility but as a carefully calculated balancing act of provocation and containment, entertainment and affront.[51]

The theater, even though Ball thought it well suited to revolutionizing the audience, is a local and contained phenomenon, not suitable for long-distance propagandistic efforts. It cannot be sent in the mail or wired; it cannot exert much influence over distance except by hearsay; it is ill suited, in other words, to the international dada network. The person who noted this deficiency and who first sought to turn dada into something international and long-distance was Tristan Tzara. Having arrived in Zurich from Romania, Tzara quickly set his eyes on Paris and began a correspondence with the younger writers there. He worked systematically on expanding his list of correspondents, asking his friends in Paris for mailing addresses and introductions until he eventually was able to contact the three editors of *Littérature*—André Breton, Louis Aragon, and Philippe Soupault—directly. When he finally moved to Paris, Tzara could make use of the dada connection established when Picabia had moved *391* from Zurich to Paris. Indeed, it was to attract the attention of the Paris avant-garde that Tzara had advocated founding a dada journal and inventing a label.[52] You do not need an ism to open a cabaret but you do need one to compete in the international avant-garde circuit.

More important than the decision to create a name and a journal, however, was the recognition that the best way of exerting influence from a distance, of promoting a label, a name, and a movement, and of attracting the attention of Paris and New York was through manifestos. This recognition was based on several international success stories, including the *Communist Manifesto*, but also Marinetti's *Manifesto of Futurism*, as well as the hundreds of futurist manifestos following it. Marinetti had managed to place his manifesto in journals all over Europe and even beyond, and it was due to a similar ambition that Tzara decided to shift emphasis away from the theater and toward the manifesto. As Hans Richter observed, "The form of the manifesto, of aggressive polemic, was tailor-made for Tzara."[53]

The first, theatrical, phase of dada in Zurich was responsible for the particular theatricality of dada manifestos. The theatricality of dada meant, for example, that its manifestos had a keen sense of the audience, which they alternately baited and shocked. Like the manifestos of futurism, many dada manifestos were actually part of dada soirees, where the compromise between provocation and entertainment was being worked out. There is no better indication that the manifesto had become a performance genre

than Tzara's retrospective account of the first dada soiree, whose program promised (with uneven capitalization): "Music, dances, Theories, Manifestos, poems, tableaux, costumes, masques."[54] The manifesto is situated between theory and poem, but, more importantly it is part of a list of what are primarily performance genres. Emphasizing the new importance of manifestos, Tzara plays on the fact that the word *manifeste* in French can be used as both a verb and a noun: "Before a compact crowd, Tzara manifestoed/manifesto . . . Huelsenbeck manifestoed/manifesto, Ball manifestoed/manifesto, Arp Erklärung."[55] All major dada figures have manifestos, and they engage in the activity of manifestoing, and all this occurs before an audience, a "compact crowd," whose hostility—"Huelsenbeck against 200"—leads once more to a riot that has to be broken up by the police. As often with dada, the provocation of the audience through manifestos is a careful balancing act. Richter observes: "Tzara had skillfully staged everything so that the first part of the program ended with this simultaneous poem. Otherwise there probably would have been a riot at this moment and the whole thing would have exploded too soon."[56] Richter then proceeds to describe the performance of his own manifesto-like speech: "I started the second half with an address, 'Against Without, For Dada.' In this address I cursed the audience but with moderation." Provocation and entertainment, attack and moderation, these two poles of the cabaret also determine the character of the early, spoken manifestos of dadaism.

Theatrical posing, unauthorized speech, projective positioning had been part of all manifestos, including the *Communist Manifesto*. But dada manifestos take this theatricality to an extreme, celebrating the power of the manifesto to occupy spaces, to make claims, to found movements, and to declare positions with little worry as to whether these acts of occupation, foundation, and declaration will be effective. While in the case of the socialist manifesto theatricality played a subordinated, though not insignificant, role—there was always the understanding that theatricality would soon be backed up by real performative power—the dada manifesto reversed this relation, pushing theatricality to the fore and effective performativity into the background. This does not mean, however, that performativity has disappeared altogether. The very prominence of dada as name and movement, its representation in the press, demonstrated that despite all the theatrical posing, successful acts of foundation and naming were still being carried out; more surprising, perhaps, they were successful *because of* all the theatrics involved. Theatricality and performativity were not simply opposed to one another; they actually sustained one another. This dynamic is at work in all manifestos, but it is particularly visible in the manifestos of the dadaists.

Just as the Cabaret Voltaire exposed and mixed the various modernist genres and arts, so the dada manifestos expose the mechanisms and strategies of the modernist and avant-garde manifesto, while at the same time repeating and amplifying them for effect.[57] Almost all of Tzara's manifestos show an awareness of the manifesto's defining features, such as the critique of the status quo, the galvanizing appeal to the audience, and the brevity and explicitness that Marinetti singled out in his "*arte di far manifesti.*" While Marinetti thinks about the manifesto in his letters, Tristan Tzara undertakes this type of reflection in the manifesto itself, for example, in his *Dada Manifest 1918*, which begins with the following words: "To launch a manifesto you have to want: A. B. & C., and fulminate against 1, 2, & 3, . . . sign, shout, swear, organise prose in a form that is absolute and irrefutably obvious."[58] A few years later, Tzara is still turning the manifesto against itself, writing in his *Dada Manifesto on Feeble Love and Bitter Love*: "A manifesto is a communication made to the entire world, whose only pretension is to the discoverty of an instant cure for political, astronomical, artistic, parliamentary, ergonomic, and literary syphilis" (33).

A similar attitude toward the manifesto led many dadaists to replace their manifestos' central names and terms with negations, producing such documents as the 1921 manifesto *DADA hebt alles auf* (DADA sublates everything): "DADA does not speak DADA does not have a fixed idea."[59] The signatories, among them Man Ray and Marcel Duchamp, not only leave the central name "DADA" unexplained but also use the term "nothing" where other manifestos concentrate all their rhetorical power to drive home a particular agenda. Dada manifestos even go so far as to claim that they are not manifestos at all. In these cases, self-referentiality leads to forms of parody. To a limited extent this tendency toward satire participates in a desire to establish a distance from Marinetti and his manifestos. Before launching his own avalanche of manifestos, Francis Picabia, for example, had railed against futurist manifestos. He even quoted Charles Baudelaire's critique of the emerging artistic avant-garde and the collectivism associated with it.[60] However, Picabia and other dadaists soon found that you can have the manifesto without piety and faith, that attacking the manifesto as doctrinaire collectivism was not the only and possibly not the best way of keeping Marinetti's influence at bay. The better strategy was to de-dogmatize the manifesto, to parody it, to theatricalize it, and then to publish as many manifestos as possible. Combining Lewis's rearguard satire with Marinetti's mania for manifestos, the dadaists thus released an endless stream of manifestos in a new mode: the metamanifesto.

The invention of the metamanifesto is the particular contribution of dada to the history of the manifesto; its marks the high-water mark of this genre's theatricalitzation, the celebration of theatrical overreaching at the expense of its performative and transformative power. This hypertheatricality exceeds the displaced theatricality of Lewis's closet drama in *Blast* but also the more openly theatrical manifestos of futurism. Even though the futurists had performed manifestos in their *serate* (theatrical evenings) and integrated them into their collages, their use of the manifesto had remained, at least in their minds, external to the production of futurist art. Tzara and other dadaists, by contrast, recognized the manifesto as a privileged genre on a par with or even superior to the simultaneous poem, dance, or music. While in futurism the form of the manifesto informs the content—the obsession with progress and its machinery, the exclusive invocation of the future—dadaism discards any such modernizing content and instead practices the form of the theatrical metamanifesto, the act of founding a movement, of creating a label, of forming a collective as an end all in itself.

Dadaist Manifesto Art

Tzara's long-distance strategy of writing and circulating metamanifestos worked out. He caught the attention of Breton and Aragon, moved to Paris, and became a founding member of dadaism there, a dadaism that now centered on the writing, performance, and publication of manifestos. At the same time, Tzara recognized how ephemeral the avant-garde manifesto really was, both as a performance script and as a leaflet handed out in public or thrown at the audience. For this reason the manifesto needed to be included in dada's extensive self-anthologizing efforts. This was precisely the purpose of *Seven Dada Manifestos* (1924), a collection dedicated to nothing but manifestos that became one of the most influential dada publications.

Seven Dada Manifestos bears the marks of a transition from the performed manifesto to one that is printed, dispatched, circulated, and finally anthologized. Three of the seven manifestos are associated with a figure taken from Tzara's play: Mr. Antipyrine. Like most dada manifestos, the *First Celestial Adventure of Mr. Antipyrine* had been performed in the Waag-Saal, the theater venue the dadaists used after having been thrown out of the Cabaret Voltaire (provocation had outweighed moderation after all). A number of characters, Mr. Antipyrine, Mr. Blueblue, Mr. Shriekshriek, Mr. Bangbang, a Pregnant Woman, Pipi, the Director, and Npala Garroo engage

in what is formally a dramatic exchange, but without identifiable topic.[61] These characters' short speeches make little sense even when they follow the rules of grammar, but sometimes we only get paratactic enumerations of objects, as when Mr. Shriekshriek says: "houses flute factory razed head" (79). At other times, these speakers fall into dada's most notorious form, the sound poem, as when Mr. Antipyrine declares: "Soco Bgai Affahou / zoumbai zoumbai zoumbai / zoum" (78).

Toward the end of this play, however, a character named Tristan Tzara appears, and his text is different from all the rest, for it presents itself as some form of a manifesto. Like all of Tzara's manifestos, it is really a metamanifesto, declaring that it is "for and against unity" (81), and claims adherence "neither to folly—nor wisdom—nor irony" (82). Even these playful paradoxes are subjected to one more level of reflection: "We know wisely . . . that our anti-dogmatism is as exclusivist as the bureaucrat and that we are not free and shriek liberty" (81). As different as this authorial manifesto speech is from the preceding dramatic text, it nevertheless includes oblique references to the dramatic part, recycling individual words and phrases, including "shriek," "shit," "circus," "bangbang," and "holy halo," as well as some of the sound poetry. It is almost as if the manifesto had gathered all the incomprehensible speeches of the dramatic characters and turned them into a somewhat more comprehensible manifesto. There is an exchange between play and manifesto: the manifesto seems to grow out of the play, containing parts of the play, even as it turns them into a performed manifesto.

Rather than being engaged in an exchange with other characters on the stage, the manifesto addresses the audience directly: "But we, DADA, do not agree with them, because art is not serious, I assure you, good listeners, I love you so much, I assure you and I adore you" (82). This "we," "you," and "they"; the collective voice, direct address, and differentiation from the opponent—all these are central features of the manifesto. *The First Celestial Adventure of Mr. Antipyrine* thus exposes the mechanisms of the manifesto, highlights the difference and the kinship between manifesto and play, and points to the theatrical traces the Cabaret Voltaire had left on the manifesto. At the same time, the fact that Tzara extracted this manifesto from the play and included it in his collection of manifestos demonstrates that the manifesto had replaced the theater as his preferred form of expression. The manifesto had become an autonomous genre.

The influence of the manifesto on art is also visible in the other texts collected in Tzara's *Seven Dada Manifestos*. A text called "Unpretentious Proclamation" combines the aphorism with the manifesto's characteristic form of commands, and the "Manifesto of Mr. AA, the Antiphilosopher,"

imposes the manifesto onto a poem. The final manifesto in the collection, "Dada Manifesto on Feeble Love and Bitter Love," echoes the dramatic origin of the performed manifesto by opening with a list of dramatis personae, but it also presents an authoritative instruction manual for the manufacturing of dada poems—the main instruments are a pair of scissors and a newspaper—complete with an example. In various ways, the manifestos collected here expand the boundaries of the genre, incorporating into the form poetry, theory, programmatic statement, example, and drama. While the Cabaret Voltaire had turned cubism into a dance on stage, Tzara turns drama, and the other arts, into a manifesto. Instead of theatricalization, we have manifestoization, what I prefer to call manifesto art.

Dada produced so many mixtures of manifesto and art that the category of manifesto art could be used to describe a significant number of dadaist works. They occur in a variety of forms, media, and venues, including dada journals, but also in the increasing number of dada anthologies, such as Tzara's own *Seven Dada Manifestos*, Huelsenbeck's *Dada, a Literary Documentation*, and the *Dada Almanach*. The latter contains one of the most elaborate pieces of dada manifesto art, Walter Mehring's "Enthüllungen." Even the title, which can be translated as "revelations," "uncoverings," or "manifestations," resonates with the act of making manifest. "Manifestations" begins like a manifesto, revealing truths through such slogans as "Dada is the central brain that oriented the world toward itself" (63), and ends by demanding, in a typically dada fashion, "Bet on Dada! / The world is only a branch of Dadaism. We pay the amount put up by all banks as profit" (81). All these outrageous claims and slogans can be found in dada's many manifestos and thus identify "Manifestations" as a text that recycles pieces from dada manifestos.

"Manifestations," however, is not a standard dada manifesto. It also contains a retrospective account of previous dada activities, written in the narrative past tense, including the Cabaret Voltaire and dada's complicated relation to World War I. "Manifestations" thus looks backward as much as forward, documenting the past even as it calls for future activity. Indeed, "Manifestations" grounds its own speech acts in an account of the past, in particular a fictional "trans-Asian Dada expedition" that led to the foundation of a dada colony. Suddenly, however, this retrospective account turns into a film script, organized into eight scenes that trace the conquering of the world by dada, only to turn into daily reports about the dada colony and the return of the expedition. Mehring also adds a heavily revised and extended version of a previously published poem, "Dadayama," to the mix. While "Dadayama" had previously obeyed the poetic form, now it is uncere-

moniously turned into prose. Of all the examples of manifesto art, "Manifestations" is perhaps the most emblematic in its irreverence toward genre, mixing expedition account, film script, report, prose poem, and manifesto. The latter is the dominant component, however, for all the other genres are saturated with abstract terms and notions taken from dada manifestos. The topic of this text, after all, is dada itself, and the text is full of manifesto-like definitions, detailing authoritatively the nature of dada.

Manifesto and Revolution (Berlin)

Just as Picabia connected New York to Zurich and Tzara, Zurich to Paris, so Richard Huelsenbeck moved dada from Zurich to Berlin. Unlike the sheltering Zurich and Paris, Berlin confronted dada with a climate of political revolt that grew more heated by the day. The leading dada figures in Berlin—Huelsenbeck, Raoul Hausmann, John Heartfield, George Grosz, and Hannah Höch—were highly politicized and worked for a number of small leftist newspapers such as *Die Aktion* and *Die freie Straße*. They were deeply ensconced in local and national politics, turning dada into a matter of war and revolution. While Lenin represented international socialism in Zurich, in Berlin the central figure working toward an international socialism was Rosa Luxemburg. One witness to the alliance between dada and the November Revolution in Berlin was Hausmann, whose comment on this relation can serve as the counterpart to Ball's remark about the "strange dialectic" between the Cabaret Voltaire and Lenin: "Some months later the military defeat and the revolt of the sailors forced the generals to accept the truce of November 11, 1918. That was the revolution. The end of the dreams of the imperialist, all-powerful German dominance. Spartacus was in the streets, everywhere, and Dada emerged in the agitated Berlin."[62] Instead of a "strange dialectic" in Zurich, we have an almost seamless continuity between dada and Spartacus, the radical communist party, founded by Karl Liebknecht and Rosa Luxemburg after the larger German Socialist Party had sided with the kaiser in the Great War. The revolutions in the arts and in the streets are placed next to one another, the one reinforcing the other. Indeed, Hausmann even goes one step further, seeing dada as the inheritor of the failing socialist revolution: "On an unhappy day, the news about the murder of Karl Liebknecht and Rosa Luxemburg spread. The proletariat was paralyzed and did not awake from its paralysis. . . . Therefore, we had to make the dada-action stronger: against a world that did not react decently

even when faced with unforgivable atrocities" (4). Dada takes the place of Spartacus, continuing its failing revolutionary project.

Hausmann's claim that dada inherited the revolution from Spartacus could easily be mocked as hubris, for dada certainly continued to be something of a quixotic, theatrical double to communism's revolutionary efficacy. But it is also true that in Berlin, dada had absorbed much of the current socialist agitation, including that of Rosa Luxemburg; the dadaist metamanifesto had been politicized. While in Zurich, the slogan "Vagabonds of all countries, unite!" had been a distanced and mostly parodic reference, in Berlin the relation between dada and socialism was more pressing and serious. In the first issue of the Berlin magazine *Der Dada* (1919), Jefim Golyscheff, Hausmann, and Huelsenbeck signed and published a manifesto that aligned itself directly with the socialist cause: "Dadaism demands: 1. The international, revolutionary unification of all creative and intellectual people of the entire world on the basis of radical communism." The same text, however, cannot resist giving this pledge of allegiance a specifically dadaist note: "The Central Committee requests: . . . e) Introduction of the simultaneous poem as communist state prayer."[63] Hausmann was also one of the signatories of the socialist manifesto *Die Kommune*. To be sure, dada never officially joined the communist party the way Breton would join the French Communist Party. Many dadaists rejected the more doctrinaire forms of proletarian art, for example, Proletkult as expressed in Alexander Bogdanov's manifesto "Art and the Proletariat" (1919), which claimed that revolutionary art must embody the collective class consciousness of the proletariat. They even rejected the less doctrinaire Anatoly Lunarcharsky, Soviet commissar for enlightenment, who tolerated the Russian futurists through most of the twenties. Nevertheless, there can be no doubt that almost all members of Berlin dada thought their activities contributed to a socialist revolution and that they defined their positions in relation to party socialism.

The desire of dada to finish what Rosa Luxemburg had begun indicates how much dada in Berlin participated in the culture of socialist propaganda and agitation, proclamations and manifestos. However, participation also meant competition. In Berlin, dada found itself surrounded by manifestos, agitation, speeches, rallies, clashes, and revolts of all kinds. It could only hope to make itself heard by both aligning itself with, but also differentiating itself from, the socialist manifestos that dominated the streets of Berlin. The most prominent of these manifestos was Rosa Luxemburg's own *Spartacus Manifesto*, which first appeared in *Die Rote Fahne* in November 26, 1918. The Spartacus Association, which was part of the Socialist International, was deeply torn between the necessity of engaging in national politics and

maintaining its internationalist orientation. Like Lenin, Luxemburg regarded the war as an imperialist and nationalist conspiracy, but she needed to agitate on behalf of a national revolution. The *Spartacus Manifesto* thus engages in a double strategy of denationalization, on the one hand, and agitating for a national revolution, on the other: "Proletarians of all countries, now the German proletarians are speaking to you. We believe we have the right to appeal before your forum in their name. From the first day of this war we endeavored to do our international duty by fighting that criminal government with all our power, and by branding it as the one really guilty of the war."[64] Even as the *Spartacus Manifesto* denounces German nationalism, it has to appeal to the proletariat of the other countries to support the German revolution: "The proletariat of Germany is looking toward you in this hour. Germany is pregnant with the social revolution, but socialism can be realized only by the proletariat of the world" (38). This manifesto is engaged in a balancing act of speaking on behalf of the German proletariat to the proletariat of other nations at war, trying to align them against an equally international imperialism.

While the *Spartacus Manifesto* was trying to revive an international socialism, dada was forming its own international network. There is one crucial difference, however, between the strategies employed in their manifestos. The socialist manifesto, in particular the *Spartacus Manifesto*, is worried about supplanting the original *Manifesto*, even though it was written explicitly for the purpose of propagating a return to the *Manifesto*'s original force. Dada, by contrast, has no such worries that restrict its use of the manifesto; in fact, it cannot get enough of the manifesto. Unlike communism, but also unlike futurism, vorticism, and surrealism, dada never expressed any reverence for its own foundational manifesto; in fact there is no *First Dadaist Manifesto* the way there is a *Foundation and Manifesto of Futurism* or a *First Manifesto of Surrealism*. Dada's practice of the manifesto followed a double strategy of using manifestos to found a movement while at the same time celebrating the endless repetition and iteration of consecutive foundational acts. What dada thus highlighted was that the foundational force of the manifesto is a performative effect that can and must be repeated: dadaism is being founded and manifested over and over again. For communist manifestos, this repetition was a painful necessity, one that threatened to take away from the foundational *Manifesto*. The dadaists, by contrast, understood these acts of foundation in theatrical terms. In each new manifesto, they could celebrate the theatrical foundation of a movement, of a name, of a program because they did not worry that the previous iteration of such a foundation might be erased or called into question. Whereas com-

munism, throughout its history, had struggled with the problem of origin and iteration, for dada there were as many origins as there were manifestos; origins could be claimed theatrically without cost; and the more origins and manifestos, the merrier. What was a tragedy for the tradition of the communist manifestos became a farce for the avant-gardes.

Dada's most elaborate foundational act took place in April 1919, when Hausmann and Baader "founded" a dada republic through a manifesto in which they instructed the mayor of Berlin to hand over the treasury and commanded city employees to obey only the two authors' orders.[65] Founding an avant-garde movement and founding a republic are two different tasks—Baader's and Hausmann's success at the one and failure at the other demonstrate this difference—but they both depend on the foundational power, however theatrical, of the manifesto. Once more, it becomes clear here that theatricality does not always mean that foundational acts are void and have no performative force, that such acts will never succeed. Rather, theatricality and performativity describe two aspects, emphasize two moments at work in all manifestos, which can never be sure about their own effect on the future even as they do everything to claim this future as their own.

The Revolution Advertised

If the theater was one source of influence on the dada manifesto, the other was the collage and the photomontage. Many dada manifestos arranged phrases, single words, and expressions without obedience to the line or the sentence to create visually striking ensembles and juxtapositions. One important model for the dada collage was the art of advertising. The avant-garde manifesto had been intimately connected to advertising ever since Marinetti launched futurism through a series of advertising techniques, including posting his manifestos as ads in newspapers and on billboards and distributing them as leaflets on the street. Dada turned these techniques into a new way of mixing collage, photomontage, and manifesto.

Leading dadaists were fascinated by and worked professionally as graphic designers. The most well-known program for appropriating the language of commerce was probably Kurt Schwitters's "Merzkunst," whose very name is a cutoff fragment of the word *Kommerz*, for commerce. This reduction, or cutting off, also indicates that the relation between dada and advertising was one of struggle and forceful appropriation. While the manifesto

is a genre infused with the desire for revolutionary action, advertising thrives on the circulation of images and words and on their total exchangeability.[66] Nevertheless, advertising, too, is meant to instigate action, to motivate an act: the purchase. From one vantage point, the manifesto and advertising are certainly opposed to one another: if the manifesto is what Marx called the poetry of the revolution, then advertising is the poetry of capitalism. This similarity between manifesto and advertising, however, should be expressed in a chiasmus, that advertising is the manifesto of capitalism, while the manifesto is advertising for the revolution.

Seeing the rightward drift of the once leftist *Simplicissimus* and other satirical magazines, cultural critics and artists such as Kurt Tucholsky demanded new forms of agitprop based on photojournalism. One result of this campaign was the emergence of illustrated party papers such as the *Arbeiter Illustrierte Zeitung* (Workers' Illustrated Newspaper), a Communist Party journal that abandoned its earlier text-only mode. Many dadaists participated in this larger project of creating new forms of political propaganda, for example, Heartfield, who was a frequent contributor to the *Arbeiter Illustrierte Zeitung*. Another example of dada's attempt to work toward a new type of propaganda journal was *Jedermann sein eigener Fussball* (Each His Own Soccer Ball), which combined satire, montage, and sexual provocation while advancing goals set by the Communist Party of Germany.[67] The result of these varying practices was the photomontage, which uses the techniques of advertising, both on a technical level and on an aesthetic level—the art of typeface and layout, of grafting slogans onto images—but estranges them from their original use. The photomontage was thus part of the search for new modes of propaganda, this time combining photojournalism with the techniques of advertising.

In a photomontage, text and image are brought into startling new relations to surprise viewers and to attract and retain their attention. Images and print are cut out, reframed, and put to new use. Like a cubist painting, the photomontage yokes together different perspectives and sizes and uses heterogeneous material. Indeed, a common understanding of the photomontage is that it mimics the disintegration of society, capturing the effects of the modern metropolis that overwhelms the senses of humans with a torrent of simultaneous impressions, as described by Georg Simmel.[68] At the same time, a second understanding of the photomontage has emerged, one that takes issue with the idea that the montage merely mimics the experience of the modern. What this view stresses instead is that the photomontage assembles material taken from different spheres—images of politicians or crowds; clippings from newspapers, advertising, and political rhetoric; ele-

ments of everyday life—but actively extracts them from their respective context to make them collide with one another. This collision is not what happens out there in the world but the work of the montage itself. In this account, the montage can be regarded as a critique of separation, an attempt to expose the cutting up of the social world into largely autonomous spheres and systems.[69]

Whether or not the photomontage mirrored modernity or prefigured it, what matters for this study is the fact that dada's two most important forms of expression, manifesto and photomontage, did not stay neatly apart but began to leak into one another, producing dadaism's most important form of manifesto art. The best example here is one of the most well-known photomontages, Hannah Höch's *Cut with the Kitchen Knife Dada through the Last Weimar Beer-Belly Cultural Epoch of Germany.*[70] Like Carrà's *Manifestazione Interventista, Cut* uses manifestos as source material, cutting them out with a kitchen knife and pasting them into the montage.[71] Among the sentences used is "Invest your money in dada," in the upper-left-hand corner, which is taken from a central collective manifesto published in the first issue of *Der Dada* (1919) and signed by the "Central Department of Dadaism." In the upper-right-hand corner, "The anti-dadaist movement" may well be taken from Hausmann's "The German Philistine Gets Upset," which elaborates on the idea that Hausmann and the other dadaists are really "anti-dadaists."[72] The slogan "Join dada" is the title of another prominent dada manifesto. Höch thus gathers the most important manifestos and their slogans and incorporates them into her montage.

Höch's manifesto-montage also constitutes a significant attempt at changing the gendering of the manifesto. Much more effective than Valentine de Saint-Point's attempt to include women in Marinetti's misogynist rhetoric by teaching them virility, Höch cuts through this heritage with a kitchen utensil. Indeed, through her coinage of "the kitchen knife Dada," dada itself is being attached to a household object and thus to the domestic sphere. *Cut,* too, can thus be seen as a "response to F. T. Marinetti," the subtitle of Saint-Point's manifesto, but one that interrupts the "virile" virtues of war. While it, too, signals an act of violence, it is a violence that cuts through masculinist manifestos, rearranging them in an altogether different manner.

In addition to using manifestos, Höch includes pictures of the authors of the main dada manifestos, including Hausmann, Grosz, and Herzfelde, and juxtaposes them with images of Marx, Rathenau, Einstein, and Ebert—fabricating a collision of the writers of art manifestos and of political manifestos. The two areas of greatest density and depth in this montage are the left lower and the right upper corner, which include images of mass

Figure 8.2. Hannah Höch, *Cut with the Kitchen Knife Dada through the Last Weimar Beer-Belly Cultural Epoch of Germany*, 1919–20, 114 × 90 in., photomontage, Nationalgalerie Staatliche Museen, Stiftung preußischer Kulturbesitz Berlin. ARS, N.Y.

gatherings and demonstrations, the mass movements with which dada aligned itself on the streets of Berlin. Höch herself participated in the so-called November Group, which had published its manifesto in 1918. The *November Group Manifesto* begins with the words "We stand on the fertile ground of the revolution" and demands to use the arts for the "common good."[73] This latter demand resembles the *Work Council for Art Manifesto*, published in 1919, which declared that "art shall no longer be the enjoyment of the few but the life and happiness of the masses."[74] *Cut* is a good example of how the photomontage can be seen as an extension of the political manifesto culture of the day, of the manner in which dada reorients—the situationists would say "detourns"— advertising toward the social revolution.

The transformation of the montage into a manifesto is most visible in Raoul Hausmann's *Synthetic Cinema of Painting*. A manifesto about photomontage, it explains the emergence of the montage as a reaction to the fact that "humans are simultaneous, monster of the self and the strange, now previously, later, and present."[75] The manifesto itself seeks to apply its own lessons and is therefore abrupt and discontinuous, as if it were ceasing to be a manifesto about photomontage and becoming a montage of manifestos. This transformation was finally accomplished when Hausmann used this manifesto as material for his photomontage *Dada Cino*. The title words dominate, seeming to gather and hold together the heterogeneous materials from which the montage is made. "Dada," placed horizontally across the page, is perhaps responsible for the square shapes of the upper part of the montage, while the sharp curve described by "Cino" affects the similarly shaped bottom part. The manifesto material is thus not simply used as one source material among others. Rather, it imposes onto the montage its shape even as it continues to draw its meaning from the manifesto.

The exchange between manifesto and photomontage thus affects both forms. The avant-garde manifesto gave up on the *grand récit* of the *Manifesto* and engaged in an art of abrupt changes, sudden exclamation, moving paratactically from slogan to slogan and from exclamation to exclamation. This also meant, however, that the manifesto was no longer in control of its own discourse, its own hierarchies of propositions and theorems. Instead, it became one voice among many, having merged with the horizontally and paratactically arranged material of the entire montage (as it did also in Pound's *Gaudier-Brzeska: A Memoir*). At the same time, however, the extractions from manifestos in turn influenced the workings of the entire montage, pushing it toward a more directed political interventionism. *Cut* can thus be seen either as being composed of manifestos cut up into pieces and reused as montage or as a photomontage refurbished as manifesto.

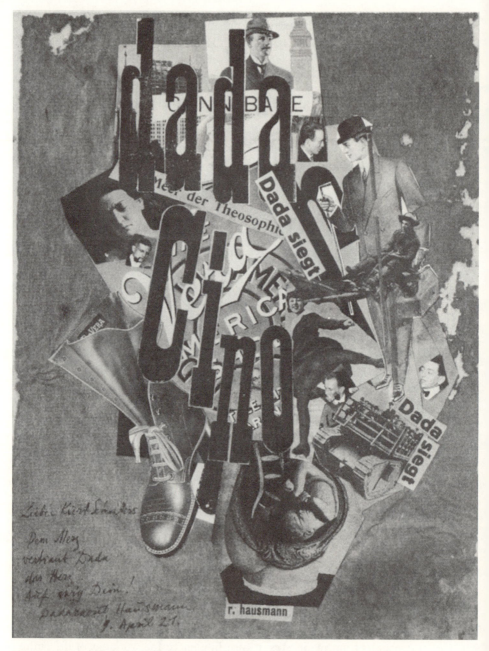

Figure 8.3. Raoul Hausmann, *Dada Cino*, 1920, 12½ × 9 in., photomontage, Collection
Dr. Philippe Guy Woog, Geneva. ARS, N.Y.

The communist parties might have been in possession of the superior revolutionary theory and in command of a tighter organizational structure, but their attempts to control the manifesto had entangled them in the insurmountable contradiction of repetition and difference. In the hands of the communist parties, the manifesto was threatening to deteriorate into a predictable, repetitive, and ineffective exercise. To have any effect, the manifesto had to become less predictable and conventional, less obsessed with performative power and more ready to embrace theatricality, and this is precisely what dada achieved through its metamanifestos and its manifesto art. Manifesto art borrows from both the traditional arts and the traditional manifesto, infusing the former with the capacity for revolutionary intervention while renewing the latter's capacity for surprise and shock. Manifesto art thus should be seen as neither failed revolution nor failed art but as a response to the contradictions within the revolutionary genre of the manifesto.

9

Huidobro's Creation of a Latin American Vanguard

The Chilean poet Vicente Huidobro spent most of his life moving back and forth between Latin America and Europe, where he met and collaborated with many avant-garde writers, including Pierre Reverdy, Breton, and Tzara. Best known for his long poem *Altazor*, Huidobro also formed the poetic doctrine of creationism, which he distributed through *Creación*, a traveling journal comparable to Picabia's *391*. Huidobro was thus working, as Jean Franco has written, "along the same lines as his French, Spanish, and English contemporaries."[1] Hidden behind the formulation, however, lies a complicated geographic question of how this Chilean writer dealt with the economic, cultural, colonial, and postcolonial relations between Latin America and Europe.

Most studies devoted to the traffic in the avant-garde between Europe and Latin America have been devoted to the novel or poetry. This is certainly true of scholarship on Huidobro, which has been focused on *Altazor* as the culmination of his career, indeed, as the realization and highest achievement of creationism. In keeping with the method pursued throughout my book, I will shift this debate and focus on Huidobro's changing attitude toward and gradual use of the manifesto. If, as I have been arguing, the manifesto is the genre through which modernity articulates itself most distinctly, then one should expect that the reception of this modernity in Latin America, what Carlos J. Alonso called "the burden of modernity," would make itself felt in the various uses, rejections, adaptations, and transformations of the manifesto.[2]

Manifestos in Latin America

As almost everywhere else, the genre of the manifesto entered Latin America in the form of translations of the *Communist Manifesto*. The *Manifesto* had been translated into Spanish in 1872, after a failed attempt in 1848, and was therefore available throughout Latin America in the later nineteenth century. The first Latin American editions of the *Manifesto* appeared in Mexico City in 1888, only two years after the first Norwegian edition and five years after the first Polish one.[3] In many ways, Mexico could be seen as the country most prone to socialism for it had not only the *Manifesto* but also one of the first major revolution outside Europe. As Hobsbawm has written, perhaps giving short shrift to the Haitian Revolution, the Mexican Revolution of 1910 was the "first of the great revolutions in the colonial and dependent world in which the labouring masses played a major part."[4]

At the same time, Mexico City became a kind of projection screen for the European avant-garde (competing, in this regard, with New York). Breton famously considered Mexico to be a quintessentially surrealist country, and Artaud hoped to find there remnants of the theater of cruelty. Mexico became the country of Trotsky's exile, from which he launched countless missives and texts, including, with Breton and Diego Rivera, *Manifesto: Towards a Free Revolutionary Art*. Indeed, Mexico produced a host of avant-garde movements, the best-known of which was probably *estridentismo*, complete with a series of manifestos and manifesto-journals. The confluence of political and avant-garde manifestos also gave rise to many examples of manifesto art, including a remarkable play by Xavier Icaza called *Magnavoz: Discurso Mexicano* (1926). *Magnavoz* is a play of truly global dimensions, demanding that speakers placed on several Mexican volcanoes engage in discussions with speakers, including Lenin, situated in the Alps. The voice that resolves this transatlantic cacophony is that of Diego Rivera. As Vicky Unruh points out in her excellent study of the Latin American vanguard, Rivera is the only speaker who addresses the audience directly and without a megaphone, commanding the audience to help build up and modernize Mexico in a rousing appeal that takes the form of a manifesto.[5] *Magnavoz* may thus be considered one more example of the competition between theatricality and performativity inherent in the manifesto.

Even though Mexico City was thus a privileged location for the American avant-garde, a second center of gravity must be placed in the south of the continent, in Argentina and in Huidobro's own Chile. Argentina could boast a long tradition of socialism. Many of the branches of the

International were set up first by German immigrants, who founded the socialist paper *Vorwärts* in Buenos Aires, and later by French and Spanish immigrants. In Chile, it was Francisco Bilbao, a Frenchman who had emigrated there after the defeat of the 1848 revolution, who founded the Sociedad de la Igualdad. Members of this society participated in the formation of the Democratic Party in 1887, the first openly socialist organization in Latin America. After the revolution of 1891, the party even managed to send several members to the Chamber of Deputies. This history of socialism culminated in the formation of the Socialist Labor Party in 1912, the product, as so often in the history of the Left, of a split from the more moderate Democratic Party. In 1919, the Socialist Party joined the newly established Third International, thus subscribing to the manifesto written by Trotsky, and accordingly renamed itself the Communist Party. Even though Marxism was continually challenged by Bakunin and other anarchists, who had a much greater following in Latin America than in Europe, the *Manifesto* managed to become a prominent and paradigmatic text among revolutionaries of all ilk.

As in Europe and Mexico, there existed many alliances between socialism and the avant-garde in Chile, where the socialists decided to name their official magazine *La Vanguardia* in 1915. Indeed, if the *Manifesto* was one widely distributed document that served as a paradigm for subsequent manifestos, the other influential and widely distributed and translated text was Marinetti's *Manifesto of Futurism*. In many ways, Marinetti's reception in Latin America resembled not that of the European periphery, including Italy and Russia, where the manifesto quickly caught on, but of England, where the manifesto had been treated with skepticism. This skepticism was grounded in a formidable tradition of *modernismo*, Latin America's symbolist variant of modernism, which viewed futurism's most aggressive export product with ambiguity and felt compelled to defend against it the integrity of the artwork.

The strongest early response to Marinetti's manifesto came from the most acclaimed Latin American poet, Rubén Darió. Only forty days after the publication of Marinetti's manifesto in *Le Figaro*, Darió wrote a response in *La Nación* that included a complete quotation of Marinetti's eleven points and was the first publication of the core of Marinetti's manifesto in Latin America. The tone of the review was bemused sympathy, the older modernist exclaims, half patronizingly and half with envy, "Ah, marvelous youth!" But he is irritated by some of Marinetti's statements, which tend to be "much too excessive."[6] Darió loses his ironic equilibrium entirely when he feels compelled to comment on the form of the manifesto: "The only thing I find

useless is the manifesto" (6). Darió objects to Marinetti's manifesto not so much for its content as for its form: "If Marinetti in his vehement works has demonstrated that he has an admirable talent and that he knows how to fulfill his mission for Beauty, I don't think that his manifesto will do anything besides encourage a good number of imitators ... without the talent or the language of its initiator." Even though Darió praises Marinetti's poetic works for their "vehemence" (*obras vehementes*), he sees no value in the equally vehement manifesto, which will only lead to the formation of schools and imitators. Poetry, including and especially Marinetti's poetry, has to be protected from his manifestos.

Darió's concern was echoed by many of Latin America's established modernists. In August of the same year, 1909, Amado Nervo wrote an article similar to Darió's that quotes liberally from Marinetti's manifesto and provides a mildly amused report on this enthusiastic and wild Italian (another publication of the eleven principles listed in Marinetti's manifesto appeared in *El Diario Espanol*, in a translation by Juan Mas y Pi). However, the more Nervo quotes and comments on Marinetti, the less he likes him, until he suddenly takes issue with the whole project of the avant-garde, bemoaning that "our industrial epoch is without spiritual qualities."[7] Now he worries whether the present can produce poets of the same rank as Homer and Shakespeare; the past is once more the measure for the present.

The modernist skepticism about Marinetti's manifesto soon gave way to a second more sympathetic reaction, coming from within the academy. Whereas in western Europe the avant-garde had to define itself against an entrenched university system, in Latin America the boundaries between the two were much more fluid. Rómulo E. Durón, editor of *Revista de la Universidad*, for example, translates the manifesto and exclaims enthusiastically that to a "new social state corresponds, as a new ideal, a new form of literary expression."[8] Slowly, then, the manifesto became an accepted or at least tolerated component of the emerging avant-garde even if it also continued to be seen with ambivalence. No matter what attitude different writers took toward futurism, their translations and extracts helped disseminate the *Manifesto of Futurism* and its succinct eleven-point program. In addition, many were able to read Marinetti's manifesto in the original, so that the translations and extracts traced here are merely the tip of the iceberg, confirming just how influential the *Manifesto of Futurism* had become. Soon enough, therefore, there were the first imitators, such as Henrique Soublette, who was so taken by the drive of Marinetti's text that he wrote, "Let's go to work, let's go!!" to put the manifesto into practice.[9] Despite a prevalent resistance, the tone and style of the manifesto began to make headway

among Latin American writers. Following on the heels the *Communist Manifesto*, the *Manifesto of Futurism* had entered Latin America.

The History and Geography of Creationism

At first, Huidobro shared the skeptical attitude of his contemporaries toward the manifesto. In a polemic called "El Futurismo," he even quotes approvingly Darió's high-handed attack on Marinetti. Yet, gradually, Huidobro begins to warm to the manifesto. His first manifesto-like text, called "Non Serviam" (1914), styles itself not so much after the *Manifesto* as one of its precursors, namely, the Declaration of Independence: "The poet, fully conscious of his past and future, launches his declaration of independence toward the world."[10] In this formulation, we can see an emerging hemispheric consciousness, centered on the Americas with their own declarations of independence and their own promise of modernity. The slogan "non serviam" is repeated many times, giving this text a sense of urgency and insistence. However, Huidobro does not worry about rival movements or predecessors, as would be the case with most avant-garde writers, but only "mother nature." In this sense, this text is more an artistic declaration of independence, a postcolonial gesture of rebellion, than a self-conscious let alone self-declared manifesto.

"Non Serviam" was published in Santiago de Chile. Soon, however, Huidobro left for Buenos Aires, where he published his second programmatic text, "Arte Poetica" (1916), which occupies a similarly ambiguous relation to the manifesto. "Arte Poetica" praises the art of invention; it does so not in the form of an aggressive manifesto, however, but in the form of verse (although one may think here of Brecht's verse rendering of the *Manifesto*). Buenos Aires was the last American station for Huidobro before he continued on to Europe. Huidobro traveled back and forth between Paris and Madrid, and it was in the latter that he gave a lecture in 1921 that was, if not a manifesto, at least the outline of a program Huidobro would later call "creationism" in that it privileges the act of creation over imitation.[11] This lecture does include some slogans, such as "Poetry is the language of creation." However, there are no numbered points, no coinage of an ism, no rivalry with specific other movements let alone a celebration of futurist speech acts. The same is true of a companion text, "Pure Creation: An Essay in Aesthetics" (1921), which indeed is, as the title announces, an essay rather than a manifesto.[12]

Even though Huidobro still avoided writing manifestos, he was increasingly drawn into the battle of movements, schools, and isms, for example, with his journal, *Creación: Revista Internacional de Arte*, that was to turn the aesthetic doctrine outlined in this programmatic text into reality. This journal, like Picabia's *391*, by which it was inspired, featured contributions in French, Spanish, English, Italian, and German by such figures as Schoenberg, Braques, Gleizes, Gis, and Picasso. And like Picabia, Huidobro traveled with the journal, taking it with him on his frequent moves from Madrid, where it was founded, to Paris, where it changed its name to *Création*.[13] It was in this journal that Huidobro also published the first of his texts to bear the word "manifesto" in its title. However, this text still signals an ambiguity toward the genre, for it is called "Manifiesto tal vez" (Manifesto Perhaps). As if this skepticism, or ironic distancing, were not clear enough, the first words we read are, "There is no certain path."[14] Instead of exclamation points we have question marks, and the whole text seems rather cautious in using the language of the manifesto.

Not only did Huidobro establish himself as an avant-garde writer in Paris, but he also had begun to write in French. This choice was significant, for upon his arrival in Paris his French was rather poor (even though his rich parents had taken him on an extended tour to France when he was still a child). Huidobro thus confirmed Paris as a central location in which one had to stake one's claim toward belonging to the avant-garde (Marinetti had done the same, by publishing his *Manifesto of Futurism* in Paris and in French). Even though Huidobro still avoided the manifesto in the early twenties, he came under increasing pressure to turn his aesthetic doctrines and his journal into a full-fledged ism, to lay claim on a movement, and to do so through a manifesto.

The more Huidobro moved toward defining creation in his journal and quasi manifestos, the more he was subject to polemics and challenges. In *Nord-Sud*, Huidobro had not felt the need to attach to such a project a label, name, movement, or manifesto. During a trip to Spain, however, where he also noticed the Barcelona issues of Picabia's *391*, he was surprised to find that in Spain cubist techniques were being used in a very different manner. Indeed, in 1921, his visit to Madrid and the debate about aesthetic doctrine triggered the foundation of ultraism.[15] While some attacked the doctrine of creation, such as the Chilean Joaquín Edwards Bello and the Spanish Guillermo de Torre, who promoted ultraism against Huidobro, others, such as his former collaborator Reverdy, challenged Huidobro's claim to have founded this movement.

And so, Huidobro himself was finally drawn into the manifesto mania and wrote a typical manifesto, unambiguously called "El Creacionismo." This document was published in 1925, four years after the first issue of *Creación* had appeared. "El Creacionismo" quickly tries to make up for its belated appearance by claiming that creationism had existed for a long time, at least since 1912. Not only does Huidobro predate his movement, but he also makes sure to locate the origin of the movement, if not in his native country, so at least in Latin America, namely, in Buenos Aires. The debate about the origin of creationism resembles similar debates surrounding surrealism. In his first *Manifesto of Surrealism*, Breton reacted to his challengers by reading surrealism back into history, and the Russian futurists tried to predate the use and practice of futurism before Marinetti's visit to Moscow. All these figures practiced the retroactive creation of an avant-garde tradition putatively independent of rivals, precursors, or obvious models such as Marinetti or Tzara. And the instrument through which these acts of retroactive foundation were accomplished was the manifesto.

Creationism is built on the very values that are at issue in the debate about it, namely, originality and authenticity. Imitation is the value against which creationism defines itself. All the manifestos of creationism fantasize about pure, unmediated expression, original creation, and a poetry free from the burden of history. In this sense, the content of creationism is a symptom of the debate that surrounded it, a symptom of the difficulties faced by a Latin American avant-garde in its struggle for independence with respect to Paris.

This geographic position also informs Huidobro's most direct challenge to the manifesto-driven avant-garde, his attempt, if you will, to out-manifesto the French avant-garde: a collection of manifestos entitled *Manifestes* (1925). The collection opens with a startling new play on the form of manifesto:

> Manifestes
> Manifeste
> Manifest
> Manifes
> Manife
> Manif
> Mani
> Man
> Ma
> M (2)

This opening salvo registers Huidobro's ambivalence toward the manifesto, and toward the manifesto-driven avant-garde in all its contradictions. The burden of writing against so many rival manifestos is visible everywhere in the collection: "The Dadaist manifestos of Tzara have been buried under so much commentary by this time that there is no point in going over them again."[16] So much commentary and history have amassed that Tzara's manifestos are in need of excavation. However, the last thing Huidobro wanted to become was the archaeologist of dadaism. Manifestos are still seen as something Huidobro needs to struggle against; he even praises surrealism, which he otherwise criticizes, for having produced fewer manifestos than other movements: "There are many more Surrealists, at least in name, than there are surrealist manifestos" (8). Manifestos are worth less than poetry; they are the refuse of history that amasses on top of literary history.

As superfluous as manifestos still may be, they seem to be unavoidable. Huidobro writes: "I am holding under my eyes the Dada manifestos of Tristan Tzara, three Surrealist manifestos, and my personal articles and manifestos"; and he admits that "in the wake of the latest manifestos swirling around poetry [acerca de la poesia], I have begun to reread my own and, more than ever, I find my earliest theories confirmed" (7). In this collection, which also features his last and only true manifesto, "El Creacionismo," Huidobro assembles all his previous quasi manifestos, including his "Manifesto Perhaps," and presents them retroactively as manifestos. In dismissing the manifestos of others and establishing his own history of manifesto writing, Huidobro sought to outmaneuver all previous manifestos generically by writing an extreme form of metamanifesto, the kind of manifesto that emerses when the poetics of the visual dada poem is applied to the manifesto itself.

While Huidobro's choice of language for this collection confirmed Paris as the center, it was from this center that Huidobro sought to affirm an independent genealogy of creationism, one originating in Chile, Argentina, and Spain.[17] Indeed, his manifestos show a hemispheric consciousness by referring to New York and New York dadaists such as Arensberg and Picabia as much as to Tzara or Breton (as well as, generically, to the Declaration of Independence). Paris is not so much a center as one of the nodal points where avant-garde activity is concentrated. Other such points, for Huidobro, are New York, Milan, Madrid, Barcelona, Zurich, Berlin, and Buenos Aires. The crossing paths of figures such as Tzara, Picabia, Huidobro—one could add Huelsenbeck, Duchamp, and Breton—do not respect origins (although they may try to create and project them), but patterns of encounters and cross-fertilization. Their travels, and not their origins, their

adopted language and not their original language, ended up having the more lasting impact.

One might describe these travels as a combination of displacement and replacement, displacement from putative origins, and their replacement by travels and transient places. This effect of displacement and replacement is in fact intimately connected to the foundational force of the manifesto. Whether Marx in Brussels, Engels in London, Tzara in Zurich, Breton and Picabia in New York, Trotsky in Mexico, Pound in Rome, or Huidobro in Madrid and Paris—the list could go on—writers of manifestos use this genre to establish and fabricate new points of departure. These manifestos respond to the experience of displacement by trying to create places, by replacing the lost with the new.

Displacement and replacement also characterize the relations among political and avant-garde manifestos. Even though historically it was the *Manifesto* that became a paradigm for artistic manifestos, the case of Huidobro shows that the influence among different manifestos could go both ways. Huidobro, who came from one of the richest families in Chile, read Marx only after the Russian Revolution, when the *Manifesto* had become virtually ubiquitous.[18] It was only after a distinguished career as an international avant-garde poet, writer of art manifestos, and founder of creationism that he joined a communist party in the early thirties. In 1937 he volunteered in the Spanish civil war, fighting under Enrique Lister, one of the important commanders of the Republican Army, to defend Madrid from the fascists. Huidobro's political activities were most pronounced in Chile, however, where he founded several political newspapers, partially modeled on his avant-garde journals, and even ran for president. Throughout this period, Huidobro wrote many political pamphlets, including one against the British Empire that putatively led to his abduction. As it turned out, the abduction was staged by Huidobro himself, one more example of how his political strategies drew on avant-garde practices.

The dynamic of moving and translating, of displacement and replacement points to the limitations of theories of modernism that depend on a more or less deterministic model according to which modernism is a response to the crisis of rapid modernization. This model works well for the semiperiphery of Europe, in particular Italy and Russia, but less well for places such as New York and Santiago de Chile that occupy very different positions with respect to industrialization and modernization more generally. The model of modernism as arising from incomplete and contested industrialization thus explains the emergence of a first modernism, but not the projection, refraction, and adaptation of this modernism ever since. In

particular, it does not work as an explanation for the avant-garde at large, which respects neither origin nor original language, which does not privilege fixed abodes and cultural frames and thrives on the instable and ephemeral even as it may fantasize about origins and headquarters. What needs to be added to this theory of uneven development is the dynamic of modernism and the avant-garde itself, the fact that once there existed a radical modernism in Europe's semiperiphery, this modernism traveled and was distributed to a much wider range of places and locales, disrespecting prevalent modes of production. There formed, in other words, a kind of feedback loop between European and American modernisms. This is nowhere as true as in the case of the manifesto, for here we are lucky enough to have a genre that uniquely exemplifies modernism and that was responsible for the distribution of modernism across different locales. While the Third International put into place the policy of "socialism in one country," the avant-gardes developed a new form of internationalism, of world literature, that had been faintly anticipated by Marx and Engels in their *Manifesto.*

Manifestos as Means and End

Surrealism, Latent and Manifest

No avant-garde collective was more devoted to the revolution than surrealism, and none was more uncertain about what this revolution should be. The first surrealist journal, the *Surrealist Revolution* (1924–29), envisioned a revolution that was specifically surrealist, a revolution according to the terms set by the new movement. Only a few years later, however, the name of the movement changed from the dominant position to a subservient one when the journal was renamed *Surrealism in the Service of the Revolution* (1930–33). Now it was no longer surrealism that forced onto the revolution its particular nature and raison d'être, but rather the revolution that determined the character of surrealism. Surrealist revolution and revolutionary surrealism—these two formulations mark the extreme poles in the continuing struggle between the two projects. In the earlier *Declaration of January 27, 1925*, for example, the surrealists announced, "3. We are determined to make a Revolution" and "8. We are specialists in Revolt," and as late as the fifties, Breton invoked the goal of revolution without letting himself be pinned down as to what kind of a revolution it would be.[1] These changing allegiances led to the many exclusions, quarrels, denouncements, and broken friendships and collaborations that litter the history of surrealism, including the notorious rupture between Breton and the author of the *Declaration of January 27, 1925*, Antonin Artaud, whose manifestos and theaters will be the subject of the next chapter.[2]

 The debate about the revolution was delimited on one side by the discipline demanded by the Third International (Comintern) and its French branch, the Parti Communiste de France (PCF), later renamed Parti Communiste Français, and on the other by the dadaist heritage of a minimally organized and exuberantly theatrical revolt. Surrealism is often regarded as

a primary example of avant-garde experimentation, freely breaking with conventions, genres, and rules in order to let the unconscious and mysterious emerge. Automatic writing, dream sequences, secret desires, sudden transformations, and far-fetched associations are some of the keywords and strategies commonly attributed to this movement. However, unlike other movements, in particular dada, surrealism must be regarded as a balancing act between avant-garde theatrics and socialist strategy. These two poles pitted against one another party politics and cultural anarchism, professional revolutionaries and amateur artistes, calculating strategists and bohemian insurrectionists, politics and art. Breton declared, "1. We have nothing to do with literature," and expelled Artaud for his "luxurious" stagings.[3] At the same time, he attacked the official party organ *L'Humanité* for its simplistic advocacy of proletarian art and demanded a more complex practice of literature, one marked by the contradictions that were invariably part of a prerevolutionary society.[4] Breton finally joined the Third International in 1927 only to leave it in disgust a few years later, and later still visited the banished Leon Trotsky and demanded the freedom of revolutionary art from the dictates of Moscow.

The main thing that had changed since dada's "strange dialectic" with Lenin (in Zurich) and Luxemburg (in Berlin) was the nature of international socialism. From the turmoil of the Great War and its competing internationalist projects such as the *Zimmerwald Manifesto*, there had emerged the Third International, disciplined and centrally run from Moscow. Avant-garde groups could still choose not to align themselves with the Third International and its tightly controlled national branches. But a "strange dialectic" was not something the Third International would tolerate, neither in Russia, as the Russian futurists found out the hard way, nor in France, as Breton would eventually realize as well. An added difficulty was that the international policy adopted by the Third International, ruthlessly imposed on all national branches, underwent frequent and fundamental changes. Moscow's control made itself felt with particular clarity after the Fifth Congress of the Comintern (1924), when the bolshevization of Western communist parties became official policy, and even more clearly after Gregory Zinoviev, a staunch internationalist, was expelled in 1927. It was just during this time of radical control and exclusion that Breton entered the party, a time when many intellectuals and artists, who were not willing to be bolshevized, were leaving it.

The increasing attempts on the part of Comintern to control its national branches were a direct result of the internal policies adopted by the Soviet Union after 1917. The first years, until 1920, were still devoted to

the expectation that the revolution would spread from Russia to Germany; indeed, the official language of the Third International in these early years was German because all the hopes for revolution in Europe were centered on that country. When it became clear that there was not going to be a successful revolution in Germany or in other Western capitalist countries, the Comintern adopted the "socialism in one country" policy, which put the demands of the new and fragile Soviet state first. Purges of national parties became more common as the twenties wore on (although it is important to note that this bolshevization had begun well before Stalin effectively took over after Lenin's death in 1924). It was only at the Seventh Congress of Comintern in 1935, when the fascist threat was becoming more and more visible, that Moscow changed its exclusionary policy, advocating a "popular front" to collaborate with other antifascist forces. The later thirties saw more shifts and turns, the most radical being the Hitler-Stalin Pact of 1939, which meant that, until Hitler's invasion of Russia in 1941, all Comintern parties were suddenly supposed to stay out of the fight against fascism. One particularly absurd consequence of this change was that after the Germans took Paris, *L'Humanité*, the official organ of the PCF, openly approached the occupiers, hoping to be granted a publication permit according to the terms set by the Hitler-Stalin Pact. More important, for the history of the manifesto, was the fact that under Comintern, the *Communist Manifesto* had become the sanctified document of truth and was therefore no longer up for grabs. It now was an official part of a well-structured International that was ready to quell dissenters and demanded blind obedience to even the most absurd of policies.

All this meant that by aligning himself with the PCF in the late twenties, Breton had to accept considerably more interference than, for example, the dadaists endured during their own association with Spartacus. This new tone in the international Left influenced, directly and indirectly, surrealism and its practice of the manifesto. Neither wanting to fall back on dadaism's parodic anarchy nor content to follow the rules of revolutionary efficacy set by the Third International, the surrealists had to impose onto themselves and their writing some kind of discipline without simply repeating official communist doctrine.[5] The question of this discipline, the mediation between the Third International and avant-garde art, affected much surrealist writing, and the tensions arising from this mediation proved to be the catalyst for surrealism's most productive achievements.

Surrealism produced a number of programmatic and polemical writings, including editorials in the leading surrealist journals, collective declarations, and position papers, but in particular it produced manifestos.

The surrealist manifestos record an astonishing zigzag trail through the cultural and political terrain of interwar France. These manifestos are more than mere documents of Breton's changing allegiances; the practice of and attitude toward the manifesto as a genre is itself a central factor in the conflicts about revolution and art. One might say that Breton had to navigate between the dadaist metamanifesto and the tradition of the socialist manifesto. Indeed, surrealism's dependence on or independence from communism involved the question of whether there should exist an independent, and specifically surrealist, manifesto. Surrealist writers thus had to choose among competing models of the manifesto, which in turn implied different models of the revolution. In other words, it had become very clear that there were now competing conceptions of what the poetry of the revolution should be.

The most significant change Breton introduced to the prevalent avant-garde culture was the attempt to control and restrain the use of the manifesto. From a surrealist perspective, dada's proliferating manifestos on the stage and in print, their various fusions with art and willful defiance of theoretical discipline, constituted a frivolous use of a genre that had to be reined in. The manifesto, for Breton, was decidedly not a genre to be used and transformed at will, grafted onto other genres, parodied, or subverted. Breton radically reduced the number of manifestos that were being published under the auspices of surrealism. Surrealism was launched by a text called *Manifesto of Surrealism* (1924), and it took almost six years until Breton was ready to follow up with a *Second Manifesto of Surrealism* (1930) to signal a major change of direction. Another twelve years passed until he wrote, with hesitation, a text called *Prolegomena to a Third Surrealist Manifesto or Not* (1942). Breton seemed to agree with the inheritors of the *Manifesto* that the foundational act of a manifesto must be preserved at all costs in order for this act to retain its force over time. Each subsequent manifesto would threaten to undermine a first and foundational manifesto, so that instead of writing new manifestos, one should adapt the original manifesto to changing circumstances through new prefaces. Rather than writing one manifesto after the other as the futurists and dadaists had done, Breton thus followed the example of Marx and Engels by writing prefaces for new editions of his existing manifestos, as he did for the 1929 and 1946 editions of the *Manifesto of Surrealism* and the *Second Manifesto of Surrealism*, respectively. Ostentatiously blaming himself for "not always and in every respect having been a prophet" (1:401), Breton affirmed that the five-year-old manifesto was still valid.

The affinity between Breton's manifestos and those of the socialist tradition was not just a matter of historical influence but a direct consequence of the pressure Breton felt from the PCF to clarify his allegiance to the Third International. This pressure was made concrete by Breton's various attempts to collaborate with the two main communist journals, the *Clarté* and the PCF's own *L'Humanité*. The first collaboration with the latter occurred early on, during the Moroccan crisis of 1925, when France joined the Spanish troops, commanded by the future General Franco. In response to the patriotic "Les intellectuelles aux côtés de la Patrie" (Intellectuals on the side of the Fatherland), many surrealists signed a manifesto against the Moroccan War printed in *L'Humanité* and written by its editor Henri Barbusse. This joining of forces with the official journal of the PCF can be seen as surrealism's political coming-of-age.[6] Nevertheless, the relations with *L'Humanité* continued to be strained; the gap between the party paper and surrealism seemed bridgeable only in the face of a common enemy. A similar pattern governed the surrealists' relation to the other communist paper and collective, *Clarté*, which could boast an international board, including Thomas Hardy, Sinclair Lewis, H. G. Wells, and Stefan Zweig. Since *Clarté* was not an official party organ, it was easier for the surrealists to make a common cause with this group, but here, too, collaborations came to fruition only against another common enemy, Anatole France, who was the target of a joint pamphlet called *Un Cadavre* (A Cadaver).

Much later, in his 1946 preface to the *Second Manifesto*, Breton would acknowledge the influence of these various collaborations on his own texts, bemoaning "the formal influence ... of revolutionary literature" (1:837). Indeed, Breton was fully caught up in the various forms and genres of revolutionary and agitational literature. His oscillations between socialism and avant-garde left their traces on the tone, language, and form of his manifestos. The collaborations with *Clarté*, for example, had a decidedly sobering influence, pushing Breton even farther in the direction of the instrumentalist, efficacious, and authoritative manifesto and thus away from dada's theatricality. The remark about the formal influence of revolutionary writing comes close to blaming socialist literature, in particular the tradition of the socialist manifesto, for imposing onto him the instrumentalist rules and forms of "revolutionary literature." In keeping with this influence, the only parts of the *Manifesto of Surrealism* that are set in bold letters and varying fonts are the newspaper clippings that Breton included as source material for surrealist poetry; all other parts are toned down, studiously avoiding the overly theatrical and collagelike layout of dadaist (and also vorticist) manifestos.[7]

Besides the quantitative restriction of the manifesto, Breton also consolidated the manifesto's traditionally anonymous or collective authorship. Surrealism was a collective enterprise, but it was more tightly controlled by one leading figure than any other comparable avant-garde movement, including Marinetti's futurism. Breton realized that whoever controlled the manifesto would control surrealism. Unlike Marinetti and Tzara, who were happy to franchise the writing of manifestos after they had created the paradigm for futurist and dadaist manifestos, respectively, Breton never left any doubt that he was the only person to author authoritative surrealist manifestos. There existed collective declarations and minor manifestos, but the principal surrealist manifestos were written by Breton and Breton alone, including the *First* and the *Second Manifesto*; collective statements, such as the one printed in the first issue of the relabeled journal, *Surrealism in the Service of the Revolution*, did little else than profess allegiance to the *Second Manifesto*. And the *Prolegomena to a Third Surrealist Manifesto or Not*, published in *VVV*, a surrealist journal edited by David Hare in New York, was written exclusively by Breton as well.

Hand in hand with the control over the manifesto went the control over the history of surrealism; exercising this control was one of the surrealist manifestos' primary functions. The *First Manifesto of Surrealism*, as well as subsequent manifestos, engaged in a critical and at times polemical history of dadaism, declaring surrealism to be dadaism's legitimate and definitive inheritor, while insisting that it had moved well beyond dada's follies. In the *First Manifesto*, for example, Breton criticizes his own dadaist past, saying that he had been misled into "defying lyricism with salvos of definitions and recipes . . . and pretending to search for an application of poetry to advertising" (1:324). In a short text on dada, written at the same time, Breton attacks Tzara even more explicitly, saying, "It seems to me that the sanction of a series of utterly futile 'dada' acts is in the process of gravely compromising one of the initiatives of emancipation to which I remain most attached" (1:260–61). Breton's critique of "futile" dada pranks, devoid of even a minimum of revolutionary efficacy, was aimed at the theatricality of dada metamanifestos; it also echoes Trotsky's attack on Russian futurism (Breton had reviewed Trotsky's *Lenin* for the fifth issue of the *Surrealist Revolution* in 1925). The critique of dada as the chaotic and theatrical predecessor of surrealism was reiterated by the first historian of surrealism, Maurice Nadeau, and by many subsequent historians; it was also repeated by Debord, who turned it against surrealism itself.[8] This history suppressed an alternative account, according to which dada's "acts" still played a role in surrealist manifestos whenever they dared or wanted to signal their distance

from official communism. Rather than overcoming dada, surrealism was a continuation of the theatrical avant-garde manifesto by other means.

The surrealist manifestos complemented their polemical history of dadaism with a prehistory of surrealism that circumvented dadaism altogether by reaching as far back as the eighteenth century. Once more, a manifesto shapes not so much the future as the past, for what Breton presents here is a history of surrealism *avant la lettre*: "Swift is Surrealist in malice / Sade is Surrealist in sadism. . . . Poe is Surrealist in adventure. / Baudelaire is Surrealist in morality. / Rimbaud is Surrealist in the practice of living, and elsewhere. / Mallarmé is Surrealist when he is confiding. / Jarry is Surrealist in absinthe . . . etc." (329). This prehistory might strike one as a curious reversal of the manifesto's futurist orientation. However, as in the case of the *Communist Manifesto* and most manifestos since, the foundational present and the envisioned future are grounded in a history that prefigures them both. For surrealism this prehistory contains partial or incomplete surrealist authors, presented in a list that could presumably go on forever, "etc." All the writers listed participated in surrealism only to the limited extent specified. It was only with the conscious and deliberate foundation of surrealism as a movement that this latent or partial surrealism became manifest and thus acquired an explicit name, a future, a prehistory, and a manifesto. The manifesto gathers the latent past, brings it to the fore through a performative act in the present that is oriented toward the future.

But how does an act of founding accomplish the challenging task of gathering the past for the future? Like the *Foundation and Manifesto of Futurism*, the *First Manifesto of Surrealism* depicts a foundational scene from which surrealism emerges. Instead of Marinetti's description of the racing car, it is a scene of writing, namely, a session of Breton and Philippe Soupault's automatic writing. Right after describing this scene, Breton begins to dismiss rival uses of the word "surrealism," such as those by Gérard de Nerval and Guillaume Apollinaire, to defend his own claim on the concept. His final move is to insert into his manifesto an imaginary encyclopedia entry on surrealism: a definitive definition of surrealism. This is the ultimate foundational act, and one that reveals how such an act must stitch together the past, present, and future through the future perfect, the *future antérieur*: I am now enacting what will have been the foundation and origin of surrealism. As in the case of the *Foundation and Manifesto of Futurism*, this foundational document acquired the label manifesto retrospectively. This (First) *Manifesto of Surrealism* had originated as a preface for *Soluble Fish*, a sequence of automatic writings; the *Manifesto of Surrealism* retained traces of this first incarnation, for example, when it refers to itself as a "preface"

(331). It was only belatedly that this "preface" was published on its own, and with its new title. Breton's manifesto, like all manifestos, thus participated in and in fact created what Rosalind Krauss calls the myth of the "originality of the avant-garde," fabricating retroactively a break and point of origin.[9]

While the *Manifesto of Surrealism* constructs a prehistory and origin of surrealism, it also controls the boundaries of surrealism in relation to rival movements by determining who is an official member of surrealism and who is not. For it was part of Breton's investment in efficacy and instrumentality, borrowed from the communist manifestos, that surrealism should not be a loose association like dada. The *Second Manifesto* functioned as an instrument with which Breton rid surrealism of suspected renegade members, most famously Artaud and Georges Bataille, while also defending the movement against the attacks of the Third International.[10] Breton dismisses Artaud through a form of antitheatrical polemic, by branding him an "actor, looking for profit and notoriety" (1:786) and seeing in Artaud's manifestos and declarations nothing but so many assumed "roles." This antitheatrical rhetoric, too, can be seen as part of Breton's attempt to reduce the theatricality of the avant-garde and of the manifesto in favor of something more effective, instrumental, and efficacious.

Artaud's theatrical deceits also represent a second danger, namely, that they may serve as a cover for, in Breton's words, the "traitors among us" (790). It is a striking parallel that just as Stalin was consolidating his power by purging the Party of supposed traitors, obsessed with the fear that alleged socialists might be only playing roles while secretly harboring counterrevolutionary sentiments, Breton started to do the very same thing with surrealism. In his hands, the manifesto became what it had never been for dadaism, namely, a disciplinary instrument. "I judge that I am not authorized to let cowards, con artists, opportunists, false witnesses, and informers run around loose" (790). Even though there was opposition among the rank-and-file surrealists to this type of autocratic behavior, Breton was able to hold on to his position and continued to exert his influence more or less unchallenged. The correspondence between Stalin and Breton also bespeaks a particularly eerie affinity between socialism and surrealism as practiced by these two respective leaders, an affinity that extends to their use of the manifesto as an instrument with which recalcitrant members could be reined in, expelled, and punished.[11] One could almost say that with surrealism the manifesto returned to its earliest function as a declaration of the will of the head of state, monarch, or leader. In any case, Breton demonstrated that the performative power of the manifesto was not only founda-

tional but also authoritarian, commanding obedience, punishing perpetrators, and announcing judgments.

Breton's authoritative manifestos may not have helped to bring about the revolution, but they helped to turn surrealism into the most widely recognized avant-garde movement—so much so that it sometimes functions as a shorthand for the avant-garde as such. Breton managed to hold together surrealism over an impressively long stretch of time while other movements were quickly dispersed or absorbed by rivals. The instrumentalist use of the manifesto, in other words, worked, and many later avant-gardists, including the situationists, learned from Breton how to form and sustain a collective against all odds.

The Surrealist International

The instrumentalist use of the manifesto assured surrealism's endurance not only over time but also over space. Unlike dada, surrealism was initially an exclusively Parisian affair. This geographic concentration, too, was a product of Breton's desire to control the membership and publications of the group. The international distribution of surrealism occurred only when various nonaffiliated avant-garde journals produced special issues on surrealism, including a 1929 issue of the Brussels journal *Variétés*; the September issue of *This Quarter*, an English-language journal published in Paris; a 1934 issue of *Documents*, published in Brussels; and the 1936 double issue of the London-based *Contemporary Poetry and Prose*. Breton was the leading contributor to all these journals, which presented surrealist texts in the original as well as in translation. At the same time, international avant-gardists such as Vicente Huidobro, who were not officially members of the surrealist group but at various times were allied with this widely recognized movement, contributed to the international reach of surrealism as well.

Increasingly, however, Breton's authority over surrealism, and thus his monopoly over its manifestos, was challenged by a process that could be described as the decentering of surrealism. New York became something of a temporary center, building on its protosurrealist tradition dating from the Armory Show, Alfred Stieglitz's gallery, and the Arensberg circle. Other surrealists had fled to Latin America. Wolfgang Paalen, for example, went to Mexico, where he founded the review *Dyn*, which published Alfonso Caso and Miguel Angel Fernandez, but also Robert Motherwell and Anaïs Nin. In Chile, Braulio Arenas started *Leitmotif*, which published texts by Benja-

min Péret and Aimé Césaire, the latter, famously, the founder of *Tropique* in Martinique.[12] Major cities in North America and Latin America, which had been connected to the European avant-garde for decades, thus became part of a surrealist network of impressive reach.

The internationalist phase of surrealism was fueled by the types of organs through which the movement increasingly presented itself, namely, a series of explicitly internationalist journals and magazines, culminating in the publication of the *Bulletin International du Surréalisme* (1935–36). Like Picabia's mobile and international *391*, the *Bulletin* became a journal on the move, constantly changing its place of publication: the first issue was published in Prague; the second in Tenerife; the third in Brussels; and the fourth in London.[13] This internationalist trend continued in the late thirties with the London-based *London Gallery Bulletin* (1938–40), which was distributed in Paris, Brussels, Amsterdam, and New York. Among its contributors were Samuel Beckett, Gertrude Stein, Lord Alfred Douglas, Charles Henri Ford, Djuna Barnes, Edward Wadsworth, and Kurt Schwitters (then residing in the Lake District) but also Diego Rivera, Pablo Picasso, and, as always, Breton himself. War and exile gave this international trend an additional impetus but also a different character, including something of a new destination: New York City. The earliest surrealist to emigrate to New York was Roberto Matta, who founded the journal *View* there in 1940, which featured Lionel Abel, Joseph Cornell, Vicente Huidobro, Wallace Stevens, William Carlos Williams, and Henry Miller. Matta was only the beginning; soon André Masson, Wifredo Lam, and, in 1941, Breton himself followed suit.[14] Upon his arrival, Breton founded *VVV*, which published the *Prolegomena to a Third Surrealist Journal or Not*, and writers such as Arthur Cravan (amateur boxer and former dadaist), Gerard Manley Hopkins, and Nicolas Calas.

James Clifford has taken surrealism as one paradigmatic model for a traveling culture, a culture based not on a stable locale but on various types of travel, including but not limited to exile, diaspora, tourism, immigration, cultural pilgrimage, and ethnographic exploration. The surrealists participated in all of these. Breton and many others fled Paris during World War II intending to return: temporary exile. Artaud went to Mexico to find among the Tarahumaras some form of a theater of cruelty, the contours of which he first fathomed while watching Balinese dancers at the Colonial Exhibition in Paris: ethnographic colonialism. Vicente Huidobro traveled to Europe from Chile and Argentina to encounter the leading figures of the avant-garde: cultural pilgrimage. Despite its more localized origin, surrealism was thus grafted onto dada and its international network of traveling journals and writers from the beginning; as Clifford writes, "Surrealism

traveled, and was translated in travel."[15] Traveling, moving, was central for surrealism, whether in an alternative topography of Paris itself, as in Aragon's *Paysan de Paris*, or the actual and far-flung travel routes of the surrealists. Journals, exhibitions, the exchange of persons, objects, and print formed international surrealism. A short-lived London publication, which included contributions by Breton, Alfred Jarry, and E. M. Forster, articulated the moving geography of surrealism through its title: *Message from Nowhere*. However, surrealism's messages were sent not from nowhere but from New York, Santiago, Tokyo, and Fort-de-France. As surrealism spiraled out of Breton's control, it became part of what one might call, borrowing from Arjun Appadurai, the avant-garde at large.[16]

The most striking representative of the decentering of surrealism was probably Aimé Césaire, who invented what he called "my special geography too; the world map made for my own use."[17] Poised against a nostalgic essentialism of culture or location, the construction of such a personal, special geography becomes an act; Césaire insisted on calling it a surrealist act, of imagination, construction, fabrication. Césaire's particular fabrication, the neologism *négritude*, does not simply critique surrealist ethnography and primitivism but salvages from it the fact that geography is bound up with an imaginative enterprise, a locality that is never given, never natural, but always a product of movement, a project for the future.[18] Césaire is not simply the postcolonial counterpart to Breton. Césaire's relation to surrealism is strategic rather than identificatory; he uses it, draws on it, is inspired by it, but also is ready to ignore, critique, and alter many of its fundamental assumptions and strategies. Perhaps one might say that through Césaire, surrealism is writing back to Paris in much the same way that world communism, from Russia, Mexico, and China, is writing back to the Paris and London of the *Manifesto*.[19] What becomes central is the possibility of manifestos to fashion and fabricate origins. In Césaire's surrealism as in his communism, the manifesto's foundational force is put to imaginative uses in a postcolonial terrain.[20]

The Latent Manifesto

If the decentering of surrealism testified to but also undermined the effectiveness of Breton's manifestos, a second dynamic undermined the surrealist manifesto from within, driven, paradoxically, by Breton's very insistence on the instrumentality of the manifesto. While many futurist and dadaist

manifestos freely mixed with other genres and modes, the surrealist manifestos, as I have argued, were much more sober and fulfilled a more limited function. This limitation, however, caused an irreducible dichotomy between the surrealist manifestos and the forms of writing propagated by them. Breton's authoritative manifestos preach a language of the latent, of dreams, of nonwork, noninstrumentality, and nonefficaciousness, culminating in the most elusive mode of surrealist writing, *écriture automatique* (automatic writing). Automatic writing is most often described as a technique of recording, a method of transcribing something that is beyond the reach of rational thought and action, an attempt to capture the latent in a pure state. In the famous definition of the *First Manifesto*, Breton writes, "Psychic automatism in its pure state, by which one proposes to express . . . the real functioning of thought. Dictated by thinking, in the absence of any control exercised by reason, outside any aesthetic or moral concern" (1:328). Defined negatively as the absence of control and of aesthetic or moral categories, automatic writing does not shape or form but records and reveals.[21] The *First Manifesto* speaks of a "general revelation" (révélation générale; 321) and the revelatory effect of dreams. One might recognize in this conception of manifestation the older, apocalyptic tradition of the manifesto as practiced by such figures as Winstanley and Münzer, but also the invocation of an obscure language that had characterized Moréas's manifesto "The Symbolism."[22]

For Breton, however, the conception of automatic writing as the avoidance of rational, ethical, and aesthetic control is derived not from religious prophecy but from Sigmund Freud. Freud also points toward the contradiction within Breton's definition of automatic writing, for Freud deemed any hope of receiving the dictates of the unconscious in a pure and unadulterated form impossible. On the contrary, any expression can maintain at most an indirect relation to the unconscious, and this necessarily indirect relation leads to a general symptomology: nothing can be taken at face value; no expression is a pure expression and no medium a pure medium; everything is symptomatic and in need of decoding. Automatic writing may function, as Breton claims, in the manner of a "writing apparatus," but it could never, as he had hoped, function "without the work of filtering" (330). Because all means of expression are filters, there is no such thing as a neutral or pure medium; because every medium mediates, automatic writing, too, demands a system of interpretation, of translation and retranslation. Something gets expressed, something is being dictated and recorded, something is brought into the open but remains in need of decoding and interpretation.

Automatic writing is thus marred by a contradiction between pure latency and its impure manifestation.

This tension between hiding and showing had direct consequences for the manifesto. Even though Breton used manifestos primarily as instrumental declarations of will, the second, latent type of surrealist writing did influence his manifestos, and with increasing intensity. The instrumentalist use of the manifesto, in other words, was being complemented by a second strand, informed by an interest in the latent and obscure. Sometimes this second strand can be found in the largely instrumentalist manifestos themselves. Because they had to accomplish such a variety of tasks, the main surrealist manifestos are substantially longer than their dadaist or futurist predecessors, resembling more long-winded essays than series of compressed slogans that are hurled at actual or imaginary enemies. Futurist manifestos tend to be of one piece, and even dada metamanifestos are brief; surrealist manifestos are much more prone to wander and meander, so that they can never be grasped at once. The *Manifesto of Surrealism* even refers to its own style as "serpentine, distracting" (331). While reading futurist and dadaist manifestos forces on readers the frantic pace of futurism or the hectic atmosphere of the Cabaret Voltaire, surrealist manifestos set them on a much more labyrinthine course, alternating between abstract definitions, remnants of dialogue, metaphorical constructions, autobiographical revelations, associative chains, and ominous suggestions.

The feature, however, that demonstrates most clearly how much surrealist manifestos depart from their predecessors is that they include footnotes, some of them quite extensive. These footnotes, rendering surrealist manifestos downright academic, signal Breton's desire to create different layers of text, registers of discourse, and modes of argument. What for Marinetti would have been anathema to the manifesto—he ridiculed the use of footnotes in academic texts—for Breton becomes a viable way of turning the manifesto into a new and specifically surrealist literary genre.

The more Breton became immersed in automatic writing, and the more he was pressed by the Third International to defend himself against the charge of being an undisciplined bohemian failure, the more this literary quality of the manifesto moved into the foreground. At this juncture, Breton started to bring the two, automatic writing and manifesto, latent and manifest, into a constructive relation. He did so in collaboration with Paul Éluard, in a text whose title seems to mock Breton's idea of a pure automatic writing: *Immaculate Conception* (1930). *Immaculate Conception* appeared with a note describing the relation of this text to surrealist manifestos in Freud's language of the latent and the manifest: "If the *First* and the *Second Manifestos*

are the exposition of the manifest content of the surrealist dream, *The Immaculate Conception* is the exposition of its latent content" (1632). While the typical surrealist manifesto is in the service of exposing a manifest content, of clearly stating positions, automatic writing prides itself on pure latency without interference. *Immaculate Conception* occupies a mediating position between the two, a text that harbors the latent but nevertheless seeks to "expose," to make visible, in other words, to create the contradictory concept of a latent manifesto.

That Breton would be tempted to bridge the gap between the manifesto and automatic writing is in keeping with his Hegelian heritage of mediation and sublation.[23] The most famous formulation in this direction occurs in the *First Manifesto*: "I believe in the future resolution of these two states, which appear to be so contradictory, which are dream and reality" (319). The difference between dream and reality, which Breton elsewhere rephrases as dream and action, is part of a whole series of oppositions that includes the instrumentalist manifesto and automatic writing, performative action and revelatory power. The conception of a latent manifesto can be seen as one more attempt to create this "future resolution," a resolution that mediates between the latent and the manifest.

"Mediations" is in fact the title of the final section of the text and may therefore be taken as its goal. Divided into three parts, entitled "Man," "Possessions," and "Mediations," *Immaculate Conception* moves between argumentative passages and poetic expressions of the human condition in a post-Freudian age. The oscillations between the latent and the manifest are visible everywhere. This text is not a "pure" example of automatic writing, a pure writing of the latent, because Breton and Éluard agreed beforehand on the section titles, which guide the automatism in a certain direction, including that of "mediation" itself.[24] Thematically, if one can speak of themes in this text, *Immaculate Conception* begins with a series of short texts about the cycle of life from conception and birth to death; a second series deals with various mental illnesses; and the final one with the mediation of life and mental illness in everyday life. The entire text borrows from a number of theorists and philosophers. The section on birth is indebted to Otto Rank's *Trauma of Birth*, which Éluard had recommended to Breton in the late twenties, and to Freud's *Three Essays on the Theory of Sexuality*, while the concept of mediation is taken from Hegel's *Philosophy of Spirit*.[25] The section on mental illness draws on a whole range of studies, including Hans Prinzhorn's *Bildnerei der Gesteskranken* (The Figural Art of the Mentally Ill), Sylvain Eliascheff's *Writing in the Delirium of Interpretation*, and Jean Pia-

get's writings on child psychology. All these theories lend an element of the explicit to the automatism of this text.

More important than these sources is what Breton and Éluard do with them, namely, to force together the latent and the manifest. One side of this endeavor is what Breton and Éluard call the "attempt to simulate mental illness" (essai de simulation de la débilité mentale). What this attempted simulation of mental illness amounts to is a simulation of its symptoms. These symptoms are primarily represented through images, borrowed from such texts as Prinzhorn's, but also through such strategies as syntactical displacements and distortions. The symptomology of psychiatric manuals, however, is only a trigger for accessing the alogical within the authors: "We have become conscious, in ourselves, of hitherto unimaginable resources" (1:849). "Simulation" therefore does not mean so much a faking, a playing at being mentally ill, but rather a stimulation of the hidden resources of the self.[26]

However, Breton and Éluard are not content with a simulated and simulating automatic writing. They add to it a second, much more explanatory and programmatic, layer that seeks to make this latent symptomology manifest. An italicized introduction to "Possessions" explains their general intentions and places them explicitly in a surrealist program, to the point where *Immaculate Conception* is seen as a new genre of literature that should replace more traditional ones: "In our eyes the 'attempt to simulate' illnesses within us could well replace the ballad, the sonnet, the epic, the poem without head or tail, and other outmoded genres" (849). This introduction is not even the most manifest part of *Immaculate Conception*, which culminates in something very close to a classical avant-garde manifesto, several pages of condensed declarations and commands: "Don't prepare the words you cry out" (880); "Semicolons; see how even in punctuation, they are astonishing" (882); "Correct your parents" (883). *Immaculate Conception* thus is internally divided between the latent and the manifest, between the simulation of mental illness and the manifesto. This logic of division goes even further and informs the manifest part of this text as well. The list of commands begins with a specific instruction: "Don't read. Look at the white figures drawn by the spaces between the words of several lines and draw inspiration from them" (880). Even within the most manifesto-like part of *Immaculate Conception*, we are told, explicitly enough, to read not for such explicit messages but for latent ones. The result is a new type of text, between literature and manifest. Showing and hiding, the latent and the manifest—Breton struggled to mediate between those two poles and in the process dislodged both. But instead of effecting their total fusion, he created

a proliferation of divisions that inserted the latent into the manifest and the manifest into the latent.

The project of a latent manifesto continued beyond *Immaculate Conception* and informed the *Prolegomena to a Third Manifesto or Not* (1942), which includes several sections that verge on the latent, the so-called prophetic interludes. These interludes punctuate the manifesto as if to counteract and disturb the workings of manifestation and to allow the latent to erupt in the middle of the manifest. The term "prophecy" points not only to the connections among surrealism, psychoanalysis, and religion as they inform its language of symbols and their exegesis but also to the lingering romanticism of surrealism, a romanticism in Shelley's prophetic sense. Romanticism appears here as a moment of doubt in the avant-garde manifesto, a moment when the reference point of socialism, after the Moscow trials and the Hitler-Stalin Pact, seems more and more tainted and when the avant-garde is forced to seek other and older predecessors. The notion of a romantic prophecy also points to the historical transition between prophetic, apocalyptic revelation and political manifesto. To the extent that romanticism is a response to the French Revolution, it belongs in the prehistory of the avant-garde, including the avant-garde manifesto. Indeed, romanticism produced the first protomanifestos in the sphere of art, including Shelley's own " A Defense of Poetry," William Wordsworth's preface to the *Lyrical Ballads*, Ludwig Tieck's *Atheneum Fragments*, and Victor Hugo's preface to *Cromwell*. Even though these texts anticipate a new revolutionary aspiration within art and a new adversarial stance with respect to existing culture, none of them are self-declared manifestos, borrowing instead from preexisting genres—the defense, the preface, and the fragment. And they are still ensconced in the revelatory modes of prophecy and manifestation. Breton's own use of revelation, his evasion of the modern manifesto's dedication to the explicit, can be seen as a partial return to the romantic prophecy. For Breton, however, such a return is always in the service of a new task, namely, of how to turn the manifesto into a literary form and how to keep it from being dominated entirely by the Communist Party.

All these difficulties are expressed in Breton's most explicitly anti-Stalinist manifesto, the widely circulated *Manifesto: Towards a Free Revolutionary Art* (1938), coauthored with Diego Rivera and Leon Trotsky, whom Breton had visited in his Mexico exile. It is a manifesto for bad times, opening with the sentence "We can say without exaggeration that never has civilization been menaced so seriously as today."[27] The purpose of this text, however, is to remove art from the direct interventions of the Third International, thus returning Breton's old question of art and its service to

the revolution. The goal of such a service is still maintained, but the form has changed. Now it is not party membership and organization but on the contrary freedom that becomes the operative term. While insisting on such freedom, the authors studiously avoid an attitude that is sometimes expressed in similar terms, namely, art for art's sake or conceptions of pure and therefore unpolitical (unrevolutionary) art. Indeed, they claim that "true art is unable *not* to be revolutionary, *not* to aspire to a complete and radical reconstruction of society" (44). This definition ends in a chiasm: "The independence of art—for the revolution; / The revolution—for the complete liberation of art!" (47). The theoretician of the permanent revolution and the revolutionary writer thus strategically refused to resolve the conflict maintained in this crossing. Both had experienced too closely the limitations of party discipline, from the inside and from the outside, as commander and as victim, to lend their own authority to a specific literary and artistic doctrine. Rather than pinning down, once and for all, what revolutionary art is, this manifesto leaves us with an oscillating chiasmus.

Just as the authors shy away from dictatorial party politics, so they shy away from authoritative manifestos. Almost like Breton's "Prolegomena," the text opens with the declaration that the theses presented in this manifesto are "only the first step in the new direction"; indeed, one wonders whether this text really deserves the title manifesto, since the authors "by no means insist on every idea put forth in this manifesto" (46). At the same time, this manifesto embraces the characteristics of the genre by presenting itself as the foundational document of the International Federation of Independent Revolutionary Art. However hesitant, the authors thus want to start a whole organization, a new International of sorts, which this manifesto names and for which it is the first and foundational document.

While the question of how to bring revolution and art into unison remains open, what can be detailed is the meandering path Breton took between those two concepts, in particular his work on the manifesto, which he, at times, turned into an instrument of power and at others into a medium of the latent. It is in this oscillation that Breton's conception of writing takes shape, a conception that seeks to infuse the manifest with elements of the latent and vice versa. It was Breton's contribution to the history of the manifesto to have given us a clearer understanding of the tension between the latent and the manifest, a tension that remained productive throughout the avant-garde. And a second contribution must be granted to Breton as well: to have made it clear that it is through the manifesto that the revolution enters and transforms twentieth-century art.

Artaud's Manifesto Theater

Artaud's career as a writer began with a significant shift in genre. Jacques Rivière, the editor of the prestigious *Nouvelle Revue Française* (NRF), rejected Artaud's poems but offered to publish instead the correspondence he had struck up with Artaud following their rejection (1923–24). Rivière thus forced onto Artaud a generic shift from poem to letter, which he defended by pointing to the stark "contrast" between the "extraordinary precision" of the program outlined by Artaud in his letters and the insufficiency and "formlessness" of its realization in poetry.[1] Artaud's poetry was "tormented, unstable, crumbling," Rivière found, while his letters were impressive in their "force and lucidity" (31). Somehow, Artaud succeeded in writing about his poetry where the poetry itself failed.

The shift from poetry to letters was only the first of a number of generic displacements that would haunt Artaud's entire oeuvre: instead of becoming a successful actor in the theater, Artaud did his most influential acting in film; instead of directing and shooting films, he published film scripts; instead of creating a new physical theater without dramatic masterworks, he adapted a romantic closet drama, Percy Bysshe Shelley's *The Cenci*; and instead of realizing his vision of a new theater in something akin to Wagner's Bayreuth, Artaud had to content himself with publishing manifestos. Those aware of these displacements have tended to view them as unfortunate accidents, moments at which Artaud's original desires were derailed by adverse circumstances.[2] Indeed, Artaud always seemed to have ended up on the wrong side of these distinctions: while his texts celebrated the immediacy and liveness of theater, he was doomed to be eternalized by dead marks on paper and celluloid. It is therefore possible to regard this tendency of Artaud's oeuvre as a tragic failure, a product of compromises

and disappointments.[3] There are two ways, however, of understanding this failure. According to a commonly held view, Artaud's tragic failure, exacerbated by his physical and mental decay, was due primarily to external difficulties. It was easier for him to make money in film than in the theater, to write film scripts than to shoot a film, to adapt existing dramatic texts than to write new ones, and to write letters and manifestos than to establish a new theater.

I propose an alternative understanding of Artaud's oeuvre, one that points to the necessity of these generic displacements, especially the last and most consequential one from theater to manifesto. I argue that in conceiving his theater of cruelty in the form of manifestos, Artaud played out the dominance of the manifesto over art that lies at the heart of the avant-garde. Artaud, arguably the most influential figure in twentieth-century theater, was responsible for introducing into the theater the full force of the manifesto. Arguing against the assumption that writing manifestos was merely a second-best option, the only avenue open for a visionary without patrons, does not mean claiming that the manifesto and the theater are simply parallel and equal venues of realization. In fact, Artaud differs from the futurists and dadaists who had assimilated their literary writing to the manifesto in that his oeuvre is marked by a raw tension between the manifesto and the theater. Indeed, it was the struggle between manifesto and theater that enabled Artaud's oeuvre.

The contentious, but intimate, relation between manifesto and theater had been at work in all manifestos, in their desire to preposterously lay claim to authority, conjure the future, and occupy ground that they did not yet posses. In the early twentieth century, theatricality came to the fore, resulting in theatrically declaimed manifestos, as well as the various forms of manifesto plays that mark the course of the avant-garde from futurism and vorticism to dadaism, creationism, and surrealism. The relation between manifesto and theater, however, was nowhere as stark as in Artaud's master project, the theater of cruelty (1931–38). The few aborted attempts to realize this theater appear pitiful when compared with the force of the manifestos, essays, and letters that Artaud wrote over the course of several years and that he published in the same *NRF* that had published his correspondence instead of his poetry. What was originally meant as an attempt to create a new theater became essentially a literary project, a heterogeneous collection of different genres grouped around two central manifestos. It is primarily through these manifestos that Artaud influenced theater history.

The relation between Artaud's theater and his manifestos is in many ways comparable to that between Breton's automatic writing and his mani-

festos. Indeed, a side effect of the perspective offered by the manifesto is that it allows us to point to a continued affinity between Artaud and the surrealists, from whom he had learned how to write manifestos. Like Artaud's poems, Breton's automatic writing is often "formeless" and "unstable," while the manifestos in which he defends and defines automatic writing tend to be "forceful" and "lucid," calculated pieces of programmatic writing. Even though Breton and Artaud went through a much-publicized break, a break about the value and meaning of art, theater, and revolution, of the relation between the avant-garde and communism, they nonetheless shared a dependence on the manifesto. Like Breton, Artaud struggled with the latent and the manifest and sought to reconcile his practice of the manifesto with his other artistic endeavors.

However, while for Breton the dichotomy between manifesto and automatic writing led to a clash between two textual genres, Artaud's manifestos confront an entirely different art form: the theater. Artaud was thus faced with the problem not only of literary form and style but also of the complex entanglement of literature and theater. There has always existed a struggle in the theater between, on the one hand, its visual elements, including acting, set design, lighting, and architectural space, and, on the other hand, the words that were spoken onstage and could therefore be represented in written form. No one pushed this struggle further than Artaud, who attacked the regime of literature and the stifling effects of dramatic masterworks. But Artaud did not content himself with debunking the literary canon and extended his critique to the much more recent icons of surrealist literature, Arthur Rimbaud, Alfred Jarry, and the Compte de Lautréamont. In the end, he attacked all forms of literature or, to be precise, all forms of written literature: "We must get rid of our superstition of *written* texts and *written* poetry. Written poetry is worth reading once, and then it should be destroyed" (4:93–94). Literature must be destroyed immediately so that it cannot fossilize and thus be conserved and repeated. The written text is "petrifying" and "stabilizing," while the theater unleashes a "vital force" (94), which is to be found "underneath" this written poetry, a force expressed in "gestures and pronouncements and which can never be reproduced twice." By definition, theater is that which cannot be repeated and which must be created each time anew, thus becoming the art form most radically opposed to the entire system of written and reproducible literature. In his most radical moments, Artaud seems to condemn all texts, mobilizing a form of orality against the authority of the dead letter.

Artaud's attacks on literature, the most well-known aspects of his manifestos, have exerted an enormous influence on twentieth-century the-

ater. It would be difficult to find a significant director of the past fifty years who would not echo Artaud's critique of masterworks by celebrating a form of live speech, or the live event, at the expense of the literary text. Artaud's understanding of the theater as a "vital force" in contrast to the dreary and mechanical repetition of written or printed words stands behind many theories and polemics within theater studies, enforced by its institutional struggle against the literature departments from which it has tried to emancipate itself.[4] The idea that text is fixed and that performance is fluid was continued with redoubled force by the first generation of performance studies scholars. Only recently has this antitextual prejudice been transformed, in part through the influence of a very different understanding of text and writing articulated in literary theory.

In light of the privileging of live speech over writing, Artaud's vision of a theater of cruelty appears to be utterly at odds with the form in which it is articulated, namely, the manifesto, which surely is part of the system of literature, of writing, and of repetition as well. The conclusion to draw from the discrepancy between manifesto and the theater of cruelty, the conclusion drawn by most scholars, is that the manifestos calling for this theater were purely instrumental means for its realization and that this theatrical end justified the literary means. This view can be supported by many pronouncements made by Artaud himself. In a letter from 1932, which sounds surprisingly like Wyndham Lewis's critique of manifestos, Artaud declares, "There are too many manifestos and not enough works of art. Too many theories and no actions" (5:85), while at the same time reducing the function of his manifesto to that of an instrument: "I simply have to write a technical and explanatory paper of what I want to realize and how I will realize it" (86). Artaud here joins the large chorus of manifesto skeptics that formed in reaction to this genre's breathtaking explosion after 1909. In this account, the manifesto is nothing but an explanatory and technical instrument that is entirely in the service of something else, the realization of works of art. The same view is reinforced in a letter to Jean Paulhan, the new editor of *NRF*, where Artaud asks to have his manifesto "La Mise en scène et la Metaphysique" published and visibly placed. About this manifesto, he says: "I think it is what it should be. This means it is efficacious. It will work, and in the sense we desire it, in terms of allowing us to realize our ideas promptly" (98). No independent value is accorded to the manifesto as a genre, as a mode of expression, as a way of organizing and articulating thought. Artaud, it seems, has learned from Breton how to discipline the manifesto, how to turn it into an instrument with which to achieve specific

and limited effects. All that counts is its efficacy, enabling something else to take place: the actual realization of the theater of cruelty.

One of the things this manifesto was supposed to accomplish was to round up patrons and supporters for the theater of cruelty. Artaud's correspondence is full of embarrassing attempts—smooth diplomacy was decidedly not his forte—to enlist the movers and shakers in art and culture, from Gaston Gallimard to André Gide, and to organize them into a circle of patrons. Because many of these individuals were not ready to lend Artaud their official support, Artaud instead decided to create an anonymous society, and his second manifesto of the theater of cruelty, which was originally published as a sixteen-page pamphlet, contained a leaflet announcing the Societé Anonyme du Théâtre de la Cruauté, formed explicitly for the purposes of attracting funds. For the same purpose, the leaflet included favorable newspaper clippings of Artaud's previous theatrical efforts. Artaud's manifestos thus are clearly instrumental texts, means to the end of fundraising. It was perhaps because of this function that Artaud reacted so violently when Paulhan accused one of his manifestos of being "chimerical": "You have reproached the chimerical character of my theater project. It is useless for me to tell you that I am far from agreeing with you. The spectacle I want rests on an abundance of material means, these material means must be paid. There is nothing chimerical in that" (5:170–71). In elaborating this point, finally, Artaud brings out the most compelling example of a theater utopia realized by generous financial support: the creation of Richard Wagner's Bayreuth with the funds of the Bavarian king. Artaud declares emphatically: "Wagner was chimerical before Bayreuth and before Ludwig II of Bavaria, without whom we would never have seen Wagner, who would have remained utopian without Ludwig II of Bavaria" (171). Money and manifestos are the means for turning utopia into reality.

Artaud's invocation of Wagner's megalomaniac Bayreuth and King Ludwig II's boundless funds indicates just how desperately Artaud held on to the hope of realization, but also how futile this hope really was. Financial impediments certainly played a role. If the theater of cruelty could be realized only through the patronage of someone like Ludwig II, then Artaud may as well give it up altogether and remain as utopian as Wagner would have remained without his patron. "Chimerical," however, refers not only to the amount of money Artaud's theater would have cost but also to the quality of the proposal itself, for the theater of cruelty, much more so than Wagner's *Gesamtkunstwerk*, raises doubts as to whether it could ever be faithfully and adequately realized, no matter how much money may be available for such an effort. In addition to financial impediments, in other words,

there were theatrical ones; it is to these impediments that the following analysis is devoted.

Theater against Theater

In claiming that there is something impossible in the theater of cruelty, I do not mean to suggest that Artaud lacked enthusiasm for the theater. On the contrary, "theater" is the term on behalf of which Artaud operates and on account of which he dismisses so vocally the dramatic text. Artaud placed the theater, what is now called the performance event, above everything, bringing to completion a development that had begun sometime in the nineteenth century: the emergence of the theatrical mise en scène, as opposed to the dramatic text, as the core of theater.[5] Artaud understood "mise en scène" as an all-encompassing term, in the tradition of Wagner's *Gesamtkunstwerk*. Wagner had demanded that the theater break with the dominance of special interests, such as star actors, difficult dramatic authors, or imperious composers; it should stop being piecemeal and focus on realizing what it means to be theater. Yet it is a mistake to think that we know what Artaud means when he uses that term. While most exegetical efforts have been spent on the explanation of the term "cruelty," the more obscure and difficult term in Artaud's theater of cruelty is in fact that of "theater" itself.

Artaud's understanding of theater is so much at odds with the realities and necessities of theatrical representation that he ends up turning against almost all existing conceptions of theater. Artaud's attack on theater revolves around two conceptions: life and metaphysics. Liveness, a term acutely theorized by Philip Auslander, is commonly understood to distinguish the theater from the other forms of art, in particular from literature.[6] Theater, like all performing arts, happens live, in real time, and each performance, no matter how meticulously rehearsed, cannot be repeated precisely and is therefore unique, as Peggy Phelan has argued with particular force and elegance.[7] However, a certain degree of repetition, be it the rehearsal process, *répétition* in French, or repeated performances, is necessary for the theater to retain some form of frame and identity, to keep it from dissolving altogether.[8] While the liveness of the theater is thus situated between the strictly unrepeatable and repetition, what is truly immediate, unique, and irreversible, what can never be repeated, is life itself.[9] Artaud, I suggest, does not simply celebrate the liveness of the theater but, by seeking to eliminate all repetition, desires what should be called the *lifeness* of the theater, in

Maurice Blanchot's formulation, "the immediate which he [Artaud] calls 'life.' "[10] The slippage from liveness to *lifeness* points beyond the theater, for no theater can ever hope to realize the *lifeness* Artaud demands. If all repetition were eliminated, nothing would remain to which we could point and which we could identify as a theatrical event.

While Artaud's desire for lifeness points beyond the theater, the other term that exceeds the theater is "metaphysical," which appears in the title of the manifesto to which Paulhan responded by calling it "chimerical": "La Mise en scène et la Metaphysique" (Metaphysics and the *Mise en Scène*). This text, one of the manifestos collected in *The Theater and Its Double*, registers the extent to which Artaud was trying to push the boundaries of what could or should be considered as theater. Despite Artaud's obsession with a *physical* theater, a theater of gestures and not of literary texts, of sounds and cries, the theater of cruelty is also, and foremost, a theater *beyond*—meta— the physical. The term "metaphysical mise-en-scène" is thus nothing short of a paradox. It describes the very act of realization, on the stage, of ideas or concepts that otherwise dwell in the more immaterial sphere of sketches, notebooks, or manifestos. A *metteur-en-scène* is a person who deals with all the problems that are implied in such an act of embodiment or realization: how these bodies and objects, gestures and movements, are to be placed on the stage; how they interact; when they are to appear and disappear. Artaud's definition of "*mise-en-scène*" does not deviate from the historical and technical meaning of the word; for him the *scène* is indeed a space of the concrete, of objects and bodies, in short of the physical: "I say that the scene [*scène*] is a physical and concrete space [*lieu physique et concret*]" (4:45). Yet this process of realizing a theatrical event turns into an exercise in metaphysics. He speaks again and again of "ideas" and of the "spirit" that is "exteriorized" (44) in the scene, and the manifesto even contains a reference to Plato.

The tension between the physical and the metaphysical is always a tension between the theater, dependent as it is on bodies and objects, and that which lies beyond it. Artaud spent much time demanding a theater of bodies, gestures, and cries, a theater everywhere infused with the physical and concrete. At the same time there is a second strain, namely, of a metaphysics that points beyond the stage. Early in his career, this second strain, which involved a fundamental critique of and even categorical rejection of the theater, had been particularly pronounced. Artaud had declared, for example, that "all great dramaturgs . . . thought outside the theater" (1:213), adding that "one must suppress the visual side of the theater" (216). Similarly, Artaud expressed his admiration for Maeterlinck, whose work prompted him to say, "Drama is the highest form of the spirit" (346). Artaud

celebrates here a writer of symbolist dramas written explicitly against the physical theater of bodies and gestures.[11]

This early, and often forgotten, symbolist phase of Artaud also offers a fresh perspective on Artaud's later theatrical ventures, including the Théâtre Alfred Jarry and the theater of cruelty, for in them Artaud's early symbolist critique of a physical and visual theater was not forgotten but only transformed. Influenced by surrealism, to which he officially belonged for a time, Artaud imagined a theater of dreams and magic, dismissing all "external" elements as mere signs of an invisible language. Indeed, he went so far as to declare that the purpose of the Théâtre Alfred Jarry was to "break with the theater" (2:27). Sounding almost like Maeterlinck, Artaud declared that he wanted to "contribute with theatrical means to the ruin of the theater" (37). His method may have changed, but his purpose, namely, to go beyond the theater, remained the same.

Artaud's antitheatrical, symbolist phase also explains what otherwise must remain a simple contradiction, namely, why he would choose as the first demonstration of the theater of cruelty not a violent, physical, and visual spectacle, as far removed from the literary tradition and its masterworks as possible, but an established literary text, Shelley's play *The Cenci*, a romantic closet drama. Even though Artaud introduced a number of changes that seem resonant with some of the doctrines outlined in his manifestos for a theater of cruelty, he admitted that *The Cenci* was not a realization of the theater of cruelty but only a tentative anticipation of it. The overwhelming impression this play leaves is that it remains, for all intents and purposes, a closet drama, a text that seems to contradict all the dogmas commonly ascribed to the theater of cruelty.

The surprising connections between the theater of cruelty and the antitheatrical closet drama can be fathomed from Artaud's fascination with another writer of closet dramas, namely, Seneca. It was with reference to Seneca that Artaud actually planned to link the theater of cruelty with public readings of closet dramas: "Once cured, I intend to organize dramatic readings—for a man who denounces the idea of a text in the theater, that's not a bad one—public readings in which I will read tragedies by Seneca, and all the subscribers we can find for the Théâtre de la Cruauté will be invited" (3:303–4). The reading or closet drama and the theater of cruelty are being set side by side because they share a desire for the "metaphysical." The "metaphysical" side of the theater of cruelty is thus much more intimately connected to dramatic literature than Artaud's attacks on dramatic masterworks and written literature more generally might lead one to expect.[12] From his admiration for Maeterlinck and Shelley to the surrealist Théâtre Alfred

Jarry and the conceptual theater of cruelty, Artaud's theory and practice of the theater had been poised against the theater from a variety of perspectives, ranging from the symbolist closet drama to a metaphysical mise-en-scène, and from a theatrical rupture with the theater to a utopian construction of a theater that must remain at odds with all attempts of realization.

The same oscillation between the physical and the metaphysical happens with regard to Artaud's most vexed topic: language. Artaud tries to distinguish between a physical and a metaphysical aspect of language, although whenever he seeks to define either they start to blend into one another: "The metaphysics of articulate language ... means to bestow on a language its possibilities of physical vibration [*ébranlement physique*] ... to use intonations in an absolutely concrete manner" (4:56). Language can become metaphysical to the extent that it becomes physical, and it can become physical only by becoming metaphysical. The insistence on the unmediated, corporeal, and physical pushes Artaud to the most abstract, spiritual, intellectual, Platonist sphere, from which he is then bounced back to the physical. What returns through this oscillation, kept in play by the exclusion of articulate language, is once more the value of *lifeness*: "Breaking language in order to touch life, that is what it means to make or remake theater" (18). Life is everything that is unmediated, unrepresented, unrepeated, unarticulated, and for this reason it can be reached or "touched" only when everything that would want to mediate, represent, repeat, or articulate it is broken apart, interrupted, suspended.[13]

When it comes to language, then, the distinction between physics and metaphysics threatens to collapse, and Artaud is not interested in collapse. And so Artaud begins to speak of two types of languages, one that is our common, everyday, and conventional language, and another that is mysterious, new, and redemptive, a language that does not yet exist and whose fantastic qualities can only be fathomed from afar: "Of this new language the grammar is yet to be found" (132). Surprisingly enough, given Artaud's rejection of written literature, this language is sometimes even described as a future writing, a theatrical writing in the spirit of what some theorists have called the performance-text: a writing onstage. The gestures of dehumanized actors, for example, are described as "animated hieroglyphics" (65).[14] Ignoring Jean-François Champollion's deciphering of the Rosetta stone in 1822, Artaud holds on to a more primitivist understanding of hieroglyphics that is connected to his hope to resurrect a "language lost since the fall of the tower of Babel."[15] Artaud's notion of hieroglyphics seems to be inherited from the eighteenth-century debate about the origin of language. William Warburton and Giambattista Vico, among others, saw hieroglyph-

ics as the notation system of a primitive language of gestures, halfway between inarticulate screams and conventional language. Artaud's reference to the origin of language, however, is in the service of gathering the contradictory attributes with which he operates and of effecting their impossible union: a speech that is not articulate; a writing that is not fixed; a language that is not conventional. What Artaud is struggling with here is another version of the latent and the manifest. Conventional language makes manifest, whereas the "new" and mysterious language Artaud imagines would guard secrets, leave the hidden, untouched and cherish the mysterious.

Artaud was never able to give us an example of such a new and hidden language before language, to define it or describe it in any concrete sense. All we have are contradictory definitions, combining physics and metaphysics, spirit and matter, the "intellectual apprehension of the flesh"; the description of a language that isn't one. The failure either to find or to create such a language marks the ultimate impossibility at the heart of the theater of cruelty. This impossibility forced Artaud to leave the theater and to find alternative figures for his project. First there was the plague, and when the plague did not work, there was the Balinese theater or the rituals of the Tarahumaras. However, the theater of cruelty is not the Balinese theater, it is not the remnant of Inca rituals, nor is it incarnate in the films of the Marx Brothers. The theater of cruelty is a theater beyond the theater, a theater against the theater, dedicated to the impossible value of immediacy, directness, and *lifeness*, to the existence of the physical and metaphysical at one and the same time.

Manifesto Theater

Once we recognize that the theater of cruelty is "chimerical" not only because of external factors but also because of internal and systematic ones, we can begin to see that despite Artaud's denials to the contrary, the manifestos of the theater of cruelty are not pure instruments in the service of an end, the realization of a theater. The more impossible this end turns out to be, the more these manifestos become an end in and of themselves. The argument that Artaud's manifestos develop a dynamic and logic of their own lines up neatly with the history of the avant-garde manifesto more generally. Rather than extracting from Artaud's manifestos the description of some text-free physical theater, as is often done, we should recognize that his theater is in fact intimately, if contentiously, tied to his manifestos, their

tone, performativity, and textuality. Only if we abandon the instrumentalist view of the manifesto can we begin to recognize a rivalry between the theater and the manifesto and thus pay attention to the form of Artaud's manifestos. And this form and language, I argue, mediates between the contradictory values that Artaud wanted but failed to realize in the theater of cruelty.

The fact that his manifestos effectively took over the function of realizing the theater of cruelty put enormous pressure on the genre. Artaud recognized that his manifestos were not just means to an end, mere fund-raising instruments, but an end in themselves, and that they therefore required particular attention and care. Like many avant-garde manifestos, Artaud's constitute a form of action speech that abounds in formulations such as "down with," or "let's do away with," or "enough of," denouncing first masterworks, then representation more generally, before turning eventually, in futurist manner, against the "past" *tout court*. The language of these texts is one of rupture: verbs such as "rupturing" or "breaking" often accumulate in the same sentence. And now that Artaud begins to pay attention to these features, he wants to protect them at all costs. Asked by his editor to supplement this manifesto with clarifications, Artaud refused, claiming that they would "deflower its [the manifesto's] accent" (*d'en déflorer l'accent*; 120). Artaud seeks to preserve the manifesto, its most characteristic mode of aggressive, accented speech, against the pressure exerted on him by the editors of *NRF* to turn it into a more explanatory, theoretical discourse, one that would be as much in control of its own language as his early letters had been.

The celebration of the manifesto's particular "accent" and the resulting resistance to explanation is visible in many of Artaud's manifestos. Again and again, they meditate on their own virtues, but they also call into question the project of making everything finally and definitively manifest: "To express it [a true sentiment] is to betray it. . . . The true expression hides what it manifests" (*cache ce qu'elle manifeste*; 86). Even though Artaud here defends the use of the manifesto, he does not simply accept the act of manifestation, of bringing the hidden into the open, without hesitation. His theater cannot be fully explained, translated, or manifested; something of it should remain hidden. This obscuring, one might say "de-manifesting," accent of the manifesto was something Artaud later partially repudiated, admitting that the editing of the manifesto had been deficient, leading to its "abrupt" quality (137). "The Theater of Cruelty (*First Manifesto*)," after all, had partially failed: "The dialectic of this manifesto is weak. I jumped from one idea to the other without transition. No inner necessity justified the layout I adopted" (137). Rather than simply celebrating the obscure, Artaud

seems to be, to some extent at least, committed to transition, necessity, and dialectic as well.

Artaud's manifestos are thus caught between two conflicting demands. On the one hand, they should not explain and express too much while translating the "hidden" language of the theater of cruelty into the manifest language of the manifesto. The manifesto's act of making manifest must be restrained, its tendency to simplify and explain kept in check. On the other hand, the manifesto must not be too obscure, abrupt, or without transition; it should retain some form of clarity. Artaud's first manifesto tends toward the latter, being entitled, appropriately, "Manifesto in Clear Language," although this title also suggests that clarity is not a necessary feature of Artaud's manifestos but only the particular attribute of just this single one. Over the course of his career, however, Artaud's manifestos became more obscure, more attuned to the hidden, less devoted to clear language, argument, transition, and dialectics. Here, too, Artaud's path toward more obscure manifestos parallels that of his former friend, Breton; and like some of Breton's manifestos, Artaud's last manifesto was written in Mexico. "The Theater of Seraphin" bears an epitaph that could not be further from the programmatic "clear language" of the first manifesto: "There are enough details to understand it. To express it more precisely would mean to spoil it" (175). Instead, this manifesto invokes and celebrates blessed ecstasies, shouts, and exclamations, all of which contribute to the great "cry of revolt." This text, half manifesto and half poem, emulates its subject matter, a newly sacred theater, by giving up almost entirely on clarity and transition, on the desire to make manifest. Even and especially when the manifesto had factually become an end in itself, Artaud remained skeptical about a pure poetics of the manifest. We are back here at the particularly surrealist problematic of the manifest and the hidden. What Artaud and Breton share, despite their many differences, is their ambivalence about the open and the manifest; they both tried to hold on to some form of the hidden, better, they tried to introduce the hidden into the genre of the manifesto itself, producing forms of latent manifestos.

In the end, Artaud's ambivalence toward the manifesto suggests that for him it was both a means and an end. His manifestos are means to the extent that they discuss the technical problems of acting, mise-en-scène, and lighting. The technical nature of these manifestos has led to renewed efforts of realization, from Jerzy Grotowski and the Living Theatre through The Performance Group to Herbert Blau and Richard Foreman.[16] At the same time, these manifestos are abrupt, poetic, and "accented," intending to hide as much as to show, and they promote such values as *lifeness* and

immediacy that are impossible to realize in the theater. It was, perhaps, this combination of means and end that has been responsible for the extraordinary impact of Artaud's manifestos on the theater of the twentieth century, as detailed recently by Arnold Aronson, an impact so pervasive that one might even compare it to Aristotle's *Poetics*.[17]

It is in contrast to *The Poetics* that the generic function of these manifestos comes most clearly into focus. *The Poetics* tries to find the structures and formulas governing the Greek tragedies Aristotle knew. To this extent it is a purely descriptive text. At the same time, however, the act of finding these structures and formulas is informed by value judgments; Aristotle does not hesitate to privilege some tragedies, such as Sophocles' *King Oedipus*, while dismissing others. While *The Poetics* distills the rules from the past to bring them to bear on the future, the manifesto calls for a new beginning, a point zero, to force the new to arise. Where *The Poetics* derives its authority from the past, the manifesto derives its authority from the future. Because nothing of the past may be used for this future, the manifesto must invent its own ground in an act of self-foundation, an act that leads it to assume an attitude of authority, trusting only the sheer force of its own intervention and self-grounding performative speech acts.

Artaud's significance lies not just in the influence of his manifestos on the theaters of the twentieth century. His varied attitudes toward and involvements with the theater also capture the ways the theater functions within the avant-garde more generally. His oeuvre demonstrates both the absolute centrality of the value of theatricality for the avant-garde and, at the same time, the fact that this value tends to eclipse the actual theater. This is true of futurism as much as of dadaism, but it is particularly pronounced in Artaud, whose dedication to the theater exceeded that of most other avant-gardists. It is therefore not surprising that it was in Artaud that the theatrical condition of the avant-garde revealed its limits and paradoxes, playing off one theater against the other, seeking theatricality where no theater could exist and exceeding the theater wherever possible. Artaud's oeuvre demonstrates that the more the avant-garde wanted from the theater, the more it would find the actually existing theater inadequate; the more it depended on the value of theatricality, the more this value had to be detached from the theater and transposed to some other form, for example, that of the manifesto. Insofar as Artaud infused the theater with the manifesto, he can be said to epitomize the theatrical condition of the avant-garde.

A New Poetry for a New Revolution

12

The Manifesto in the Sixties

When the art manifesto split off from the political manifesto in the early twentieth century, different types of manifestos found themselves in a fierce competition, at times seeking to build on their common ancestry and at others trying to establish their independence from one another. Breton, Rivera, and Trotsky's *Manifesto: Towards a Free Revolutionary Art* (1938) can be seen as one of many attempts to bring the political manifesto and the art manifesto together again. The theme of this widely circulated text, how art should relate to politics, was also a question of authorship, how avant-gardists such as Breton should collaborate with professional revolutionaries such as Trotsky, and of form, how the art manifesto should relate to the political manifesto. *Manifesto: Towards a Free Revolutionary Art* expresses the troubled relations among political and artistic avant-gardes in the thirties; it also marks the end of an era characterized by the twin concepts of revolution and manifesto. During the forties and fifties, in the midst of World War II and reconstruction, avant-garde art and manifesto politics receded into the background, at least in the West, even though they never went entirely away.

All this began to change in the sixties, culminating in what is sometimes call the high sixties, a period that witnessed nothing less than a second wave of avant-garde activity.[1] Once more, the horizon of the revolution seemed to define the culture, politics, and forms of expression in Europe, North America, and many former colonies, and once more revolutionary art and revolutionary politics competed for attention and influence. The resurgence of political and artistic avant-gardes is nowhere as visible as in the resurgence of manifesto writing. However else one may judge the sixties' mixture of personal liberation, drug culture, protest behavior, and new avant-garde art, it proved to be a powerful formula for the manifesto. New

manifestos and new versions of older manifestos once more populated journals, magazines, and billboards, and some of them even demanded, in a Marxian manner, a new poetry of the revolution. Art manifestos, political manifestos, and, most importantly, combinations of the two began to spring up everywhere, articulating dissent, accusation, and resistance. Small, local groups demanded to be heard and soon began to form associations and networks across national borders. The sixties and early seventies witnessed not only a quantitative rise but also a qualitative change with respect to the manifesto. Even though many writers of manifestos looked for guidance to the avant-gardes of the early twentieth century as well as to the political manifestos of the nineteenth, they recognized that the new poetry of the revolution could not simply rely on its past and that new forms needed to be invented to meet the challenges of their own time. The second wave of a manifesto-driven vanguard was holding Western societies in thrall.

One term that is commonly used for the avant-garde art of the sixties is "neo-avant-garde," which is problematic not only because its meaning mostly emphasizes repetition but also because it forces into one category a large variety of art movements, collectives engaged in civil rights battles, protesters against the Vietnam War, mass universities in France and Germany, and repressive, alienated society everywhere. Sometimes the manifestos written by these so-called neo-avant-gardes repeated slogans from the early twentieth century, for example, when one group, Black Mask, demanded, futurism-like, "DESTROY THE MUSEUMS" (37) or when the Living Theatre ordered: "Abandon the theatres" (88).[2] Such repetitions, however, were driven not so much by nostalgia for earlier times as by a sense of history; they were recognitions of the fact that even something as skeptical of history as the avant-garde had acquired a tradition of its own.

If the historicity of the avant-garde is an irony, it is a productive one for the avant-gardes of the sixties used this history with profit. Far from being burdened or paralyzed by the earlier avant-gardes, the newer avant-gardes learned from their predecessors' successes and failures and managed to transform their techniques. Rather than speaking of a historical and authentic avant-garde and its empty repetition in a neo-avant-garde, a distinction that has been criticized most succinctly by Hal Foster, one should consider the repetition indicated in the prefix "neo" a productive transformation, indeed, a condition, as I will argue more explicitly at the end of this book, for inventing new and timely articulations.[3]

The perspective offered by the history of the manifesto allows us to specify the relation of the new avant-gardes to earlier political and cultural vanguards. The frame of reference used by these newer groups and forma-

tions spans the entire gamut of the history of the manifesto and even includes much of the prehistory of the genre. The San Francisco Diggers, for example, constructed a genealogy going all the way back to the Diggers. At the same time, they turned to another text in the prehistory of the manifesto, namely, the Declaration of Independence, which they transformed into a "prophecy" of an independent free city.[4] Other groups, such as the Dutch Provos (a band of angry young Amsterdam intellectuals specializing in provocation) riffed on the *Communist Manifesto*, coining the notion of the "Provotariat" (20). Such borrowings seemed to confirm, once more, the authority of the *Manifesto*, but their wit also dissociated the Provos from the more orthodox Marxist groups whose legitimacy had become increasingly hollow.

Indeed, the new avant-garde manifestos, like their early twentieth-century predecessors, were highly attuned to the history of socialism and its manifestos. However, while the avant-gardes of the thirties had been in thrall of the Third International and needed to struggle against its dominance, the new avant-gardes of the sixties by and large refused to bow to Moscow and the reconstituted International, Cominform. Communism and socialism in the West had undergone a profound shift and fragmentation. One reason was that the communist parties in the West woefully underestimated the transformative potential of the sixties. Because many of the protest movements, in Europe as much as in the United States, were triggered by students, communist parties denounced them as petty bourgeoisie phenomena; the PCF even thought that the students were being manipulated by Charles de Gaulle.[5] Many of the intellectuals who had not participated in the exodus following the party's endorsement of the Soviet invasion of Hungary in 1956 were finally turned away by the entrenched dogmatism of the party in the sixties and instead associated themselves with various splinter groups known as the New Left.

The fragmentation of socialism was also due to the fact that in contrast to the twenties and thirties, there were now several different communist nations and thus several models of actually existing socialism, including Cuba, Vietnam, and China. The latter constituted a real competition for bolshevism—but also for Trotskyism—in the West. For many, Mao represented a return to Marxian values such as equality and collectivism, and his call for the continuation of the class struggle in socialist societies, his "continuing revolution" (*jixu geming*), promised to redress the hierarchical bureaucratism of the Soviet Union and most of its satellites without, however, adopting the watered-down model of Yugoslav market socialism.[6] This fragmentation of socialism had profound consequences for the manifesto. It meant that no party or International controlled either the form or the

content of manifestos. Despite the close attention paid to Marx's writings, the preservation of the *Manifesto* and its immediate legacy became secondary, and the need to invent new manifestos occupied center stage. The result was an unparalleled explosion of manifestos, quasi manifestos, and mixtures of manifestos and artworks.

The heterogeneity of protest writing in the sixties was also a product of its social formation, of the uncountable number of small groups, sometimes consisting of only a handful of members or even of a single member, located in the gray area of artistic expression and political activism. One such party of one was the Society for Cutting Up Men (SCUM), founded by Valerie Solanas through her *SCUM Manifesto* of 1967. Avital Ronell has recently observed that Solanas's manifesto occupies a "nonplace" in the sense that it did not bring together a party, a group of like-minded fighters or sympathizers.[7] With nothing to back her up, Solanas was speaking from nowhere. This precarious position echoes Althusser's discussion of *The Prince* as a utopian manifesto, a text that does not trust its own speaking position to realize the goals set forth and therefore has to construct an agent, the prince, to do so.

Solanas, needless to say, did not wait for a prince to rescue her. Instead, she created a fictive scenario for the total elimination of men, based on a number of figures and distinctions, including drag queens, lesbians, and women indoctrinated by patriarchal society. There is one force, however, that is capable of bringing about a new maleless society by creating alternative modes of reproduction: science. SCUM, in other words, is only a question of time, and Solanas is merely helping this history to manifest itself. This, of course, was a strategy employed in many manifestos, including the *Communist Manifesto*. Unlike Marx, however, Solanas does not have a theory or concept of the forces driving this history. She gives no details as to how and when reproduction without the male will be possible; she only makes it clear that such a technique will be, or will have to be, found.

Since history cannot be trusted, violence must come to its aid. Some commentators on Solanas's manifesto tend to see its violence as a "payback," as Ronell put it, for the history of misogynist manifestos, especially those of the futurists.[8] Solanas's relation to futurism is complicated, however, for her belief in techno-history is indebted to that movement. Perhaps SCUM's violence, and its relation to gender, can be better gauged by comparing it to Höch's *Cut with the Dada Kitchen Knife through the Last Weimar Beer Belly Cultural Epoch of Germany*, which cuts not only through the undoubtedly male "Weimar beer belly" but also through manifestos written by her male dada brothers-in-arms. Höch cuts through the genre of the manifesto with

(banding)

her domestic utensil; she attacks the manifesto on gender grounds, thus anticipating third-wave feminism as expressed, for example, in the recent book, whose title announces a specifically female manifesto, *Manifesta: Young Women, Feminism, and the Future.*[9]

Solanas's knife, however, is precisely not a kitchen knife but a switchblade used in street combat. She does not find it necessary to critique, queer, or gender the manifesto as a form. For her it does not seem to be in any way tainted or otherwise incompatible with the project of a maleless society. It is simply there for the taking, and take it Solanas does, adopting and inhabiting many of its features to the full, including the violence, the invocation of history, the belief in a futurist technology, and also its extreme impatience. Indeed, the *SCUM Manifesto* unapologetically articulates a universalist and hegemonic position. Perhaps Solanas's isolation and her universalism are two sides of the same coin, the two poles of an absolutism that speaks through every word of this text. In this respect, one is reminded here not so much of Höch or the *Manifesto of the Futurist Woman* but of Marx or Luxemburg, for whom every word of the manifesto is met with impatience lest the action that will finally bring about the revolution be further postponed. Perhaps it was this fear of postponement that gave rise to the seemingly wanton violence that characterizes the *SCUM Manifesto*, the only means this text can trust to turn its "nonplace" into utopia.

Violence is also what made the *SCUM Manifesto* notorious, not the violence it recommended but the violence of a much-publicized act by its author: the shooting of Andy Warhol. For some, this act resonated with Breton's provocative definition of surrealism as an act of randomly firing into a crowd.[10] For others, it anticipated radical feminist groups of the seventies such as Women's International Terrorist Conspiracy from Hell (WITCH), Cell 16, the Furies, the Redstockings, and the Feminists. When Solanas turned herself in, she made sure to closely align her act with the content of the manifesto, commending it to the policeman who arrested her. Nevertheless, it would be hasty to understand this act as the enactment of the manifesto, the warning shot and first taste of the SCUM violence to come. The immediate cause for the shooting was not the manifesto but a play: Andy Warhol, who had previously given Solanas small parts in his films, had lost the only copy of her play *Up Your Ass*. This play, written in conjunction with the manifesto, was supposed to be the enactment of the manifesto. The shot was only an act of desperation and substitution at the moment when Warhol seemed to be responsible for having made the manifesto's theatrical enactment impossible.

It is a historical irony that in the end it was the act of shooting Warhol that returned *Up Your Ass* to theater history. A researcher working on the movie *I Shot Andy Warhol* (1996) found the play, which is now part of the Warhol museum.[11] The play, whose full title reads, *Up Your Ass or from the Cradle to the Boat or the Big Suck or Up from the Slime*, takes terms and figures from the *SCUM Manifesto* and turns them into characters. We have the idiotic chauvinist in the sheepskins of liberalism, and the woman who is completely indoctrinated by patriarchal society, but also the drag queen, whom Solanas sees as an appropriately self-hating man, and the wavering mother, whom Bongi, a stand-in for Solanas herself, manages to convert in the end.

Up Your Ass is many things, including agitprop theater and a conversion tale. Most importantly, however, it is an enactment of the *SCUM Manifesto*. Because of the extreme isolation of Solanas, her program called for the most imaginary and imaginative form of enactment, precisely not an actual shooting but a theatrical enactment. But what would an enactment, even in the theater, of the *SCUM Manifesto* look like? The gap between the nonplace from which the manifesto speaks cannot so easily be filled by the theater. The play culminates, and abruptly ends, with the seemingly wanton murder of a young boy by his mother, Bongi's only convert. The conversion to SCUM thus leads to a repulsive act, more repulsive, certainly, than the shooting of Warhol. Indeed, the two acts of violence have a common structure: they are the consequences of the fact that an enactment of SCUM remains illusory, even in the theater.

Even though it fails as an enactment of the manifesto, *Up Your Ass* must be considered one more form of manifesto theater. Play and manifesto depend on one another, support one another, and are translations of one another. *SCUM Manifesto* and *Up Your Ass* form a diptych, comparable to the many forms of manifesto drama in the twentieth century, including those by Tzara, Lewis, and Artaud. In the case of Solanas, the dependence of the manifesto on the theater and vice versa is particularly intense, but also particularly precarious. We are encountering here a limit case of manifesto theater, the extreme isolation of a manifesto that can find enactment only in the theater, but this theater can only figure this enactment as an act of random violence. Performativity and theatricality have seldom been so far apart as in the case of Solanas, and rarely have they been forced back together with as much determination.

Solanas was isolated but not alone. She was surrounded, in Greenwich Village and elsewhere, by countless groups and associations with differing agendas and programs, languages and manifestos. The ephemeral and

heterogeneous nature of this second wave of manifesto writing makes a survey or quantitative analysis impossible. Too many small groups issued manifestos and declarations, too many utopias were constructed, too many programs outlined, and too many of them disappeared almost instantaneously. In 1971, two participant observers noticed that the hundreds and thousands of sixties manifestos, pamphlets, leaflets, and declarations were disappearing as fast as they had appeared and decided to collect them in an anthology; one might consider it the '68 version of Tzara's collection of dadaist manifestos or Huidobro's collection of creationist ones. The result was an extraordinary anthology, named after the Malcolm X slogan, *BAMN (By Any Means Necessary): Outlaw Manifestos and Ephemera 1965–1970*, which ranged from the situationists and the Weathermen to the Living Theatre.

Published in 1971, only one year after the fact, this editorial project is preservationist even as it conjures the immediacy of the events preserved. In the opening sentence, the two editors declare:

> At some moment in the social frenzy of the past six years, you may have held a piece of this book in your hand. Perhaps you read it or glanced at it and, seeing it was only a thing of the moment, you added it to the great paper oceans that fill your streets. Or perhaps it caught your eye as a flyposter, nailed to a tree, published in a "now-you-see-it-now-you-don't" magazine or news-sheet. . . .
>
> This book is an attempt to offer up to you for a second time certain bits of paper, now embalmed between covers, which once got away. (12)

From the immediacy and danger of the street to the "embalmed" preservation in a book, these second-wave manifestos are printed "a second time," which also means that the collection is "by its nature incomplete and out-of-date" (13). Embalming the ephemeral, archiving what was once immediate, is the necessary operation of all anthologies, but an anthology committed to the manifesto must view this necessity with regret. At the same time, the editors endow these manifestos' original context with revolutionary myth. In a gloss on "My Cultural Revolution," a manifesto written by Salvador Dalí, they inform us that this manifesto was "picked up behind the barricades in Paris" (130) before it was included in the collection. Dalí's pamphlet, however, had tried to distance itself precisely from this romanticism of the barricades: "The finest and most profound cultural revolutions take place without barricades." The editors' barricade fantasy can be found in most manifestos: the desire to be the trace of an action that took place in

its name. While "embalming" the manifesto is a rescue operation that is necessarily belated and "out-of-date"—part of cleaning up the streets after the battle—this barricade fantasy fulfills the manifesto's most secret wish, namely, that of becoming the weapon itself: "[A piece of this book] may even have whizzed past your head while wrapped round a brick and thrown through an established window" (12). An explicitly "cultural" manifesto is thus turned into political violence, the "finest and most profound" revolution into the realities of street combat.

All twentieth-century avant-gardes had been political in some sense, and all had been driven by some conception of a social revolution, whether a socialist revolution, as in the case of Berlin dada, surrealism, and Russian futurism, or a fascist one, as in the case of Italian futurism and British vorticism. But the second-wave manifestos were even more directly involved in making political interventions. How to relate an artistic avant-garde to revolutionary politics, as Breton and Trotsky had tried but failed to do, how to integrate the artistic manifesto with the political one and the new avant-garde with a new Marxism, became the central task of the sixties' avant-gardes.

On both sides of the Atlantic, one prominent paradigm for political revolt was the struggle of the Black Panthers. Their widely circulated manifesto, also collected in *BAMN*, deliberately evokes the American prehistory of the manifesto, namely, the Declaration of Independence, which the Panthers reproduced word by word as the tenth point of their program (1967). The Panthers borrowed this strategy from the nineteenth-century women's suffrage movement, whose Seneca Falls convention had led to a rewriting of the Declaration as a suffragist text. In the Americas more so than in Europe, the influence of the *Manifesto* thus competed and sometimes fused with declarations of independence.

One of the most vocal advocates of the Panthers in Europe was the thief-turned-writer Jean Genet. After having become an infamous novelist and then famous playwright, Genet became a political activist late in his life, living with a group of Palestinian freedom fighters and with the Panthers. Shortly before his death, Genet turned these experiences into his last work, *Prisoner of Love*, which is an extraordinary meditation on the relation between revolution and theater: "The Panthers' demands, as expressed in their 'ten points,' are both simple and contradictory. They are like a screen behind which what's done is different from what's seen to be done."[12] The manifesto as screen—one of Genet's most famous plays is called *The Screens*—is a figure for the manifesto's theatricality, but at the same time that which en-

ables the political struggle to take place. This relation between theatricality and revolution becomes the center of Genet's analysis:

> The Whites' recoil from the Panthers' weapons, their leather jackets, their revolutionary hair-dos, their words and even their gentle but menacing tone—that was just what the Panthers wanted. They deliberately set out to create a dramatic image. The image was a theatre both for enacting a tragedy and for stamping it out—a bitter tragedy about themselves, a bitter tragedy for the Whites. . . . And they succeeded. The theatrical image was backed up by real deaths. The Panthers did some shooting themselves, and the mere sight of the Panthers' guns made the cops fire. (97)

Even though the theater of the revolution was "backed up by real deaths," Genet does not see the theatrical image adopted and the real act committed as opposed, or the one as the realization of the other. The two merge in a double tragedy in which the "mere sight" of an armed Panther leads to an actual shot. The costumes of the revolutionary, to which the gun belongs as well, thus become a weapon in the struggle over the image, the play, and the revolution. Genet's description fuses theatrical pose and performative action. Indeed, no one was more attuned to the theatrical reality of the Panthers than Genet, who had immersed himself both in the artifice of race onstage and in the hardship of revolutionary struggle on the ground. While many of the '68 groups and formations can be accused of having been, in the end, of little consequence, the Panthers were a highly disciplined, organized, and effective group that managed to change the discourse of race in the United States. That they, and not their more idiosyncratic and quixotic contemporaries, can be read in terms of theatricality proves just how closely theater and performative action, theater and revolution are intertwined.

13

Debord's Society of the Counterspectacle

Of all the second-wave groups documented in *BAMN*, Genet singled out one that aimed at precisely the conjunction of theater and revolution driving his analysis: the situationists. Incidentally, they were also among the strongest supporters of the Panthers in France.[1] The situationists had emerged from an assortment of neo-avant-gardes in the 1950s, including CoBrA (Denmark, Belgium, Holland), the Lettriste Internationale (France), and the Imaginist Bauhaus (Italy). In existence from the fifties to the early seventies, they came into their own during the May '68 revolt in Paris by advocating and participating in the occupation of universities and factories. As was the case with so many avant-garde movements, situationism was based in Paris but not exclusively French. Important members came from Holland, Scandinavia, Italy, Romania, and Tunisia, and smaller groups formed elsewhere, in particular in England and the United States. Even more international than their actual practice was the range of their interests. The situationists wrote about the war in Algeria and the Watts riots in Los Angeles, the Vietnam War and lynchings in Alabama, urban poverty in Berlin and student life in Paris. May '68 was their moment of fame, but it was also their downfall. Attempting to marry a new avant-garde practice to a new revolution, they did not survive the triumph and failures of the student revolt and dissolved in the early seventies. Nevertheless, they left their marks on resistance movements in Europe and the United States, including the Provos, the Yippies, the Weathermen, the Black Panthers, and Up Against the Wall/Motherfucker (Valerie Solanas's sometime boyfriend, who organized a guerrilla street theater on her behalf after her arrest, was a member of Up Against the Wall/Motherfucker) all the way to the Sex Pistols.[2]

The significance of the situationists, however, lies not so much in their influence on others as in their attempt to bring the two major strands of the manifesto, namely, the communist manifesto and the avant-garde manifesto, to a new conjuncture. Inspired by the Marxist philosopher of the everyday, Henri Lefèbvre, the situationists tried to base a cultural revolution on a critique of capitalism in its newest, mediatized form. For this form, they famously chose the term "spectacle," which found its most sustained and influential theoretical treatment in Debord's *Society of the Spectacle* (1967). The term "spectacle" denotes not simply the mediatization of postwar Western capitalism but its entire ideology: television, advertising, commodity fetish, superstructure, the whole deceptive appearance of advanced capitalism. Debord anticipated what Althusser would soon call the ideological state apparatuses.[3] Together with Herbert Marcuse's *One-Dimensional Man* (1964), *Society of the Spectacle* became a foundational theoretical text for the May '68 revolt in France and elsewhere—*L'Espresso* called it the "manifesto" of a new generation.[4]

Like so many 68ers, as they are still called in France, the situationists continued to think of themselves as part of a Marxian tradition, but they did not accept orthodox Marxism either in its content or in its forms. In particular, they did not accept the *Manifesto* as the original and authoritative articulation and genre of revolutionary writing. Both its mode of expression and its claims had to be revised, updated, and transformed. For this purpose, the situationists undertook the most sustained attempt to let the communist manifesto and the avant-garde manifesto inform one another. To be sure, the avant-garde manifesto had never been completely unhinged from the socialist tradition. But even though some avant-garde movements, such as Berlin dada and surrealism, had associated themselves with communist parties, their writings had never stood directly in the tradition of Marxian theory. The situationists made the most sustained attempt to confront the two traditions of the manifesto and to forge from this confrontation a new and third tradition.

To specify the particular form of the manifesto developed by the situationists, it is thus necessary to distinguish their manifestos from both the traditional communist manifestos and the manifestos of the historical avant-garde. For just as the situationists did not accept the *Communist Manifesto*, so they did not simply repeat the various avant-garde manifestos either. In contrast to the metamanifestos of the historical avant-garde, in particular those of dadaism, the situationists' use of the manifesto was more restrained, calculated, and serious. And unlike the similarly restrained manifestos of Breton, theirs were less meandering, latent, and allusive and more

intent on making explicit political interventions. Despite this restraint, they never produced a foundational and authoritative "Manifesto of Situationism." It was only when they were about to break up that the question of such a synthesizing manifesto was brought up by Paolo Salvadori, a member of the Italian branch. In an unpublished but circulated text, he warned that such a manifesto should not be "a book, or an article (like the "Address to Revolutionaries of All Countries," for example) that would arbitrarily be called a 'manifesto.' "[5] He made it clear that such a manifesto would have to undertake a full-fledged critical revision of Marxism.

Salvadori's proposal was not taken up because it was ultimately superfluous: the situationists had been rewriting the *Manifesto* all along through an avalanche of texts ranging from short and provisional manifestos to longer treatises such as *Society of the Spectacle*, whose 221 numbered paragraphs combined the equally numbered bullets of avant-garde manifestos with the historical sweep and theoretical aspiration of the *Manifesto*. Even though they rejected some of the more playful excesses of avant-garde manifestos, the situationists profited from the irreverence of the historical avant-garde: unlike more orthodox Marxists, they were not worried about supplementing and supplanting the *Manifesto* and thereby challenging its authority. Indeed, they understood, and this insight is registered in Salvadori's proposal, that a new manifesto would have to openly compete with and replace the *Manifesto*. The countless and creative manifestos of the historical avant-gardes thus encouraged them to invent their own particular forms of manifesto writing.

The most important lesson the situationists learned from the historical avant-garde, however, was to emphasize that aspect of the *Manifesto* that had mostly been ignored in twentieth-century socialism, namely, its poetic form and language. The socialist tradition had spent a lot of time arguing about whether the content of the *Manifesto* had to be updated or left unchanged, but this tradition had neglected to do the same for the *Manifesto*'s language and form (while, conversely, the avant-garde had worked on the *Manifesto*'s form, but little on its content). The situationists thus devoted their energies to refining and redefining the form of the manifesto.

The phrase they used with particular frequency to signal their reform of the manifesto was none other than Marx's call for a new "poetry" of the revolution. Indeed, the situationists can be said to have derived from this phrase a theory and practice of language that have been implicit in my own study: to the extent that the manifesto is the poetry of the revolution, it demands a revolutionary theory of that poetry. The situationists knew that the revolution of "poetry," and of language more generally, must go

hand in hand with the revolution of the social world: "Words will not stop working until people have stopped working."[6] However, this equation works in the other direction as well. A revolution that leaves intact the language of bureaucracy, as it occurred, for example, in the Soviet Union, is incomplete. Language itself must thus be subjected to a revolution: "The critique of the old world is achieved with the language of this world and at the same time against this world" (462). A new manifesto, a new poetry of the revolution, must thus be born from a revolutionary theory of language.

Speaking of a "poetry" of the revolution in this manner, as the situationists recognized, had little to do with lyrical poetry. "Today for the S.I. [Situationist International] it is all about a poetry necessarily without poems" (327). Instead, "poetry" signified the challenge of unmaking and remaking language for the purpose of the revolution. Such unmaking and remaking was based on a critique of language that is reminiscent of Nietzsche and Foucault. Recognizing that "words co-exit with power" (325), the situationists argued that language had become a tool of suppression. In this form, language played into the hands of bureaucrats who use words as if they were "identity cards" (325). This is not simply the claim that whoever controls language will control people but that language itself, the way we use language and are used by it, works for the forces of order and stability, the bureaucratic societies of the first and second worlds.

Language plays into the hands of the state, but it can be reclaimed and turned against the state as well. Some proposals in this direction were utopian. Mustapha Khayati, for example, envisioned a dictionary that would "be a kind of machine with which one can decipher information and tear apart the ideological veil" (467). Other projects and practices, however, were more plausible and productive, trying to take advantage of moments of resistance within language, what the situationists called the "phenomenon of the in-submission of the words, their flight, their overt resistance" (325). At times, these proposals sound outright Artaudian, for example, when they recommend that we help language "regain its richness and, breaking its signs, recover at the same time, the words, the music, the cries, the gestures, the painting, the mathematics, the facts" (327). According to the situationists, there existed an "écriture moderne" (325) and a "poetry" that could tap into "the revolutionary moment in language" (326) and thus turn language against the state and even against its own tendency toward order and control. Finally, they conclude that "all revolutions were born from poetry, were created through the power of poetry" (328). Pointing to the collaboration between language and power, language and ideology, language and capitalism is a familiar exercise, and the situationists cannot claim to have in-

vented this type of analysis. But they can be credited with having pursued this analysis to the end and with having used it as a point of departure for creating a new practice of theory and writing, based on the recognition that a poetry of the revolution must arise from a revolution of poetry.

Initiating a revolution of poetry to create a poetry of the revolution is a project that was also pursued by the authors and theorists gathered around the journal *Tel Quel* and in particular by Julia Kristeva in her study *The Revolution of Poetic Language.*[7] Here Kristeva applies a Marxist vocabulary to the analysis of language and seeks to consider stable names and terms as products and commodities in a Marxian sense: words hide the labor that produced them just as commodities hide the social relations that went into their production. It is remarkable that *Tel Quel* and the situationists never recognized or at least never acknowledged their mutual interests, their common attempts to connect an "écriture moderne" to a poetry of the revolution. It would take a more thorough analysis of the sociology of Parisian avant-gardes to determine why *Tel Quel* and the main situationist journal, the *Situationist International (SI)*, never bothered to interact, not even when *Tel Quel* refashioned itself as a political avant-garde (complete with manifestos) in the late sixties. Criticism has by and large reproduced this noninteraction, with scholars of the situationists rarely mentioning the striking similarities at work in *Tel Quel* and vice versa. Critical clichés about the "conservative" nature of poststructuralism, on the one hand, and dismissals of activism as being naive about language, on the other, have perhaps reinforced this scission. What Parisian infighting and our own critical traditions have kept apart should now be brought together, and the two must be seen as complementing one another in their common goal of attempting a conjunction of revolution and poetic language.

The specific technique developed and perfected by the situationists to use a language tainted by power against that power, to turn the instrument of the state against that state, was that of *detournment*. Detournment denotes the use of old material for new ends, a belief that anything can be unhinged from its original context, turned around, and put to fresh uses.[8] Convinced that the spectacle had infiltrated everything, including those societies that defined themselves as actually existing instantiations of the legacy of the *Manifesto*, the situationists knew that they could not find a mode of articulation, a sphere of society, a technique of revolt untainted by the spectacle. The spectacle's ubiquity, however, did not lead them to give up all hope for resistance, but to invent strategies that would take this ubiquity as a point of departure. Detournment is such a strategy, a way of turning the products of the spectacle against itself. Since everything is part of the spectacle, resis-

tance can only take the form of targeting the spectacle with
by perverting, displacing, disfiguring, and redefining the
that the ideology of the spectacle is both revealed and cha

Detournment was applied to the spectacle but als
particular to language insofar as it had been used by the
the spectacle is attacked at the level of language can a t
strategy be born: "The critique of the dominant language, its detournment,
will become the permanent practice of the new revolutionary theory" (462).
Both this practice and this theory are brought together by a new manifesto.
Here, too, the situationists took a development within the historical avant-
garde to an extreme. Retrospectively, we can recognize that Tzara, Lewis,
Breton, and Artaud had all been trying to detourn the manifesto, but only
Debord elevated this technique to the status of an explicit doctrine.

An alternative way of describing detournment is as a form of dialec-
tics, a dialectical approach applied to language. Just as Marx did not follow
the utopian socialists in dreaming up worlds free of the forces of industrial-
ization, the situationists did not hope for a pure and original language un-
touched by the spectacle; and just as Marx tried to locate a revolutionary
potential at the very core of industrialization, the situationists hoped to find
it in the very language used by the state: "The replacement . . . of the master
of speech (and of thinking), of the entire inherited and domesticated lan-
guage, will find its adequate expression in the revolutionary cells of lan-
guage, in the detournment, generally practiced by Marx, systematized by
Lautréamont and which *S.I.* made available for the entire world" (463). This
way, detournment was grounded in Marx.

Nevertheless, the situationists even applied detournment to Marx's
writings themselves, including to the signature phrase "poetry" of the revo-
lution. One can find this phrase therefore in many forms scattered among
situationist texts. "The revolution of everyday life cannot draw its poetry
from the past, but only from the future" (202) is a relatively felicitous ver-
sion, adding only the new keyword "everyday" to Marx's phrase from the
18th Brumaire.[9] In another text we read: "The next revolutions are con-
fronted with the task of understanding themselves. They must totally rein-
vent their own language and defend themselves against all recuperations
prepared for them" (460). And in yet another text it is claimed, "Future
revolutions have to invent their proper language themselves" (467). The
texts of the situationists, like no others, take up this challenge of reinventing
the poetry of the revolution, thus continuing the task Marx had set for him-
self, and their recycled quotations of Marx's phrase are themselves instances

both their dedication to Marx and their hope to use—detourn—the past in order to create a new poetry, a new manifesto, a new revolution.

The Detournment of Art

While one target of Debord's detournment was the manifesto, the other was art, including avant-garde art. Like other figures associated with the new avant-gardes of the sixties, Debord recognized that far from interrupting the spectacle, even the most experimental and disruptive avant-garde art had become part of the spectacle by having acquired a comfortable place in the world of art auctions, museums, and academies. Moreover, the spectacle had even managed to incorporate many avant-garde techniques themselves, using them freely for advertising and marketing. Recognizing the failure and "ideological confusion" (36) of the avant-garde, the situationists thus drew a radical conclusion that set them apart from most neo-avant-garde movements: to renounce the making of art entirely. Instead, they devoted themselves to making anti-art, which they called "situation." The notion of anti-art had of course been part of the avant-garde since dadaism.[10] But as in the case of the manifesto, the situationists were willing to go farther than many in systematically calling into question the production of art. For this purpose, they relied on a critical theory of the spectacle: only by means of a critical theory of the spectacle could anti-art be kept from being co-opted by the cunning of the spectacle.[11] What was central, however, for the relative success of their strategy was not just this theoretical insight but the practical consequence they drew from it: to confront the practice of art with a second practice, that of theory. The result was a mixture of art and theory that was meant to keep art from being commodified even as it kept theory from being aloof.

The requirements for achieving this mixture of anti-art and theory were high: not only did such a mixture need to be resistant to the spectacle's most cunning seductions, it also had to gesture toward or even partially effect the transformation of everyday life. Despite their utopian aspirations and enthusiasm, the situationists were not naive about the chances for a profound transformation of society. From Marx they had learned to define their world as a prerevolutionary one, and the revolutionary horizon implied in this definition meant that the total transformation of everyday life, the end of alienation, or what they preferred to call "separation," was only possible after a full-fledged social revolution.

Nevertheless, the situationists hoped that it would be possible to create pockets of nonalienation or nonseparation as an anticipation of and preparation for the total transformation achieved by a revolution. The term for this provisional nonalienated totality was what gave the group its name: the situation. It was the situation that would be the alternative to the art-work: "The situation is conceived as the opposite of the artwork" (75). Op-position, here, means substitution: after the failure of avant-garde art to resist co-optation, something different and altogether new has to take its place, and this new practice is the creation of situations. Even though the creation of situations was supposed to be the "opposite" of the artwork, the situationists could not help but use various art forms as models for these constructed situations, preferably those arts that themselves aspired to some kind of all-encompassing totality. Prominent among them were three: urban design (what they called urbanism), theater, and cinema.

The situationists were drawn to urban design because it is the art form most fully integrated into the everyday life of the city, their primary habitat. As true dialecticians, however, they mistrusted their own fascination with urban design and proceeded to critique all of its existing forms, espe-cially the still dominant Bauhaus, regarding them as tools of the bureau-cratic state, which was responsible for alienation and discontentment. To come up with an alternative, the situationists built on one of the groups from which they had emerged in the fifties: the so-called Imaginist Bauhaus. According to the Imaginist Bauhaus (and the later situationists), the central fault of the original Bauhaus had been its collaboration with the state; the building of workers' cities and corporate headquarters, no matter how pro-gressive and utopian they may have been, had invariably increased the effi-ciency of capitalism, to say nothing of the Bauhaus's use of the latest indus-trial prefab techniques. Increasingly radical (and in accordance with their general anti-art stance), the situationists attacked not just particular build-ings and building techniques but the construction of buildings *tout court*. Later, Debord expelled one member from the group for accepting a commis-sion for a building, and, what was worse, a church. "Art is the opium of the people," the Imaginist Bauhaus had proclaimed in one of their countless detournments of Marx in 1956; building a church then must have struck them as an outright overdose.[12]

Instead of building houses, the situationists developed the protocol of the *dérive*, the organization of anarchic drifts through existing city space. The drift not only was supposed to have evaded the opium of art; it also became a means of disintegrating the city so that it could no longer increase the stratification of alienated society. These drifts sometimes lasted for days

and were recorded or recounted later in a nonnarrative and nonlinear fashion, combining local experience, perception, and deliberate disorientation. Drifting through Paris, without goal or purpose, was seen as a way of decentering the city, of turning it into a labyrinth without center, axes, peripheral rings, and commuters' cities; it became the activity with which to resist all the ways in which urban spaces channel people and commodities, separating classes, professions, and races. In the *dérive*, or so was the hope, the city would finally be unhinged from the oppressive state and become a true situation.

In the process of elaborating the drift, an element of urban architecture came into view that perhaps most embodied urbanism's complicity with social engineering: the map. Once more, however, the situationists used an oppressive system where it was strongest in order to turn against it: to transform the city into a labyrinth open for a *dérive*, they detourned the map. Maps were cut up and reconnected by arrows and drawings, or they were juxtaposed with old maps, such as medieval T-shaped maps. Sometimes these decentered maps coalesced into whole model cities, for example, Debord and Asger Jorn's Naked City or Constant Nieuwenhuis's New Babylon.[13] But the purpose of all these constructions and projects, undertaken under the new label "unitary urbanism," continued to be the destruction of the spectacle: "The situationist destruction of the actual conditioning is already at the same time the construction of situations" (216). Destruction and construction remained a balancing act, whose one extreme would be purposeless vandalism and the other naive utopianism. The performance of a drift and the detourned map are located between those two extremes; they are both an undoing of the city and the emergence from this undoing of a "situation." The detourned map is thus the counterpart to the performance of a drift, its trace.

The oscillation between destruction and construction corresponds to the situationist use of the manifesto. Like the map or the sketch, the manifesto is the articulation of a preliminary and provisional project. Indeed, the situationist sketches, models, maps, and drafts were often combined with manifestos.[14] Constant, for example, used his models and drawings of New Babylon not as actual blueprints, but as part of his lectures, demonstrations, and manifestos, as imaginative ways of changing the way people think about and use maps and models. Again, it is central here to consider these architectural and urbanist manifestos not simply as additions to real architecture, to actually existing buildings, but as part of an architecture that no longer views building as its only goal and instead hovers between theory and realization. Situationist architecture therefore deserves to

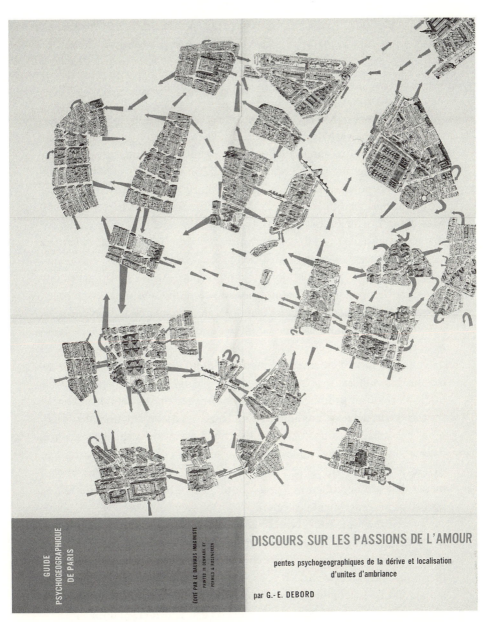

GUIDE PSYCHOGEOGRAPHIQUE DE PARIS

ÉDITÉ PAR LE BAUHAUS IMAGINISTE
PRINTED IN DENMARK BY
PERMILD & ROSENGREEN

DISCOURS SUR LES PASSIONS DE L'AMOUR

pentes psychogeographiques de la dérive et localisation
d'unites d'ambriance

par G.- E. DEBORD

Figure 13.1. Guy Debord, *Psychogeographical Guide to Paris: Discourse on the Passions of Love*, 1956. Beinecke Rare Books and Manuscripts Library, Yale University.

be called manifesto architecture to the extent that its maps and models are in the service not of practice but of a practice of theory, a theory, moreover, that regards the designing of buildings and urban spaces with suspicion and whose primary purpose is the revolutionary undoing of all existing architecture and urbanism.

This manifesto-driven urbanism emerged from the avant-garde architecture of the early twentieth century. There existed a tradition of such projective and provisional architecture—manifesto architecture—ranging from Bruno Taut to Walter Gropius, a tradition that anticipated the explosion of conceptual, model-oriented, and theory-driven star architects currently concentrated in leading U.S. architecture schools such as Rem Koolhaas, Peter Eisenman, or Bernard Tschumi. One might go so far as to say that a substantial part of the history of architecture, at least in the twentieth century, has been driven by unrealized projects, sketches, maps, and manifestos. Once more, the situationists did not invent a whole new practice but recognized a development within modernist culture and took it to an extreme. In their hands, the map, the model, and the manifesto were brought to a moment of fusion, creating a unique example of manifesto art: manifesto urbanism.

The task of creating situations without falling prey to the spectacle led the situationists to experiment with a second art form, one that like unitary urbanism promised some kind of integrated and total experience: the theater. In the text "Preliminary Problems in the Construction of a Situation," the creation of a situation is described in an unabashedly theatrical manner as a "collective" endeavor that nevertheless requires a "director" as well as a "metteur en scène," who "coordinates" the arrangement of elements that are described as "decoration" (12). The situation here is described as an experimental theater.

At the same time, however, the situationists considered the theater to be dangerously complicit with the spectacle—*spectacle*, after all, also means "theater" in French. This complicity was visible in those theaters that mimicked the spectacle by obscuring the manner in which theatrical representation is actually created. A prime example of such a deceptive, theatrical spectacle was Wagner's total work of art, which created the appearance of an organic, theatrical unity while hiding the mechanisms required for its production. In an early text, Debord explicitly denounces Wagner for attempting a grandiose but "futile" and even dangerous "aesthetic synthesis."[15] It was precisely this "synthetic" tendency of the Wagnerian theater that was unacceptable to Debord.

The situationists' critique of theatrical totality, Wagnerian or otherwise, encoded in the term "spectacle," was part of a long tradition of Marxian thought that used the theater or theatricality to describe the representational practices and effects of capitalism. This tradition begins with Marx's own theatrical analysis of the revolution and also of the commodity fetish and continues with Walter Benjamin's and Lukács's notion of "phantasmagoria," which Theodor W. Adorno would relate back to Wagner's *Gesamtkunstwerk*.[16] From this vantage point, Debord's theater-inspired notion of the spectacle is one more way of identifying and denouncing the deceptive theatrics of capitalism.

Torn between relying on the theater to describe the situation and attacking the theater for its affinity to the spectacle, the situationists viewed the theater with profound ambivalence. At times, they wanted to do away with it entirely: "The construction of situations will replace the theater" (12). But for imagining such a posttheatrical situation, they borrowed from all kinds of modernist theater visionaries and practitioners who themselves had critiqued the theater. The theater thus kept reappearing in the pages of *SI*, but not as an art form that was to be practiced but as a concept that could be both used and attacked.

In the fifth issue (1960) of *SI*, for example, we find a text, signed by one André Frankin, that diagnoses the demise of theater as we know it. Beginning with the sentence "The theater is dead" (173), the text attacks the theater via a critique of repetition borrowed from Artaud. The theater is denounced as a machine for generating selfsame performances night after night and for creating a representational space populated by actors impersonating characters: "An efficacious, theatrical, character is thus a character that has been repeated" (174).[17] Any truly new theater will not rely on dramatic texts, plots, and sequences; it "is thus not at all dramatic ... it is dialectical." Dialectical theater, however, is not something associated with Artaud but with Brecht, who is indeed Frankin's second point of reference. Like the Brechtian actor, Frankin demanded that the participant in the situation should be "as distant from his or her own emotions as from those of the spectator" (174). Frankin thus borrows from various modernist or avant-garde theaters to keep the theater from gravitating toward the spectacle, a tendency most overtly exemplified by Wagner but present in almost all existing forms of theater.

Artaud and Brecht remained the two major points of reference for the situationists' struggle with and against the theater. Anticipating the argument of Frankin's text, an earlier contribution to *SI* in fact grounds its version of the theater's demise explicitly in Brecht: "One can see in ... Brecht

the destruction of the theatrical spectacle" (*spectacle théâtral*; 12). And much later texts are drawn to Brecht as well: "The most valuable revolutionary research in the sphere of culture tried to break the psychological identification of the spectator with the hero, to inspire the spectators to become active to provoke them to turn their lives upside down" (699).[18] The fact that the situationists would keep coming back to Brecht is one of the best indications that they, like Brecht, found themselves engaged in a struggle against the false totality of the total work of art, that their search for situations was one of many endeavors toward an anti-*Gesamtkunstwerk* that have driven much of modern theater.

At the same time, Artaud quotations circulate everywhere in *SI* as epithets, allusions, and detournments.[19] It is this second, Artaudian heritage that also points beyond theater as representation and toward some notion of life: "The situation is made to be lived by its creators" (699). The notion of life takes over so that actor and spectator end up being nothing but "viveurs" (people who live, "livers"). "Life" was a resonant term for the situationists, but they usually prefaced it with a term alien to Artaud: "everyday life." From the beginning, the situation was a name for a reformed and revitalized everyday life, which the situationists, with Lefèbvre, understood as the undoing of the division of labor and alienation: "Everyday life is what remains once all specialization has been removed" (219). The situation is a glimpse, however preliminary, of such an undivided, nonseparated life; it is a constructed version of a coming theater of everyday life. In conceiving of situations as a form of participatory theater that becomes life, the situationists attacked the representational quality of theater as such. One of their models for an alternative was the emerging New York happening, which they admired greatly: "[The happening] is a kind of spectacle in the state of extreme dissolution" (316). Like the happenings of Allan Kaprow and John Cage, the situation was supposed to be a type of performance art that somehow avoided the techniques and deceptions of theatrical representation; the situationists imagined what Michael Kirby called "non-matrixed performance," a situation-happening that is folded into life.[20]

Here we begin to see why, despite all their critiques, the situationists would nevertheless continue to be drawn to the theater and more particularly to the total theater: the situation, the undivided life, nonalienation—all these terms point toward an all-encompassing totality and unity. Even as Frankin is opposing the false total theater, for example, he demands "total representation" (*représentation totale*; 174) and "scenic unity," phrases that sound dangerously close to the *Gesamtkunstwerk*. They are also reminiscent of another Wagnerian, namely, Marinetti, whose *sintesi*—short, compressed

pieces of theater that erase narrative and chronology—Frankin might have in mind when he says, "Its [this theater's] ambition tends toward a total representation of all moments of a represented action, against or despite their chronological order" (174). A tendency toward totality is visible on a theoretical level as well. Critics have pointed out that Debord's own notion of the spectacle, designed to capture the entirety of capitalism under a single term, threatens to become as totalizing as the spectacle itself.[21] There is, then, a triple gesture at work here: identifying the kinship between theater and spectacle; attacking the theater; but replacing it with a concept of situation and of everyday life that is as unifying and totalizing as the most ambitious of total theaters.

The only way out of these conflicting imperatives was by way of detourning the theater, of creating a radical antitheater. While it is no longer possible to make theater, it is possible to use it for "partisan propaganda purposes."[22] The situationist antitheater is thus one of several attempts to detourn the spectacle, to create the counterspectacle: the situation. Such a counterspectacular situation, ultimately, must remain a thing of the future: "Finally, when we have got to the stage of constructing situations, the ultimate goal of all our activities, it will be open to everyone to detourn situations by deliberately changing this or that determinant condition of them,"[23] Yes, the situationists engaged in all kinds of practices, from drifting through cities to constructing models and maps, working with the world they found and turning it against itself. But the actual construction of a true and ultimate situation, a theater of everyday life, had to remain the "ultimate goal" of their activities.

For the time being, then, the construction of situations had to rely on critical theory, on texts such as those by Frankin and others, that guarded all preliminary situations from the spectacular dangers of the theater. As in the case of manifesto urbanism, this critical theory took the form of the manifesto. Given this central and strategic role of the manifesto, one might see in the situationists' use and abuse of theater one more form of manifesto theater, a version of the tradition of manifesto theater whose most influential articulation had been presented by Artaud. Like the realization of the theater of cruelty, the construction of true situations became secondary and the writing of manifestos the form in which these situations received their provisional shape.

One might take this strategic use of the manifesto as evidence that the situationists were part of what Paul Mann has described as the "theory death of the avant-garde."[24] Not only were they dedicated to the task of theorizing, they also wanted to let this theorizing interfere with their art.

What is often not recognized by the "theory death" argument, however, is that for the situationists, theory was not something opposed to and devoid of action, something that occurs in a reified abstract sphere, like the cloud inhabited by the philosophers in *Gulliver's Travels*.[25] Rather, it was itself first and foremost a practice, and one that took the form of a new manifesto.[26] This had been the task of the manifesto all along, at least since Marx and Engels, namely, to create a genre, a poetry that would relate theory and practice more closely to one another, if not create a complete fusion between the two. If we keep in mind this heritage of the manifesto, and the various forms and productions it inspired, we can come to a conclusion quite different from that of death or demise. Far from leading to the avant-garde's "theory death," the manifesto led to forms of manifesto art, of which manifesto urbanism and manifesto theater were two prominent examples. If anything, the situationists tried to revive the avant-garde, albeit in a different mode, by means of theory, what should be called the theory rebirth of the new avant-gardes of the sixties.[27]

The most elaborate juxtaposition of art and manifesto occurred in the situationists' use of the art form that constituted the second meaning of *spectacle* and that even more than the theater (or urbanism) seemed to come close to embodying the spectacle itself: cinema. Debord's most important definition of the spectacle was "The spectacle is capital to such a degree of accumulation that it becomes image."[28] True, the spectacle cannot be identified with any single art form. Even the visual media of mass communication, cinema and television, are only the external and "superficial manifestations" (26) of the spectacle, which Debord identifies at times with ideology, with false consciousness, and more generally with everything that dissimulates the reality of capitalist production. Thesis 4 of *Society of the Spectacle* states: "The spectacle is not an ensemble of images, but a social relation between people, mediatized by images" (16). This sentence itself borrows from, or rather detours, Marx's sixth thesis on Feuerbach, where Marx had defined the individual as an ensemble of social relations. Yet, there can be no doubt that cinema and television are at least figures for the spectacle, as well as its most frequent forms of manifestation. Due to the association of the cinematic image with the spectacle, the cinema is seen as the false double of—or "substitute" for—the situation: "The cinema presents itself as the passive substitute of the unitary, artistic activity which is possible now. It brings new powers to the reactionary power used by the spectacle without participation" (*SI*, 9). Film and the film camera frequently feature as the very tools the spectacle employs for its purposes. One of the last issues of *SI*, for example, captions an ad for a film camera thus: "The domination of the spectacle

over life" (553). To the extent that the camera becomes the agent of the spectacle's domination over life, the cinema represents everything that has to be opposed and destroyed.

As in the case of urbanism and theater, however, Debord did not simply oppose the cinema but worked toward detourning it. The result was a series of films, or rather counterfilms, that must be considered the high-water mark of negative cinematography. To be sure, Debord was not the first to envision such a project.[29] Among his contemporaries, the most prominent figure working in a similar direction, and whose work has been labeled "countercinema" by Peter Wollen, was Jean-Luc Godard. Not coincidentally, Debord hated Godard the way one can only hate a close rival.[30] But it was Debord who most consistently attempted to undo the cinema with cinematic techniques by creating a number of idiosyncratic counterfilms.

Only a dialectical understanding of mass media can explain why Debord would be tempted to turn his longest and most demanding theoretical text, *Society of the Spectacle*, into a film. He did so through several, related techniques of detournment. The first was collage. Rather than shooting film himself, Debord took existing material from the history of cinema and other sources: live footage of policemen clubbing down demonstrators; newsreels showing politicians, including Giscard d'Estaing and Fidel Castro; images from Vietnam and the stock market; documentary footage showing the processes of production inside factories and construction sites; images taken from film history, especially Hollywood films, depicting everything from war to love. Using clips from preexisting films was motivated in part by the fear of adding more images to the spectacle. In addition, however, by bringing these clips into new and startling juxtapositions, Debord meant to reveal the connections kept hidden by the spectacle—a critical collage of images that suggests the interdependence of, for example, democratic party politics and police violence, Hollywood film and political reality. The most important of these hidden connections is that between the process of production and the consumer product. The critical theory behind this connection is, of course, taken from *Das Kapital* and its theory of commodity fetishism, the erasure of the process of production in the product. But the film version of *Society of the Spectacle* takes this critique one step further, by targeting the latest forms of advertising. Debord's film uses ads depicting all kinds of commodities, including television sets and an unending series of nude women who lazily inhabit the spectacle as if they were allegorical figures of the spectacle itself.

To counter the seduction of the spectacle personified in such figures, Debord used a second technique: the voice-over. A good reader of

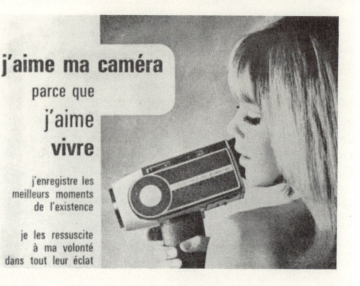

j'aime ma caméra
parce que
j'aime
vivre

j'enregistre les
meilleurs moments
de l'existence

je les ressuscite
à ma volonté
dans tout leur éclat

LA DOMINATION DU SPECTACLE SUR LA VIE

Cette publicité de la caméra Eumig (été 1967) évoque très justement la glaciation de la vie individuelle qui s'est renversée dans la perspective spectaculaire : le présent se donne à vivre immédiatement **comme souvenir.** Par cette spatialisation du temps, qui se trouve soumis à l'ordre illusoire d'un présent accessible en permanence, le temps et la vie ont été perdus ensemble.

socialiste », que « nous trouvons inintéressants ceux qui y parlent et ceux qui les écoutent ».

La palme revient à Kostas Axelos (voir plus haut) qui nous écrivit le 27 février, nous proposant, en tant que directeur de la collection « Arguments » des Éditions de Minuit, de lui « envoyer pour lecture le *Traité* de Vaneigem ». Nous lui avons répondu brièvement mais grossièrement.

Un moraliste

Janover, ex-directeur de *Front Noir*, qui semble maintenant seul auteur du n° 1 des *Cahiers de Front Noir*, est un moraliste, ne serait-ce que parce qu'il a ramassé chez Rubel la fameuse explication « éthique » de l'œuvre de Marx, un des nombreux principes de pseudo-unification utiles, pour le *job* de marxologue bien payé par tous les États modernes, à quiconque est incapable de concevoir la pensée dialectique. Stirner n'avait pas tort de dire que tous les moralistes ont couché dans le lit de la religion ; et par exemple la morale affirmée de Janover, malgré son coup de chapeau au « rêve dyonisiaque » du socialisme utopique, sent plus l'éteignoir que le fouriérisme : « Toute forme de réciprocité amoureuse, pour autant qu'elle s'éloigne des rapports sexuels fondés sur la satisfaction animale ou la nécessité de la reproduction, est indissociable de la fidélité sexuelle. Toute affinité intellectuelle, morale ou

57

Figure 13.2. "I Love My Camera Because I Love to Live," *Internationale Situationniste* 11 (October 1967): 57. Labadie Collection, University of Michigan.

Apollodorus, Debord chooses not to block his ears with wax like the Homeric Odysseus but to counter these sirens with his own voice, just as Orpheus had drowned out the sirens with his song in *The Argonauts*. Debord, to be sure, does not sing. On the contrary, he assumes a voice of utmost sobriety. Nevertheless, it is his voice that is supposed to save him (and us) from the seductions of the image: the entire collage of detourned images is accompanied by the calm murmur of Debord reading from the text of *Society of the Spectacle*. As in the case of manifesto urbanism and manifesto theater, Debord trusts his theory, in the form of his most ambitious manifesto, to keep the cinema in check.

Using the image, however framed by the manifesto, is not without risks, for the power of the image always threatens to dominate over the critical edge of the manifesto. As if the confrontation of detourned image and critical manifesto were not enough to assure the defeat of the spectacle, Debord uses a third technique to break its rule: the sequence of images is interrupted several times with a blank screen. This interruption, however, not only has a negative purpose; it is also used to make space for the manifesto, not in the form of Debord's voice but in the form of writing. What we see on-screen during these interruptions are text passages taken from *Society of the Spectacle*: theory is moved from Debord's voice-over to writing on the screen. The first and most dramatic interruption occurs when Debord recites his key slogan: "The spectacle is capitalism in such a state of accumulation that it becomes image." When the screen turns blank, we read: "One could still recognize some cinematographic value in this film if this rhythm were continued; and it will not be continued."[31] Worried that despite the critical collage, despite his own sober voice reading the text of the *Society of the Spectacle*, the spectacular image might still exert its dissimulating power, Debord does not know what to do except to pull the plug and replace the film with the manifesto. More and more, the text of the manifesto is not only attacking but infiltrating the image, adding reflexivity. "Critical theory has to communicate in its proper language. This is the language of contradiction, which must be dialectical in its form as well as in its content" (74). But such moments of self-reflexivity are not ends in themselves but means of destroying the spectacle. This ultimate purpose is confirmed in the text of another imageless screen which echoes Marx's "Theses on Feuerbach": "That which the spectacle has taken from reality, must be taken back from it. The spectacular expropriators must in turn be expropriated. The world is already filmed. It now must be transformed" (78). This is Debord's most daring and most dialectical strategy: not to rely on the sobriety of his own voice but to turn the critical text of his manifesto into an image; once more

the spectacle is used for its own destruction; the screen must show the text that denounces and replaces it.

What makes *Society of the Spectacle* such an extraordinary experiment is the fact that it mixes two forms of detournment, the detournment of theory and that of the cinematic image. The spoken text of the manifesto, itself full of detourned quotations from Marx, is pitted against the image collage. At the same time, however, this critical text enters the image itself as text on the screen. Critical theory continues its work of keeping the image in check, but it does so by participating in the image, by becoming image itself. This participation, however, is not to be understood as a giving in to the image. On the contrary, it is used so that critical theory can take the place of the image to extract it from the clutches of the spectacle. Only to the extent that theory becomes image can it hope to achieve its goal of interrupting the cinematic flow. The same principle applies to theory as well: only by acknowledging its own limits, the necessity of becoming image, can theory become an effective force. *Society of the Spectacle*, the film, is something of a final showdown or rather two showdowns: the battle of the cinema against its detourned double, and the battle of the manifesto against the cinema. Even though Debord made films before and after *Society of the Spectacle*, this text and this film remain the high point of his career, both as a theorist and as a cinematographer, as a theoretical cinematographer and a cinematographic theorist. Debord's career can be seen as a culmination of a double history: the history of the socialist manifesto and the history of the revolutionary avant-garde.

The Returns of the Revolution

The last couple of years have witnessed a remarkable resurgence of interest in '68, including a documentary film about the Weather Underground, which found critical acclaim among mainstream critics. For the opening night at Film Forum in New York, Mark Rudd and other former members and affiliates engaged in a heated debate about the efficacy of revolutionary violence (Mark Rudd, for one, claimed that the only way to effect change now was through the Democratic Party). This was in the summer of 2003. Valerie Solanas, too, has returned of late. After the notorious film *I Shot Andy Warhol* (1996), the dramatic script of the play *Up My Ass* resurfaced, and even though it remains unpublished, it was performed, in a small theater in New York to receptive audiences. And the *SCUM Manifesto* was hon-

ored with a deluxe edition from Verso, including an excellent introduction by Avital Ronell. Even the anthology of '68 ephemera, *BAMN*, was reissued. Finally, there is a broad revival of the situationists, with several new editions, exhibitions, and theatrical performances inspired by or dedicated to their work. What are the forces driving these returns? And what are their effects?

The more this study moves toward the present, the more it will have to face the question of how to write a history of the manifesto without suggesting that the manifesto is nothing but history, how to present a history of the future without presuming that futurist writing is a thing of the past. It is a dilemma that concerns all interested histories of the avant-gardes, of revolutions, and of manifestos. A noteworthy response to this dilemma occurred in the late eighties, when Debord and the situationists acquired an advocate in Greil Marcus and his book *Lipstick Traces: A Secret History of the Twentieth Century* (1989). Written by a former contributor to the music magazine *Rolling Stone, Lipstick Traces* has itself acquired a kind of rock-star fame and become a fixture on the countercultural bookshelf. Refusing to tell a single history of the avant-garde, the kind of history that would conjure the master plots of decline, repetition, and failure, Marcus writes a "secret history." The avant-garde is featured as a subterranean force that erupts at different times in different places, whether they be World War I Zurich, '68 Paris, or seventies Britain and the United States. These eruptions disturb the official history without ever becoming part of it; they appear, disappear, and reappear, leaving traces here and there, but they do not form a lineage that could be told in a single story line. The ephemeral nature of these disturbances betrays Marcus's inclination toward the performing arts, and indeed the three main exhibits of his secret history are the Cabaret Voltaire, the Sex Pistols' punk rock performance, and the situationist counterspectacle. These three types of performance shape Marcus's view of an ephemeral avant-garde that relies on direct shock, rough provocation, performative assault, and shrill gestures; an avant-garde at home in performance and theater. Marcus suggests a history of repetition, of a repeated avant-garde that takes different forms at different times but nevertheless can be captured by one term.

While I question the notion of a "secret" history, in part because my emphasis on the manifesto suggests that the history of the avant-garde is a history of the struggle for manifestation, I find Marcus's notion of repetition a useful point of departure. My own view of the manifesto as a genre oscillating between avant-garde theatrics and revolutionary performativity represents a similar attempt at resisting histories of linear development and therefore of the inevitable aging and decline of the idea of the avant-garde. Marcus's concept of return (and of theatricality) was proved right most strik-

ingly in the surprising return of his 1989 text itself, when a small theater company based in Austin, Texas, turned *Lipstick Traces* into a theatrical production that ultimately traveled to the Ohio Theater on Wooster Street in New York City.[32] The result was intriguing. Who would have thought that re-creating an evening of Cabaret Voltaire, a performance of "Anarchy in the U.K.," and a lecture/film of Debord would, as they say, "work" on the stage? For work they did; the material, undeniably, made for great characters and scenes. The actors were good; the set was evocative; the dramaturgy, even though it was based on some sort of an academic study, surprisingly varied.

However, even though we got some recited manifesto-like passages onstage, they were all framed by the explanations of the narrator, who assumed the posture of a researcher: "according to my research" was her repeated phrase. This narrator was a combination of a talk-show host (part of this staging in fact takes the form of a talk show) and a patient teacher explaining an obscure historical phenomenon in an overly pedagogical tone to a class of students. This explanatory frame could not have been more different from Debord's own techniques of interrupting the spectacle by means of witty theory, pointed phrases, and targeted quotations. And even though we saw glimpses of Debord's iconoclastic film, the theater that staged and framed this viewing had not learned from Debord's interruptions and proceeded without hesitation or doubt. Rather than having to confront an empty screen, we were able to enjoy Debord's own funny reactions and those of the audience onstage, an amusing scene, to be sure, but one that utterly undid the film's negativity. The actual audience was left in the dark and positioned to absorb a historical curiosity: no reaction was expected or invited. One might say that *Lipstick Traces* retheatricalized Debord's counterspectacle, removing the critical edge from Debord's dialectical strategy through an unquestioned, uninterrupted belief in the theater when the theatrical performance should have been detourned and infused with the manifesto's disruptive force.

Anticipating the problem of relying on the spectacle to bring about its destruction, Debord had always feared that the situationists would become not the revolution of the spectacle but the "latest revolutionary spectacle."[33] *Lipstick Traces*, the theatrical version, proved this fear right. Even though Marcus had undertaken the delicate task of an archaeology of lipstick traces, the stage was able to turn these traces into a performance without negativity, a show without remorse, a theater without interruption: a spectacle of critique, not a critique of the spectacle.

14

The Avant-Garde Is Dead: Long Live

the Avant-Garde!

A few summers ago, I opened the playbill for a show at the Lincoln Center Festival and read on the first page, "Isabella Rossellini's Manifesto," followed by an instruction saying, "Write your own manifesto." An unsurprising command. After all, the show in question was an art circus, an inheritor of the avant-garde's fascination with the lower theatrical genres, and Isabella Rossellini herself had featured in some undeniably avant-garde films. But just as I was about to take a pen, eager to start writing, I began noticing other things about the page: two images of young women with red lipstick and lots of makeup, and then, finally, at the bottom: "Available at Bloomingdale's, 1-800-555-SHOP." Rossellini's manifesto turned out to be an ad for cosmetics, and it was with a complimentary lipstick that one was asked to write one's own manifesto. I did not call Bloomingdale's, and I did not write a manifesto— in any medium. Instead, I began to worry that the time of the manifesto was over and that instead of writing a manifesto I should write its history.

Theories of the death of the avant-garde are not difficult to come by these days. The manifesto seems to epitomize the utopian progressivism of the early twentieth century and thus everything the postmodern present is not. Perry Anderson articulates this view with particular succinctness:

> Since the seventies, the very idea of an avant-garde, or of individual genius, has fallen under suspicion. Combative, collective movements of innovation have become steadily fewer, and the badge of a novel, self-conscious "ism" ever rarer. For the universe of the postmodern is not one of delimitation, but

No delimitation or collectivism

Figure 14.1. Advertisement for cosmetic products by Isabella Rossellini, Blooming-dale's, in *Stagebill*, Lincoln Center Festival, 2000.

intermixture—celebrating the cross-over, the hybrid, the pot-pourri. In this climate, the manifesto becomes outdated, a relic of an assertive purism at variance with the spirit of the age.[1]

There is a gulf between manifesto modernism and a postmanifesto post-modernism that turns the manifesto into an "outdated" "relic" incapable of capturing the "spirit of the age." What is not "at variance" with this spirit is presumably something like Rossellini's ad, which demonstrates just how thoroughly the poetry of the revolution has been co-opted by the poetry of capitalism, a capitalism so rampant that it leaves no place from which to launch a manifesto that would be untainted by it. Whether you like it or not, all manifestos today seem to be versions of Rossellini's, speaking for multinational capitalism.

It is worth noting, however, that the Marxian history of capitalism on which Anderson's writing is premised itself derives, however indirectly, from the manifesto of manifestos, the *Communist Manifesto*. In this sense, at least, Anderson does not entirely leave the manifesto-driven history of modernity behind—but only applies it to the manifesto itself. Nor is Rossellini's ad entirely outside the horizon of the manifesto.[2] Starting with Marinetti's advertisement blitz and going all the way to dada's use of new advertising techniques, the manifesto has been intimately connected to advertising. This lineage includes Hannah Höch and Raoul Hausmann, both of whom worked in advertising, and it points to an aspect of manifestos I have called the advertising for the revolution. Rather than a postmodern perversion, Isabella Rossellini's manifesto is but the latest version of the collaboration of manifesto and advertising that has characterized the history of the manifesto throughout the twentieth century. Indeed, perhaps Rossellini's is just the most literal version of Marcus's title *Lipstick Traces*. The "assertive purism," as it putatively informed the manifestos of the early twentieth century, never really existed in the first place.

While many theorists of periodization decided that the time of the manifesto was over, various political, social, and artistic groups and individuals have continued writing manifestos with impunity. In 1995, for example, a collective of Danish filmmakers published the *Dogma Manifesto*, which continues to influence international filmmaking to this day. Other contemporary groups are drawn to the manifesto as well. In a recent interview conducted by Jon McKenzie and Rebecca Schneider, Critical Art Ensemble (CAE) a collective exploring new modes of civil and artistic disobedience, was asked about its use of the manifesto today: "So, the manifesto style: Does the manifesto function as a kind of outmoded backward glance, then?

A kind of quotation? Or affect?"[3] CAE answered with a defense of the manifesto: "Well, manifestos have never really gone away," adding, "we also like it because it's a fast style, perhaps the fastest" (140), while insisting that "the book is far too slow" (141). Like Dogma, CAE is not ready to bury the manifesto quite yet. How can we gauge the significance of the manifesto for the present? Given the geographic imperative I have been pursuing in addition to a historical one, it would seem fitting to end my analysis with a localized reflection on the present. How, then, has the manifesto fared in the United States, in New York City, since the second wave of manifesto writing in the sixties?

The brief case study I offer here, the path through this complex historical and geographic terrain, is the history of one journal that testified to the theatricalization of the avant-garde like no other and that prodded CAE into its defense of the manifesto: *TDR*, subtitled *A Journal of Performance Studies*. Begun in the fifties, *TDR* became the foundational journal of a new discipline, performance studies, whose primary venue it has remained until today. In the process, it has reflected and articulated the fate of the theatrical avant-garde and of the manifesto in the United States from the sixties to the present. *TDR* makes for a useful case study because unlike most academic journals, it has shunned specialization and regarded culture at large as its domain. Like the discipline of performance studies more generally, *TDR* came to regard every social, political, and aesthetic phenomenon to potentially lie within its field of interest. At the same time, *TDR* has had a keen sense of its own mission, which amounted to nothing less than promoting and furthering what could be gathered under an expanded notion of the avant-garde. Challenging, shocking, subverting, transgressing, resisting—these are the keywords of the vocabulary promoted with varying emphasis in the pages of *TDR*, coupled with an awareness that the techniques of the historical European avant-garde had to be studied but also changed to serve the new purpose of forging an avant-garde in the United States. There are few journals as dedicated to the avant-garde, few as attuned to its historical challenges, and none that can show us better how difficult and how necessary it has remained to write manifestos—even now.

TDR

The history of *TDR* closely tracks the emergence of the second wave of manifestos.[4] *TDR* began as a small journal in 1955 under the name the *Carleton Drama Review*, published at Carleton College in Northfield, Min-

nesota, by Robert Corrigan, a professor of English and drama. After only a few issues, Corrigan and his journal moved to Tulane University in New Orleans, where the publication acquired the initials it was to retain throughout its tumultuous history: *TDR*, standing then for *Tulane Drama Review*. In this initial phase, the journal was dedicated to a high modernism, featuring articles on such dramatists as Eugène Ionesco, Samuel Beckett, and Jean-Paul Sartre, discussing a theater whose political ambitions were rarely stated explicitly and were rather mediated by existentialism and the theater of the absurd. In fact, Martin Esslin published the lead essay of *Theater of the Absurd* in the pages of *TDR* in 1961. A translated piece by the German playwright Friedrich Dürrenmatt epitomizes the dedication to high modernism and the rejection of manifesto-driven avant-gardes that informed this era: "For me, the stage is not a battlefield for theories, philosophies and manifestos."[5] Some authors bemoaned the decline of political theater. What they meant by political theater, however, was nothing akin to the avant-garde or manifestos, but instead Clifford Odets, the Group Theatre, and the Federal Theatre Project. Mostly, the review published texts by Lionel Trilling, Eric Bentley, Jacques Barzun, and Lionel Abel, leading intellectuals, writers, and dramatists who captured these final years of the fifties with their reflective type of criticism.

Soon, however, the journal would get caught up in precisely the "theories, philosophies and manifestos" it had studiously avoided in the fifties. This second phase was initiated with a change in editors: Richard Schechner, also teaching at Tulane, succeeded Corrigan. The new tone of *TDR* could be heard immediately when Schechner initiated the so-called "Comment" in the first issue of 1962. The "Comment," Schechner writes, will serve the editors by "presenting as forcefully as we know how our views on the theatre. These views will often be personal and affective; sometimes they will be angry and outrageous. *TDR* will . . . be a rallying point for those young and eager theatre-workers. . . . In some sense we hope to restore virginity to the theatre, and purpose to theatre-workers."[6] *TDR* was entering a discursive field in which it was necessary to be angry and affective to achieve such a high goal as restoring to the theater not only its "virginity" but also, and perhaps more important, a new "purpose." What this would mean became clear a few issues later, when Schechner and his associate editor Theodore Hoffman found that the best way of giving the theater such a new purpose was to write a manifesto:

> The new theatres, with rare exceptions, have been founded
> without overt ideology. There are no manifestoes to collect
> and dissect, no stylistic innovations to brag about. But new

theatres ask for new ideas, and if we are to have a real theatre on this continent, one which readily translates art and theory, ideas will necessarily emerge that recognize the particular historical, political, and social facts of American life as well as the unique aesthetics of our own theatre practice. . . . Right now our task is to explore the implicit framework that binds the new theatres into a fertile conspiracy (if not a "movement"), despite their admirable diversity.[7]

The new theaters springing up everywhere are promising, but they have not yet found their guiding theory. Supplying such a theory is the purpose of Hoffman and Schechner's manifesto, whose seven succinct points make the implicit manifest and lay the foundation for the unification of all these admirably diverse activities.

The decision to write a manifesto was itself well attuned to the "historical, political, and social facts of American life," which was moving into the period of the high sixties, brimming with all kinds of manifestos, theories, and practices. As in the teens and twenties, the significance of this second wave of manifestos can be fathomed from the opposition it encountered. Corrigan, the former editor, attacked Schechner and Hoffman for writing a manifesto, a form he found "pretentious," "inflated," and bound to "alienate" the audience. "Manifestoes," he concludes his rant, "are an absolute necessity for politicians and certain of our public institutions, and sometimes even for daily newspapers, but they are a useless appendage to a quarterly magazine."[8] Corrigan was fighting a losing battle. In 1964, manifestos were beginning to be written in increasing numbers; Schechner quotes, for example, from a manifesto written by Judith Malina, cofounder of the Living Theatre, which was to become one of *TDR*'s favorite theaters. It is noteworthy, however, that both Schechner's defense of the manifesto and Corrigan's critique associated manifestos primarily with political pamphlets. Schechner had mentioned as his model "political pamphlets" that "record, assess, and influence" the future, and Corrigan's attack was likewise premised on the assumption that manifestos are "necessary for politicians" but not for artists.[9] The controversy about the manifesto was thus a controversy about *TDR*'s relation to politics.

If there still existed opposition to the manifesto in the early sixties by the later sixties, the manifesto had clearly won. In defense of Schechner and Hoffman, Paul Gray had written a letter to the editor, stating: "Even if we have a manifesto every day, there can be no more creative a magazine than one which admits to growing pains in the search for a new theatre."[10]

In the high sixties, Gray was going to have his "if" clause fulfilled with a vengeance: there indeed were new manifestos every day. The high sixties can be considered a third phase in the history of *TDR*, marking its full engagement with the political and avant-garde spirit of the time. Around the same time, *TDR* moved from Tulane to New York University, where it has remained, along with its editor, until today (and where it changed its three initials to stand for *The Drama Review*). Schechner's first manifesto of 1963 turned out to have been only an anticipation of the kind of writing that was going to populate *TDR* in the coming years. In 1968, for example, Schechner launched his famous "6 Axioms for Environmental Theatre," which is widely regarded as a foundational manifesto for performance art and performance studies. This third phase witnessed a quantitative increase in manifestos, and *TDR* was now thriving in the gray area between political intervention and street theater. Schechner wrote enthusiastically about the Bread and Puppet Theater and guerrilla theater, supplying his readers with excerpts from a "handbook" on how to do guerrilla theater themselves. A 1968 issue featured a Black Panthers cover, and the following year an issue opened with a Provo manifesto. *TDR* became the kind of journal from which the editors of *BAMN* had picked their material, a central player in the second wave of manifestos. This volatile period also saw two editorial changes: in 1969 Schechner resigned as editor to devote his time to the Performance Group, and Erika Munk took over only to be succeeded, less than two years later, by Michael Kirby, who was to remain with the journal for the next fifteen years.

My central question is how *TDR* tried to salvage its avant-garde orientation in the seventies and eighties, a period that witnessed a sharp decline in manifestos and avant-garde consciousness. This was a period, after all, in which the exuberance of the high sixties turned into anger and frustration, with the police and the Weather Underground feeding off one another in a cycle of violence. Kirby's first strategy for saving the avant-garde from decline was to connect it to its historical predecessors in the teens and twenties. Schechner, too, had published historical material, including the manifestos of Artaud and others, but only Kirby systematically pointed to the roots of the present avant-garde in the historical one. Many of his special issues contained an explicit "historical" section, acquainting American readers with the more outlandish products of the largely, though not exclusively, European avant-garde of the early twentieth century. Among those exhibits, manifestos featured prominently.

Kirby's attitude toward the avant-garde of the twenties also sheds light on how this American avant-garde relates to its European antecedents.

It has been repeatedly argued that it is inaccurate to refer to the sixties and early seventies in the United States as a neo-avant-garde, since this period witnessed the first real avant-garde in North America. This argument can be supplemented. As I argue in an earlier chapter, dada was as much at home in New York as in Zurich through such travelers as Picabia, local patrons such as Stieglitz and Arensberg, and permanent exiles such as Marcel Duchamp. And even though there had been no full-fledged avant-garde in North America in the teens and twenties, Kirby and the North American avant-garde of the sixties were able to adopt this earlier European avant-garde, actively forging a lineage, tradition, and inheritance across the Atlantic. In other words, nothing could keep a U.S. avant-garde from retroactively appropriating an earlier avant-garde located primarily in Europe, especially since this earlier "historical" avant-garde had already crossed the Atlantic with frequency. Kirby, for example, spent a lot of effort resuscitating futurism; in fact, his study of futurist theater and futurist manifestos is still in print today. One might say that Kirby connected the American avant-garde, retrospectively, to the futurism effect and that *TDR* can thus be seen as a late version of a history that had begun in Paris in 1909. Such an active, even retrospective, construction of predecessors and history is not an exception but the norm. Similar appropriations have informed the avant-gardes throughout, as when Parisian avant-gardes were being used, modified, and recast in places such as Russia, England, and Latin America.

Kirby himself extended his notion of the avant-garde to the present, placing contemporary happenings side by side with futurist manifestos. Where Jameson and Anderson diagnose the irredeemable loss of the avant-garde and therefore speak of a necessarily and exclusively *historical* avant-garde, Kirby envisions something closer to a *perennial* avant-garde. The historical section of *TDR* was motivated by a second doctrine: the documentary style. Through his own experience, Kirby had seen just how fleeting and ephemeral most avant-garde products really were and how difficult it therefore was to reconstruct them properly afterward. Why not, therefore, anticipate this continual disappearance and document the present so that future avant-gardes will have available to them a complete record of the vanguards of the sixties? Working for the future as "tomorrow's past," Kirby imposed on his writers the bitter cure of a radically descriptive, rigorously objective, deliberately opinion-free style.[12] It was a style in every sense opposed to the manifesto. *TDR* began to read like a *nouveau roman*, one descriptive sentence following the other. No polemic, no value judgment, no criticism, no manifesto, no comment were allowed. This documentary style constituted a radical break with Schechner's *TDR* "Comment" and his manifestos, with

all the ways in which *TDR* had actively participated in the manifesto craze of the high sixties.

The descriptive, documentary style preserved the current avant-garde for future use, but it also helped Kirby evade the kind of historiography that would declare the avant-garde to be over. Kirby sometimes calls his method formalist and sometimes structuralist; what these terms have in common is that they downplay historical change. Each performance, happening, action, and event is analyzed as to its components, the mixing of media and art forms, and documented properly without any sense of historiography. History is something that is being recorded and preserved for future use, but not something that is made. Connections among current and former avant-gardes abound, and Kirby often reminds his audience how much a putatively new performance borrows from earlier ones. But in no case are such connections allowed to become a threat or a problem. Kirby's formula is an intriguing combination of formalism and history, a conception of the avant-garde that is grounded in history yet never threatened by it, an avant-garde that is aware of its past yet also knows that it will be around forever. *aligns w/ formalist theatre*

However, the act of documenting avant-garde performance cannot change the hard facts on the ground, namely, that by the midseventies there were markedly fewer self-declared avant-garde groups, that their tone had changed, and that the revolutionary esprit of the sixties had subsided. In 1975, Kirby complains: "Some have given up the search for new ideas; some repeat themselves; some copy what has already been done."[13] While he is doing *his* part by documenting performances for the future, the avant-garde is not doing *its* part in producing works worthy of such attention. The task, as becomes increasingly clear, is not how to document the avant-garde but how to stimulate and revive it.

In this time of need, Kirby turned to the manifesto. Given his belief in borrowing from previous avant-gardes, Kirby promptly turned to the history of the manifesto, publishing in his "historical" section a documentary appendix with several Russian futurist manifestos and underlining their influence on theater practice. This is precisely the kind of hope Kirby harbors for the present. His special issue is entitled *New Performances and Manifestos,* and it is through new manifestos that he wants to stimulate the apparently exhausted avant-garde into producing new work. Here, however, his doctrine of the documentary style imposes constraints on his role as editor. Where Schechner could have turned out manifestos by the dozen, getting artists fired up through the very pages of *TDR* as he had done in the sixties, Kirby's hands are tied by the self-imposed discipline of merely documenting

what is out there already. This meant that Kirby had to maintain that the manifestos collected in the special issue were not written especially for *TDR* but arose naturally out of the avant-garde culture around him: "Of the manifestos we are publishing only that of Charles Ludlam was written specifically for *The Drama Review*."

However, the manifesto issue abounds in signs that Kirby is doing much more than merely gathering manifestos. The seventies were not a time in which one could find manifestos lying on the street or simply pick them up behind barricades as was, presumably, the case in the sixties: "Perhaps the manifesto is not as popular with the avant-garde as it once was," even Kirby admitted in his editorial preface. Reviving the avant-garde by publishing new manifestos was therefore an uphill battle, and the very next sentence reveals the sad reason that prompted Kirby to this insight: "Several of the people we asked to contribute to our collection declined." But hadn't Kirby just said that his manifestos were not written especially for *TDR* and not solicited by him, the editor? The oscillation between solicitation and documentation reveals a tension within Kirby's strategy caused by the desire to document a thriving avant-garde that apparently no longer exists.

The manifestos published in this special issue only confirm this tension. Besides Ludlam's admittedly solicited manifesto, we have only three real manifestos, and they are difficult to characterize. The most compelling one is the "Ontological-Hysteric Theatre: Third Manifesto" by Richard Foreman, whose title suggests that Foreman had been writing manifestos willingly in the past. However, if Kirby had hoped that the historical manifestos would influence contemporary ones, this hope was not fulfilled; Foreman's text is much more meandering and allusive than the direct texts of the sixties or twenties. Only a third manifesto, written by Shuji Terayama, presents provocative slogans and demands in a confident tone and with a polemical edge. Revealing, however, is the fourth and last of these manifestos, written by none other than Kirby himself. His "Manifesto of Structuralism" works well as a manifesto for his descriptive style, but as a manifesto it violates the descriptive doctrine it preaches. Kirby apparently had given up on the strict diet of the descriptive, documentary style and taken it upon himself to write the kind of manifesto no one else would write for him.

Kirby's special issue, despite this temporary sacrifice of the documentary style, did not fulfill its purpose of reviving avant-garde theater. And so, in the early eighties, the whole thing had to start over again. For the 1983 anniversary, celebrating one hundred issues of *TDR*, Kirby repeated his experiment from 1975 and initiated another special issue devoted to manifestos. This second special issue had learned from some of the difficulties of the

first one. We find none of the contortions about the agency of the editor; now Kirby admits that "we have asked a number of people to give us their dreams, proposals and manifestos for the future."[14] Despite this changed strategy and the expanded category that now includes dreams and proposals in addition to manifestos, most of the texts collected do not embrace the genre of the manifesto (nor that of the dream or proposal, for that matter) and instead hesitate, resist, or reject the kind of writing "for the future" Kirby wants. Only three texts resemble manifestos. One presents a disturbing fantasy of a technologically updated Wagnerian total work of art; a second is an uninspired proposal for a feminist theater without interest in the text's own form or style; only the third manifesto engages the genre, for it is a pastiche of the *Manifesto*, substituting the proletariat with a new vanguard of "people's theatres" that will make "a new world" (73). Most of the other texts go out of their way to evade anything resembling the manifesto's poetry of the future revolution. This resistance, visible throughout, is particularly evident in a text called "Anti-Manifesto," which declares: "One could make a manifesto regarding a particular view of the future" (32). However, the author, Daryl Chin, all too soon decides against "making" such a manifesto because of the "act of aggression" (35) this would entail. Unfortunately, what follows this pointed critique is not much better, namely, a long-winded complaint that the author's work has been most shamefully "neglected." Instead of an aggressive manifesto, we have a passive-aggressive antimanifesto.

Like the first manifesto issue, this second one includes a text authored by Kirby himself. This time, however, it is not a manifesto but an "In Memoriam" for Shuji Terayama, whom we remember as the author of one of the manifestos published in the first manifesto issue. It is tempting to take this piece as a eulogy of Kirby's own dream that people would write manifestos the way Terayama did. But this was not meant to be, and Kirby's tenure remained marked by the contradiction between the documentary, nonpolemical style he demanded for *TDR* and the opinionated, polemical, and overreaching manifestos he hoped to collect. The most compelling and most symptomatic manifesto to appear in the eighties in *TDR* did not even make it into this second special issue but was reprinted as part of an article by Arnold Aronson, about the Wooster Group's performance, *L.S.D.*[15] The *L.S.D. Manifesto* that accompanied this performance was written on top of a dadaist one: the word "dada" itself as well as other keywords from the twenties are struck out and replaced by new ones. This manifesto-palimpsest corresponds precisely to the logic of Kirby's strategy of turning to the historical avant-garde to revive the avant-garde of the present: if previous manifestos are supposed to stimulate new ones, then these manifestos will be torn

~~DADAIST/MANIFESTO/(1920)~~

L.S.D. MANIFESTO

~~Art~~ (Theatre) in its Execution and Direction is dependent o
n the Time in which it Lives, and (Theatre) Artists are cre
atures of their Epoch. The highest ~~Art~~ (Theatre) will be t
hat which in its ~~conscious~~ Content presents the thousandfol
d Problems of the Day, the Art which has been visibly shatt
ered by the Explosions of last Week, which is forever tryin
g to collect its Limbs after yesterday's Crash. The best a
nd most extraordinary Artists will be those who every hour
snatch the tatters of their Bodies out of the frenzied cata
ract of Life, who,~~/with/bleeding/Hands/and/Hearts,~~ hold fas
t to the Intelligence of their Time. Has ~~Expressionism~~ (To
day's Theatre) fulfilled our Expectations of such an Art, w
hich should be an Expression of our most vital Concerns?

NO! NO! NO!

~~Have/the/Expressionists~~ (Has Today's Theatre) fulfilled our
Expectations of an Art that burns the Essence of Life into
our Flesh?

NO! NO! NO!

Under the Pretext of ~~Turning/Inward~~ (Organizational Surviva
l), ~~the/Expressionists/in/Literature/and/Painting~~ (we) (the
New York Theatre Scene) (Theatre in America) have banded to
gether into a Generation which is already looking forward t
o Honorable Mention in the Histories of Literature and Art
and aspiring to the most Respectable civic distinctions. On
Pretext of carrying on Propaganda for the Soul, ~~they/they~~ t
hey (dramatists and avant-gardists alike) have,~~/in/their/st~~
~~ruggle/with/Naturalism,~~ found their way back to the ~~abstrac~~
~~t,/pathetic~~ (illustrative, falsely naturalistic) gestures (
the Authoritative Voice, empathy with) which (allows the pu
blic to) presuppose a comfortable Life free from ~~Content~~ (A
mbivalence) or ~~Strife~~ (Contradiction)...Hatred (contempt) o
f ~~the/Press~~ (Popular Culture), hatred of ~~Advertising~~ (T.V.)
, hatred of ~~Sensations~~ (NOISE), are typical of People who p
refer their armchair to the Noise (Life) of the Street, ~~and~~
~~who/even/make/it/a/point/of/pride/to/be/swindled/by/every/s~~
~~maltime/Profiteer.~~ That (It is a) Sentimental Resistance
to the Times, which are neither Better nor Worse, neither m
ore Reactionary nor more Revolutionary than other Times, th
at Weak-kneed Resistance, flirting with Prayers and Incense
...(which attempts to find in the Theatre what it has Lost
in the Church.)

~~DADA/!!!!!~~

L.S.D. !!!!!

~~gathered/together/to~~ put(s) forward a New ~~Art~~ (Theatre), fr
om which ~~they~~ (we) Expect (Pursue) the Realization of New I
deals. What then is ~~Dadaism~~ (L.S.D.)?
~~The/word/Dada~~ (L.S.D.) symbolizes the most Primitive Relati
on to the Reality of the Environment; with ~~Dadaism~~ (L.S.D.
) a New Reality comes into its own. Life appears as a simu
ltaneous Muddle of Noises, Colors and Spiritual Rhythms, wh
ich is taken unmodified into ~~Dadaist/Art~~ (the Theatre), wit
h all the sensational Screams and Fevers of its Reckless ev
eryday Psyche and with all its brutal Reality. This is the
sharp dividing line separating ~~Dadaism~~ (L.S.D.) from all ~~ar~~
~~tistic~~ (theatrical) Directions up until now and particularl
y from ~~FUTURISM~~ (POST-MODERNISM) which not long ago some ~~em~~
~~ptyheads~~ (dodos) took to be a new version of Impressionis
t realization. ~~Dadaism/for/the/first/time~~ (L.S.D.) has cea
sed to take an (Exclusive) Aesthetic Attitude toward Life,
and this it accomplishes by ~~tearing~~ (exploding) all the slo
gans of ~~Ethics~~ (Morality), ~~Culture~~ (Politics), and ~~Inwardne~~
~~ss~~ (Psychology), which are merely cloaks for weak Muscles,
into their Components...(TO BE CONTINUED)

(Performing Garage, 1984)
212-966-3651

Figure 14.2. Wooster Group, *LSD Manifesto*, *TDR* 29, no. 2
(1985): 66.

between the present and the past, creating the new in the form of a pastiche of the past.

From the perspective of the manifesto, things had thus come to an impasse: the documentary doctrine simply did not allow *TDR* to actively participate in and thus generate a new avant-garde; to counteract the decline of the avant-garde throughout the seventies and early eighties, *TDR* had to take the writing of manifestos into its own hands. In a symptomatic and perhaps inevitable move, *TDR* responded to the decline of the avant-garde by asking Schechner to be its editor again. Once more, Schechner promised, *TDR* would forcefully participate in the battle of manifestos; once more, it would risk being wrong by trying to predict and shape the future; once more, it would be opinionated, combative, and assertive in its stewardship of the performing arts; once more, it would allow itself, through the revived "Comment," to intervene *actively* rather than merely document the avant-garde (or the lack thereof) *passively*.

Even though this regained ability to solicit and author manifestos promised a way out of the difficulties caused by the documentary style, a return to and of the sixties on the part of *TDR* did not automatically guarantee the revival of the avant-garde at large. Times had changed, and Schechner harbored no illusions about them, finding the present marred by a "sterile repetition of old experiments." After the demise of the Vietnam War protests, he noted, the seventies had indeed experienced a "deep freeze" of avant-garde activity. "There are young people working," Schechner observed, adding woefully, "but they don't cohere as a group, or a movement."[16] In particular, he diagnosed the fate of manifestos such as the ones written by Foreman and published in *TDR*: "Scholars file them [his manifestos] in a drawer marked 'M' " (17). However, this decline is somehow less threatening now, after Kirby's insistence on pure documentation has been abolished; if *they* do not write manifestos, Schechner will simply do it for them. This, after all, was what he had done all along, beginning with his first manifesto of 1963, which he had written for and on behalf of the new theater that could not formulate a program on its own.

The only difference was that in the eighties there were no new theaters on behalf of which one could write manifestos. As a consequence, *TDR* started to feature manifestos not only *by* itself but *for* itself. *TDR* no longer worked itself to death for a reluctant and vanishing avant-garde out there; it was going into the avant-garde business for itself. But how can a partially academic journal *be* the avant-garde? Schechner argued that the avant-garde was no longer located in the theater but had moved to two "non-art performance fronts: the intercultural and the theoretical."[17] The second term re-

peats a move that had been made by Debord and by such journals as *Tel Quel* back in the sixties; it has since spread to a large number of groups and art forms, including the language poets in Britain and the United States. *Tel Quel* and the *Situationist International,* too, had moved from merely discussing and recording the avant-garde to thinking of themselves as avant-garde, a development registered most clearly in their willingness to author and publish manifestos.

That the writing of theory had partially absorbed the energy and form of the manifesto was visible in the explosion of performance theory but also in the more activist tone in some segments of academia, for example, cultural studies. Paul de Man noted this trend even in the seventies: "The gap between the manifestoes and the learned articles has narrowed to the point where some manifestoes are quite learned and some articles—though by no means all—are quite provocative."[18] Certain academic texts verge on the manifesto, for example, the last, short, and activist section in Judith Butler's *Gender Trouble,* not to speak of Cary Nelson's *Manifesto of a Tenured Radical.*[19] As Nelson's title suggests, this shift from manifesto to theory has to do with the institutional and cultural function of the university in North America. While the different avant-gardes in Europe defined themselves against the university, this was not always the case in the United States, although here, too, one can find arguments that as soon as an avant-garde is integrated into the institutional structure of the university, it has sold out. However, this argument, borrowed from the European avant-garde, never quite worked for the United States, where universities have at times fulfilled the role of harboring avant-garde artists. The advocates of high modernism and avant-garde art were trained by teachers at such places as Harvard and Columbia, and many of the language poets have teaching posts in such places as SUNY Buffalo. Richard Schechner's own institutional affiliations are thus not the exception but the rule. From the beginning, he was employed by universities, especially New York University, which also funded *TDR* until it moved to MIT Press. Schechner kept his post and salary even when he engaged in radical theater, with the Performance Group, in the late sixties and seventies.[20] Rather than simply denouncing such affiliations as inherently "anti-avant-garde," we should recognize them and adapt our conception of the avant-garde accordingly.

Besides theory, the second new front of the avant-garde, interculturalism, merits special attention because it signals a novel strategy for dealing with the apparent decline of avant-garde art. Interculturalism, along with the discipline of performance studies to which it eventually gave rise, is a complex phenomenon to which I cannot do justice here. Its principal

ambition was to analyze ritual and theater across cultures, recognizing differences but also making these differences intelligible. My analysis is restricted to the context of its emergence, in the pages of *TDR*, and its original function within that journal, namely, as a way out of Kirby's seventies conundrum. From this perspective, it presents itself as a response to the challenge of declaring the sixties (and twenties) avant-gardes over without giving up on the idea of the avant-garde as such. Interculturalism, including intercultural theory, was that new avant-garde and *TDR* its new venue.

Schechner had written a manifesto of interculturalism in the latter days of Kirby's editorship in the form of an introduction to a special issue called *Intercultural Performance* (1982). To be sure, Schechner had downplayed the manifesto nature of this text, mindful, probably, of Kirby's opposition to polemic. But it is a text that nevertheless clearly outlines the claim that interculturalism was the legitimate heir to the historical avant-garde:

> This is a brief note. The issue I've edited speaks its own language, and I don't want to introduce it with any lengthy essay or manifesto. Except to say that the world is learning to pass from its national phase to its cultural phase: the markers that are increasingly meaningful are not those that distinguish nations but those that distinguish cultures. . . . Thus, I am arguing for both an experiment and a return to traditional, even ancient, values. This argument has been implicit in experimental art for a long time: it is the root of that art's "primitivism." Interculturalism is a predictable, even inevitable, outcome of the avant-garde, its natural heir.[21]

Interculturalism is presented as the "inevitable" and "natural" heir to the avant-garde even as it signals a return to older, even "ancient," values. The word that holds these two, seemingly contradictory, terms together is the one Schechner cautiously puts in quotation marks: "primitivism." Primitivism is indeed a good way of remembering the historical and European avant-garde, including the primitivist paintings of Gauguin, the "negro" rhymes of dadaism, and Artaud's fascination with the rituals of the Tarahumaras in Mexico. It would be inaccurate to reduce Schechner's entire program to this early formulation. Not all of what was to become performance studies, not even all of interculturalism, should be called primitivist.[22] But this term is crucial in the way it connects interculturalism to the European avant-garde, including that aspect of the European avant-garde that has become the most suspect.

Turning the emerging performance studies into the natural heir of the European avant-garde is one function of "primitivist" interculturalism, but not the only one. In addition—and here we are reminded of the double move to history and formalism made by Kirby—it serves as a shield against the claim that the avant-garde may be over. Not coincidentally, this is the function primitivism had fulfilled for the historical avant-garde as well, namely, that of an escape from the progressive time of modernity. Primitivism, now and then, replaces history with geography, and in particular with the kind of geography that is exotic and ancient. Interculturalism, at this early moment, envisions something of a natural geography of the primitive. This is when Schechner develops his famous graphs, charts, and drawings, which abound in categories and figures that connect different types of performance, moving from one culture to the other with relative ease. It does not matter whether the ritual in question is ancient, "primitive," or contemporary, when it originated and what transformations it went through; it does not matter whether these rituals are anachronistic, for export only, or secret—they all can be accommodated, they are all compatible with one another through the charts and graphs whose abstract and schematic nature guarantees ultimate exchangeability.

Exchange can take place through travel, but when actual transportation is too complicated, we may opt for an imaginative, "theatrical," exchange in the classroom, where all kinds of rituals can be performed at will. Schechner's interculturalism is based on the concept of behavior and thus on something that can be adopted and reenacted. Enactment, the heart and soul of the theatrical or performance paradigm, allows us all to do, to behave, to experience, no matter where and who we are.[23] History is not exactly erased, but it has become secondary so that it cannot be an obstacle, an abyss, or a trap into which one might fall while connecting, experiencing, and reenacting cultures. The primitivism of interculturalism can be seen as Schechner's response to Kirby's formalism in that it, too, implies that all the types of avant-gardes are protected against those who argue that the time of the avant-garde is over.

A new avant-garde in the form of a new primitivism was not something the historians of the postmodern were going to accept easily. In the end it was Schechner himself, always out for a good fight, who initiated a confrontation by attacking an article by Philip Auslander, published in *TDR*'s rival, *Theatre Journal*.[24] Accepting the postmodern no-return thesis, Auslander had developed an argument for a postmodern politics based on Lyotard's conception of language games, on the theory of incommensurable and incompatible discourses and systems of signification. On the face of

it, one might have thought that the postmodern belief in irreducible and fragmented systems of meaning would have been amenable to Schechner's interculturalism. *TDR* was regularly publishing articles on rituals here, historical reenactments there, freely mixing U.S., European, and non-Western cultures and all in the spirit Anderson had identified with the postmodern, namely, by "celebrating the cross-over, the hybrid, the pot-pourri." In addition, postmodern theory, as represented by Auslander, had departed from a historical premise shared by Schechner, namely, that a simple return to the avant-gardes of the sixties and twenties was impossible.

There was one difference, though, between Schechner and postmodernism: precisely his continued dedication to some kind of avant-garde, now in the form of avant-garde theory and interculturalism. Postmodernism, by contrast, implied a break with the past, the defining of the present condition as postmodern and therefore post-avant-garde. When Schechner therefore called, against Auslander, for a "linkage" between postmodern fragments, language games, and cultures, he was calling precisely for something like his own (avant-garde) theory of interculturalism and his own charts to bring all these disparate entities together again.[25]

Looking back at the history of *TDR* through the lens of the manifesto reveals a meandering path that is nevertheless driven by a continued dedication to the idea of an avant-garde. After defining itself as a manifesto-driven, engaged journal in the sixties, *TDR* has had to find ways of sustaining that impetus in the face of a changing cultural and political environment. Kirby's combination of looking back to the historical avant-garde while insisting on an ahistorical formalism constitutes one rescue operation for saving the avant-garde; his attempt to revive the avant-garde through two manifesto issues demonstrated the limits of this formalism. Schechner gave up on Kirby's perennial avant-garde by declaring the sixties and twenties over, shifting his focused to a theory and performance avant-garde whose realization was to be found in the very pages of *TDR*. The manifesto can be found at the center of every one of these changes in direction. It defined *TDR*'s coming-of-age in the sixties, it was a central part of Kirby's attempts to revive the failing avant-garde, and it constituted Schechner's own strategies for a *TDR*-based avant-garde in the eighties and nineties.

The dedication to a theory avant-garde still informs *TDR* today. At a conference in July 2003 in New York City, Schechner argued vehemently against the idea, presented by Auslander and his four-volume anthology of performance studies, that performance studies had acquired a canon and was now based on a series of foundational texts.[26] Instead of consolidating the past, Schechner pleaded, performance studies should continue to invite

the new. He even argued for the adaptation of a quota system according to which the latest work would be privileged over the classics of the past, thus actively making the formation of a canon impossible. One might translate this attitude as saying that instead of deriving its poetry from the past, performance studies should derive its poetry from the future.

It is as part of this continued futurist and avant-garde mission that *TDR* has begun to transform its interculturalism with the help of theories of globalization. This itself was not a radically new departure, since even long before the nineties Schechner had defined intercultural performance as "joining together certain of the techniques of experimental performance with certain of the social concerns of an emerging globalism."[27] One proponent of such a joining is Jon McKenzie, whose recent *TDR* "Comment" invokes none other than Hardt and Negri's *Empire*.[28] Once more, an avantgarde tradition meets Marxism, a journal devoted to the avant-garde manifesto searches out a text that wants to lay the groundwork for a new communist manifesto. How these two traditions might be related to one another in the future, what consequences can be drawn from their intertwined histories, is the topic of a short, concluding epilogue.

Poetry for the Future

Writing the history of a futurist genre such as the manifesto is a paradoxical if not outright perverse enterprise. Yet, the search for a new poetry, a new manifesto, a new mode of articulation should be able to profit from similar endeavors in the past, from the history of the manifesto I have been trying to sketch. There is somewhere in this meandering and multiple record of successes and failures a lesson to be learned for the present. This, at least, is what I am going to suggest in a final backward glance and epilogue to this history of the future.

The history of the political manifestos is a history of repetition, of attempts to navigate between the incompatible imperatives of adapting the *Communist Manifesto* and preserving its original force. Again and again, manifestos have turned back to the *Manifesto* while trying to go forward. What would happen if we took this history of repetition not as a violation of Marx's futurist demand—that the revolution should derive its poetry from the future—but as a necessary and productive feature that defines all manifestos? The result would be an understanding of the "poetry" of the revolution as a poetry of repetition. Indeed, repetition is the original meaning of the word "revolution." Copernicus used it to describe the repetitive movements of the stars, and the makers of the French Revolution considered their revolution as the return to a previous epoch. This older meaning of revolution as repetition has intrigued historians and philosophers of revolutions, including Hobsbawm, Arendt, and Marx himself. What we can see from the vantage point of the early twenty-first century is that the modern meaning of revolution as an absolute break has itself acquired a history, that modernity should be defined not by the figure of the break but by the break's repetition. Translating "revolution" as "repetition" does not necessarily

imply advocating a simple return to the manifestos of the past. Repetition is not limited to the mechanical, eternal repetition of the same but can include a more productive repetition that embraces and produces difference.[1] Such a recognition removes the telos of an all-encompassing revolution from the horizon of the manifesto and instead accepts the necessity of revolutions and revolutionary interventions variously drawing upon, repeating, and revising one another. But it is only by recognizing the poetry of the revolution as a poetry of repetition that we can hope to make a choice between different types of repetition in the first place.

A clue to translating "revolution" as "repetition" can be found in Marx's *18th Brumaire*, in the very sentence that demands that the poetry of the revolution be derived from the future: "The revolution of the nineteenth century must let the dead bury the dead in order to arrive at its own content." As a number of readers have pointed out, the phrase "let the dead bury the dead" is itself derived from Matthew, where Jesus prevents one of his disciples from burying his father by saying: "Follow me; let the dead bury their dead" (Matt. 8:21–22).[2] In Matthew, this passage is itself part of a complicated negotiation between the past and the future in which Jesus shows that breaking with the past is a way of fulfilling it. It is striking that Marx cannot avoid borrowing from the past at the very moment when he tells us not to, and that he borrows a passage that itself deals with the problem of repetition and difference. Buried in Marx's text we thus find a clue that the poetry of the revolution is in fact a poetry of repetition even if it ultimately wants to produce a different future. The first conclusion to be drawn here is that this buried and hidden repetition must come to the fore, that a new manifesto must make manifest, rather than hide, that the poetry of the revolution is also a poetry of repetition.

Just as the manifesto can learn from its history, so it can learn from its geography. Again and again, manifestos have been engaged in laying a foundation, in declaring a point zero, in assuming a central position from which to make declarations, be they industrial London or avant-garde Paris. At the same time, however, the actual geographic condition of most manifestos was one of displacement. These displacements ranged from the exile of manifesto writers and their theories of translation to the creation of moving avant-garde journals. Many writers of manifestos were aware of this condition of displacement, but their manifestos borrowed their geography from the old manifestos, the type that was too certain of its position and place. The manifesto of the future must recognize the displacement already at work in these manifestos; it must learn how to be displaced and then install this displacement at the center of its own language and mode of articulation.

Displacement, however, describes the condition of noncenteredness only in negative terms. Avant-garde manifestos and even the *Communist Manifesto* have attempted, however hesitantly, to turn the experience of countrylessness into new forms of internationalism, be they the dadaist, surrealist, or situationist internationals, the performance studies international, or the various communist and socialist internationals. We can find here the seeds of a different geographic practice that uses the state of being displaced as a point of departure for a new geography that turns *displace*ment into *re*placement. Replacement does not mean reverting to former centers, but inventing and instituting new nodes within networks, nodes that are not fixed and given but made and remade. Replacement is to the manifesto's geography what repetition is to its history: not a return to a given center or point of origin but an active fabrication and creation of an alternative standpoint.

But how can the manifesto learn repetition and replacement? Repetition and replacement arise from a combination of the two, multiply intertwined, traditions of the manifesto: the socialist manifesto and the avant-garde manifesto. The split between the socialist and the avant-garde manifesto emerged in Marinetti's attempt to create a political wing of futurism, in the collision between Russian futurism and the Soviet state, in the "strange dialectic" between dada and Lenin, in the struggles between Breton and the French Communist Party, and between Debord and Cominform, and even in the hesitant approach between *Empire*, which concludes my first chapter, and *TDR*, which concludes the last. Can this series of splits, divisions, and divergences be brought, if not into unison, at least into a productive alliance?

Combining these two traditions or, better, having them inform one another implies a crossing of their dominant traits, which I have identified as performativity and theatricality. While the socialist manifesto is driven by the goal of transforming the world, of making performative speech acts and interventions, the avant-garde manifesto revels in these speech acts' theatrical play. This distinction between performativity and theatricality can be phrased in terms of means and end: the socialist manifesto has tended toward seeing itself as an instrument, as a means to an end, whereas the avant-garde manifesto has tended toward seeing the manifesto as an end in itself. This opposition identifies only the dominant strains in the two traditions, for performativity and theatricality, means and ends, are present in both types of manifestos throughout their histories. Just as the socialist manifesto had to admit to a certain degree of theatricality, so the avant-garde manifesto achieved speech acts and transformative interventions despite its

dominant theatricality. More importantly, different combinations of theatricality and performativity have been central for both manifestos in accomplishing their respective effects. It is, therefore, not a question of the avant-garde manifesto abandoning performativity or of the socialist manifesto banishing theatricality, but of coming up with new and unforeseen combinations of the two.

In calling for a crossing of these two traditions, I am resisting the argument that now, more than ever, the Left must be purely instrumentalist and therefore insist on a new, instrumentalist manifesto. At the same time, I am also resisting proposals, such as the one made by Giorgio Agamben, for a writing that is a pure "means without end" or Jean-Luc Nancy's conception of an "inoperative" community, whose "literary communism" is defined by a purely negative act of "interruption" that avoids all "invocation, proclamation, or declaration," that avoids, in other words, the manifesto.[3] Means without end, interruption, inoperative communities—these are but the negative formulations that must be turned around to produce a new manifesto, otherwise they will remain a *via negativa* that trusts the negative to transform the existing world. Even the situationists, masters of the negative, realized that the negative must be detourned to become a weapon.

Is there a way for the "inoperative" avant-garde manifesto to learn from the socialist manifesto how to infuse theatricality with performativity? And, conversely, for the socialist manifesto to learn something from the avant-garde's creative experimentations? How can a text be means *and* end, theatrical *and* performative, without, in the process, becoming neither? My formulations remain, if not negative and aporetic, certainly paradoxical. But must not the future be a paradox, something that will come as a surprise, going counter to our expectation, opinions, and received wisdom? For the time being, it is necessary to inhabit this paradox and demand a manifesto that would be, at one and the same time, a means to an end and an end in itself, that would fold means and end together while sustaining them both, without collapse, in a kind of balancing act or dance, suspended between past and future yet tied to both by repetition and replacement in order to make the new once more.

Introduction

1. Karl Marx, *Der achtzehnte Brumaire des Louis Napoleon*, with an afterword by Herbert Marcuse (Frankfurt am Main: Insel, 1965). First published in *Die Revolution: Eine Zeitschrift in zwanglosen Heften*, edited by J. Weydemeyer (New York: Deutsche Vereins-Buchhandlung von Schmidt and Helmich, 1852). All translations are mine unless otherwise noted. In Karl Marx and Friedrich Engels, *Werke*, vol. 8 (Berlin: Dietz Verlag, 1960), 117. Subsequently this edition will be cited as *MEW*.

2. Also see Jürgen Habermas, *Die Moderne—ein unvollendetes Projekt: Philosophisch-politische Aufsätze* (Leipzig: Reclam Verlag, 1981).

3. While insisting on this openness toward the future, Marx himself borrows from the past when using the phrase "must let the dead bury the dead," which is a quotation from Matthew. See also the epilogue of this book.

4. Fredric Jameson, *The Political Unconscious: Narrative as a Socially Symbolic Act* (Ithaca, NY: Cornell University Press, 1981).

5. Raymond Williams, *Marxism and Literature* (Oxford: Oxford University Press, 1977), 206ff.

6. Also see Reinhart Koselleck, *Vergangene Zukunft: Zur Semantik geschichtlicher Zeiten* (Frankfurt am Main: Suhrkamp, 1989).

7. The project of tracking the diffusion of manifestos is shared by various anthologies, for example, by Mary Ann Caws's collection *Manifesto: A Century of Isms* (Lincoln: University of Nebraska Press, 2001), and the manifesto section in David Norman Damrosch's *Longman Anthology of World Literature*, vol. F, edited by Djelal Kadir and Ursula Heise (New York: Longman, 2004).

8. Marjorie Perloff, *The Futurist Moment: Avant-Garde, Avant Guerre, and the Language of Rupture* (Chicago: University of Chicago Press, 1986).

9. Luca Somigli, *Legitimizing the Artist: Manifesto Writing and European Modernism 1885–1915* (Toronto: University of Toronto Press, 2003).

10. Janet Lyon, *Manifestoes: Provocations of the Modern* (Ithaca, NY: Cornell University Press, 1999). The recent interest in manifestos extends to European scholar-

ship, including a collection of manifestos edited by Wolfgang Asholt and Walter Fähnders, *Manifeste und Proklamationen der europäischen Avantgarde (1919–1938)* (Stuttgart: Metzler, 1995). A recent study of the historical avant-garde and its manifestos by Hanno Ehrlicher, *Die Kunst der Zerstörung: Gewaltphantasien und Manifestationspraktiken europäischer Avantgarden* (Berlin: Akademie Verlag, 2001), unfortunately has come to my attention too late to be substantially integrated in the present book, even though there are many common areas of interest as well as methodological differences among our projects.

Chapter I
The Formation of a Genre

1. In his essay on genre, Jacques Derrida argues that a text must both quote and enact genre laws in order to participate in a genre. "The Law of Genre," in *Acts of Literature*, edited by Derek Attridge (London: Routledge, 1992), 221–52.

2. In 1775, E. Allen reports, for example, "I . . . delivered the General's written manifesto to the Chiefs." Quoted in the *OED*, in Sparks Corr. Amer. Rev. (1853) I. 463.

3. For the most extended discussion of this authoritarian use of the manifesto, see Somigli *Legitimizing the Artist*, 29ff.

4. The text itself was called "To My Peoples" (*An meine Völker*), but was commonly referred to as a "Manifest."

5. The significance of the Diggers for the modern manifesto has been discussed by Lyon, *Manifestoes*, 16–22. Lyon argues that Digger tracts are "group-defining texts" (19), moments of identity formation.

6. Luther's texts, from the Theses to his translation of the Bible, amounted to roughly one-third of all German-language books published between 1518 and 1525, and, as Anderson observes, Luther was the first author able to sell his books on the basis of his name alone. See Benedict Anderson, *Imagined Communities: Reflections on the Origin and Spread of Nationalism* (London: Verso, 1983), 40ff.

7. Thomas Müntzer, "Vindication and Refutation," in *The Collected Works of Thomas Müntzer*, translated and edited by Peter Matheson (Edinburgh: T&T Clark, 1988), 332.

8. Ibid., 330.

9. *Thomas Müntzer, Schriften und Briefe: Kritische Gesamtausgabe*, edited by Günther Franz, with the assistance of Paul Kirn (Gütersloh: Gerd Mohn, 1968), 464, 469, 470, 265.

10. Friedrich Engels, *Der deutsche Bauernkrieg*, in Karl Marx and Friedrich Engels, *Werke*, vol. 7 (Berlin: Dietz Verlag, 1960): 327–413.

11. Karl Marx, *Zur Kritik der Hegelschen Rechtstheorie*, in *MEW*, vol. 1, 386.

12. Ernst Bloch, *Das Prinzip Hoffnung* (Frankfurt am Main: Suhrkamp, 1959); Bloch, *Der Geist der Utopie* (Munich: Duncker & Humblot, 1918).

13. Ernst Bloch, *Thomas Münzer als Theologe der Revolution*, in *Gesamtausgabe*, vol. 2 (Frankfurt am Main: Suhrkamp, 1969).

14. Georg Lukács, *History and Class Consciousness: Studies in Marxist Dialectics*, translated by Rodney Livingstone (Cambridge, MA: MIT Press, 1971); originally published as *Geschichte und Klassenbewußtsein*, 1923.

15. Recognizing Bloch's identification with Münzer, Fredric Jameson calls Bloch a "theologian of the revolution." Fredric Jameson, *Marxism and Form: Twentieth-Century Dialectical Theories of Literature* (Princeton, NJ: Princeton University Press, 1971), 117.

16. Lyon, *Manifestoes*, 16ff. This characterization is also based on Christopher Hill, *The World Turned Upside Down: Radical Ideas during the English Revolution* (New York: Viking, 1972), 86ff.

17. *The Leveller Tracts: 1647–1653*, edited by William Haller and Godfrey Davies (New York: Columbia University Press, 1944), 276, 286.

18. *The English Levellers*, edited by Andrew Sharp (Cambridge: Cambridge University Press, 1998), 54.

19. Gerrard Winstanley, "To All the Severall Societies of People, Called Churches, in the Presbyterian, Independent, or any other Forme of Profession, in the Service of God," in *The Works of Gerrard Winstanley*, edited and with an introduction by George H. Sabine (Ithaca, NY: Cornell University Press, 1941), 445.

20. Eduard Bernstein, *Cromwell and Communism: Socialism and Democracy in the Great English Revolution* (London: Allen and Unwin, 1930), 117. See also Winthrop S. Hudson, "Economic and Social Thought of Gerrard Winstanley: Was He a Seventeenth-Century Marxist?" *Journal of Modern History* 18 (1946): 1–21; John R. Kott Jr., *The Sword of the Spirit: Puritan Responses to the Bible* (Chicago: University of Chicago Press, 1980).

21. Bloch, *Thomas Münzer*, (1969), 64ff.

22. Engels, *Bauernkrieg*, 382.

23. Haller and Davies, *Leveller Tracts*, 1; Hill, *World Turned Upside Down*, 95; Don Marion Wolfe, *Leveller Manifestoes of the Puritan Revolution* (New York: T. Nelson and Sons, 1944).

24. Kenneth Burke, *A Grammar of Motives* (1945; Berkeley: University of California Press, 1969), 323.

25. Self-foundation as a philosophical problem is often said to have started with Descartes, which is why even his *Discourse* has received the retrospective label "manifesto" by Chantal Mouffe and Ernest Laclau. Ernesto Laclau and Chantal Mouffe, *Hegemony and Socialist Strategy: Towards a Radical Democratic Politics*, translated by Winston Moore and Paul Cammack (London: Verso, 1985), 2.

26. Cf. *MEW*, vol. 4, 640n237.

27. Friedrich Engels, "Grundsätze des Kommunismus," and *MEW*, vol. 4, 361–80.

28. Letter of November 23–24, 1847, in *MEW*, vol. 27, 107.

29. Hayden White calls Marx's theory a "philosophical defense of history." Hayden White, *Metahistory: The Historical Imagination in Nineteenth-Century Europe* (Baltimore: Johns Hopkins University Press, 1973), 281ff.

30. Karl Marx and Friedrich Engels, *Manifesto of the Communist Party*, in *Birth of the Communist Manifesto: With Full Text of the Manifesto, all Prefaces by Marx and Engels, Early Drafts by Engels and Other Supplementary Material*, edited and annotated, with an introduction by Dirk J. Struik (New York: International Publishers, 1971), 113, 115, 116, 119, 120. All references to the *Communist Manifesto* and its prefaces are to this edition, unless otherwise noted.

31. Marshall Berman, *All That Is Solid Melts into Air: The Experience of Modernity* (London: Penguin, 1988).

32. Maurice Blanchot, *L'amitié* (Paris: Gallimard, 1971), 116.

Chapter 2
Marxian Speech Acts

1. Pierre Bourdieu, *Language and Symbolic Power*, edited and introduced by John B. Thomson, translated by Gino Raymond and Matthew Adamson (Cambridge: Polity Press, 1991), 107ff.

2. J. L. Austin, *How to Do Things with Words* (Cambridge, MA: Harvard University Press, 1962), 164. I would like to thank J. Hillis Miller for calling my attention to this passage. Miller also discusses this formulation in his *Speech Acts in Literature* (Stanford, CA: Stanford University Press, 2001).

3. Jacques Derrida, *Specters of Marx: The State of the Debt, the Work of Mourning and the New International*, translated by Peggy Kamuf (New York: Routledge, 1994). Also see Martin Harries, *Scare Quotes from Shakespeare: Marx, Keynes, and the Language of Reenchantment* (Stanford, CA: Stanford University Press, 2000).

4. The climactic showdown is also cast in terms of two textual genres, for the battle between the specter and the party becomes a battle between the "nursery tale" and the manifesto. The manifesto, it turns out, is an anti–fairy tale, and it is through an attack on the fairy tale, which was then just at the height of its nineteenth-century resurgence, that the manifesto constitutes itself.

5. Burke, *Grammar of Motives*, 200ff.

6. Karl Marx, *Die Deutsche Ideologie*, in *MEW*, vol. 3, 26–27.

7. Karl Marx, "Thesen über Feuerbach," in *MEW*, vol. 3, 7.

8. Louis Althusser, Jaques Rancière, and Pierre Macherey, *Lire le capital*, vol. 1 (Paris: François Maspero, 1967), 14.

9. Louis Althusser, *Machiavelli and Us*, edited by François Matheron, translated with an introduction by Gregory Elliott (London: Verso, 1999). Gramsci calls *The Prince*, but not without placing quotation marks around this label, a "manifesto politico." Antonio Gramsci, *Quaderni del Carcere*, vol. 3, edited by Valentino Gerratana (Milan: Einaudi, 1975), 1556.

10. Cf. Derrida's remarks on a similar act of self-foundation in *Otobiographies: L'enseignement de Nietzsche et la politique du nom propre* (Paris: Editions Galilée, 1984), 19–20.

11. Gayatri Chakravorty Spivak, "Can the Subaltern Speak?" in *Marxism and the Interpretation of Culture*, edited and with an introduction by Cary Nelson and Lawrence Grossberg (Urbana: University of Illinois Press, 1988), 271–313.

12. Laclau and Mouffe, *Hegemony and Socialist Strategy*, 151.

Chapter 3
The History of the *Communist Manifesto*

1. Engels, *MEW*, vol. 28, 118.

2. Karl Marx and Friedrich Engels, in collaboration with Ernst Dronke, *Die Großen Männer des Exils*, MEW, vol. 8, 274.

3. Bert Andréas, *Le manifeste communiste de Marx et Engels: Histoire et bibliographie, 1848–1918* (Milan: Feltrinelli, 1963).

4. Bakunin in a letter to *Liberté*, quoted in K. J. Kenafick, *Michael Bakunin and Karl Marx* (Melbourne: A Maller, 1948), 276n.1.

5. The relation between utopia and manifesto was touched upon in a recent debate between Fredric Jameson and Perry Anderson. Jameson relates utopias to manifestos, without, however, recognizing the rivalry between the two genres. Fredric Jameson, "The Politics of Utopia," *London Review of Books* 25 (January–February 2004): 41. Anderson takes up this relation but hints at a transformative relation by saying that "utopian" texts in the twentieth century were "criss-crossed by traces of the manifesto." Perry Anderson, "The River of Time," *New Left Review* 26 (March–April 2004): 67.

6. Equally important is Lenin's relation to a second text, also called *What Is to Be Done?* (1886), by Leo Tolstoy. Tolstoy recounts, in a quasi-autobiographical and essayistic mode, the attempts of a protagonist to alleviate the lot of the poor through acts of charities, before turning to a theoretical meditation on the root causes of poverty.

7. Later, Marx would refer to the German translation of this text as "Manifest." *Karl Marx Friedrich Engels Gesamtausgabe (MEGA)*, series 1, vol. 20 (Berlin: Dietz Verlag, 1977), 920.

8. Marx's margin notes are preserved in *MEGA* I, vol. 25, 468–86.

9. Leon Trotsky, *Manifesto of the Communist International to the Workers of the World*, in Leon Trotsky, *The First 5 Years of the Communist International*, vol. 1 (New York: Monad Press, 1972), 19.

10. The original title was "Richtlinien für die Arbeiter- and Soldatenräte Deutschlands" [Guidelines for the Workers' and Soldiers' Councils], published in the Left journal *Die Rote Fahne* November 26, 1918. Only later, once it had acquired foundational power, was it called "manifesto."

11. Rosa Luxemburg, "Unser Programm und die politische Situation: Rede auf dem Gründungsparteitag der KPD (Spartakusbund) December 31, 1918," in Rosa Luxemburg, *Politische Schriften*, edited and with an introduction by Ossip K. Flechtheim (Frankfurt am Main: Athäneum, 1987), 395.

12. Klara Zetkin, Rosa Luxemburg, Karl Liebknecht, and Franz Mehring, *Spartacus Manifesto*, in *The Weimar Republic Sourcebook*, edited by Anton Kaes, Martin Jay, and Edward Dimendberg (Berkeley: University of California Press, 1994), 38. English translation first published in the *New York Times*, November 29, 1918.

13. *Writings of Leon Trotsky*, edited by Naomi Allen and others (New York: Pathfinder Press, 1973); (1939–40), 183–222.

14. *Secret Diplomatic Documents and Treaties from the Archives of the Ministry of Foreign Affairs of the Former Russian Government*, with an introduction by Leon Trotsky, translated from the originals (Petrograd: Bureau of International Revolutionary Propaganda, attached to the Commissariat for Foreign Affairs of the Provisional Workmen's and Peasants' Government of the Russian Republic, 1918), 2.

15. *Writings of Leon Trotsky* (1937–38), 18.

16. In an "appendix," Zizek confirms this semimanifesto status of Laclau's work, in particular of *Hegemony*, saying that this text is not "just one in a series of 'post-' works" and insisting instead that "for the first time, it articulates the contours of a political project based on an ethics of the real" (259). Indeed, what Marx called "poetry" of the future can be translated into Laclau and Mouffe's term "articulation." In "New Reflections on the Revolution of Our Time," Laclau writes what he calls "something of an introduction and something of a manifesto," a generic designation that is repeated in the book series it inaugurates, the Phronesis series, which takes up the challenge to define a Left after 1989. Ernesto Laclau, *New Reflections on the Revolution of Our Time* (London: Verso, 1990), 5.

17. Michael Hardt and Antonio Negri, *Empire* (Cambridge, MA: Harvard University Press, 2001).

18. Slavoj Zizek denies *Empire* the status of a manifesto. Slavoj Zizek, "Have Michael Hardt and Antonio Negri Rewritten the Communist Manifesto for the 21st Century?" *Rethinking Marxism* 13, nos. 3–4 (2001): 190–98.

Chapter 4
The Geography of the *Communist Manifesto*

1. G.W.F. Hegel, *Vorlesungen über die Philosophie der Geschichte, Werke 12* (Frankfurt am Main: Suhrkamp, 1986).

2. David Harvey, *Spaces of Hope* (Berkeley: University of California Press, 2000), 55. Harvey writes: "While it is clear that the bourgeoisie's quest for class domination was (and is) a very geographical affair, the almost immediate reversion in the text to a purely temporal and diachronic account is striking. It is hard, it seems, to be dialectical about space, leaving many Marxists in practice to follow Feuerbach in thinking that time is 'the privileged category of the dialectician, because it excludes and subordinates where space tolerates and coordinates' (Ross, 1988, 8)" (55). Among the texts collected in his *Spaces of Capital: Towards a Critical Geography* (New York: Routledge, 2001), we find one entitled, "On the History and Present Condition of Geography: A Historical Materialist Manifesto," first published in 1984, which cul-

minates thus: "5. Define a political project that sees the transition from capitalism to socialism in historico-geographical terms" (120).

3. Johann Peter Eckermann, *Gespräche mit Goethe in den letzten Jahren seines Lebens*, edited by Fritz Bergmann (Wiesbaden: Insel, 1955), 211.

4. Preface to *German Romance* (Edinburgh, 1827). In *Johann Wolfgang Goethe, Sämtliche Werke*, Münchner Ausgabe, edited by Karl Richter, vol. 18.2 (Munich: Carl Hanser Verlag, 1985–98), 86.

5. Johann Wolfgang von Goethe, *Die Zusammenkunft der Naturforscher in Berlin*, Weimar Edition II, 13 (Weimar, 1828), 449.

6. Karl Marx, *Das Kapital: Kritik der politischen Ökonomie*, edited and with an afterword by Alexander Ulfig (Cologne: Parkland, 2000), 61ff.

7. A recent example is the new biography of Marx by Francis Wheen, who uses the term "frightful hobgoblin" as an ironic chapter heading. Francis Wheen, *Karl Marx* (London: Fourth Estate, 1999), 115.

8. Karl Marx, *MEW*, vol. 4, 465.

9. Erich Auerbach, "Weltliteratur," in *Gesammelte Aufsätze zur romanische Philologie* (Bern: Francke, 1967).

10. David Norman Damrosch, *What Is World Literature?* (Princeton, NJ: Princeton University Press, 2003). Among the examples cited is Steven Own's critique of Bei Dao as "world poetry" written for easy consumption by culturally hegemonic French or Anglo-American modernism (19ff.); the linguist David Crystal, whose *English as a Global Language* (1997) paints a similar horror picture, predicting "the greatest intellectual disaster the world has ever known" if English displaces or even replaces other languages (225). Tim Brennan bemoans the availability of international junk novels, which he calls "market realism" (18). In a parallel argument that is directed less at the production of literature than at the production of literary criticism, Jonathan Arac has shown to what extent the study of world literature depends on what he calls "Anglo-Globalism," the dominance of English as the language of scholarship. Jonathan Arac, "Anglo-Globalism?" *New Left Review* 16 (July–August 2002): 35–45.

11. Achebe, quoted in David Crystal, *English as a Global Language* (Cambridge: Cambridge University Press, 1997), 136.

12. Gilles Deleuze and Félix Guattari, *Kafka: Toward a Minor Literature*, translated by Dana Polan, with a foreword by Réda Bensmaia (Minneapolis: University of Minnesota Press, 1986).

13. If Marx is pursuing a Pentecostal fantasy, one might see in this the Protestant influence of Marx's father, who had converted to Protestantism.

14. George Steiner, *After Babel: Aspects of Language and Translation* (Oxford: Oxford University Press, 1975).

15. Quoted in Damrosch, *What Is World Literature?* 20.

16. Jean Baudrillard developed his critique of the sign as the latest stage of capital in *For a Critique of the Political Economy of the Sign*, translated by Charles

Lewis (St. Louis: Telos Press, 1981), and in *The Mirror of Production*, translated and with an introduction by Mark Poster (St. Louis: Telos Press, 1975).

17. Karl Marx, *The 18th Brumaire*, in *MEW*, vol. 8, 115.

18. Edward Said, *The World, the Text, and the Critic* (Cambridge, MA: Harvard University Press, 1983), 241; James Clifford, *Routes: Travel and Translation in the Late Twentieth Century* (Cambridge, MA: Harvard University Press, 1997).

19. P. N. Fedoseyev et al., *Karl Marx: A Biography*, prepared by the Institute of Marxism-Leninism of the Central Committee of the Communist Party of the Soviet Union, translated by Yuri Sdobinkov (Moscow: Progress Publishers, 1973), 225.

20. I would like to thank Djelal Kadir for this suggestion.

21. Perry Anderson, "Internationalisms: A Breviary," *New Left Review* 14 (March–April 2002): 4.

22. Karl Marx and Friedrich Engels, in collaboration with Ernst Dronke, *Die Großen Männer des Exils*, in *MEW*, vol. 8, 233–335.

23. Bruce Robbins, *Feeling Global: Internationalism in Distress* (New York: NYU Press, 1999).

24. Foreign-language editions of the *Manifesto* in the United States could be related to what Marc Shell and Werner Sollers call "Longfellow literature," a project gathering U.S. literature written in languages other than English.

25. Franco Moretti, "Conjectures on World Literature," *New Left Review* 1 (January–February 2000): 54–68.

26. Regrounding or reorienting the manifesto in a new locale triggers a crisis of articulation whose most poignant formulation can be found in Spivak, "Can the Subaltern Speak?" 271–313.

27. Hu Shih, "Some Modest Proposals for the Reform of Literature," translated by Kirk A. Denton, in *Longman Anthology of World Literature*, 47–55.

28. Min-Chih Chou, *Hu Shih and Intellectual Choice in Modern China* (Ann Arbor: University of Michigan Press, 1984), 144.

Chapter 5
Marinetti and the Avant-Garde Manifesto

1. For an extended discussion of romantic prophecy, see Ian Balfour, *The Rhetoric of Romantic Prophecy* (Stanford, CA: Stanford University Press, 2002).

2. Caws, *Manifesto*, 50; *Les manifestes littéraires de la Belle Époque 1886–1914*, edited by Bonner Mitchell (Paris: Éditions Seghers, 1966).

3. Among the schools mentioned are romanticism and naturalism. "Le Symbolism," *Figaro*, September 18, 1886, in Jean Moréas, *Les première armes du symbolisme*, edited and annotated by Michael Pakenham (Exeter: Exeter University Print Unit, 1973), 29, 30.

4. The classic studies of the avant-garde follow this pattern, for example, Peter Bürger's *Theorie der Avantgarde* (Frankfurt am Main: Suhrkamp, 1974) and Maurice Nadeau's *The History of Surrealism*, translated by Roger Shattuck (New York: Macmillan, 1965).

5. This trend was set by the early collection *Les manifestes littéraires de la Belle Époque 1886–1914*. Of the fourteen manifestos presented here, all with the title "Manifeste," only a single one actually presented itself under this generic title, namely, "Un Manifeste Symboliste," written by Jean Royère and printed in the literary magazine *Grande Revue*, August 25, 1909, after Marinetti had started to republish his "Le Futurisme" under the title *Fondazione e Manifesto del Futurismo* or *Primo Manifesto del Futurismo*.

6. One example is Fernand Desnoyers's "Du Réalisme" (1855), which calls itself an "article," but which refers to itself, in the body of the text, as a "profession of faith" or "manifesto." In *Documents of Modern Literary Realism*, edited by George J. Becker (Princeton, NJ: Princeton University Press, 1963), 80.

7. The term *manifeste* appeared, for example, in *Le Décadent*, the art magazine edited by Anatole Baju, which published texts that were retrospectively called "manifestos." The editor's so-called "Manifeste Décadent" (April 1886) was in fact an editorial called "Aux Lecteurs!" In *Le Décadent*, Ernest Raymond would write, mixing an apocalyptic understanding of the manifesto with a more modern one: "L'heure a sonné, des manifestes parmi l'odeur de poudre et les bruits d'armes de cette fin de ciècle tourmentée," March 15, 1888, ser. 2, no. 7, p. 10. At the same time, the term *manifeste* was still used in the more general sense of stating an opinion. Baju himself would write, "Voila pourquoi la Jeunesse laborieuse méprise cet homme et manifeste contre lui," May 1, 1888 serie 2, no. 10, p. 13, or, in a similar vein: "Nous avons à différentes reprises manifesté ici-même des sentiments suffisamment antiboulangistes," 4th year, no. 27, p. 17. In those last instances, the verb form of *manifester* does not seem to refer yet to a specific genre called *manifeste*.

8. The different versions of the manifesto can be found among the Marinetti Papers at the Beinecke Library, Yale University; Marinetti, +M317, second box. See especially folders 51, 52, 59, 60, and 61.

9. The different signatures can be found among the Marinetti Papers at the Beinecke Library, Yale University; Marinetti, +M317, second box. See especially folders 51, 52, 59, 60, 61.

10. For a detailed discussion of Baju, this important transitional figure, also see Somigli, *Legitimizing the Artist*, 57ff.

11. *Marinetti, Teoria e Invenzione Futurista*, edited by Luciano De Maria (Milan: Mondadori, 1968), 77. All references to Marinetti are to this edition unless otherwise noted.

12. Perloff, *Futurist Moment*, 80ff.

13. Kenneth Burke, *Attitudes toward History*, with a new afterword (Berkeley: University of California Press, 1984), 32.

14. F. T. Marinetti, letter to Severini (1913), in *Archivi del futurismo*, vol. 1, edited by M. Drudi Gambillo and T. Fiori (Rome: De Luca, 1958), 295.

15. Marinetti Papers, Beinecke, Mss Gen 133, box 28, folder 1395.

16. Ibid., folder 1389, p. 25 (photocopy). This is an autograph manuscript draft of the first futurist manifesto, on the paper of the Grand Hôtel Paris.

17. It might well have been his explicitly antisocialist, "neutral" politics that kept Poggioli from fully grasping the import of the manifesto. Poggioli articulates this neutralist stance in the last section of his book. Renato Poggioli, *The Theory of the Avant-Garde*, translated by Gerald Fitzgerald (New York: Harper and Row, 1971).

18. One such exception was Baju, who, after propagating symbolism, became a socialist. Another exception is Oscar Wilde's pro-socialist text "The Soul of Man under Socialism."

19. As Matei Calinescu details, the term "avant-garde" entered the social struggle in the aftermath of the French Revolution, in the journal *L'Avant-garde de l'armée des Pyrénées orientales*, which appeared in 1794 and was devoted to the defense of Jacobin ideas. Matei Calinescu, *Five Faces of Modernity: Modernism, Avant-Garde, Decadence, Kitsch, Postmodernism* (Durham, NC: Duke University Press, 1987).

20. Charles Baudelaire, *Mon coeur mis à nu*, in *Œuvres Complètes*, edited by Claude Pichois, 2 vols. (Paris: Gallimard, 1975–76), vol. 1, 691.

21. Details about Zola are based on *The Dreyfus Affair: "J'Accuse" and Other Writings*, edited by Alain Pagès, translated by Eleanor Levieux (New Haven, CT: Yale University Press, 1996).

22. Pierre Bourdieu, *The Rules of Art: Genesis and Structure of the Literary Field*, translated by Susan Emanuel (Stanford, CA: Stanford University Press, 1996).

23. Neither of these texts was actually called a manifesto. The only text called "manifesto" was issued by Zola's enemies, the infamous "Manifeste des Cinq," published in *Le Figaro* in 1887. Here a number of writers denounce Zola's latest novel, *La Terre*, for having sacrificed, in the terms of the authors, eloquence for pornography.

24. Bürger, *Theorie der Avantgarde*.

25. Benito Mussolini, "Address to the National Corporative Council," in *A Primer of Italian Fascism*, edited and with an introduction by Jeffrey Schnapp, translated by Jeffrey Schnapp, Olivia E. Sears, and Maria G. Stampino (Lincoln: University of Nebraska Press, 2000), 163–64.

26. Antonio Gramsci confirms Marinetti's claim to the adjective "revolutionary," in his text "Marinetti the Revolutionary," *L'Ordine Nuovo*, January 5, 1921.

27. Hannah Arendt, *On Revolution* (London: Penguin, 1965).

28. As Robert Jackall and others have shown, the word "propaganda" did not acquire its current, entirely negative meaning before the Nazi period. Robert Jackall, "Introduction," in *Propaganda*, edited by Robert Jackall (New York: NYU Press, 1995), 5.

29. Georges Sorel, *Reflections on Violence*, authorized translation by T. E. Hulme (New York: B. W. Huebsch, 1914).

30. This quotation is of somewhat questionable origin. Donald Drew Egbert quotes it in *Social Radicalism and the Arts: A Cultural History from the French Revolution to 1968* (New York: Knopf, 1970), 281, but refers only to an undocumented quotation in Edward H. Carr's *Studies in Revolution* (London, 1950), 163.

31. Sergio Panunzio, "What Is Fascism?" (1924), in Schnapp, *Primer of Italian Fascism*, 88.

32. Gioacchino Volpe, "History of the Fascist Movement," in Schnapp, *Primer of Italian Fascism*, 21.

33. Benito Mussolini (in collaboration with Giovanni Gentile), "Foundations and Doctrine of Fascism," in Schnapp, *Primer of Italian Fascism*, 51.

34. Volpe, "History of the Fascist Movement," 22.

35. The question of whether Italian and German fascism can be fully explained as a "damming of the Bolshevik flood" has been a highly controversial issue, giving rise to a reactionary historiography, which led to the so-called *Historikerstreit*, the battle of the historians in Germany.

36. Valentine de Saint-Point, *Manifeste de la Femme Futuriste suivi de Manifeste Futuriste de la Luxure, Le Théâtre de la Femme, La Métachorie*, edited by Giovanni Lista (Paris: Séguier, 1996), 13–21.

37. Georges Sorel, *La décomposition du marxisme* (Paris: Librairie des Sciences Politiques et Sociales, 1925).

38. Volpe, "History of the Fascist Movement," 21.

39. Adolf Hitler, *Mein Kampf*, edited by John Chamberlain and Sidney B. Fay (New York: Reynal and Hitchkcock, 1941), 708.

40. George L. Mosse, *The Nationalization of the Masses: Political Symbolism and Mass Movements in Germany from the Napoleonic Wars through the Third Reich* (New York: H. Fertig, 1975).

41. Günter Berghaus, *Italian Futurist Theatre, 1909–1944* (Oxford: Clarendon Press, 1998).

42. Giovanni Lista, *La scène futuriste* (Paris: Éditions du Centre National de la Recherche Scientifique, 1989).

43. See my *Stage Fright: Modernism, Anti-Theatricality, and Drama* (Baltimore: Johns Hopkins University Press, 2002).

44. Berghaus (*Italian Futurist Theatre*, 156ff) argues that the 1913 and 1914 manifestos on futurist theater mark a turning point in the development of futurist theatricality, namely, a turning away from the *serate* and the theatricality built around political agitation and provocation and a turning toward a renewed interest in such traditional theatrical topics as drama, acting, and mise-en-scène.

45. Wyndham Lewis, "The Six Hundred, Verestchagin and Ucello," in *Blast II: War Number*, July 1915 (Santa Rosa, CA: Black Sparrow Press, 1993), 25.

46. *Marinetti*, 148.

47. One of the texts can be identified as Marinetti's *Zang Tumb Tuuumb* (1914), itself a combination of sound collage and manifesto. In its original appearance, Carrà's collage was not yet labeled "manifestazione interventista" but rather *Dipinto prolivero (festa patriottica)* (Free-word picture [patriotic festival]). It is as if Carrà had only realized later that his real innovation was not the use of free words but the fusion of manifesto and collage.

48. Bürger, whose assumptions about the division between modernism and avant-garde I oppose, moves in this direction at one point by observing that works such as Duchamp's *Fountain* are not simply works of art but "manifestations." Bürger, *Theorie der Avantgarde*, 71.

Chapter 6
Russian Futurism and the Soviet State

1. Of the wide-ranging literature on this subject, see Ken Post, *Revolution's Other World: Communism and the Periphery, 1917–39* (New York: St. Martin's Press, 1997); *Revolutionary Socialist Development in the Third World*, edited by Gordon White, Robin Murray, and Christine White (Lexington: University Press of Kentucky, 1983); *Marxian Theory and the Third World*, edited by Diptendra Banerjee (New Delhi: Sage, 1985).

2. Data based on Andréas, *Le manifeste communiste de Marx et Engels*.

3. Leon Trotsky, *Literature and Revolution* (Ann Arbor: University of Michigan Press, 1960), 126–27.

4. Jameson writes, "Modern art . . . drew its power and its possibilities from being a backwater and an archaic holdover within a modernizing economy." Fredric Jameson, *Postmodernism or, The Cultural Logic of Late Capitalism* (Durham, NC: Duke University Press, 1991), 307.

5. Perry Anderson, *The Origins of Postmodernity* (London: Verso, 1998), 55.

6. Igor Severyanin, *Ruchyi v liliyakh* (Brooks Full of Lilies), 1911. See Vladimir Markov, *Russian Futurism: A History* (Berkeley: University of California Press, 1968), 63. My understanding of Russian futurism is greatly indebted to this work. In an essay, "The First Year of Futurism," Kazansky admits openly that the "Italian-French *Futurism*" of Marinetti had been created three years prior to the beginning of ego-futurism. Ivan Kazansky, "The First Year of Futurism," in *Russian Futurism through Its Manifestoes, 1912–1928*, edited and with an introduction by Anna Lawton and an afterword by Herbert Eagle (Ithaca, NY: Cornell University Press, 1988), 113.

7. "The Word as Such," in Lawton, 55.

8. Markov, *Russian Futurism*, 150ff.

9. See ibid., 154.

10. "The Word as Such," in Lawton, 55.

11. Quoted in Markov, *Russian Futurism*, 283.

12. Roman Jakobson, "Linguistics and Poetics," in *Language in Literature*, edited by Krystyna Pomorska and Stephen Rudy (Cambridge, MA: Harvard University Press, 1987): 64.

13. Markov writes: "There were few translations of Marinetti's non-theoretical works, and his poetry, to the best of my knowledge, has been translated into Russian only once" (*Russian Futurism*, 160).

14. Ibid., 144.

15. Quoted in Cesare G. De Michelis, *Il Futurismo Italiano in Russia 1909–1929* (Bari: De Donato Editore, 1973), 30.

16. *Futurizm*, edited by M. Engelhadt (St. Petersburg: Prometej, 1914); F. T. Marinetti, *Guerra sola igine del mondo* (Milan: Edizioni Futuriste di Poesia, 1915); F. T. Marinetti, *El Futurismo* (Valencia: F. Sempere, 1916).

17. Panda, "Nabroski sovremennosti (futuristy)," *Večer*, March 8, 1909; reprinted in De Michelis, *Il Futurismo Italiano in Russia*, 80.

18. Before 1914, there were at least twenty-six articles that discuss and quote from Marinetti, in addition to direct translations of the following futurist manifestos into Russian: Russolos's *Arte dei Rumori* (1912); Pratella's *Manifesto dei musicisti futuristi* (1912); Marinetti's *La voluttà d'essere fischiati* (1912); the *Manifesto dei pittori futuristi* (1912); and *Gli espositori al pubblico* (1912). Data based on De Michelis, *Il Futurismo Italiano in Russia*.

19. C. M. Fofanov and Mirra Lokhvitskaya's "Academy of Ego-Poetry," which came to be known as "The Tables," was published in St. Petersburg in 1912 (Lawton, 109); I. V. Ignatyev's "Ego-Futurism" was published in St. Petersburg in 1913 (Lawton, 118).

20. Alexei Kruchenykh's Declaration of the Word as Such appeared in the summer of 1913 as a leaflet (Lawton, 67); "Trumpet of the Martians," by Victor Khlebnikov, Maria Sinyakova, Bozhidar, Grigory Petnikov, and Nikolay Aseyev, was printed on a scroll in Kharkov in 1916 (Lawton, 103). *Virgin Soil* appeared on October 16, 1914 (Lawton, 87–89).

21. See Markov, *Russian Futurism*, 131ff.

22. The most famous Russian manifestos that appeared in almanacs and anthologies include "A Trap for Judges, 2," "New Ways of the Word," "The Liberation of the Word," "Go to Hell!" and "A Drop of Tar."

23. Lawton, 58.

24. Some examples are Kruchenykh's *Explodity* (Lawton, 65); his "Declaration of the Word as Such" (Lawton, 67); his "New Ways of the Word" (Lawton, 69); Burliuk's "Poetic Principles" (Lawton, 82); the collective "Go to Hell!" (Lawton, 85); Mayakovsky's "We, Too, Want Meat!" (Lawton, 87).

25. Trotsky, *Literature and Revolution*, 209.

26. Lawton, 193.

27. Sergei Tretyakov, "Lef's Tribune," *Lef*, no. 3 (1923), reprinted in Lawton, 235.

28. Cf. chap. 5, n. 26.

29. Lawton, 192.

30. Osip Brik, "We Are the Futurists," *New Lef*, nos. 8–9 (1927): 49; reprinted in Lawton, 251.

Chapter 7
The Rear Guard of British Modernism

1. Wyndham Lewis, *Blasting and Bombarding* (London: Calder and Boyars, 1967), 254.

2. The notion of a rear guard has been subject to a conference and collection of essay, edited by William Marx, in which a shorter version of this chapter appeared. *Les arrière-gardes au XXe siècle: L'autre face de la modernité esthétique*, edited by William Marx (Paris: Presses Universitaires de France, 2004).

3. In a letter from 1932, Artaud expressed his frustration with manifestos, declaring, "There are too many manifestos and not enough works of art. Too many theories and no actions," in Antonin Artaud, *Œuvres Complètes*, vol. 5 (Paris: Gallimard, 1956), 85.

4. These two manifestos are reprinted in Asholt and Fähnders, *Manifeste und Proklamationen der europäischen Avantgarde*, 59, 63.

5. This reservation is also the reason why expressionism does not fit easily in the dominant definitions of the avant-garde, as discussed in Richard Murphy, *Theorizing the Avant-Garde: Modernism, Expressionism, and the Problem of Postmodernity* (Cambridge: Cambridge University Press, 1999).

6. A playful yoking of an aesthetic program and a dramatic text occurred in Oscar Wilde's dialogue, "The Decay of Lying."

7. What Pound called the "Tenets of Imagiste faith" was published in 1913. "A Few Don'ts" was first printed in *Poetry* 1, no. 6 (March 1913), and "Credo," as part of "Prolegomena," in *Poetry Review*, later *Poetry and Drama*, February 1912. All these manifesto-like statements were written before Marinetti's third visit to London and before the publication of *Blast*.

8. Lyon, *Manifestoes*, 124ff.

9. Pound writes: "I made the word—on a Hulme basis—and carefully made a name that never had been used in France . . . specifically to distinguish 'us' from any of the French groups catalogued by Flint in the P[oetry R[eview]." Quoted in Hugh Kenner, *The Pound Era* (Berkeley: University of California Press, 1971), 178.

10. Somigli, *Legitimizing the Artist*, 162ff.

11. Quoted in Hugh Kenner, *Wyndham Lewis* (Norfolk, CT: New Directions, 1954), 62.

12. Lawrence Rainey has shown to what extent Marinetti's well-attended lectures and publicity put pressure on Pound, who at the time was lecturing to small audiences about esoteric subjects such as Provençal poetry. Lawrence Rainey, *Institutions of Modernism: Literary Elites and Public Cultures* (New Haven, CT: Yale University Press, 1998), 11ff.

13. Paul Peppis, *Literature, Politics, and the English Avant-Garde: Nation and Empire, 1909–1918* (Cambridge: Cambridge University Press, 2000).

14. Reed Way Dasenbrock comments on the playfulness of Lewis's manifestos, as well as on the importance of the image. Reed Way Dasenbrock, *The Literary Vorticism of Ezra Pound and Wyndham Lewis: Towards the Condition of Painting* (Baltimore: Johns Hopkins University Press, 1985), 25ff.

15. Ezra Pound, *"Ezra Pound Speaking": Radio Speeches of World War II*, edited by Leonard W. Doob (Westport, CT: Greenwood Press, 1978), 107.

16. *Blast I*, edited by Wyndham Lewis, foreword by Bradford Morrow (Santa Rosa, CA: Black Sparrow Press, 1997), 7.

17. See Karl Heinz Bohrer, *Suddenness: On the Moment of Aesthetic Appearance*, translated by Ruth Crowley (New York: Columbia University Press, 1994).

18. Burke, *Grammar of Motives*, 200ff.

19. David Kadlec has pointed to the significance of suffragist pamphlets for *Blast*. David Kadlec, "Pound, *Blast*, and Syndicalism," *ELH* 60 (1993): 1015–31.

20. See Vincent Sherry on the significance of European modernism for Pound and Lewis. Vincent Sherry, *Ezra Pound, Wyndham Lewis, and Radical Modernism* (Oxford: Oxford University Press, 1993).

21. For more details on women's suffrage agitation, see Mark S. Morrisson, *The Public Face of Modernism: Little Magazines, Audiences, and Reception, 1905–1920* (Madison: University of Wisconsin Press, 2001), 84ff.

22. Keith Tuma has demonstrated that *Blast* is directed against the academy but not against the artwork as such. Keith Tuma, "Wyndham Lewis, *Blast*, and Popular Culture," *ELH* 54 (1987): 403–19.

23. More than twenty years later, Virginia Woolf reflected on the relation between manifestos and women's suffrage in her *Three Guineas* (1938). The occasion for this text had been a request to sign a manifesto against the war and for an independent, democratic culture. Rather than signing on, Woolf subjects the context of the manifesto, the culture and society that gave rise to it and enabled its political intervention, to critical scrutiny. Woolf's letter points out that the manifesto's reliance on the fiction of its own efficacy leads it to ignore the cultural context that makes this fiction possible. *Three Guineas* is a late reaction against the manifesto-driven politics before and after World War I, as well as the resurgence of political tracts during the Spanish Civil war. At the same time, it itself has become a powerful tract in the history of feminism (even though Woolf distances herself from the term).

24. In a distinction made by Bürger, vorticism does not belong to the avant-garde, which he defines as the desire to attack art as such, but to modernism, which only seeks to distance itself from nineteenth-century or "academic" art. Upon closer examination, the strategies of *Blast* with respect to the continental avant-garde are much too contradictory to be classified according to Bürger's modernism/avant-garde scheme.

25. Wyndham Lewis, *Men without Art*, edited by Seamus Cooney (Santa Rosa, CA: Black Sparrow Press, 1987), 231.

26. Douglas Mao has argued that aestheticism is recoded in modernism: "One of modernism's key moves in its own defense of poesy—one so far accorded surprisingly little attention by scholars—was to try to legitimate Nineties aestheticism by, in effect, rewriting it along the lines of mid-Victorian moral earnestness." Douglas Mao, *Solid Objects: Modernism and the Text of Production* (Princeton, NJ: Princeton University Press, 1998), 38.

27. Lewis, *Men without Art*, 225.

28. Fredric Jameson, *Fables of Aggression: Wyndham Lewis, the Modernist as Fascist* (Berkeley: University of California Press, 1979).

29. Cf. Janet Lyon's argument about Pound's struggle with the "we" of the manifesto (*Manifestos*, 133ff.).

30. The text features a deadly fight between husband and wife in a vortex of water only to reveal in the end that the wife survived this fight without difficulty; the

vortex turns out to have been nothing but a splash. I would like to thank David Damrosch for his suggestions regarding this text.

31. Lewis, *Blasting and Bombarding*, 14.

32. One model for *Blast*'s pan-art ambition was an influential expressionist manifesto-journal, *Der Blaue Reiter* (*The Blue Rider*) (1912). In fact, *Blast* even printed excerpts from a text by the founder of *The Blue Rider*, Wassily Kandinsky, whose theory about the relation between the arts may have had some influence on the manner in which Lewis sought to integrate literature and painting in the conception of his journal.

33. For an extensive discussion of this antitheatrical tradition, see my *Stage Fright*. In an unpublished essay, David Kornhaber has proposed to label *Enemy* an "impossible play."

34. This arrangement was allegedly an error. Another example of mixing closet drama and painting that comes to mind, albeit in a very different context, is Charlotte Salomon's *Life? Or Theater? An Operetta*, which consists of paintings and words and which was written and painted in 1941 in the south of France. See Mary Lowenthal Felstiner, *To Paint Her Life: Charlotte Salomon in the Nazi Era* (Berkeley: University of California Press, 1994).

35. This pan-art aspiration turns *Blast* into complex assemblages of pictorial and textual signs that would ultimately call for readings of the sort W.J.T. Mitchell has proposed in his *Picture Theory: Essays on Verbal and Visual Representation* (Chicago: University of Chicago Press, 1994).

36. Puchner, *Stage Fright*.

37. Dasenbrock also emphasizes the programmatic nature of this play (*Literary Vorticism*, 135).

38. Jameson, *Fables of Aggression*.

39. Lewis, *Blasting and Bombarding*, 85.

40. Even though "On Impressionism" was published in 1914, the term had been in use much longer and therefore constituted part of the field of isms within which vorticism was situated. For an extended discussion of Ford and the status of impressionism, see Jesse Matz's excellent *Literary Impressionism and Modernist Aesthetics* (Cambridge: Cambridge University Press, 2001), in particular 161–64.

41. Ford Madox Ford, "Dedicatory Letter to Stella Ford," in *The Good Soldier*, edited by Martin Stannard (New York: Norton, 1995), 4.

42. Ford, "On Impressionism," 257.

43. Wyndham Lewis, *Tarr: The 1918 Version*, edited by Paul O'Keeffe (Santa Rosa, CA: Black Sparrow Press, 1996), 14.

44. Ezra Pound, *Gaudier-Brzeska: A Memoir* (New York: New Directions, 1970).

45. Perry Anderson, "Modernism and Revolution," in *Marxism and the Interpretation of Culture*, edited and with an introduction by Cary Nelson and Lawrence Grossberg (Chicago: University of Chicago Press, 1988).

46. Pound, *"Ezra Pound Speaking,"* 107.

47. For an intriguing discussion of the relation between Pound's Imagism and his use of the radio, see Daniel Tiffany's *Radio Corpse: Imagism and the Cryptaesthetic of Ezra Pound* (Cambridge, MA: Harvard University Press, 1995), 221ff.

48. Lewis, *Blasting and Bombarding*, 288.

49. Ezra Pound, *Jefferson and/or Mussolini: L'Idea Statale, Fascism as I Have Seen It, by Ezra Pound, Volitionist Economics* (New York: Liveright, 1970).

50. Wyndham Lewis, *The Art of Being Ruled*, edited and with an afterword and notes by Reed Way Dasenbrock (Santa Rosa, CA: Black Sparrow Press, 1989); Lewis, *Time and Western Man*, edited by Paul Edwards (Santa Rosa, CA: Black Sparrow Press, 1993).

51. Eliot retreated from the manifesto-driven revolutionary futurism through his backward-looking essays, in particular, *Tradition and the Individual Talent* (1919).

52. José Ortega y Gasset, *The Revolt of the Masses* (Notre Dame, IN: University of Notre Dame Press, 1985).

53. In *Time and Western Man*, Lewis backpedaled politically, admitting that he had sold liberal democracy short by his overenthusiastic embrace of fascism: "Since writing *The Art of Being Ruled* (1925) I have somewhat modified my view with regard to what I then called 'democracy.' I should express myself differently today. I feel that I slighted too much the notion of 'democracy' by using that term to mean too exclusively the present so-called democratic masses, hypnotized into a sort of hysterical imbecility by the mesmeric methods of Advertisement" (25).

54. Tyrus Miller, *Late Modernism: Politics, Fiction, and the Arts between the World Wars* (Berkeley: University of California Press, 1999), 19ff.

Chapter 8
Dada and the Internationalism of the Avant-Garde

1. For a detailed analysis of *Blast II* in terms of war propaganda, see Peppis, *Literature, Politics, and the English Avant-Garde*, 96ff.

2. Walter Conrad Arensberg, "Dada Is American," in *Dada Total: Manifeste, Aktionen, Texte, Bilder*, edited by Karl Riha and Jörgen Schäfer, with the help of Angela Merte (Stuttgart: Reclam, 1994), 188.

3. Theo van Doesburg, "Characteristic of Dadaism," translated by Hansjürgen Bulkovski, in *Dada Total*, 181.

4. This list is based on *Dada Global*, edited by Raimund Meyer (Zürich: Limmat Verlag, 1994).

5. See Anderson, *Imagined Communities*.

6. For an excellent discussion of Duchamp as an international dadaist, see T. J. Demos's "Duchamp's *Boîte-en-valise*: Between Institutional Acculturation and Geopolitical Displacement," *Grey Room* 8 (2002): 6–73.

7. One collection, for example, begins with the foundation of *Camera Work*, in 1902, while suggesting as an alternative origin Huidobro's *Musa Joven* in 1912. *Dada in Europa: Werke und Dokumente*, edited by Klaus Gallwitz (Berlin: Dietrich

Reimar Verlag, 1977). Others emphasize the influence of *291*, with its experiments in machine art and typography. Ileana B. Leavens, *From "291" to Zurich: The Birth of Dada* (Ann Arbor, MI: UMI Research Press, 1983), 5, 17. Also see William Rozaitis, " 'The Joke at the Heart of Things': Francis Picabia's Machine Drawings and the Little Magazine *291*," *American Art* 8 (Summer/Fall 1994): 42–59.

8. Data based on William Camfield, *Francis Picabia* (New York: Solomon Guggenheim Museum, 1970), 22.

9. In a letter to Stieglitz, Picabia calls *291* the "double" of *391*; quoted in *391, Revue publiée de 1917 à 1924 par Francis Picabia*, new edition by Michel Sanouillet (Paris: Elfond and Losfeld, 1960), 46.

10. Tristan Tzara, "Chronique Zurichoise: 1915–1919," in *Dada Almanach: Im Auftrag des Zentralamtes der deutschen Dada-Bewegung*, edited by Richard Huelsenbeck (Hamburg: Edition Nautilus, 1987), 24.

11. Arjun Appadurai, *Modernity at Large: Cultural Dimensions of Globalization* (Minneapolis: University of Minnesota Press, 1996).

12. Dada can be seen as a precursor of what Craig Saper has called "networked art," in *Networked Art* (Minneapolis: University of Minnesota Press, 2001).

13. Francis Picabia, *The Dada Painters and Poets*, edited by Robert Motherwell (New York: Wittenborn Schultz, 1951), 206.

14. Using James Clifford's notion of traveling theory, one might speak here of a traveling journal. *Traveling Theories, Traveling Theorists*, edited by James Clifford and Vvek Dhareshwar (Santa Cruz: Center for Cultural Studies, Oakes College, University of California, Santa Cruz, 1989). Also see Clifford, *Routes*.

15. One list of fifty-six cities appeared in *Dada Almanach*, including New York, Bologna, Nuremberg, Bari, Bucharest, Santa Cruz, Santiago, and Washington (28–29). Newspaper clippings from "all newspapers of the world" appeared in the same publication (41).

16. *Dada Berlin: Texte, Manifeste, Aktionen*, edited by Karl Riha in collaboration with Hanne Bergius (Stuttgart: Reclam, 1977), 59.

17. Walter Mehring, "Enthüllungen: Historischer Endsport mit Pazifisten-toto," in *Dada Almanach*, 62–81.

18. *Dada Almanach*, 64.

19. See, for example, Karl Riha, "Amerika im Kopf der Dadaisten," in *Sinn aus Unsinn: Dada International*, edited by Wolfgang Paulsen und Helmut G. Hermann (Bern: Francke Verlag, 1982), 249–64.

20. Hugo Ball, *Flucht aus der Zeit* (Lucerne: Joseph Stocker, 1946), 74.

21. *Dada Total*, 188.

22. *Dada Almanach*, 4.

23. Gilles Deleuze and Felix Guattari, *Anti-Oedipus: Capitalism and Schizophrenia*, preface by Michel Foucault (Minneapolis: University of Minnesota Press, 1983), 34.

24. To the horror of the Second International, the SPD, the largest socialist party in the world, voted in favor of war bonds.

25. *Dada Berlin*, 62.

26. The French consulate in Barcelona, for example, suspected Francis Picabia of espionage. See Sanouillet, *391*, 11.

27. Emmy Ball-Hennings, "Das 'Cabaret Voltaire' and the 'Gallery Dada,' " in *Das War Dada*, edited by Peter Schifferli (Munich: DTV, 1963), 117.

28. Reinhart Meyer et al., *Dada in Zürich and Berlin 1916–1920: Literatur zwischen Revolution und Reaktion* (Kronberg: Scriptor, 1973), 60.

29. Ibid.

30. Hans Richter, *DADA—Kunst und Antikunst: Der Beitrag Dadas zur Kunst des 20. Jahrhunderts* with an afterword by Werner Haftmann (Cologne: DuMont, 1964), 25.

31. Richard Huelsenbeck, *Mit Witz, Licht, und Grütze: Auf den Spuren des Dadaismus* (Wiesbaden: Limes Verlag, 1957), 14.

32. Ibid., 28.

33. Although generally referred to as the "Zimmerwald Manifesto," the full title of the document was "Proposed Resolution of the Zimmerwald Left at the Zimmerwald Conference in September, 1915—The World War and the Tasks of Social-Democracy." English translation in *Collected Works of V. I. Lenin*, vol. 20, book 2 (New York: International Publishers, 1929), 386–87.

34. *A Documentary History of Communism and the World: From Revolution to Collapse*, edited, with introduction, notes, and original translations by Robert V. Daniels (Hanover: University of Vermont Press, 1994), 5.

35. Richter called Zürich the city at the "center of the non-war." Richter, *Kunst und Antikunst*, 11.

36. John Dos Passos, *Nineteen Nineteen*, illustrated by Reginald Marsh with an introduction by Alfred Kazin (New York: Penguin, 1969), 253–54.

37. John Maynard Keynes, *The Economic Consequences of the Peace* (London: Harcourt Brace and Howe, 1920); Margaret MacMillan, *Paris 1919: Six Months That Changed the World*, foreword by Richard Holbrooke (New York: Random House, 2002).

38. Richard Huelsenbeck, "Erklärung," in *Dada Zürich*, 29.

39. Ball reproduces this note in his diary, *Flucht aus der Zeit*, 71.

40. Ball, *Flucht aus der Zeit*, 79.

41. Ibid., 12.

42. In a letter to his sister, May 27, 1914, Ball mentions his great admiration for Kandinsky. Hugo Ball, *Briefe 1911–1927* (Einsiedeln: Benziger Verlag, 1957), 30.

43. Ball, *Flucht aus der Zeit*, 11.

44. Richard Huelsenbeck, "Ein Besuch im Cabaret Dada," in *Dada Berlin*, 95.

45. "Manifest Dada," in *Dada Berlin*, 24.

46. Peter Jelavich, *Munich and Theatrical Modernism* (Cambridge, MA: Harvard University Press, 1985), 139ff.

47. See Laurence Senelick, "Text and Violence: Performance Practices of the Modernist Avant-Garde," in *Contours of the Theatrical Avant-Garde: Performance and*

Textuality, edited by James M. Harding (Ann Arbor: University of Michigan Press, 2000), 15–42.

48. Manfredo Tafuri, *The Sphere and the Labyrinth: Avant-Gardes and Architecture from Piranesi to the 1970s*, translated by Pellegrino d'Acierno and Robert Connolly (Cambridge, MA MIT Press, 1987), 98.

49. Otto Julius Bierbaum, "Manifesto for a Cabaret Theatre," in *Cabaret Performance, Vol. 1, Europe 1890–1920, Sketches, Songs, Monologues, Memoirs*, selected and translated, with commentary, by Laurence Senelick (New York: PAJ Publications, 1989), 68. The editorial choice of labeling this text "manifesto" is part of the larger pattern of applying this generic title retrospectively. In the novel, the word "manifest" does not appear; in fact, the very fabrication of a separate text, be it manifesto or pamphlet, is an editorial choice.

50. Ball, *Flucht aus der Zeit*, 71.

51. One can speak here not only of a "cabaretic modernism," as Peter Jelavich has done, but also of a "cabaretic avant-garde," so that more traditional turn-of-the-century cabarets such as *The Chat Noire* and *Die 11 Scharfrichter* can be seen as the predecessors of the *Cabaret Voltaire*.

52. As one of the competing stories of origin had it, dada had been a name for the singer of the cabaret, Madame le Roy. Richard Huelsenbeck remembers this origin of the name dada in "When Dada Began," in *Das War Dada*, 110.

53. Richter, *Kunst und Antikunst*, 32.

54. *Dada Almanach*, 13.

55. Ibid.

56. Richter, *Kunst und Antikunst*, 81.

57. For a discussion of the parodic aspects of the dada manifesto, see Alfons Backes-Haase, *Kunst und Wirklichkeit. Zur Typologie des DADA-Manifests* (Frankfurt am Main: Hain, 1992), 27ff. Backes-Haase also speaks of the meta-manifesto, which he calls "metaartistic" manifesto (42ff.).

58. Tristan Tzara, *Dada Manifesto 1918*, in *Seven Dada Manifestos and Lampisteries*, translated by Barbara Wright (London: Riverrun, 1977), 3.

59. Edgar Varèse et al., "DADA hebt alles auf," in *Manifeste*, 223.

60. Picabia wrote: "Les manifestes et les professions de foi ne nous paraissent écrits que pour donner la mesure vertigineuse de ce abîme qui sépare le rêve de celle qui—consultez Baudelaire—n'est acunement sa soeur: l'action. / Mais je conterai une histoire." In *391*, 20.

61. Tristan Tzara, *The First Celestial Adventure of Mr. Antipyrine*, in Tristan Tzara, *Œuvres complètes*, vol. 1 (1912–24), edited by Henri Béhar (Paris: Flammarion, 1975), 75–84.

62. Raoul Hausmann, "Dada empört sich, regt sich, und stirbt in Berlin," in *Dada Berlin*, 4.

63. Jefim Golyscheff, Raoul Hausmann, and Richard Huelsenbeck, "What Is Dadaism and What Does It Want in Germany?" in *Dada Berlin*, 61, 62.

64. Klara Zetkin, Rosa Luxemburg, Karl Liebknecht, and Franz Mehring, *Spartacus Manifesto*, in *The Weimar Sourcebook*, edited by Anton Kaes, Martin Jay, and Edward Dimenberg (Berkeley: University of California Press, 1994), 37. English translation first published in the *New York Times*, November 29, 1918.

65. See *Dada in Zürich*, 249ff.

66. For a sustained critique of this aspect of Marx's thought, see Baudrillard, *For a Critique*.

67. For a more detailed analysis, see Barbara McClosky, *George Grosz and the Communist Party: Art and Radicalism in Crisis, 1918 to 1936* (Princeton, NJ: Princeton University Press, 1997), 55ff.

68. Georg Simmel, "The Metropolis and Mental Life," in *On Individuality and Social Forms: Selected Writings*, edited and with an introduction by Donald N. Levine (Chicago: University of Chicago Press, 1971).

69. See, for example, Franz Mons, in *Dada in Europa*, 3–31ff. Also see Benjamin Buchloh, "Allegorical Procedures," in *Neo-avantgarde and Culture Industry: Essays on European and American Art from 1955 to 1975* (Cambridge, MA: MIT Press, 2000), 43–56.

70. Also see Maud Lavin's excellent book *Cut with the Kitchen Knife: The Weimar Photomontages of Hannah Höch* (New Haven, CT: Yale University Press, 1993).

71. Marjorie Perloff has analyzed the process of using and quoting manifestos in various collages and texts in her *Dance of the Intellect: Studies in the Poetry of the Pound Tradition* (Cambridge: Cambridge University Press, 1985), 33ff.

72. *Dada Berlin*, 66.

73. *November Group Manifesto*, in *Weimar Republic Sourcebook*, 477. The November Gruppe was a political association or council composed of artists led by Max Pechstein and Ludwig Meidner.

74. *Weimar Republic Sourcebook*, 478.

75. *Dada Berlin*, 30.

Chapter 9
Huidobro's Creation of a Latin American Vanguard

1. Jean Franco, *Spanish American Literature since Independence* (London: Ernest Benn, 1973), 173.

2. Carlos J. Alonso, "The Burden of Modernity," in *Places of History: Regionalism Revisited in Latin America*, edited by Doris Sommer (Durham, NC: Duke University Press, 1999), 94–103. Fernando Ortiz, *Contrapunteo cubano del tabaco y el azúcar* (Caracas: Ayacucho, 1987). In her *Imperial Eyes: Travel Writing and Transculturation* (London: Routledge, 1992), Mary Louise Pratt details the history and complexities of transculturation in Latin America.

3. Data based on Andréas, *Le manifeste communiste*.

4. Eric J. Hobsbawm, *The Age of Empire, 1875–1914* (London: Weidland and Nicolson, 1987), 286.

5. Vicky Unruh, *Latin American Vanguards: The Art of Contentious Encounters* (Berkeley: University of California Press, 1994), 51. Unruh's excellent study also discusses Latin American manifestos that were being performed in avant-garde cabarets.

6. Rubén Darió, "Marinetti y el Futurismo," *La Nación de Buenos Aires*, April 5, 1909; reprinted in *Manifiestos, proclamas y polemicas de la vanguardia literaria Hispanoamericana*, edited by Nelson Osorio T. (Caracas: Biblioteca Ayacucho, 1988), 6.

7. Amado Nervo, "Nueva Escuela Literaria," *Boletin de Instrucción Pública* (Mexico), August 1909; reprinted in *Manifiestos*, 12.

8. Rómulo E. Durón, "Una Nueva Escuela Literaria," reprinted in *Manifiestos*, 19–23, 20.

9. Henrique Soublette, "El Futurismo Italiano y Nuestro Modernismo Naturalista," reprinted in *Manifiestos*, 28.

10. Vicente Huidobro, "Non Serviam," in Osorio T., *Manifiestos*, 33. "Non serviam" is also the phrase with which Satan declares his rebellion against God.

11. Vicente Huidobro, "La Poesia," presented as a talk at the Ateneo in Madrid in 1921 and published in *Temblor del cielo* (Madrid: Plutarco, 1931); reprinted in Osorio T., *Manifiestos*, 90.

12. Vicente Huidobro, "La Creacíon Pura : Ensayo de estética," *L'Esprit Nouveau* (Paris), no. 7 (April 1921): 769–76 ; in Osorio T., *Manifiestos*, 92–96.

13. For this and other biographical details pertaining to Huidobro, I am indebted to René de Costa's excellent *Vicente Huidobro: The Careers of a Poet* (Oxford: Clarendon Press, 1984).

14. Vicente Huidobro, "Manifiesto tal vez," in *Obras Completas de Vicente Huidobro*, vol. 1, with an introduction by Hugo Montes (Santiago, Chile: Editorial Andres Bello, 1976), 751.

15. Hanno Ehrlicher, *Die Kunst der Zerstörung*, provides the most recent discussion of this influence (336ff.).

16. Vicente Huidobro, *Manifestes*, translated from the French by Gilbert Alter-Gilbert (Los Angeles: Green Integer, 1999), 8.

17. In "Creationism," Huidobro writes: "Creationism is a general aesthetic theory that I began to elaborate around 1912," in *Manifestes*, 40.

18. Volodia Teilelboim, *Huidobro: La marcha infinita* (Santiago de Chile: Ediciones BAT, 1993), 156.

Chapter 10
Surrealism, Latent and Manifest

1. Caws, *Manifesto*, 450.

2. Breton declared the final break in the *Second Manifesto of Surrealism*, in André Breton, *Œuvres complètes I–II*, edited by Marguerite Bonnet, in collaboration with Philippe Bernier, Étienne-Alain Hubert, and José Pierre (Paris: Gallimard, 1988–92), 1:786ff. All references to texts by Breton are to this edition unless otherwise noted.

Translations are based on André Breton, *Manifestoes of Surrealism*, translated by Richard Seaver and Helen R. Lane (Ann Arbor: University of Michigan Press, 1972).

3. Caws, *Manifesto*, 450; Breton, *Second Manifesto of Surrealism*, 1:786.

4. Breton, *Second Manifesto of Surrealism*, 1:798ff.

5. As early as 1920, the politically inexperienced young dadaists Breton and Aragon offered their help to the PCF, an offer that was greeted with suspicion, as were many subsequent ones. This instance was the first in a long series of offers and rebuffs. This anecdote is based on Alan Rose, *Surrealism and Communism: The Early Years* (New York: Peter Lang, 1991), 23.

6. Several historians of surrealism have pointed to the importance of the Moroccan crisis, for example, Rose, *Surrealism and Communism*, 105ff.

7. *Breton Œuvres complètes*, 1:341ff.

8. Maurice Nadeau, *The History of Surrealism*, translated from the French and with an introduction by Roger Shattuck (New York: Macmillan, 1965), 319, 66–67. Another example is Georges-Emmanuel Clancier, *De Rimbaud au surréalisme* (Paris: Seghers, 1953).

9. Rosalind E. Krauss, *The Originality of the Avant-Garde and Other Modernist Myths* (Cambridge, MA: MIT Press, 1985).

10. The exclusions announced in the *Second Manifesto* found their counterpart in Breton's famous "wall," the wall behind his desk on which he collected postcards, ready-mades, letters, and other paraphernalia from the different members and which can be seen as an archive of surrealism. Breton purged his wall of all letters and objects that were produced by the renegade members he had expelled.

11. Other critics have also recognized the resemblance of surrealist and Soviet purges, for example, Peter Wollen in his *Raiding the Ice Box: Reflections on Twentieth-Century Culture* (Bloomington: Indiana University Press, 1993), 131.

12. Some of these data are derived from Jacqueline Chénieux-Gendron, *Surrealism*, translated by Vivian Folkenflik (New York: Columbia University Press, 1990), 78–79.

13. *Le surréalisme autour du monde: 1929–1947*, ed. Jaqueline Chénieux-Gendron, Françoise Le Roux, and Maité Vienne (Paris: CNRS Éditions, 1994).

14. For a more elaborate account of French exiles in New York, see Jeffrey Mehlman, *Émigré New York: French Intellectuals in Wartime Manhattan, 1940–1944* (Baltimore: Johns Hopkins University Press, 2000). Mehlman describes the political difficulties created for French exiles by the U.S. government's ambivalent attitude toward Charles de Gaulle.

15. Clifford, *Routes*, 30.

16. Appadurai, *Modernity at Large*. One should also add that Breton was suspicious of the more obvious examples of "primitivism" and therefore preferred the, to his mind, less ritualistic sculptures of Oceania to those of Africa.

17. Aimé Césaire, *Notebooks for a Return to the Native Land*, in *Aimé Césaire: The Collected Poetry*, translated and with an introduction and notes by Clayton Eshleman and Annette Smith (Berkeley: University of California Press, 1983), 77.

18. Other theorists and practitioners of *négritude*, such as Léopold Sédar Senghor, have downplayed this constructivist understanding of the concept, but Césaire held on to it in opposition to more essentializing theorists.

19. Quoted in Césaire, *Collected Poetry*, 4.

20. This dislocation of surrealism also had its consequences for the manifestos. Césaire's *Discours sur le Colonialisme* is one of the prominent documents that rewrites the history of the Enlightenment and of the revolution, the two central traditions for the *Manifesto*. Previously, Césaire had exposed the double standard of the French Revolution and of the Code Napoleon when it came to the colonies in such texts as *Toussaint Louverture: La Revolution Française et le problème colonial*. Aimé Césaire, *Œuvres complètes*, vol. 3, *Œuvres historique et politique: Discours et communications*, 11–355.

21. Krauss (*Originality of the Avant-Garde*, 96) understands Breton's conception of automatism as a writing without representation.

22. This relation between the latent and the manifest can be seen as another version of what Mary Ann Caws has described as the dialectic between the manifest and the hidden in surrealist poetry. *Le manifeste et le caché: Langages surréalistes et autres*, edited by Mary Ann Caws (Paris: Lettres Modernes, 1974).

23. Caws has discussed in detail the extent to which Breton and other surrealists were invested in mediation, connection, communication, and Hegelian sublation. Mary Ann Caws, *The Poetry of Dada and Surrealism: Aragon, Breton, Tzara, Éluard and Desnos* (Princeton, NJ: Princeton University Press, 1970), 15ff.

24. Jacqueline Chénieux-Gendron speaks of an "automatism induced by titles." "Towards a New Definition of Automatism: L'Immaculée Conception," *Dada-Surrealism* 17 (1988): 76.

25. See Breton *Œuvres complètes*, 1:1635.

26. As Chénieux-Gendron argues, Dalí, the designated illustrator, is the third subjectivity involved in the fabrication of this text ("Toward a New Definition of Automatism," 81).

27. André Breton, Leon Trotsky, and Diego Rivera, *Manifesto: Towards a Free Revolutionary Art*, translated by Dwight MacDonald, in *Longman Anthology of World Literature*, vol. F, p. 44.

Chapter 11
Artaud's Manifesto Theater

1. Jacques Rivière to Antonin Artaud, Paris, March 25, 1924, in Antonin Artaud, *Œuvres complètes*, vol. 1 (Paris: Gallimard, 1956), 30. All references to Artaud are to this edition unless otherwise noted. Translations of the *Theater and Its Double* are based on Antonin Artaud, *The Theater and Its Double*, translated by Mary Caroline Richards (New York: Grove, 1958).

2. One example is Eric Sellin, *The Dramatic Concepts of Antonin Artaud* (Chicago: University of Chicago Press, 1968). Sellin writes, "His [Artaud's] actual dra-

matic efforts [meaning Artaud's efforts to put the theater of cruelty into practice] were held to a minimum by financial and critical adversity" (109).

3. Maurice Blanchot is one of the readers of Artaud who recognized a more necessary development in these generic shifts. Blanchot considered the correspondence a necessary "supplement" to the poems, which Artaud was ready to "sacrifice." Blanchot, "Artaud," in *The Blanchot Reader*, edited by Michael Holland (Cambridge: Blackwell, 1995), 129.

4. For an excellent discussion of the institutional history of theater and performance studies, see Shannon Jackson, *Professing Performance: Theatre in the Academy from Philology to Performativity* (Cambridge: Cambridge University Press, 2004).

5. Pierre Bourdieu (*Rules of Art*) has argued that the conception of the mise-en-scène as an autonomous aspect of the theater emerged with naturalism and symbolism.

6. Philip Auslander, *Liveness: Performance in a Mediatized Culture* (London: Routledge, 1999).

7. Peggy Phelan, *Unmarked: The Politics of Performance* (London: Routledge, 1993).

8. In his second letter about language, Artaud writes: "My spectacles will have nothing to do with the improvisations of Copeau," and he insists that nothing must be left to chance (4:131). Jacques Derrida, in his influential essay on Artaud, critiques those practitioners of improvisational theater who claim for themselves Artaud's heritage. Jacques Derrida, "Le théâtre de la cruauté et la clôture de la représentation," in *L'écriture et la différence* (Paris: Édition du Seuil, 1967), 341–68.

9. In his *From Acting to Performance: Essays in Modernism and Postmodernism* (London: Routledge, 1997), Auslander had noted the purely instrumental nature of the theater of cruelty, writing, "Artaud saw the theater as a means to an end," and concluding that the theater's final goal was "to re-establish life on healthier spiritual terms" (20).

10. Blanchot, "Artaud," 132.

11. For a detailed study of Maeterlinck's tension with theatrical representation, see Patrick McGuinness: *Maurice Maeterlinck and Modern Drama* (Oxford: Oxford University Press, 2000).

12. Even Artaud's most overtly "cruel" script, *A Jet of Blood*, can be seen as closet drama, since it goes beyond the limits of the theater, demanding that a women give birth to an array of objects and creatures. RoseLee Goldberg, for example, writes that "Artaud's *Le Jet de Sange* ('The Jet of Blood') of 1927 only barely escaped the classification 'play for reading' " (95), emphasizing that this play is "virtually unrealisable" (96). *Performance Art: From Futurism to the Present*, revised and enlarged edition (New York: Abrams, 1979).

13. Similarly, Herbert Blau observed, "It was the desire for an anteriority before separation—or the dream of appearance as pure manifestation—that made him want to bring the whole system of reproduction down with him into the abyss." Herbert Blau, *To All Appearances: Ideology and Performance* (London: Routledge, 1992), 18.

14. Jacques Derrida noted: "For the gestures of an actor are so many ephemeral arabesques drawn with his body, the actors together constructing a sort of moving and colorful graphism akin to painting, having the stage for its frame." Jacques Derrida and Paule Thévenin, *The Secret Art of Antonin Artaud*, translation and preface by Mary Ann Caws (Cambridge, MA: MIT Press, 1998), 13. David Graver also recognized the extent to which this notion of the actor-hieroglyph "dangles the lure of readability before what might otherwise be taken as superficial physical play." "Antonin Artaud and the Authority of Text, Spectacle, and Performance," in *Contours of the Theatrical Avant-Garde: Performance and Textuality*, edited by James M. Harding (Ann Arbor: University of Michigan Press, 2000), 49.

15. Antonin Artaud, *Messages révolutionnaires* (Paris: Gallimard, 1971), 60.

16. Among the early commentators on the impossibility of the theater of cruelty was Jacques Derrida, in his "Le théâtre de la cruauté et la clôture de la représentation."

17. In his vivid history of American avant-garde theater, Arnold Aronson emphasizes Artaud's influence: "Artaud's writings were an immediate and direct progenitor of Happenings, much of the work of the Living Theatre, the physical-ensemble work of the Open Theatre, and the environmental theatre of the Performance Group, among others." Arnold Aronson, *American Avant-Garde Theatre: A History* (London: Routledge, 2000), 30.

Chapter 12
The Manifesto in the Sixties

1. The term "high sixties" is used, for example, by Arthur Marwick in his book *The Sixties: Cultural Revolution in Britain, France, Italy, and the United States, 1958–1974* (Oxford: Oxford University Press, 1998), 247ff.

2. Peter Stanstill and David Zane Mairowitz, eds., *BAMN (By Any Means Necessary): Outlaw Manifestos and Ephemera 1965–1970* (Brooklyn, NY: Autonomedia, 1999), 37, 88.

3. Hal Foster argues against the notion of empty repetition, showing that it was only through the so-called neo-avant-garde that the original, historical avant-garde was retroactively created. Hal Foster, *The Return of the Real: The Avant-Garde at the End of the Century* (Cambridge, MA: MIT Press, 1996).

4. *BAMN*, 44.

5. Donald Sassoon, *One Hundred Years of Socialism: The West European Left in the Twentieth Century* (New York: New Press, 1996), 384.

6. At the same time, calls for a return to Marx led to a renewed interest in and study of Marx's writings, often in the form of a combination of scholarly and philosophical interest and activism, including Christopher Hill, Louis Althusser, Herbert Marcuse, and Franz Fanon. Indeed, this tradition has served as a methodological inspiration for my own focus on the generic qualities and circulation of Marx's *Manifesto*.

Manifesto, with an introduction by Avital Ronell

... aumgardner and Amy Richards, *Manifesta: Young Women, Femi-* ... (New York: Farrar, Straus and Giroux, 2000).

... Harding, "The Simplest Surrealist Act: Valerie Solanas and the ... ntgarde Priorities," *TDR* 45, no. 4 (2001): 142–62.

... like to thank Alexis Soloski for calling my attention to this

12. Jean Genet, *Prisoner of Love*, translated from the French by Barbara Bray, with an introduction by Ahdaf Soueif (New York: New York Review of Books, 2003), 98.

Chapter 13
Debord's Society of the Counterspectacle

1. Genet, *Prisoner of Love*, 133.

2. Some of these international alliances and correspondences were documented in *BAMN*.

3. Louis Althusser, "Ideology and Ideological State Apparatuses (Notes towards an Investigation)," in *Lenin and Philosophy and Other Essays*, translated by Ben Brewster (New York: Monthly Review Press, 1971), 127–86. The historical emergence of the spectacle as Debord conceives of it remains a topic of discussion. T. J. Clark, in the introduction to *The Painting of Modern Life: Paris in the Art of Manet and His Followers* (Princeton, NJ: Princeton University Press, 1984), dates it as far back as the 1870s, while Jonathan Crary locates it in the late twenties with the introduction of synchronized sound and the first emergence of television, in "Spectacle, Attention, Counter-Memory," *October* 50 (Fall 1989): 97–107.

4. *L'Espresso*, December 15, 1968, cited in *Situationist International Anthology*, edited and translated by Ken Knaab (Berkeley: Bureau of Public Secrets, 1981), 384.

5. *Situationist International Anthology*, 358.

6. *Internationale Situationniste*, augmented edition, edited by Patrick Mosconi (Paris: Librairie Arthème Fayard, 1997), 467. All references to situationist texts are to this edition, unless otherwise noted.

7. Julia Kristeva, *La révolution du langage poétique. L'avant-garde à la fin du XIXe siècle: Lautréamont et Mallarmé* (Paris: Éditions du Seuil, 1974).

8. Among the many meanings of the word "detournment" is that of hijacking airplanes and corrupting minors.

9. *Internationale Situationniste*, augmented edition (Paris: Librairie Arthème Fayard, 1997), 202. All references to the situationists are to this edition of their journal. All translations are mine unless otherwise noted.

10. See Ursula Meyer, "The Eruption of Anti-Art," in *Idea Art: A Critical Anthology*, edited by Gregory Battcock (New York: Dutton, 1993), 116–34.

11. Richter, *Kunst und Antikunst.*

12. Cited in Anselm Jappe, *Guy Debord*, translated from the French by Donald Nicholson-Smith, with a foreword by T. J. Clark and a new afterword by the author (Berkeley: University of California Press, 1999), 57.

13. Mark Wigley, *Constant's New Babylon: The Hyper-architecture of Desire* (Rotterdam: Witte de With, Center for Contemporary Art, 1998).

14. A sample of this history of architectural manifesto is collected in *Programs and Manifestoes on 20th Century Architecture*, edited by Ulrich Conrads and translated by Michael Bullock (Cambridge, MA: MIT Press, 1970).

15. Guy Debord, "Architecture and Play" (*Potlatch 20*), in *Potlatch 1954–57*, presented by Guy Debord (Paris: Gallimard 1985), 157. Simon Sadler has pointed out the relation between the situation and the *Gesamtkunstwerk* in *The Situationist City* (Cambridge, MA: MIT Press, 1998), 106ff.

16. For an analysis of Marx's theatrical language, see Derrida, *Specters of Marx.* Also see Harries, *Scare Quotes from Shakespeare.*

17. A similar critique of repetition can be found in what is probably the second most important book-length situationist text, Raoul Vaneigem's *Revolution of Everyday Life*, whose French title is *Traité de savoir-vivre à l'usage des jeunes générations* (Paris: Gallimard, 1967), 170. Artaud's battle against repetition has been particularly highlighted by Jacques Derrida, in his "Le théâtre de la cruauté et la clôture de la représentation," 341–68.

18. As Martin Jay has suggested, one can see in the situationists' notion of detournment another connection to Brecht, namely, to his *Umfunktionierung*, which likewise indicates a process by which something is taken from the dominant culture, recoded, and thus turned against this culture. Martin Jay, *Downcast Eyes: The Denigration of Vision in Twentieth-Century French Thought* (Berkeley: University of California Press, 1993), 424.

19. One example is Alexander Trocchi's "Technique du coup du monde" (*IS*, 344).

20. With the notion of "non-matrixed performance," Kirby describes the kind of avant-garde performance that does not rely on a representational matrix, that is, a performance that is presentational rather than representation. Michael Kirby, *A Formalist Theater* (Philadelphia: University of Pennsylvania Press, 1987).

21. See, for example, Jean Baudrillard, *The Consumer Society: Myths and Structures* (Thousand Oaks, CA: Sage, 1998), 193.

22. Guy Debord, in *Situationist International Anthology*, 9.

23. Guy Debord, in *Situationist International Anthology*, 14.

24. Paul Mann, *The Theory-Death of the Avant-Garde* (Bloomington: Indiana University Press, 1991).

25. In a related argument, Arthur Danto connects the influence of the manifesto to the end of art. Arthur Danto, *After the End of Art: Contemporary Art and the Pale of History* (Princeton, NJ: Princeton University Press, 1997), 3ff. Danto sees in the manifesto a conduit for philosophy so that art is being replaced by philosophy in

an explicitly Hegelian scenario. W
tional influence of manifestos or
nals a break with philosophy, o

26. The influence of
been used as a proof that D
featist attitude: everything
Without focusing on the
has been discussed insig
written the most eloquent critiqu
Sadie Plant, *The most radical Gesture. The Situationist International in a Postmodern*
Age (London: Routledge, 1992). The only component I would add to this defense is
the emphasis on the manifesto, which encapsulates the difference between Baudrillard's theory of the simulacrum and Debord's critical practice.

27. An understanding of theory dissociated from practice also informs some
critical accounts of the situationists themselves, for example, Thomas F. McDonough's "Rereading Debord, Rereading the Situationists," *October* 79 (Winter 1997):
3–14, which critiques Sadie Plant's emphasis on textuality and agitation (8). While I
think Plant is right in her emphasis on theory, she herself has no systematic conception of the situationists' practice of theory either and therefore reproduces the
theory/art or theory/practice dichotomy.

28. Guy Debord, *La société du spectacle* (Paris: Gallimard, 1992), 32. All translations are mine unless otherwise noted.

29. In an important article, Peter Wollen has described Godard's oeuvre in
terms of a countercinema; "Godard and Counter-Cinema: *Vent d'Est*," *Afterimage*,
no. 4 (1972): 6–17.

30. Wollen, *Raiding the Icebox*, 158.

31. Guy Debord, *Œuvres cinématographiques complètes: 1952–1978* (1978;
Paris: Gallimard, 1994), 73.

32. *Lipstick Traces: A Secret History of the 20th Century*, conceived and directed by Shawn Sides, adapted by Kirk Lynn, created by Rude Mechs of Austin,
Texas, presented by the Foundry Theater.

33. *Situationist International Anthology*, 368.

Chapter 14
The Avant-Garde Is Dead: Long Live the Avant-Garde!

1. Anderson, *Origins of Postmodernity*, 93.

2. For a more extensive discussion of Isabella Rossellini's ad, see my "Manifesto = Theatre," *Theatre Journal* 54 (2002): 449–65.

3. "Critical Art Ensemble: Tactical Media Practitioners: An Interview by
Jon McKenzie and Rebecca Schneider," *TDR* 44, no. 4 (2000): 139.

4. For a general history of *TDR*, especially its origins, see Brooks McNamara's introduction to *The Drama Review: Thirty Years of Commentary on the Avant-*

(1979), edited by Brooks McNamara and Jill Dolan (Ann Arbor, MI: UMI Research Press, 1986).

 5. *TDR* 3, no. 1 (1958): 9.

 6. *TDR* 7, no. 2 (1962): 8.

 7. *TDR* 8, no. 2 (1963): 10.

 8. *TDR* 8, no. 4 (1964): 16.

 9. The Schechner-Hoffman manifesto was dedicated to Artaud, and the whole issue in which it appeared featured several of Artaud's manifestos.

 10. *TDR* 8, no. 4 (1964): 13.

 11. See Andreas Huyssen, *After the Great Divide: Modernism, Mass Culture, Postmodernism* (Bloomington: Indiana University Press, 1986).

 12. *TDR* 15, no. 4 (1971): 3.

 13. *TDR* 19, no. 4 (1975): 3.

 14. *TDR* 27, no. 4 (1983): 2.

 15. *TDR* 29, no. 2 (1985): 66.

 16. Richard Schechner, *The End of Humanism: Writing on Performance* (New York: Performing Arts Journal Publications, 1982), 17, 69.

 17. *TDR* 30, no. 1 (1986): 5.

 18. Paul de Man, "Literary History and Literary Modernity," in *Blindness and Insight: Essays in the Rhetoric of Contemporary Criticism*, 2nd ed., revised, with an introduction by Wlad Godzich (Minneapolis: University of Minnesota Press, 1983), 144.

 19. Judith Butler, *Gender Trouble: Feminism and the Subversion of Identity* (New York: Routledge, 1990); Cary Nelson, *Manifesto of a Tenured Radical* (New York: NYU Press, 1997).

 20. A comparable argument has been made by Sally Banes in "Institutionalizing Avant-Garde Performance: A Hidden History of University Patronage in the United States," in *Contours of the Theatrical Avant-Garde*, 217–38.

 21. *TDR* 26, no. 2 (1982): 3–4.

 22. One of the many studies that applied a performance paradigm to study transportation, circulation, and power is Joseph Roach's *Cities of the Dead: Circum-Atlantic Performance* (New York: Columbia University Press, 1996). For a more developed version of Schechner's own intercultural analysis, see his *Between Theater and Anthropology*, with a foreword by Victor Turner (Philadelphia: University of Pennsylvania Press, 1985).

 23. See the theatrical exercises described in Victor Turner, *From Ritual to Theatre: The Human Seriousness of Play* (New York: Performing Arts Journal Publications, 1982).

 24. Philip Auslander, "Towards a Concept of the Political in Post-modern Theatre," *Theatre Journal* 39, no. 1 (March 1987): 20–34.

 25. *TDR* 31, no. 3 (1987): 5.

 26. Philip Auslander, *Performance: Critical Concepts*, 4 vols. (London: Routledge, 2003).

27. *The Drama Review: Thirty Years of Commentary*, 24.

28. Also see Jon McKenzie's *Perform or Else: From Discipline to Performance* (London: Routledge, 2001).

Epilogue
Poetry for the Future

1. I am thinking here of repetition the way Gilles Deleuze uses this term in his early and still underappreciated treatise, *Difference and Repetition*, translated by Paul Patton (New York: Columbia University Press, 1994.

2. Michel Chaouli, "Masking and Unmasking: The Ideological Fantasies of the *Eighteenth Brumaire*," *Qui Parle 3*, no. 1 (1989): 53–72. See also Harries, *Scare Quotes from Shakespeare*, 87.

3. Giorgio Agamben, *Means without End: Notes on Politics*, translated by Vincenzo Binetti and Cesare Casarino (Minneapolis: University of Minnesota Press, 2000). Agamben's book is dedicated, "In Memoriam," to Debord, and yet Agamben does not recognize the side of Debord that was dedicated to efficacy. Jean-Luc Nancy, *The Inoperative Community*, edited by Peter Connor, translated by Peter Connor, Lisa Garbus, Michael Holland, and Smona Sawhney (Minneapolis: University of Minnesota Press, 1991), 71.

BIBLIOGRAPHY

Agamben, Giorgio. *Means without End: Notes on Politics.* Translated by Vincenzo Binetti and Cesare Casarino. Minneapolis: University of Minnesota Press, 2000.

Alonso, Carlos J. "The Burden of Modernity." In *Places of History: Regionalism Revisited in Latin America*, edited by Doris Sommer, 94–103. Durham, NC: Duke University Press, 1999.

Althusser, Louis. "Ideology and Ideological State Apparatuses (Notes towards an Investigation)." In *Lenin and Philosophy and Other Essays*, 127–86. Translated by Ben Brewster. New York: Monthly Review Press, 1971.

———. *Machiavelli and Us.* Edited by François Matheron. Translated and with an introduction by Gregory Elliott. London: Verso, 1999.

Althusser, Louis, Jacques Rancière, and Pierre Macherey. *Lire le capital.* Vol. 1. Paris: François Maspero, 1967.

Anderson, Benedict. *Imagined Communities: Reflections on the Origin and Spread of Nationalism.* London: Verso, 1983.

Anderson, Perry. "Internationalisms: A Breviary." *New Left Review* 14 (March–April 2002): 5–25.

———. "Modernism and Revolution." In *Marxism and the Interpretation of Culture*, edited and with an introduction by Cary Nelson and Lawrence Grossberg, 317–33. Chicago: University of Chicago Press, 1988.

———. *The Origins of Postmodernity.* London: Verso, 1998.

———. "The River of Time." *New Left Review* 26 (March–April 2004): 67–77.

Andréas, Bert, ed. *Le manifeste communiste de Marx et Engels: Histoire et Bibliographie, 1848–1918.* Milan: Feltrinelli, 1963.

Appadurai, Arjun. *Modernity at Large: Cultural Dimensions of Globalization.* Minneapolis: University of Minnesota Press, 1996.

Arac, Jonathan. "Anglo-Globalism?" *New Left Review* 16 (July–August 2002): 35–45.

Arendt, Hannah. *On Revolution.* London: Penguin, 1965.

Aronson, Arnold. *American Avant-Garde Theatre: A History.* London: Routledge, 2000.

Artaud, Antonin. Messages révolutionnaires. Paris: Gallimard, 1971.

Artaud, Antonin. *Œuvres Complètes.* Paris: Gallimard, 1956.

Asholt, Wolfgang, and Walter Fähnders, eds. *Manifeste und Proklamationen der euro-päischen Avantgarde (1919–1938).* Stuttgart: Metzler, 1995.

Auerbach, Erich. *Gesammelte Aufsätze zur romanische Philologie.* Bern: Francke, 1967.

Auslander, Philip. *From Acting to Performance: Essays in Modernism and Postmodernism.* London: Routledge, 1997.

———. *Liveness: Performance in a Mediatized Culture.* London: Routledge, 1999.

———, ed. *Performance: Critical Concepts.* 4 vols. London: Routledge, 2003.

———. "Towards a Concept of the Political in Post-modern Theatre." *Theatre Journal* 39, no. 1 (March 1987): 20–34.

Austin, J. L. *How to Do Things with Words.* Cambridge, MA: Harvard University Press, 1962.

Backes-Haase, Alfons. *Kunst und Wirklichkeit. Zur Typologie des DADA-Manifests.* Frankfurt am Main: Hain, 1992.

Balfour, Ian. *The Rhetoric of Romantic Prophecy.* Stanford, CA: Stanford University Press, 2002.

Ball, Hugo. *Briefe 1911–1927.* Einsiedeln: Benziger Verlag, 1957.

———. *Flucht aus der Zeit.* Lucerne: Joseph Stocker, 1946.

Banerjee, Diptendra, ed. *Marxian Theory and the Third World.* New Delhi: Sage, 1985.

Banes, Sally. "Institutionalizing Avant-Garde Performance: A Hidden History of University Patronage in the United States." In *Contours of the Theatrical Avant-Garde,* edited by James M. Harding, 217–38. Ann Arbor: University of Michigan Press, 2000.

Baudelaire, Charles. "Mon coeur mis à nu." In *Œuvres Complètes.* Edited by Claude Pichois. 2 vols. Paris: Gallimard, 1975–76.

Baudrillard, Jean. *The Consumer Society: Myths and Structures.* Thousand Oaks, CA: Sage, 1998.

———. *For a Critique of the Political Economy of the Sign.* Translated by Charles Lewis. St. Louis, MO: Telos Press, 1981.

———. *The Mirror of Production.* Translated and with an introduction by Mark Poster. St. Louis, MO: Telos Press, 1975.

Baumgardner, Jennifer, and Amy Richards. *Manifesta: Young Women, Feminism, and the Future.* New York: Farrar, Straus and Giroux, 2000.

Becker, George J., ed. *Documents of Modern Literary Realism.* Princeton, NJ: Princeton University Press, 1963.

Berghaus, Günter. *Italian Futurist Theatre, 1909–1944.* Oxford: Clarendon Press, 1998.

Berman, Marshall. *All That Is Solid Melts into Air: The Experience of Modernity.* London: Penguin, 1988.

Bernstein, Eduard. *Cromwell and Communism: Socialism and Democracy in the Great English Revolution.* London: Allen and Unwin, 1930.

Blanchot, Maurice. *L'amitié.* Paris: Gallimard, 1971.

———. *The Blanchot Reader.* Edited by Michael Holland. Cambridge: Blackwell, 1995.

Blau, Herbert. *To All Appearances: Ideology and Performance.* London: Routledge, 1992.

Bloch, Ernst. *Der Geist der Utopie*. Munich: Duncker & Humblot, 1918.

———. *Das Prinzip Hoffnung*. Frankfurt am Main: Suhrkamp, 1959.

———. *Thomas Münzer als Theologe der Revolution*. In *Gesamtausgabe*. Frankfurt am Main: Suhrkamp, 1969.

Bohrer, Karl Heinz. *Suddenness: On the Moment of Aesthetic Appearance*. Translated by Ruth Crowley. New York: Columbia University Press, 1994.

Bourdieu, Pierre. *Language and Symbolic Power*. Edited and introduced by John B. Thomson. Translated by Gino Raymond and Matthew Adamson. Cambridge: Polity Press, 1991.

———. *The Rules of Art: Genesis and Structure of the Literary Field*. Translated by Susan Emanuel. Stanford, CA: Stanford University Press, 1996.

Breton, André. *Œuvres complètes I–II*. Edited by Marguerite Bonnet, in collaboration with Philippe Bernier, Étienne-Alain Hubert, and José Pierre. Paris: Gallimard, 1988–92.

Buchloh, Benjamin. *Neo-avantgarde and Culture Industry: Essays on European and American Art from 1955 to 1975*. Cambridge, MA: MIT Press, 2000.

Bürger, Peter. *Theorie der Avantgarde*. Frankfurt am Main: Suhrkamp, 1974.

Burke, Kenneth. *Attitudes toward History*. Berkeley: University of California Press, 1984.

———. *A Grammar of Motives*. Berkeley: University of California Press, 1969.

Butler, Judith. *Gender Trouble: Feminism and the Subversion of Identity*. New York: Routledge, 1990.

Calinescu, Matei. *Five Faces of Modernity: Modernism, Avant-Garde, Decadence, Kitsch, Postmodernism*. Durham, NC: Duke University Press, 1987.

Camfield, William. *Francis Picabia*. New York: Solomon Guggenheim Museum, 1970.

Caws, Mary Ann, ed. *Le manifeste et le caché: Langages surréalistes et autres*. Paris: Lettres Modernes, 1974.

———. ed. *Manifesto: A Century of Isms*. Lincoln: University of Nebraska Press, 2001.

———. *The Poetry of Dada and Surrealism: Aragon, Breton, Tzara, Éluard and Desnos*. Princeton, NJ: Princeton University Press, 1970.

Césaire, Aimé. *The Collected Poetry*. Translated and with an introduction and notes by Clayton Eshleman and Annette Smith. Berkeley: University of California Press, 1983.

———. *Oeuvres Complètes*. Fort-de-France: Editions Désormeaux, 1976.

Chaouli, Michel. "Masking and Unmasking: The Ideological Fantasies of the *Eighteenth Brumaire*." *Qui Parle 3*, no. 1 (1989): 53–72.

Chénieux-Gendron, Jacqueline. *Surrealism*. Translated by Vivian Folkenflik. New York: Columbia University Press, 1990.

———. "Towards a New Definition of Automatism: L'Immaculée Conception." *Dada-Surrealism* 17 (1988): 74–90.

Chénieux-Gendron, Jaqueline, Françoise Le Roux, and Maité Vienne, eds. *Le surréalisme autour du monde: 1929–1947*. Paris: CNRS Éditions, 1994.

Chou, Min-Chih. *Hu Shih and Intellectual Choice in Modern China*. Ann Arbor: University of Michigan Press, 1984.

Clancier, Georges-Emmanuel. *De Rimbaud au surréalisme.* Paris: Seghers, 1953.

Clark, T. J. *The Painting of Modern Life: Paris in the Art of Manet and His Followers.* Princeton, NJ: Princeton University Press, 1984.

Clifford, James. *Routes: Travel and Translation in the Late Twentieth Century.* Cambridge, MA: Harvard University Press, 1997.

Clifford, James, and Vvek Dhareshwar, eds. *Traveling Theories, Traveling Theorists.* Santa Cruz: Center for Cultural Studies, Oakes College, University of California, Santa Cruz, 1989.

Conrads, Ulrich, ed. *Programs and Manifestoes on 20th Century Architecture.* Edited and translated by Michael Bullock. Cambridge, MA: MIT Press, 1970.

Costa, René de. *Vicente Huidobro: The Careers of a Poet.* Oxford: Clarendon Press, 1984.

———, ed. *Vicente Huidobro y el creacionismo.* Madrid: Taurus, 1975.

Crary, Jonathan. "Spectacle, Attention, Counter-Memory." *October* 50 (Fall 1989): 97–107.

"Critical Art Ensemble: Tactical Media Practitioners: An Interview by Jon McKenzie and Rebecca Schneider." *TDR: The Drama Review* 44, no. 4 (2000): 136–50.

Crystal, David. *English as a Global Language.* Cambridge: Cambridge University Press, 1997.

Damrosch, David Norman, gen. ed. *The Longman Anthology of World Literature.* Vol. F. Edited by Djelal Kadir and Ursula Heise. New York: Longman, 2004.

———. *What Is World Literature?* Princeton, NJ: Princeton University Press, 2003.

Daniels, Robert V., ed. *A Documentary History of Communism and the World: From Revolution to Collapse.* With an introduction, notes, and original translation by Robert V. Daniels. Hanover: University of Vermont Press, 1994.

Danto, Arthur. *After the End of Art: Contemporary Art and the Pale of History.* Princeton, NJ: Princeton University Press, 1997.

De Man, Paul. *Blindness and Insight: Essays in the Rhetoric of Contemporary Criticism.* 2nd ed. Revised, with an introduction by Wlad Godzich. Minneapolis: University of Minnesota Press, 1983.

De Michelis, Cesare G. *Il Futurismo Italiano in Russia 1909–1929.* Bari: De Donato Editore, 1973.

Debord, Guy. *Œuvres cinématographiques complètes: 1952–1978.* Paris: Gallimard, 1994.

———. ed. *Potlatch 1954–57.* Paris: Gallimard, 1985.

———. *La société du spectacle.* Paris: Gallimard, 1992.

Deleuze, Gilles. *Difference and Repetition.* Translated by Paul Patton. New York: Columbia University Press, 1994.

Deleuze, Gilles, and Felix Guattari. *Anti-Oedipus: Capitalism and Schizophrenia.* Preface by Michel Foucault. Minneapolis: University of Minnesota Press, 1983.

———. *Kafka: Toward a Minor Literature.* Translated by Dana Polan. With a foreword by Réda Bensmaia. Minneapolis: University of Minnesota Press, 1986.

Demos, T. J. "Duchamp's *Boîte-en-valise*: Between Institutional Acculturation and Geopolitical Displacement." *Grey Room* 8 (2002): 6–73.

Derrida, Jacques. *L'écriture et la différence*. Paris: Édition du Seuil, 1967.

———. "The Law of Genre." In *Acts of Literature*, edited by Derek Attridge, 221–52. London: Routledge, 1992.

———. *Otobiographies: L'enseignement de Nietzsche et la politique du nom propre*. Paris: Editions Galilée, 1984.

———. *Specters of Marx: The State of the Debt, the Work of Mourning and the New International*. Translated by Peggy Kamuf. New York: Routledge, 1994.

Derrida, Jacques, and Paule Thévenin. *The Secret Art of Antonin Artaud*. Translation and preface by Mary Ann Caws. Cambridge, MA: MIT Press, 1998.

Dos Passos, John. *Nineteen Nineteen*. Illustrated by Reginald Marsh with an introduction by Alfred Kazin. New York: Penguin, 1969.

Eckermann, Johann Peter. *Gespräche mit Goethe in den letzten Jahren seines Lebens*. Edited by Fritz Bergmann. Wiesbaden: Insel, 1955.

Egbert, Donald Drew. *Social Radicalism and the Arts: A Cultural History from the French Revolution to 1968*. New York: Knopf, 1970.

Ehrlicher, Hanno. *Die Kunst der Zerstörung: Gewaltphantasien und Manifestationspraktiken europäischer Avantgarden*. Berlin: Akademie Verlag, 2001.

Fedoseyev, P.N., et al. *Karl Marx: A Biography*. Prepared by the Institute of Marxism-Leninism of the Central Committee of the Communist Party of the Soviet Union. Translated by Yuri Sdobinkov. Moscow: Progress Publishers, 1973.

Felstiner, Mary Lowenthal. *To Paint Her Life: Charlotte Salomon in the Nazi Era*. Berkeley: University of California Press, 1994.

Ford, Ford Madox. *The Good Soldier*. Edited by Martin Stannard. New York: Norton, 1995.

Foster, Hal. *The Return of the Real: The Avant-Garde at the End of the Century*. Cambridge, MA: MIT Press, 1996.

Franco, Jean. *Spanish American Literature since Independence*. London: Ernest Benn, 1973.

Franz, Günther. Ed. *Thomas Müntzer, Schriften und Briefe: Kritische Gesamtausgabe*. With the assistance of Paul Kirn. Gütersloh: Gerd Mohn, 1968.

Gallwitz, Klaus, ed. *Dada in Europa: Werke und Dokumente*. Berlin: Dietrich Reimar Verlag, 1977.

Gambillo, M. Drudi, and T. Fiori, eds. *Archivi del futurismo*. Rome: De Luca, 1958.

Genet, Jean. *Prisoner of Love*. Translated from the French by Barbara Bray. With an introduction by Ahdaf Soueif. New York: New York Review of Books, 2003.

Goethe, Johann Wolfgang. *Johann Wolfgang Goethe, Sämtliche Werke*. 18:2. Edited by Karl Richter. Munich: Carl Hanser Verlag, 1985–98.

———. *Die Zusammenkunft der Naturforscher in Berlin*. Weimar Edition II, 13. Weimar, 1828.

Goldberg, RoseLee. *Performance Art: From Futurism to the Present*. Revised and enlarged edition. New York: Abrams, 1979.

Gramsci, Antonio. *Quaderni del Carcere*. vol. 3. Edited by Valentino Gerratana. Milan: Einaudi, 1975.

Graver, David. "Antonin Artaud and the Authority of Text, Spectacle, and Performance." In *Contours of the Theatrical Avant-Garde: Performance and Textuality*, edited by James M. Harding, 43–57. Ann Arbor: University of Michigan Press, 2000.

Habermas, Jürgen. *Die Moderne—ein unvollendetes Projekt: Philosophisch-politische Aufsätze*. Leipzig: Reclam Verlag, 1981.

———. *Der philosophische Diskurs der Moderne: Zwölf Vorlesungen*. Frankfurt am Main: Suhrkamp, 1985.

Haller, William, and Godfrey Davies, eds. *The Leveller Tracts: 1647–1653*. New York: Columbia University Press, 1944.

Harding, James M. "The Simplest Surrealist Act: Valerie Solanas and the (Re)Assertion of Avantgarde Priorities." *TDR* 45, no. 4 (2001): 142–62.

Hardt, Michael, and Antonio Negri. *Empire*. Cambridge, MA: Harvard University Press, 2001.

Harries, Martin. *Scare Quotes from Shakespeare: Marx, Keynes, and the Language of Reenchantment*. Stanford, CA: Stanford University Press, 2000.

Harvey, David. *Spaces of Capital: Towards a Critical Geography*. New York: Routledge, 2001.

———. *Spaces of Hope*. Berkeley: University of California Press, 2000.

Hegel, G.W.F. *Vorlesungen über die Philosophie der Geschichte, Werke 12*. Frankfurt am Main: Suhrkamp, 1986.

Hill, Christopher. *The World Turned Upside Down: Radical Ideas during the English Revolution*. New York: Viking, 1972.

Hitler, Adolf. *Mein Kampf*. Edited by John Chamberlain and Sidney B. Fay. New York: Reynal and Hitchcock, 1941.

Hobsbawm, Eric J. *The Age of Empire, 1875–1914*. London: Weidland and Nicolson, 1987.

———. *Age of Revolution: Europe, 1789–1848*. Cleveland, OH: World, 1962.

Hudson, Winthrop S. "Economic and Social Thought of Gerrard Winstanley: Was He a Seventeenth-Century Marxist?" *Journal of Modern History* 18 (1946): 1–21.

Huelsenbeck, Richard, ed. *Dada Almanach: Im Auftrag des Zentralamtes der deutschen Dada-Bewegung*. Hamburg: Edition Nautilus, 1987.

———. *Mit Witz, Licht, und Grütze: Auf den Spuren des Dadaismus*. Wiesbaden: Limes Verlag, 1957.

Huidobro, Vicente. *Manifestes*. Translated from the French by Gilbert Alter-Gilbert. Los Angeles: Green Integer, 1999.

Huyssen, Andreas. *After the Great Divide: Modernism, Mass Culture, Postmodernism*. Bloomington: Indiana University Press, 1986.

Internationale Situationniste. Augmented edition. Paris: Librairie Arthème Fayard, 1997.

Jackall, Robert, ed. *Propaganda*. New York: NYU Press, 1995.

Jackson, Shannon. *Professing Performance: Theatre in the Academy from Philology to Performativity.* Cambridge: Cambridge University Press, 2004.

Jakobson, Roman. *Language in Literature.* Edited by Krystyna Pomorska and Stephen Rudy. Cambridge. MA: Harvard University Press, 1987.

Jameson, Fredric. *Fables of Aggression: Wyndham Lewis, the Modernist as Fascist.* Berkeley: University of California Press, 1979.

———. *Marxism and Form: Twentieth-Century Dialectical Theories of Literature.* Princeton, NJ: Princeton University Press, 1971.

———. *The Political Unconscious: Narrative as a Socially Symbolic Act.* Ithaca, NY: Cornell University Press, 1981.

———. "The Politics of Utopia." *London Review of Books* 25 (January–February 2004): 35–54.

———. *Postmodernism or, The Cultural Logic of Late Capitalism.* Durham, NC: Duke University Press, 1991.

Jappe, Anselm. *Guy Debord.* Translated from the French by Donald Nicholson-Smith, with a foreword by T. J. Clark and a new afterword by the author. Berkeley: University of California Press, 1999.

Jay, Martin. *Downcast Eyes: The Denigration of Vision in Twentieth-Century French Thought.* Berkeley: University of California Press, 1993.

Jelavich, Peter. *Munich and Theatrical Modernism.* Cambridge, MA: Harvard University Press, 1985.

Kadlec, David. "Pound, *Blast*, and Syndicalism." *ELH* 60 (1993): 1015–31.

Kaes, Anton, Martin Jay, and Edward Dimendberg, eds. *The Weimar Republic Sourcebook.* Berkeley: University of California Press, 1994.

Karl Marx Friedrich Engels Gesamtausgabe (MEGA). Edited by the Institute for Marxism-Leninism of the Central Committee of the Communist Party of the Soviet Union and by the Institute of Marxism-Leninism of the Central Committee of the Socialist Unity Party of Germany. Berlin: Dietz Verlag, 1977.

Kenafick, K. J. *Michael Bakunin and Karl Marx.* Melbourne: A Maller, 1948.

Kenner, Hugh. *The Pound Era.* Berkeley: University of California Press, 1971.

———. *Wyndham Lewis.* Norfolk, CT: New Directions, 1954.

Keynes, John Maynard. *The Economic Consequences of the Peace.* London: Harcourt Brace and Howe, 1920.

Kirby, Michael. *A Formalist Theater.* Philadelphia: University of Pennsylvania Press, 1987.

Knaab, Ken, ed. *Situationist International Anthology.* Translated by Ken Kaab. Berkeley: Bureau of Public Secrets, 1981.

Koselleck, Reinhart. *Vergangene Zukunft: Zur Semantik geschichtlicher Zeiten.* Frankfurt am Main: Suhrkamp, 1989.

Kott, John, R., Jr. *The Sword of the Spirit: Puritan Responses to the Bible.* Chicago: University of Chicago Press, 1980.

Krauss, Rosalind E. *The Originality of the Avant-Garde and Other Modernist Myths.* Cambridge, MA: MIT Press, 1985.

Kristeva, Julia. *La révolution du langage poétique. L'avant-garde à la fin du XIXᵉ siècle: Lautréamont et Mallarmé.* Paris: Éditions du Seuil, 1974.

Laclau, Ernesto. *New Reflections on the Revolution of Our Time.* London: Verso, 1990.

Laclau, Ernesto, and Chantal Mouffe. *Hegemony and Socialist Strategy: Towards a Radical Democratic Politics.* Translated by Winston Moore and Paul Cammack. London: Verso, 1985.

Lavin, Maud. *Cut with the Kitchen Knife: The Weimar Photomontages of Hannah Höch.* New Haven, CT: Yale University Press, 1993.

Lawton, Anna, ed. *Russian Futurism through Its Manifestoes, 1912–1928.* With an introduction by Anna Lawton and an afterword by Herbert Eagle. Ithaca, NY: Cornell University Press, 1988.

Leavens, Ileana B. *From "291" to Zurich: The Birth of Dada.* Ann Arbor, MI: UMI Research Press, 1983.

Lenin, Vladimir, Ilyich. *Collected Works of V. I. Lenin.* New York: International Publishers, 1929.

Lewis, Wyndham. *The Art of Being Ruled.* Edited and with an afterword and notes by Reed Way Dasenbrock. Santa Rosa, CA: Black Sparrow Press, 1989.

———, ed. *Blast 1.* Foreword by Bradford Morrow. Santa Rosa, CA: Black Sparrow Press, 1997.

———, ed. *Blast II.* Foreword by Bradford Morrow. Santa Rosa, CA: Black Sparrow Press, 1997.

———. *Blasting and Bombarding.* London: Calder and Boyars, 1967.

———. *Men without Art.* Edited by Seamus Cooney. Santa Rosa, CA: Black Sparrow Press, 1987.

———. *Tarr: The 1918 Version.* Edited by Paul O'Keeffe. Santa Rosa, CA: Black Sparrow Press, 1996.

———. *Time and Western Man.* Edited by Paul Edwards. Santa Rosa, CA: Black Sparrow Press, 1993.

Lista, Giovanni. *La scène futuriste.* Paris: Éditions du Centre National de la Recherche Scientifique, 1989.

Lukács, Georg. *History and Class Consciousness: Studies in Marxist Dialectics.* Translated by Rodney Livingstone. Cambridge, MA: MIT Press, 1971.

Luxemburg, Rosa. *Politische Schriften.* Edited and with an introduction by Ossip K. Flechtheim. Frankfurt am Main: Athäneum, 1987.

Lyon, Janet. *Manifestoes: Provocations of the Modern.* Ithaca, NY: Cornell University Press, 1999.

Macmillan, Margaret. *Paris 1919: Six Months That Changed the World.* Foreword by Richard Holbrooke. New York: Random House, 2002.

Mann, Paul. *The Theory-Death of the Avant-Garde.* Bloomington: Indiana University Press, 1991.

Mao, Douglas. *Solid Objects: Modernism and the Text of Production.* Princeton, NJ: Princeton University Press, 1998.

Marinetti, F. T. *Marinetti, Teoria e Invenzione Futurista.* Edited by Luciano De Maria. Milan: Mondadori, 1968.

Markov, Vladimir. *Russian Futurism: A History.* Berkeley: University of California Press, 1968.

Marwick, Arthur. *The Sixties: Cultural Revolution in Britain, France, Italy, and the United States, 1958–1974.* Oxford: Oxford University Press, 1998.

Marx, Karl. *Der achtzehnte Brumaire des Louis Napoleon.* With an afterword by Herbert Marcuse. Frankfurt am Main: Insel, 1965. First published in *Die Revolution: Eine Zeitschrift in zwanglosen Heften.* Edited by J. Weydemeyer. New York: Deutsche Vereins-Buchhandlung von Schmidt and Helmich, 1852.

———. *Das Kapital: Kritik der politischen Ökonomie.* Edited and with an afterword by Alexander Ulfig. Cologne: Parkland, 2000.

Marx, William, ed. *Les arrière-gardes au XXe siècle: L'autre face de la modernité esthétique.* Paris: Presses Universitaires de France, 2004.

Matz, Jesse. *Literary Impressionism and Modernist Aesthetics.* Cambridge: Cambridge University Press, 2001.

McClosky, Barbara. *George Grosz and the Communist Party: Art and Radicalism in Crisis, 1918 to 1936.* Princeton, NJ: Princeton University Press, 1997.

McDonough, Thomas F. "Rereading Debord, Rereading the Situationists." *October* 79 (Winter 1997): 3–14.

McGuinness, Patrick. *Maurice Maeterlinck and Modern Drama.* Oxford: Oxford University Press, 2000.

McKenzie, Jon. *Perform or Else: From Discipline to Performance.* London: Routledge, 2001.

McNamara, Brooks, and Jill Dolan, eds. *The Drama Review: Thirty Years of Commentary on the Avant-Garde.* Ann Arbor, MI: UMI Research Press, 1986.

Mehlman, Jeffrey. *Émigré New York: French Intellectuals in Wartime Manhattan, 1940–1944.* Baltimore: Johns Hopkins University Press, 2000.

Meyer, Raimund, ed. *Dada Global.* Zürich: Limmat Verlag, 1994.

Meyer, Reinhart, et al., eds. *Dada in Zürich and Berlin 1916–1920: Literatur zwischen Revolution und Reaktion.* Kronberg: Scriptor, 1973.

Meyer, Ursula. "The Eruption of Anti-Art." In *Idea Art: A Critical Anthology,* edited by Gregory Battcock, 116–34. New York: Dutton, 1993.

Miller, J. Hillis. *Speech Acts in Literature.* Stanford, CA: Stanford University Press, 2001.

Miller, Tyrus. *Late Modernism: Politics, Fiction, and the Arts between the World Wars.* Berkeley: University of California Press, 1999.

Mitchell, Bonner, ed. *Les manifestes littéraires de la Belle Époque 1886–1914.* Paris: Éditions Seghers, 1966.

Mitchell, W.J.T. *Picture Theory: Essays on Verbal and Visual Representation.* Chicago: University of Chicago Press, 1994.

Moréas, Jean. *Les première armes du symbolisme.* Edited and annotated by Michael Pakenham. Exeter: Exeter University Print Unit, 1973.

Moretti, Franco. "Conjectures on World Literature." *New Left Review* 1 (January–February 2000): 54–68.

Morrisson, Mark S. *The Public Face of Modernism: Little Magazines, Audiences, and Reception, 1905–1920.* Madison: University of Wisconsin Press, 2001.

Mosse, George L. *The Nationalization of the Masses: Political Symbolism and Mass Movements in Germany from the Napoleonic Wars through the Third Reich.* New York: H. Fertig, 1975.

Müntzer, Thomas. "Vindication and Refutation." In *The Collected Works of Thomas Müntzer.* Translated and edited by Peter Matheson, 324–50. Edinburgh: T&T Clark, 1988.

Murphy, Richard. *Theorizing the Avant-Garde: Modernism, Expressionism, and the Problem of Postmodernity.* Cambridge: Cambridge University Press, 1999.

Nadeau, Maurice. *The History of Surrealism.* Translated by Roger Shattuck. New York: Macmillan, 1965.

Nancy, Jean-Luc. *The Inoperative Community.* Edited by Peter Connor. Translated by Peter Connor, Lisa Garbus, Michael Holland, and Smona Sawhney. Minneapolis: University of Minnesota Press, 1991.

Nelson, Cary. *Manifesto of a Tenured Radical.* New York: NYU Press, 1997.

Ortega y Gasset, José. *The Revolt of the Masses.* Notre Dame, IN: University of Notre Dame Press, 1985.

Ortiz, Fernando. *Contrapunteo cubano del tabaco y el azúcar.* Caracas: Ayacucho, 1987.

Osorio T., Nelson, ed. *Manifiestos, Proclamas y Polemicas de la Vanguardia Literaria Hispanoamericana.* Caracas: Biblioteca Ayacucho, 1988.

Pagès, Alain, ed. *The Dreyfus Affair: "J'Accuse" and Other Writings.* Translated by Eleanor Levieux. New Haven, CT: Yale University Press, 1996.

Paulsen, Wolfgang, and Helmut G. Hermann, eds. *Sinn aus Unsinn: Dada International.* Bern: Francke Verlag, 1982.

Pavis, Patrice. *Languages of the Stage: Essays in the Semiology of the Theatre.* Baltimore: Johns Hopkins University Press, 1993.

Peppis, Paul. *Literature, Politics, and the English Avant-Garde: Nation and Empire, 1909–1918.* Cambridge: Cambridge University Press, 2000.

Perloff, Marjorie. *The Dance of the Intellect: Studies in the Poetry of the Pound Tradition.* Cambridge: Cambridge University Press, 1985.

———. *The Futurist Moment: Avant-Garde, Avant Guerre, and the Language of Rupture.* Chicago: University of Chicago Press, 1986.

Phelan, Peggy. *Unmarked: The Politics of Performance.* London: Routledge, 1993.

Picabia, Francis. *The Dada Painters and Poets.* Edited by Robert Motherwell. New York, Wittenborn Schultz, 1951.

———. *391, Revue publiée de 1917 a 1924 par Francis Picabia.* New edition presented by Michel Sanouillet. Paris: Elfond and Losfeld, 1960.

Plant, Sadie. *The Most Radical Gesture: The Situationist International in a Postmodern Age.* London: Routledge, 1992.

Poggioli, Renato. *The Theory of the Avant-Garde.* Translated by Gerald Fitzgerald. New York: Harper and Row, 1971.

Post, Ken. *Revolution's Other World: Communism and the Periphery, 1917–39.* New York: St. Martin's Press, 1997.

Pound, Ezra. *"Ezra Pound Speaking": Radio Speeches of World War II.* Edited by Leonard W. Doob. Westport, CT: Greenwood Press, 1978.

———. *Gaudier-Brzeska: A Memoir.* New York: New Directions, 1970.

———. *Jefferson and/or Mussolini: L'Idea Statale, Fascism as I Have Seen It, by Ezra Pound, Volitionist Economics.* New York: Liveright, 1970.

Pratt, Mary Louise. *Imperial Eyes: Travel Writing and Transculturation.* London: Routledge, 1992.

Puchner, Martin. "Manifesto-Theatre." *Theatre Journal* 54 (2002): 449–65.

———. *Stage Fright: Modernism, Anti-theatricality, and Drama.* Baltimore: Johns Hopkins University Press, 2002.

Rainey, Lawrence. *Institutions of Modernism: Literary Elites and Public Cultures.* New Haven, CT: Yale University Press, 1998.

Richter, Hans. *DADA—Kunst und Antikunst: Der Beitrag Dadas zur Kunst des 20. Jahrunderts.* With an afterword by Werner Haftmann. Cologne: DuMont, 1964.

Riha, Karl. *Dada Berlin: Texte, Manifeste, Aktionen.* In collaboration with Hanne Bergius. Stuttgart: Reclam, 1977.

Riha, Karl, and Jörgen Schäfer, eds. *Dada Total: Manifeste, Aktionen, Texte, Bilder.* With the help of Angela Merte. Stuttgart: Reclam, 1994.

Roach, Joseph. *Cities of the Dead: Circum-Atlantic Performance.* New York: Columbia University Press, 1996.

Robbins, Bruce. *Feeling Global: Internationalism in Distress.* New York: NYU Press, 1999.

Rose, Alan. *Surrealism and Communism: The Early Years.* New York: Peter Lang, 1991.

Rozaitis, William. " 'The Joke at the Heart of Things': Francis Picabia's Machine Drawings and the Little Magazine 291." *American Art* 8 (Summer/Fall 1994): 42–59.

Sabine, George H., ed. *The Works of Gerrard Winstanley.* With an introduction by George H. Sabine. Ithaca, NY: Cornell University Press, 1941.

Sadler, Simon. *The Situationist City.* Cambridge, MA: MIT Press, 1998.

Said, Edward. *The World, the Text, and the Critic.* Cambridge, MA: Harvard University Press, 1983.

Saint-Point, Valentine de. *Manifeste de la Femme Futuriste suivi de Manifeste Futuriste de la Luxure, Le Théâtre de la Femme, La Métachorie.* Edited by Giovanni Lista. Paris: Séguier, 1996.

Saper, Craig. *Networked Art.* Minneapolis: University of Minnesota Press, 2001.

Sassoon, Donald. *One Hundred Years of Socialism: The West European Left in the Twentieth Century.* New York: New Press, 1996.

Schechner, Richard. *Between Theater and Anthropology.* With a foreword by Victor Turner. Philadelphia: University of Pennsylvania Press, 1985.

Schechner, Richard. *The End of Humanism: Writing on Performance.* New York: Performing Arts Journal Publications, 1982.

Schifferli, Peter, ed. *Das War Dada.* Munich: DTV, 1963.

Schnapp, Jeffrey, ed. *A Primer of Italian Fascism.* With an introduction by Jeffrey Schnapp. Translated by Jeffrey Schnapp, Olivia E. Sears, and Maria G. Stampino. Lincoln: University of Nebraska Press, 2000.

Sellin, Eric. *The Dramatic Concepts of Antonin Artaud.* Chicago: University of Chicago Press, 1968.

Senelick, Laurence, ed. *Cabaret Performance.* Vol. 1, *Europe 1890–1920, Sketches, Songs, Monologues, Memoirs.* Translated, with commentary, by Laurence Senelick. New York: PAJ Publications, 1989.

———. "Text and Violence: Performance Practices of the Modernist Avant-Garde." In *Contours of the Theatrical Avant-Garde: Performance and Textuality,* edited by James M. Harding, 15–42. Ann Arbor: University of Michigan Press, 2000.

Sharp, Andrew, ed. *The English Levellers.* Cambridge: Cambridge University Press, 1998.

Sheppard, Richard. *Modernism—Dada—Postmodernism.* Evanston, IL: Northwestern University Press, 2000.

Sherry, Vincent. *Ezra Pound, Wyndham Lewis, and Radical Modernism.* Oxford: Oxford University Press, 1993.

Simmel, Georg. "The Metropolis and Mental Life." In *On Individuality and Social Forms: Selected Writings,* edited and with an introduction by Donald N. Levine, 324–39. Chicago: University of Chicago Press, 1971.

Solanas, Valerie. *SCUM Manifesto.* With an introduction by Avital Ronell. London: Verso, 2004.

Somigli, Luca. *Legitimizing the Artist: Manifesto Writing and European Modernism 1885–1915.* Toronto: University of Toronto Press, 2003.

Sorel, Georges. *La décomposition du marxisme.* Paris: Librairie des Sciences Politiques et Sociales, 1925.

———. *Reflections on Violence.* Authorized translation by T. E. Hulme. New York: B. W. Huebsch, 1914.

Spivak, Gayatri Chakravorty. "Can the Subaltern Speak?" In *Marxism and the Interpretation of Culture,* edited and with an introduction by Cary Nelson and Lawrence Grossberg, 271–313. Urbana: University of Illinois Press, 1988.

Stanstill, Peter, and David Zane Mairowitz, eds. *BAMN (By Any Means Necessary): Outlaw Manifestos and Ephemera 1965–1970.* Brooklyn, NY: Autonomedia, 1999.

Steiner, George. *After Babel: Aspects of Language and Translation.* Oxford: Oxford University Press, 1975.

Struik, Dirk J., ed. *Birth of the Communist Manifesto: With Full Text of the Manifesto, All Prefaces by Marx and Engels, Early Drafts by Engels and Other Supplementary Material.* Annotated, with an introduction, by Dirk Struik. New York: International Publishers, 1971.

Tafuri, Manfredo. *The Sphere and the Labyrinth: Avant-Gardes and Architecture from Piranesi to the 1970s.* Translated by Pellegrino d'Acierno and Robert Connolly. Cambridge, MA: MIT Press, 1987.

Teilelboim, Volodia. *Huidobro : La marcha infinita.* Santiago de Chile: Ediciones BAT, 1993.

Tiffany, Daniel. *Radio Corpse: Imagism and the Cryptaesthetic of Ezra Pound.* Cambridge, MA: Harvard University Press, 1995.

Trotsky, Leon. *The First 5 Years of the Communist International.* New York: Monad Press, 1972.

———. *Literature and Revolution.* Ann Arbor: University of Michigan Press, 1960.

———. *Writings of Leon Trotsky.* Edited by Naomi Allen and others. New York: Pathfinder Press, 1973.

Tuma, Keith. "Wyndham Lewis, *Blast*, and Popular Culture." *ELH* 54 (1987): 403–19.

Turner, Victor. *From Ritual to Theatre: The Human Seriousness of Play.* New York: Performing Arts Journal Publications, 1982.

Tzara, Tristan. *Seven Dada Manifestos and Lapisteries.* Translated by Barbara Wright. London: Riverrun, 1977.

Unruh, Vicky. *Latin American Vanguards: The Art of Contentious Encounters.* Berkeley: University of California Press, 1994.

Wheen, Francis. *Karl Marx.* London: Fourth Estate, 1999.

White, Gordon, Robin Murray, and Christine White, eds. *Revolutionary Socialist Development in the Third World.* Lexington: University Press of Kentucky, 1983.

White, Hayden. *Metahistory: The Historical Imagination in Nineteenth-Century Europe.* Baltimore: Johns Hopkins University Press, 1973.

Wigley, Mark. *Constant's New Babylon: The Hyper-architecture of Desire.* Rotterdam: Witte de With, Center for Contemporary Art, 1998.

Williams, Raymond. *Marxism and Literature.* Oxford: Oxford University Press, 1977.

Wolfe, Don Marion. *Leveller Manifestoes of the Puritan Revolution.* New York: T. Nelson and Sons, 1944.

Wollen, Peter. "Godard and Counter-Cinema: *Vent d'Est.*" *Afterimage*, no. 4 (1972): 6–17.

———. *Raiding the Ice Box: Reflections on Twentieth-Century Culture.* Bloomington: Indiana University Press, 1993.

Zizek, Slavoj. "Have Michael Hardt and Antonio Negri Rewritten the Communist Manifesto for the 21st Century?" *Rethinking Marxism* 13, nos. 3–4 (2001): 190–98.

Blanchot, Maurice, 22, 202
Blanqui, Louis Auguste, 20
Blast, 90, 112–131, 135, 153
Blau, Herbert, 207
Bloch, Ernst, 14, 15, 38
Bloomsbury, 110–111, 116, 117
Bogdanov, Alexander, 157
Bourdieu, Pierre, 24, 79
Bourgeoisie, 21; and criticism, 57; and
 literature 57
Bread and Puppet Theater, 247
Brecht, Bertolt, 148, 231–232, 290n18;
 his verse translation of *Communist
 Manifesto*, 52
Breton, André, 4, 103, 150, 153, 166, 167,
 197–198, 207, 225; *Immaculate Conception*,
 191–194; *Manifesto of Surrealism*, 7, 172.
 See also Trotsky, Leon: *Manifesto: Towards
 a Free Revolutionary Art*
Brik, Osip, 105
Bürger, Peter, 5, 71, 79, 273n48
Burke, Kenneth, 2, 113; his theory of dra-
 matism, 26, 118; his theory of manifesto,
 18–19, 74
Butler, Judith, 254

Cabaret: avant-garde, 5; and Cabaret Vol-
 taire, 143, 146–153, 156, 191, 239; Neopha-
 ntisches, 149
Cage, John, 232
Calinescu, Matei, 272n19
Capitalism, 21, 48, 96, 141, 146, 160, 227; his-
 tory of, 11, 57, 141; media-driven, 6, 221;
 and nationalism, 144
Carrà, Carlo, 92, 161
Castro, Fidel, 235
Caws, Mary Ann, 71
Césaire, Aimé, 188–189, 286n20
Chin, Daryl, 251
Church, 12; authority of, 13
Clarté, 183
Class: and struggle, 21; and viewpoint, 30
Clifford, James, 59, 88–189, 245
Closet drama, 118–120, 153, 196, 203–204
CoBrA, 220
Collage, 93, 123, 125, 138, 235, 283. *See also*
 Montage
Colonies, 11, 36, 47
Communist League, 20, 33
Communist Manifesto, 1; authorship of, 33;
 composition of, 19–22, 59–60; diffusion

of, 3; form of, 4, 11, 214; as genre, 11; ge-
 ography of, 47–66, 95, 260–261; influence
 of, 11; in Latin America, 167–168; publica-
 tion history of, 34–39, 59; quotations
 from, 7; reception of, 34–46; rewritings of,
 213–214, 221–222: in Russia, 95; transla-
 tion of, 51–58, 62
Conrad, Joseph, 122
Considérant, Victor, 20, 86
Constitutions, 18–19
Copernicus, 259
Corrigan, Robert, 245, 246
Cosmopolitanism, 61. *See also* Robbins,
 Bruce
Craven, Arthur, 188
Création, 171–172
Critical Art Ensemble, 243
Cromwell, Oliver, 13, 16
Cubism, 149, 160

Dadaism, 86, 101, 113, 135–165, 173; and au-
 dience, 150–151; in Berlin, 156–165; Bret-
 on's critique of, 183–185; and gender, 161;
 international, 135–145; journals of, 136; in
 Paris, 150–156; and translation, 138; in Zu-
 rich, 138, 143–148
Dalí, Salvador, 217
Damrosch, David, 54–55
D'Annunzio, Gabriele, 80
Darió, Rubén, 168
Darwin, Charles, 128
Debord, Guy, 4, 7; *Society of the Spectacle*,
 221–222
Declaration of Independence, 17–18, 30, 125,
 213; rewritings of, 218
Declaration of the Rights of Man and Citi-
 zen, 18, 19
Deleuze, Gilles, and Felix Guattari, 55, 141
Depersonalization, 7
Derrida, Jacques, 25, 287n8, 288n14
Descartes, 265n25
Diegetic theater, 120
Diggers, 13, 16–17, 213
Doesburg, Theo van, 135
Dogma Manifesto, 243
Dos Passos, John, 145
The Drama Review, 244–258, 261
Dreyfus, Alfred, 79
Duchamp, Marcel, 139, 152
Durón, Rómolo E., 169
Dürrenmatt, Friedrich, 245

International literature, 3. *See also*
World literature
International Socialist Organizations: Comin-
form, 213; First International, 37, 40, 63;
Fourth International, 44, 106; Second In-
ternational, 41, 60, 63, 81, 109, 142; Third
International (Comintern), 41, 142, 143,
144, 175, 179–181, 191, 213
Ionesco, Eugène, 245
Italian Communist Party (PCI), 79,
81–82, 144
Italy: belated unification of, 82. *See also*
Futurism, in Italy

Jackson, Shannon, 287
Jakobson, Roman, 99, 108
Jameson, Fredric, 2, 96, 116, 120, 148
Janco, Marcel, 147
Jappe, Anselm, 291n26
Jarry, Alfred, 149, 185, 189, 198
Jay, Martin, 290
Jefferson, Thomas, 125
Jelavich, Peter, 149
Jesus, 260
Jorn, Asger, 228
Joyce, James, 118, 128

Kandinsky, Wassily, 146, 148, 278n32
Kanehl, Oskar, 109
Kaprow, Alan, 232
Kautsky, Karl, 126
Keynes, John Maynard, 145
Khayati, Mustapha, 223
Khlebnikov, Velimir, 4, 97–98, 101–102, 106
Kirby, Michael, 232, 247–253
Kokoschka, Oskar, 146
Koolhaas, Rem, 230
Krauss, Rosalind, 186
Kristeva, Julia, 224
Kruchenykh, Aleksei, 97–98, 101–102
Lacerba, 93

Laclau, Ernesto, 31, 268n16.
Lautréamont, Compte de, 146, 198, 225
Lawrence, D. H., 123, 128
Le Bon, Gustave, 86
Le Figaro, 72, 94, 100
League of Nations, 145
Lef, 104–105

Lefèbvre, Henri, 221, 232
Lenin, Vladimir, 4, 77, 78, 81, 82, 125, 140,
142–146; *Imperialism*, 144; *What Is to Be
Done?* 40, 47
Lettriste internationale, 220
Levellers, 15–16,
Lewis, Sinclair, 183
Lewis, Wyndham, 3, 7, 77, 90, 107–131, 199,
225; *Apes of God*, 116; *Art of Being Ruled*,
126, 130; *Enemy of the Stars*, 118–120; *Men
without Art*, 129; and satire, 128–131; *Tarr*,
122–123; *Time and Western Man*, 126, 128
L'Humanité, 180–182
Liebknecht, Karl, 156
Lipstick Traces, 239, 243; theater adaptation
of, 240
Lista, Giovanni, 88
Liveness, 196, 201–204. *See also* Auslander,
Philip; Phelan, Peggy
Living Theatre, 207, 212, 217, 246
Ludlam, Charles, 250
Lukács, Georg, 231
Lunarcharsky, Anatoly, 104, 157
Luther, Martin, 1, 13, 14, 15, 145; Bible trans-
lation of, 13, 264n6; critique of, 13;
Ninety-five Theses, 14
Luxemburg, Rosa, 4, 42, 47, 156–158, 215;
Spartacus Manifesto, 157–158
Lyon, Janet, 4, 16, 71, 112, 115
Lyotard, Jean François, 256

Machiavelli: *The Prince*, 28–31, 45. *See also*
Manifesto: utopian
Maeterlinck, Maurice, 202–203
Mallarmé, Stéphane, 73, 74, 146, 149, 185
Man, Paul de, 254
*Manifesta: Young Women, Feminism, and the
Future*, 215
Manifestation: apocalyptic, 12, 15, 194; of un-
conscious, 2
Manifesto: authoritative, 12, 24; feminist re-
writings of, 4; first occurrence of, 12; in-
truding onto art, 6; poetics of, 4, 74; pre-
cursors of, 20; prehistory of, 11–19;
retrospective labeling as, 17; romantic, 69–
70, 89–90, 106; updating of, 35; utopian,
214; voice of, 22, 28, 42, 43
Manifesto of Futurism (*Foundation and Mani-
festo of Futurism*), 72; creation of, 72–76;
in Latin America, 168–170; in Russia,
100–101

Mann, Paul, 233
Marcus, Greil, 239,
Marcuse, Herbert, 221
Maréchal, Sylvain, 20
Marinetti, Filippo Tommaso, 3, 28, 232; in
 England, 111, 121; in Moscow, 98–102,
 274n6; *parole in libertà*, 88–93, 98, 148;
 running for political office, 4, 6; his theory
 of declamation, 87; *Zang Tumb Tuuum*,
 90–93
Markov, Vladimir, 99
Marx, Karl, 9–66; detournment of, 225–226;
 Eighteenth Brumaire, 1, 14, 58, 105, 225,
 260; *German Ideology*, 27; *Great Men of the
 Exile*, 34, 60–61; *Kapital*, 51, 235; "Theses
 on Feuerbach," 2, 27–28, 234, 237. See
 also *Communist Manifesto*
Marx Brothers, 205
Mayakovsky, Vladimir, 98, 101, 103–104, 106
McKenzie, Jon, 243
McMillan, Margaret, 145
Mehring, Walter, 140, 155–156
Miller, Tyrus, 128, 129
Modern drama, 149
Modernism: avant-garde, 6, 7; high, 6
Modernity, 166; geography of, 47; temporal-
 ity of, 7, 48, 107, 128
Modernization, 5, 96; driven by outsourcing
 of services, 6; waves of, 6
Moéas, Jean: *Symbolist Manifesto*, 70–75, 190
Montage, 159–164
Moretti, Franco, 63
Morris, William: *Manifesto of the Socialist
 League*, 41
Mosse, George L., 87
Motherwell, Robert, 187
Mouffe, Chantal, 31
Munk, Erica, 247
Münzer, Thomas, 13–15, 17, 190
Mussolini, Benito, 4, 78–81, 84–86, 97, 124.
 See also Fascism: in Italy

Nadeau, Maurice, 184
Nancy, Jean-Luc, 262
Nationalism, 82, 135–136, 141–145
Négritude, 189
Nelson, Cary, 254
Neo-avant-garde, 212, 248
New Left, 213
Nietzsche, Friedrich, 27, 130, 223
Nieuwenhuis, Constant, 228

Nin, Anaïs, 187
Nouvelle Revue Française, 196–197, 199
November Group Manifesto, 163

Odets, Clifford, 245
Ortega y Gasset, José, 127
Owen, Steven, 56

Palmieri, Mario, 85
Paris Commune, 11, 34, 37, 81
Paulhan, Jean, 199, 202
Péguy, Charles, 108
Performance Group, 207, 247, 254. *See also*
 Schechner, Richard
Performance studies, 257–258. *See also*
 Schechner, Richard
Performativity, 5
Perloff, Marjorie, 4, 71, 74
Phelan, Peggy, 201
Philosophy, critique of, 27–28
Photomontage. *See* Montage
Picabia, Francis, 108, 137–139, 152
Piscator, Erwin, 148
Plato, 202, 204
Poggioli, Renato, 71, 272n17
Popular Front, 181
Postmodernism, 96, 256–257
Pound, Ezra, 3, 7, 77, 107, 110–111, 113;
 Gaudier-Brzeska, 123–124, 163; *Jefferson
 and/or Mussolini*, 125
Primitivism, 255–256
Proletariat, 21, 30; as class for itself, 31; per-
 formative creation of, 31, 57; unified, 15
Propaganda, 3, 40, 108, 110, 113–114, 135,
 143, 160
Provos, 213, 220, 247

Rainey, Lawrence, 112
Ray, Man, 152
Rear-guardism, 3, 107, 131; ideology of,
 124–131
Revelation: religious, 12, 18, 19, 194; of god
 to the people, 12, 14; language of, 13–17,
 190. *See also* Automatic writing
Revelation to St. John, 12, 13, 14, 16, 18
Reverdy, Pierre, 166, 171
Revolution: of 1848, 1, 14, 21, 33, 34; French,
 1, 79, 86, 194, 259; German November, 81;
 Haitian, 167; history as, 21; making of, 22;

Ultraism, 171
Uneven development, 5, 6. *See also*
 Capitalism
Unruh, Vicky, 167
Up Against the Wall/Motherfucker, 220
Utopia, 38, 40, 45, 77, 200, 215, 217, 226,
 267n5. *See also* Manifesto: utopian

Vico, Giambattista, 204
Vietnam War, 212, 220, 235
Volpe, Gioacchimo, 85
Vorticism, 112–131

Wagner, Richard, 148, 196, 200,
 230–232, 251
Warburton, William, 204
Warhol, Andy, 215–216
Weathermen, 217, 220, 238, 247
Wells, H. G., 183
West, Rebecca, 117
Wilde, Oscar, 127, 129
Williams, Raymond, 2

Wilson, Thomas Woodrow, 145, 146
Winstanley, Gerrard, 13, 16–17, 190
 See also Diggers
Wittgenstein, Ludwig, 27
Wollen, Peter, 235
Women's suffrage movement, 4, 109,
 115–117
Woolf, Virginia, 277n23
Wooster Group, 251
Wordsworth, William, 69, 194
World literature, 3, 48–66; capitalist, 51.
 See also international literature
World War I, 12, 81, 93, 120, 139
World War II, 211
Worringer, Wilhelm, 126

Zimmerwald Manifesto, 144–145, 180,
 281n33
Zinoviev, Gregory, 180
Zizek, Slavoj, 168
Zola, Émile, 79
Zurich, 142–150
Zweig, Stefan, 183